100 BEST
ALBUM COVERS

FRONTISPIECE
Weasels Ripped My Flesh
The Mothers of Invention
Warner Bros. (Reprise), 1970
Design and Illustration by Neon Park

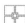

100 BEST
ALBUM COVERS

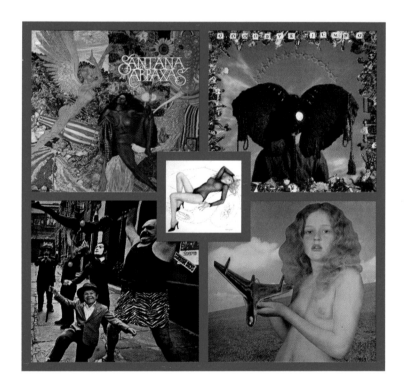

COMPILED AND WRITTEN BY STORM THORGERSON AND AUBREY POWELL

DESIGN RICHARD EVANS, STORM THORGERSON AND PETER CURZON
RESEARCH JILL WETTON AND POLLY THOMAS

DK Publishing, Inc.
LONDON • NEW YORK • SYDNEY
www.dk.com

A DK PUBLISHING BOOK
www.dk.com

Art Director Peter Luff
Senior Managing Editor Anna Kruger
Art Editor Simon Murrell
DTP Rob Campbell
US Editor Chuck Wills

First American edition, 1999
2 4 6 8 10 9 7 5 3 1

Published in the United States by
DK Publishing, Inc.
95 Madison Avenue
New York, New York 10016

DK Publishing books are available at special discounts for
bulk purchases for sales promotions or premiums. Special
editions, including personalized covers, excerpts of existing
guides, and corporate imprints can be created in large
quantities for specific needs. For more information, contact
Special Markets Dept./DK Publishing, Inc./95 Madison Ave.
New York, NY 10016/Fax:800-600-9098.

Library of Congress Cataloging-in-Publication Data

Thorgerson, Storm. 1944-
 100 best album covers: the stories behind the sleeves /
Storm Thorgerson & Aubrey Powell. -- 1st American ed.
 p. cm.
 Includes index
 ISBN 0-7894-4951-X (alk. paper)
 1. Sound recordings--Album covers. 2. Rock music--History and criticism.
I. Powell, Aubrey. II. Title. III. Title: One hundred best album covers.
NC1882.7.R62T56 1999
741.6'6--dc21 99-24280
 CIP

Color reproduced by Sonicon, London
Printed and bound in Spain by AGT, Toledo
D.L. TO: 1263 - 1999

ABOUT THE AUTHORS

Storm Thorgerson has an English degree from Leicester University and an MA in Film and Television from the Royal College of Art. A self-taught photographer and graphic designer (as many have already guessed), he founded Hipgnosis with Aubrey Powell in 1968. During the early 80s he directed videos for Paul Young, Nik Kershaw, Robert Plant, and Yes. He has also directed concert films for Pink Floyd and made documentaries for television. Storm has written several other books on album covers and has published his own work including *Mind Over Matter* and *Eye of the Storm*. He continues to design album graphics for such bands as Catherine Wheel, The Cranberries, Ian Dury, Anthrax and, of course, Pink Floyd. He lives with Barbie, her two children, five cats, and one budgerigar (God help him!).

•

Aubrey Powell was educated at Kings School, Ely, and later at the London School of Film Technique. With co-founder of Hipgnosis, Storm Thorgerson, he created covers for such luminaries as Pink Floyd, Led Zeppelin, Paul McCartney, The Rolling Stones, and Peter Gabriel. Aubrey went on to direct successful music videos and music-related films as well as major rock-concert documentaries, including Paul McCartney's *Live in the New World*. In 1994 his book *Classic Album Covers Of The 1970s* was published. He continues to write, direct, and produce and is currently working on a musical about the life of his grandfather, the composer of "Pack Up Your Troubles In Your Old Kit Bag". His main interests are his four wonderful children and long-distance sailing.

•

To Reid Miles, Barney Bubbles,
Neon Park, and Mike Doud –
gone to the great studio in the sky.

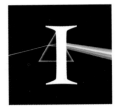

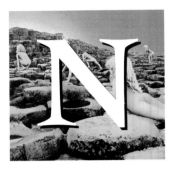

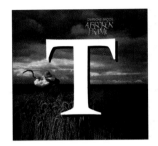

FOREWORD

Twelve inches by twelve inches. One foot square. It was the perfect size to design for, although in fact it was, of course, exactly twelve and three-eighths inches square, which left just enough room to insert a long-playing record which was twelve inches in diameter.

Among the most interesting works of art made in the 20th century were the designs for the LP record. That is what this book is about, and I hope you will find your favorite designs have been included. I personally have lots of favorite designs. I particularly like the drawings and photographs for the Blue Note jazz label and the inspired work of designer Barney Bubbles in the 70s. But there are many others to choose from.

Although I didn't do too many album covers myself (and some that I did do were eventually rejected), I was involved in the making of *Sgt. Pepper's Lonely Hearts Club Band* with The Beatles. I designed the cover for them. As I write, in the past month in a survey, conducted for the London *Sunday Times*, of the Top Fifty Millennium Masterworks, there at number 16 is the *Sgt. Pepper* cover, between number 15, Chartres Cathedral, and number 17, *War And Peace* by Leo Tolstoy. In another recent survey produced by the BBC of the 20th century's best art and design masterpieces, *Sgt. Pepper* reappears at number 13, so the LP cover has found recognition as a serious and valid art form. I have to say though that the album jacket isn't always given the credit that it deserves because it is usually an integral and important part of the record.

Looking through this book recalls that sometimes unbearable excitement of going to your local record shop to buy the latest album by your favorite singer or band and the first thing you always saw was the design on the front cover.

Peter Blake

Peter Blake, London, April 1999

We like music. All kinds of music. Music at a dance or a concert; at a party even, or in a garden. Music at home and in the car. (Though not so much in stores and elevators, and certainly not outside on mountain slopes, which was the case once in a certain Japanese ski resort.) And this liking of music is part of a really big kind of liking. It's shared, it's universal, since everybody likes music. From Boston to Beijing, people really like music, be they teenagers or grannies, priests or policemen.

And we designers like this "liking." Designing album covers is designing for music, for something intrinsically satisfying. If you're going to work in commercial art (designing for products) better here perhaps than somewhere else. Which is not to say that some musical product isn't poor or badly executed; only that, in principle, designing for music, doing album covers, is ethically rewarding. This is reflected in the freedom of album design, in its glittering diversity and unbridled enthusiasm, not, as it were, enslaved to product.

Another direct result of this general liking of music is, of course, the existence of a busy record market. Where possible, people purchase albums, especially in developed countries (materially developed, that is, not spiritually). Millions of people from Australia to Japan, from Israel to Canada, possess albums. Millions of albums mean millions of album covers, and millions of different cover designs. These designs are the visual signposts, the flags, symbols, the awning, the camouflage, the "skin" of these much loved records. They always accompany the music. They last as long. Album covers rarely change, though the band might, or the manager, or even the record company. A cover design is the icon that identifies – and is invariably associated with – the music it represents. Your favorite record conjures to mind the accompanying cover, which gets to be cherished either by association or in its own right. People like music. People like album covers. People sometimes remember album covers even when they don't like the music. Designers like album covers (mostly).

ALL FRONTS AND NO BEHINDS

Trying to represent a whole album of music visually is a very challenging exercise, especially within a single square. This is because of the obvious complexity, the shifting moods, and the emotional range which might characterize the music, whether it be the music of The Rolling Stones or Freddie Hubbard, of Led Zeppelin or of Joni Mitchell – all different, but all powerful in their own ways. So powerful that one might wonder if it's at all possible to represent the music suitably with one little design, in one single image, or by one set of graphics. So daunting is this task that fifty percent or more of all album covers avoid it by showing a picture of the musicians, which sort of answers the problem of what goes on an album cover, but usually doesn't tell you much about the music within.

Even if the design is abstract and can draw on any source or deploy any technique, it is often only possible to echo the music contents, represent only a part of the experience, just a soupçon of tone and texture. Cover designs rarely tell the whole story; instead they have to be really good at hinting. But album cover fronts are what you see most, what often determine the rest of the designs, what usually absorb the energy (and the money), and in this tome therefore, fronts is what you're gonna get.

NO BEER CANS

Music is not like other products in that it is very varied across the board (Pink Floyd are not like Blur who are not like Talking Heads); but it is also varied within its own canon (one Blur record is not like another Blur, unless you're a professional critic). This huge variety, this perpetual individuality, stimulates and allows an equally varied and individual world of design. Album covers are a form of packaging, to be sure, but unlike most other forms they are free to vary, to experiment, and to be radical.

Album covers can be outrageous, subtle, nostalgic, innovative, direct, up-front, elegant, or humorous. They can use any technique from acrylic to collage, from linocut to photography. And they can be executed by a wide range of artists, from many different backgrounds, young or old, educated or homespun, fastidious or reckless.

And finally, album covers don't have to show the actual product! Instead, they can reflect all the feelings and ideas that the product entails. Cover designs depict what the product means, not what it physically is. Cover designs attempt to represent the imagination, the passion, and the artistry of the music – not feature the flat, round pieces of silver or black plastic. Sounds obvious, but what a treat for the commercial artist. No beer cans or cornflakes to show, no sneakers or toilet paper. What a pleasure. What an honor.

AND NO TURKEYS

But there are, sadly, lots of bad album covers. Notwithstanding all the possible virtues there are some real turkeys. Whether this is the law of averages, the demands of the business (as record company people like to say), the ego whims of recording artists who insist on a dull picture of themselves (or on their relatives or household pet designing it). Or bad designers (hush my mouth). Or even unkind circumstance, or any combination of these and other causes is, of course, a mystery not to be unraveled now, thankfully, because… well, because there are no turkeys here!

This book, our humble offering, contains absolutely no turkeys because this book contains the 100 best covers ever. We swear it. Herewith, the greatest album covers of all time. The 100 best designs we have ever seen (and we've seen some dogs, I can tell you, including some of our own). They are also, just by chance, our 100 favorite album covers of all time. What we consider to be the 100 best looking, visually innovative, graphically

The Art Of Noise – In No Sense? Nonsense!

dynamic, historically influential, and in all probability the best representations of the music they embellish! And that, in our opinion, is a fact.

Herewith, the definitive list (not that we're really into lists, you understand). The front runners. The top bananas. The 100 best album covers, that's what this book is.

A MATTER OF TASTE

Oh yeah? Says who? And more to the point, by what right? By what criteria? What factors determine the 100 best covers, or 100 best of anything, unless it's some form of objective measurement or cold statistic. Like many lists, this one is largely a matter of taste. That's right, isn't it? A matter of taste.

But this matter of taste is a tasty matter. When it comes to issues of design, it is the taste that matters. It is arguably what matters most. Dissenting voices somewhere in the "corridors of design" clamor that it's communication – the effective passing-on of information – that matters most. But then, that's only their opinion, or taste. (And very difficult to assess in most cases.)

But lest this issue of taste, our taste, were to become too immodest, or too narrow, or even too forgetful, while compiling this book, it was moderated by several other factors. First, we elicited the opinions of other designers, either by direct request or through the pages of previous album cover books, especially *Album Cover Album*, where preferential choices were indicated. We'd like to thank (and blame) in no particular order, Peter Curzon, Richard Evans, Peter Christopherson, Rob O'Connor, Vaughan Oliver, Roger Dean, David Howells, Nigel Grierson, and Paul Maxon, to name but a few, for guiding and influencing our selection.

REASONS TO BE CHOSEN

Second, the reasons for selection were more than just taste, but an admixture, a cocktail of "qualifications," not entirely subject to rational scrutiny. For example, worthy designs might be innovative ones – those breaking new ground. The work of Reid Miles at Blue Note in the late 50s/early 60s is a good example, as is 13th Floor Elevators from the psychedelic era. It might be that a cover was humorous, like *Lovesexy* (Prince), *Licensed To Ill* (The Beastie Boys), or *Nevermind* (Nirvana), or beautifully illustrated, like *Aoxomoxoa* (by Rick Griffin) and *Tales From Topographic Oceans* (by Roger Dean). Sometimes the selection procedure was tainted by nostalgia (*Candy-O* or *Some Girls*) or by the evocation of youth, like *Crush* (OMD). It could be that certain designs were considered to be the best of their kind, like the portraits of Patti Smith or Laurie Anderson, or the haunting photographs for Wes Montgomery (by Pete Turner) or Bill Evans (by Tony Frizzel), or the graphics of ABC (by Keith Breeden).

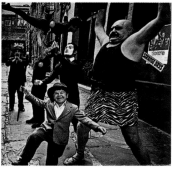

Some designs were chosen mainly for their bizarre qualities, like *Strange Days* (The Doors) by Bill Harvey and *Nothing's Shocking* by Perry Farrell, and most notably, Little Feat by the late but much loved Neon Park – not to mention his surreal *Weasels Ripped My Flesh* (The Mothers Of Invention). Other designs were chosen for their sense of controlled chaos, i.e., *Kings of Noise* (Slammin' Watusis) and the undiminished *Never Mind The Bollocks Here's The Sex Pistols* by Jamie Reid. Others still for their clean, minimalist qualities like *Closer* (Joy Division) by Peter Saville and *Fear Of Music* (Talking Heads) by Jerry Harrison.

Conversely, some album covers were chosen mainly for excessiveness, like The Stones' *Satanic Majesties*, or for their provocative nature, like *Blind Faith* (by Bob Seideman) or *Sticky Fingers* (by Andy Warhol); or for their graphic appeal, like *Free* or *The Dark Side Of The Moon*. Or for the use of typography, like *Little Johnny C* (Reid Miles) or *Home Is In Your Head* (Vaughan Oliver); or for audacious color, like *Hapshash And The Coloured Coat* (Michael English)

The 13th Floor Elevators – The Psychedelic Sounds of…
The Doors – Strange Days

and *The Pacific Age* (OMD) by Mick Haggerty. Some cover designs were chosen mainly for their exotic abundance – *Agharta* (Miles Davis) by Tadanori Yokoo and *Liquid Love* (Freddie Hubbard) by Lou Beach – while others were chosen principally because of their shape (*Ogdens' Nut Gone Flake*) and some, dare we say, just because they were Japanese (*Mermaid Boulevard*), and what kind of reason is that, you might ask.

A much better, and more easily substantiated, reason for inclusion was do-it-yourself, where the album cover was designed and, more particularly executed, by the recording artist themselves. Though this may seem to bring the viewer closer to the source and could be seen to represent the music more clearly and directly, it does not necessarily follow. The designs still have to work well in and of themselves – which we believe to be true for both Captain Beefheart (*Doc At The Radar Station*) and the gossamer Joni Mitchell (*Mingus* and *The Hissing Of Summer Lawns*).

However, no cover design was selected for one single reason. Instead, it was for a few reasons – some unspoken interweaving of the aforementioned qualities, underpinned, as ever, by our taste. In the end we had to like them. Despite the rational arguments that could be mustered in their favor, we needed to appreciate them primarily as fine examples of graphic design. Our final corrective, as it were, was to compare our 100 best with other "best selections" to see if we were either completely insane, i.e., zero correspondence, or

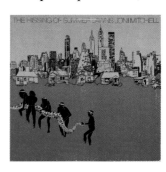

horribly predictable, i.e., total correspondence. We mention perhaps one of the most authoritative lists, i.e., *Rolling Stone's* 100 best covers, issued in 1993 and chosen by respected art directors John Berg, Tony Lane, and Chris

Austopchuk, among others – and we found a fifty percent correspondence! What a result. Perfect. QED. Our own selection is neither too mad nor too common.

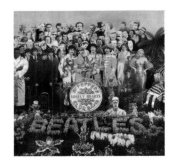

ANNOTATION

What this selection is not based upon, ironically, is the annotative potential of cover designs. When approaching this project we had a few misgivings along the lines of "Oh no, not another book on album covers." But when we thought about it some more, and did some rough specs on *Sgt. Pepper*, *Sticky Fingers,* and a couple of Floyd covers, we found that the annotated system worked reasonably well. Something about record sleeves lent itself to the process of information bytes (i.e., annotation). Some quirky mixture of technical detail and anecdote, of craft and scandal, of diligence and excess made annotation very suitable. These infobytes can tell you how covers were created, provide insights into the ideas behind the design, uncover difficulties and arguments, and reveal aspects of the music or tell lurid tales of musician behavior. These infobytes can also say something about the complex relation between design and music.

In short, album cover art is topical, glamorous, and artistic, not too precious nor hidebound. Album covers are not sacred or venerable (like old masters), nor so disposable or branded as cereal boxes. Album covers are good for annotation – sort of newsworthy, but at the same time nice to look at – and annotation is good for album covers (provided of course that the leader lines are not too obtrusive nor that the pieces of information are too crowding).

Annotation made this project viable, but album covers were not selected because they were obvious candidates for the annotated treatment. And that is because most album

Miles Davis – Agharta The Beatles – Sgt. Pepper's Lonely Hearts Club Band
Joni Mitchell – The Hissing Of Summer Lawns Pink Floyd – The Dark Side Of The Moon

covers have plenty to say, usually a case of more rather than less infobytes. It is also because the annotation might have more to do with the volubility of designers and musicians, more to do with rigorous research, than with the merits of the actual cover. Occasionally, the newsworthiness might nudge us in one direction more than another (*Sticky Fingers*, for example), but we are not even too sure of that. However spicy the stories, however rewarding the researched information, it was always an issue of taste – we had to like them. In fact, we had to lose some really great stories (*Electric Ladyland*) because the cover design was not considered good enough. Any book (even an encyclopedia of 23 volumes) is by definition a limited selection. Something has to go. Plenty of candidates cannot make the final hurdle, and many favorites fall by the wayside. It's heartbreaking, but nevertheless it just has to be.

Are we men, or mice?

ATTITUDE

We are a bit mouselike, if not uneasy, about the politics of cover design (if we ever get to know them) and about what attitudes, if any, might lie behind. For example, *Two Virgins* by John and Yoko is an interesting case, since the design and photography are rather pedestrian: nothing to shout about. What is to be admired is the attitude, the implications of the nudity. Is it a statement, possibly a very brave statement, about ordinariness and mortality? Is it a blatant swipe at the establishment? Or, more cynically, a daring piece of PR ("this will get us talked about")? Similar but different is the infamous Sex Pistols' lurid attack in lurid colors on conservatism in general and the hypocrisy of the music business in particular. And even if the ransom lettering was not original, it was appropriate and hugely effective. Different but similar is *Modern Life Is Rubbish* (Blur), where the meaning and implications of the front painting, composed of irony and pastiche, nihilism and

nostalgia, are what's important, not how original or custom-made. In this instance (as perhaps with *Road Song* or *The Fat Of The Land*) the image was taken from somewhere else (i.e., a photo library) and not initially conceived for the music. Such art direction (as it's called) is to be applauded, but not too much, for it sends originality and commissioning further down the priority list, and puts new imagemaking at a premium (and the likes of us out of a job). What commends the Blur cover (by Stylorouge) is the attitude (or politics), and the precision of choice. What commends The Sex Pistols' cover is the attitude, and the verbal acuity; and what commends *Two Virgins* is the attitude, and its glaring honesty. Attitude is what also commended *Atom Heart Mother*; but there were more than enough of our own designs in the selection, so it was excluded. (We will return to this megalomania later.)

POPULAR AND NOT SO POPULAR

Another reason for nonselection was the question of popularity. Our publishers, God bless them, probably thought that famous covers would be preferable – or covers by famous bands (one is never sure which is meant) – thus appealing to a theoretically larger audience and so theoretically selling more books. But what is a famous cover? Which bands are famous? Do famous bands have famous, or even good, album covers anyway? The popularity of records themselves can be measured in part by the number they sell. It could be argued that covers of the biggest-selling albums, though not necessarily the most effective or the best designed, would be the best known and therefore the most famous. Unfortunately (or not) the top-selling albums have some of the worst designed, most boring covers ever conceived. In fact, the British Phonographic Industry's list of top ten best-selling albums includes only two covers featured in this book *(Sgt. Pepper* and *The Dark Side Of The Moon*), while the other

Pink Floyd – Atom Heart Mother

eight include Michael Jackson and The Bee Gees. Need we say more. (In fact, The Bee Gees have two albums in the Top 10 of all time, *Grease* and *Saturday Night Fever*, which is an extraordinary testament to their musical talent, to their very enduring popularity, and nothing whatsoever to do with their truly awful taste in visual design.)

Perhaps these statistics only go to show that people, thankfully, buy records for the music not for their covers. Two Bee Gees and a Whitney Houston cover underline the general observation that popularity does not necessarily mean anything other than that. Popular is popular, not good, nor innovative, nor artistically challenging. Fame or infamy is a separate matter. The Sex Pistols, Madonna, Jimi Hendrix, Guns 'n' Roses, Kiss, Oasis, Ice-T, Michael Jackson, may all have covers that became famous (or notorious) for their crudity, salaciousness, or megalomania. Famous cover designs may just mean contentious content, or, worse still, their fame is equated with the status of the recording artist. It is both too complex and too trivial to consider notoriety alone and so, dear reader, you will find both well-known and not so well-known examples of the designer's art in this book.

You will also, we guess, find some favorites, and some not so favorite. Impossible to satisfy everyone, of course; impossible for our selection to be precisely your selection, for that would be seriously spooky. But you may ask why some more obvious candidates have been omitted (comments in parentheses are just our opinion, that's all). Where is *Rumours*, for example (indifferent concept)? Or *Tubular Bells* (ugly technique)? Where is *Blues For Allah* (dull illustration) or *Bridge Over Troubled Water* and *Born To Run* (average portraits)? Where is *Exile On Main Street* (borrowed material) or *Ladies and Gentlemen We Are Floating in Space* (difficult to represent 3-D design in a 2-D book)? Where is *Electric Ladyland* (emotionally

offensive) or the *White Album* (it's only white, isn't it?)? Just as the major reason for inclusion is taste (our taste), so taste (our taste) is the major reason for exclusion. If art wasn't about taste, all opinions might be the same (how boring).

MUSIC A CLOSE SECOND

Not only are there debatable individual omissions, but there are also vast areas of music genres that have been neglected. We looked but we could not find, for example, any country-and-western album covers (too many portraits), nor any rap (also too many portraits), hardly any techno (too computerized), or classical (found photos or old paintings), or heavy metal (simplistic illustration) – much as we may like or dislike the music in question or respect what the fans seem to prefer. Great characters like James Brown or John Lee Hooker, great bands like REM, Eagles, or Genesis, cult figures like Syd Barrett or Philip Glass, female vocalists like Diana Ross or Celine Dion, pop phenomena like Boys II Men or The Spice Girls and so on and so forth just didn't cut it for us when it came to the designs on their covers.

The focus here, if you're in any doubt, is about how something looks – about graphic design, about imagery, and how that imagery was produced, and how it refers to the intentions of the recording artists. The focus is on the designers and their craft: in this instance the music is secondary, even though we love it. It is partially because we can't easily put music in a book, partially because plenty of other books prioritize it, and partially because the relationship of music to design is hard to pin down. We suspect that good design reflects the music it tries to represent, but we can't be sure. Some musicians are disappointed by their album covers even though their fans, and their designers, may not be. All we're trying to say is that the connection of visual to aural, of design to music, and how successfully

that is accomplished, is an arbitrary matter – and not that pivotal in a visual book. Let's face it, a lot of great albums have lousy covers and some great covers adorn lousy music.

We tried hard, therefore, not to focus on the kind of music (what genre) or whether we liked it. We're not even sure if we know some of it. Johnny Coles, System 7, and many others have not (greatly) affected our choice, though it was certainly one of the questions we asked designers. We asked some musicians, too. We did not take into account commercial criteria (did a cover help sell records?) because we were not that interested, nor do we think there's any way to assess it. We tried to ignore celebrity issues – who was the designer, painter, photographer, or recording artist – in order to focus on the art itself and avoid being swayed by the chimeras of fashion and reputation.

Even so, some great covers may have escaped our attention, some excellent designs may have slipped through the net. We trawled the waters pretty thoroughly; but as the old fisherman says, there's always one that gets away (which old fisherman is that?). One ironic example is Dexter Gordon's *Dexter Blows Hot And Cool*, which "got away" in the sense that we couldn't find an actual cover to reproduce, the designers are dead and gone, as is dear Dexter, and the record company evaporated in 1960. A second example is Ry Cooder's *Into The Purple Valley*, where Mr. Cooder, through his punctilious lawyer, denied permission, even though the cover has already been published in several other books. Very odd.

NOSTALGIA

Much more complex is the thorny issue of nostalgia and its effect on the selection process. Nostalgia in all its forms – nostalgia of technique, where a design is executed in an old style; nostalgia of content, where the subject matter is from the past, particularly one's own; and nostalgia where the cover design reminds you forcibly of the time when you first heard the music. Your humble authors fought valiantly against these specters, not always successfully, enduring many an argument, sometimes descending into squalid bickering and bitter recrimination. Oh how we tried to avoid it and ensure that the selection and the annotation that ensued were as artistically integral, or as "critically subjective," as possible. But, then, nobody's perfect; and anyway, nostalgia is a thing of the past.

EGOTISM

Talking of "perfect" brings us to a touchy subject, namely the inclusion of some of our own work. By way of an apology we'd like to come clean and own up to putting some of our own album designs in this book. Such nerve! What egotism! What immodesty! In our defense, which already feels a little ragged, we'd like to say three things. First, if you can't be good to yourself you can't be good to others (this is from my mom). You gotta believe in yourself, lest others do not; and if we didn't think that three or four of ours were in the best 100, we might as well have thrown in the towel. Secondly, other designers (kindly), and other sources, like *Rolling Stone,* (unknowingly) suggested including a few of our own cover designs. And thirdly, egotism and megalomania are part of the very stuff, the underlying fabric, of popular music. It is only appropriate, if not reasonable, for us to be full of ourselves, and therefore unreasonable.

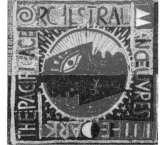

System 7 – 777 Dexter Gordon – Dexter Blows Hot And Cool
*Johnny Coles – **Little Johnny C** Orchestral Manœuvres In The Dark – The Pacific Age*

NOW AND THEN

It is hard to include many album covers from recent years, basically because not enough time has elapsed to decide how good they really are. One also wants to counter fashion or currency because it is so biased in the here and now, and to avoid the influence of overexposure to news and hype. One will hear, via the ubiquitous media, more about current musicians than the old farts we used to love. Oasis command more air time than Little Feat, Celine Dion more column space than Patti Smith; but your humble authors managed to both include the latter two for brilliance, and exclude the former two for mediocrity.

 The other side of this time coin is to live in the past and ignore the present. Conscious efforts were made to counter this failing by soliciting the opinions of younger designers, though not necessarily agreeing to their every suggestion (or even very many, lest they get uppity). A failing we may not have countered so well is our own pictorial bias. We are image people. We like pictures and may have given less space to graphic or typographical design than we should. But then again, Reid Miles, Peter Saville, Neville Brody, and Vaughan Oliver are here, so things are not so bad.

FINALLY...

We commend this book to your attention because album cover design is full of excellent work, because album covers are an integral part of pop culture, because lots of people possess album covers, and because album art is a barometer of the times. We commend this book because album design is a place to see innovative techniques, because it's our peculiar niche and we love it, because album art may soon become a thing of the past (as the Internet takes over), and because there are great visuals to see, memories to rekindle, stories to enjoy, details to be absorbed, characters to meet, and scandals to savor. After all, this book contains the best 100 covers ever.

And that, in our opinion, is a fact.

Storm Thorgerson and Aubrey Powell (formerly Hipgnosis)

ONE HUNDRED ALBUM COVERS

BIG APPLE ELECTRIC ZAP
"The painting was called The Annunciation and was done in the summer of 1962 in Mallorca. It was the first picture that I painted after my initial New York awakening. I was 28 years old and had been studying with Fernand Léger and Ernst Fuchs in Paris in the 50s. You can feel the sudden burst of the Big Apple electric zap in the composition. Carlos Santana discovered the painting eight years later in a magazine and thought it appropriate for his album cover." – *Mati Klarwein*

INFLUENCES
Mati Klarwein: "The idea came from God. Both Christ and Buddha were immaculately conceived and the painting is of their Annunciation. The main influence on my work is early Renaissance art and oriental kitsch."

CARLOS SANTANA
was attracted to the work by the image of the conga drum between the angel's legs, and by the vibrant colors of the whole painting.

ANNUNCIATION
The painting is derived from the story of the Archangel Gabriel announcing to the Virgin Mary that she will give birth to Jesus. A winged, crimson Angel Gabriel descends from heaven astride a conga drum. Drums are always used to announce something – in Africa they are a medium of communication.

EROTIC TENSION
The model for the Angel Gabriel was a local Mallorcan girl who posed, one knee on a chair, her hand holding a string hung from the ceiling. Mati: "I needed the erotic tension of a live model inside my studio. Those muscles she acquired carrying vegetables to market."

SANTANA, Abraxas

WHEN CARLOS SANTANA bought the *Abraxas* cover painting from a US gallery, the German painter Mati Klarwein was partying with Timothy Leary in Tangiers. Mati recalls: "I have seen the album cover in a shaman's hut in Niger, in a Rastafarian's ganja truck in Jamaica, on the floor of the Duchess of Bedford's living room in Woburn Abbey, on the set of *Miami Vice*, and in the bar of the Darling Massage Parlor in Bangkok. Few people know who painted it. I am the most famous unknown painter." And to this day Mati has never met nor spoken to Carlos Santana.

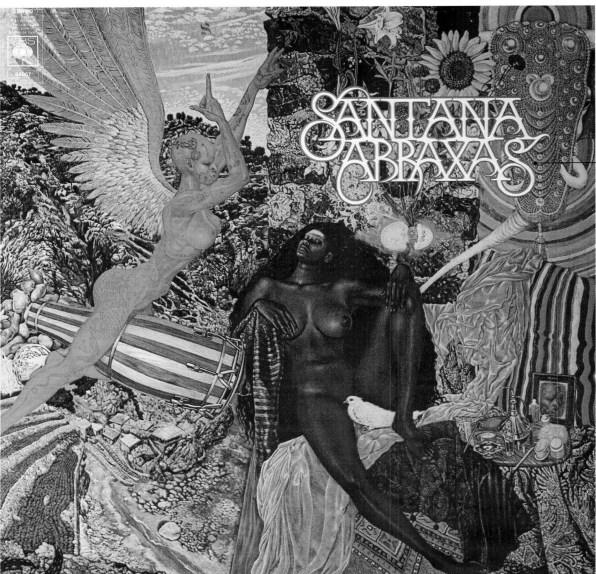

THE TYPE and logo were designed by Bob Venosa, an artist living in Boulder, Colorado.

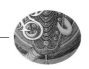

BUDDHA is represented by the elephant inseminating his own mother with his trunk so that he can be born into our world as a human Buddha or Christ.

THE BLACK Virgin Mary was modeled by Mati Klarwein's girlfriend, Jill, who came from Guadeloupe.

SELF-PORTRAIT
On the back cover, Mati included a portrait of himself wearing a straw hat.

WORK OF ART
The work was painted with oil paints and casein tempera on canvas glued to a wooden board. All the characters are painted from life.

SPECIFICATION
- *Artiste* Santana
- *Title* Abraxas
- *Design* Mati Klarwein
- *Typography* Bob Venosa
- *Record Co.* CBS, 1970

THE ARTIST...
*Mati Klarwein: "When Carlos Santana wanted this painting for the cover of Abraxas, it did me the world of good. This painting knocks the mustache off the **Mona Lisa** for it's popularity."*

...AND THE ARTISTE
Carlos Santana noted that the cover fitted with the music like a hand in a glove. "When I saw it, I discovered that music and color are food for the soul – and this is a great feast."

MATI KLARWEIN
Mati Klarwein was born in Hamburg, Germany, in 1932 and emigrated to Palestine in 1934. He has led a nomadic life, and his travels all over the world have greatly influenced his painting. He has had solo exhibitions of his work in galleries in Paris, Washington, Palma, New York, California, Switzerland, Madrid, and Barcelona. Among the many artistes who have commissioned his paintings for album covers are Miles Davis, Earth, Wind, and Fire, Buddy Miles, Jimi Hendrix, and Jerry Garcia.

JOHN SURMAN, The Amazing Adventures Of Simon Simon

THE QUIET POWER OF THIS COVER DESIGN for jazz clarinettist John Surman says a lot about design and, surprisingly, the music business. The image is low key but evocative. It has a touch of mystery yet remains simple. Very "uncommercial" in normal business parlance. The layout is cool and measured to let the photograph breathe and to reflect the measured intensity of the music. No brash titles here. It also happens to reflect the philosophy of the record label ECM with regard to this product and all their product (see page 152). Though the photograph was not originally intended for this album, John Surman thought it so apt he changed the title and thereby appropriated the image. Sometimes off-the-rack is as good as hand-tailored, especially in the hands of sensitive artists.

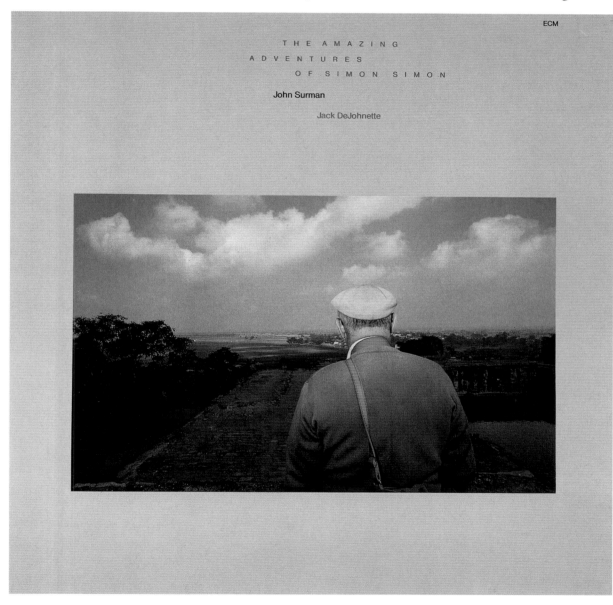

THE AMAZING

ADVENTURES

OF SIMON SIMON

John Surman

Jack DeJohnette

ECM

MANFRED EICHER of ECM chose this Christian Vogt photograph for the cover. It was one of a series taken between 1977-78 called *Onlookers*. No brief was given to Susan Nash but she felt great respect for Manfred – he is as sensitive visually as he is musically.

THE BLUE border had two functions – first, that the photographic image was presented as a framed work in itself. Second, the light blue color was chosen to echo the color of the figure's hat in the photograph – giving another dimensional play within the image itself.

ONLOOKING AT INDIA Christian Vogt took the photograph in India in 1978. The figure is his father, but Vogt says that it is far more significant that he is a Western figure in an Indian landscape. The figures in the Onlookers series were lit by flash so that they integrate on the same plane as the background – conceptually as well as visually. None of the images in this series are manipulated. The red strap over his shoulder is incidental but was understood as an important element within the image.

AZIMUTH *The Amazing Adventures Of Simon Simon was the first record cover that designer Susan Nash and photographer Christian Vogt had produced for ECM. Another Christian Vogt photo was later used for ECM's release Azimuth 85, by Azimuth.*

THE BACK COVER
"I still like the cover, and through this project I became aware that back covers are a different problem to front covers but equally important." – Susan Nash

CHRISTIAN VOGT AND SUSAN NASH

Born in Switzerland in 1946, Christian Vogt has been as an independent photographer since 1969. His work has been exhibited in galleries worldwide and is represented in many private and public collections. He has produced several books of his work, and currently lives in Basel, Switzerland. Susan Nash studied at Camberwell School of Art, UK, and at the University of Atlanta, where she gained a BA in Fine Arts. She designed exhibitions and worked as a graphic designer there and has worked with Christian Vogt since 1982.

SPECIFICATION

- *Artiste* John Surman
- *Title* The Amazing Adventures Of Simon Simon
- *Design* Susan Nash
- *Photography* Christian Vogt
- *Record Co.* ECM, 1981

MILES DAVIS, Agharta

THE ART OF TADANORI YOKOO was once described by the Japanese writer Yukio Mishima as "Popcorn Spiritualism." It was a flattering acknowledgement of his ability to link pop culture with Japanese tradition. The cover for Miles Davis' *Agharta* album was a perfect example of this skill, and suited the "out of this world" quality of Miles' trumpet playing. Critics of the album cover thought that Tadanori Yokoo's work had been inspired by the use of psychedelic drugs, popular at the time, but this was not so. His ideas came naturally, from the study of meditation and yoga. The spiritual influence, combined with the use of everyday tourist postcards, created an edgy and disturbing atmosphere, both in content and composition.

DURING VARIOUS periods in history the supermen of Agharta came to the surface of Earth to teach the human race how to live together in peace and save us from wars, catastrophe, and destruction. The apparent sighting of several flying saucers soon after the bombing of Hiroshima may represent one visitation. The UFO shown here symbolizes a similar communication.

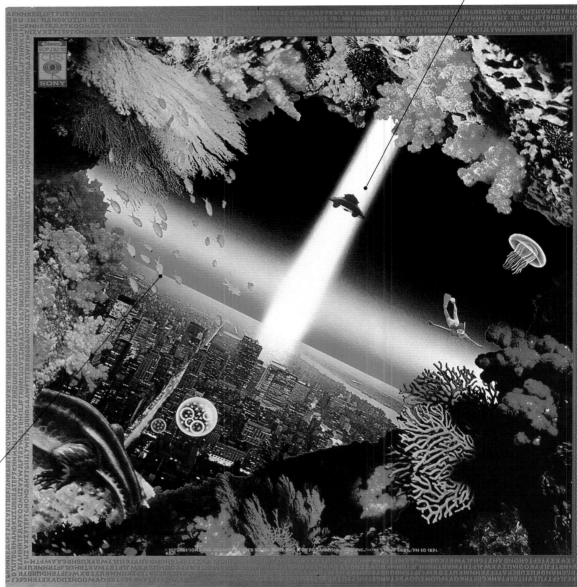

TADANORI YOKOO

Tadanori Yokoo was born in 1936 in Nishiwaki, in the Hyogo prefecture of Japan. In 1965 he won his first major art awards at an animation festival and a graphic design exhibition. The following year he staged his first one-man exhibition and by 1969 was exhibiting internationally. He also became a TV and movie star, but then left Japan for the US to concentrate more on his art. By 1981 he was a full-time painter. Among his countless credits are a one-man show in 1972 at the Museum of Modern Art in New York, the 13th Paris Biennial in 1985, the 45th Venice Biennial in 1993, and in 1997, the prestigious Mainchi Art Award in Tokyo. Tadanori Yokoo is regarded as Japan's foremost Pop artist.

SCHOOLS OF brightly colored fish, jellyfish, and coral reefs suggest that Tadanori Yokoo had combined Agharta with the legend of the lost underwater world of Atlantis, believed by some to be one and the same.

THE ENTRANCES TO AGHARTA
The inner spread includes images of the Agharta supermen – winged gods who guard the secret tunnels and entrances to the subterranean world. Legend has it that these tunnels crisscross the jungles of Brazil and Peru, the mountains of Tibet, Scandinavia, the Egyptian deserts, and the mountains of Greece.

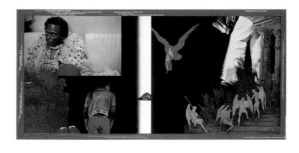

THE HOLLOW EARTH

*"At the time I was into meditation and yoga, and was reading many books about the spiritual world. I was very influenced by Indian culture. I meditated and listened to Miles Davis' tape and thought about a book I had read by Raymond Bernard called **The Hollow Earth**. It is a legend about a land called Agharta, which exists in a huge cavern in the center of the earth. But for me, Agharta could be down there somewhere under the sea like Atlantis or even hidden in the jungle like the lost city of El Dorado." – Tadanori Yokoo*

SPECIFICATION

- *Artiste* — Miles Davis
- *Title* — Agharta
- *Design* — Tadanori Yokoo
- *Photography* — Tadayuki Naitoh and Shigeo Anzai
- *Record Co.* — CBS, 1975

NO MEETING

*"Some artists you meet and some you don't I am a very good friend of Carlos Santana, who I have worked with on several occasions, but with Miles Davis I never ever met him. I named the picture **Agharta** and he accepted that as the title of the album."* – Tadanori Yokoo

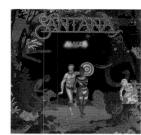

LOTUS

*The theme of the Subterranean World of Agharta appears in other works by Tadanori Yokoo, such as on the cover of **Lotus – Carlos Santana Live in Japan**.*

THE RED SUNBURST FLAMES

rising out of the city of Shamballah represent the mighty power of Agharta.

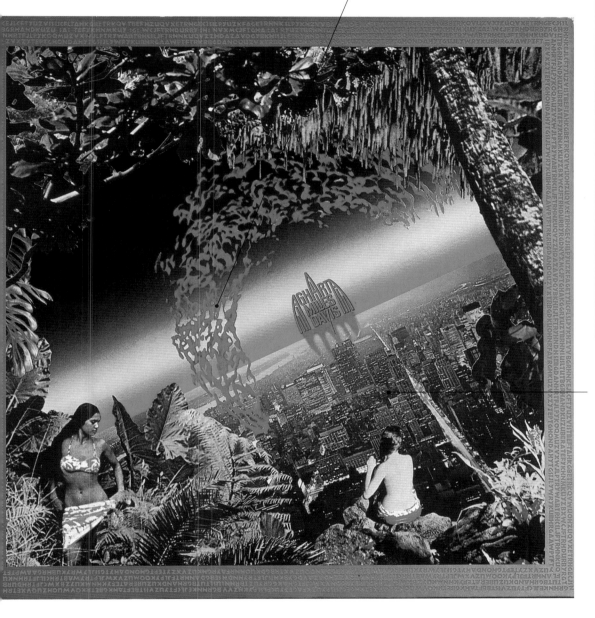

AGHARTA

*In his book **The Hollow Earth**, Raymond Bernard describes Agharta thus: "The word 'Agharta' is of Buddhist origin. It refers to the existence of a Subterranean World or Empire that all true Buddhists fervently believe in. They also believe that this Subterranean World has millions of inhabitants and many cities, all under the supreme domination of the subterranean world capital, Shamballah, where dwells the Supreme Ruler of this Empire, known in the Orient as the King of the World. It is believed that he gave his orders to the Dalai Lama of Tibet, who was his terrestrial representative, his messages being transmitted through certain secret tunnels connecting the Subterranean World with Tibet, the entrance to this world being guarded by Tibetan lamas.*

Similar mysterious tunnels reputedly honeycomb Brazil and Peru, and a tunnel is believed to connect with the secret chambers of the Pyramid of Gizeh by which the Pharaohs established contact with the gods or supermen of the underworld… These supermen represent descendants of the lost continents of Lemuria and Atlantis, as well as the original perfect race of Hyperboreans, the race of gods."

SHAMBALLAH

The postcard cityscape is of Shamballah, the City of Mystery (Shamb Allah means the "Temple of the Gods") the subterranean capital of Agharta. It is also known to the Tibetans and Mongols as Erdami.

ART PRODUCTION

"My work is a combination of collage, airbrushing, and painting. I like collecting postcards, and on this cover for Miles Davis I used some that I had brought back from Tahiti and New York. When the artwork is finished I don't send the original work itself to the client. I have my own printing plates made in Japan because it's easier to check my work. I don't touch the work once it's done, I am only concerned with the quality of the plates." – Tadanori Yokoo

POSTERS

Tadanori Yokoo was well known for his posters combining old-style Japan with Western pop culture.

THE STAR AND AGHARTA

Tadanori Yokoo: "When I was about 29 I suddenly became very popular, like a superstar. I had to do interviews for TV and radio, and was even offered parts in the movies – one for the famous Japanese director Nagisa Oshima. This actually became a nuisance as I became so busy doing other things that I had no time to create my art. So, I decided to escape to America for a while. I did quite a lot of work in the States and not long after I returned to Japan I received a phone call from Miles Davis. He had seen my work published somewhere, and decided that he wanted me to create an album cover for him."

THE GRATEFUL DEAD, Aoxomoxoa

RICK GRIFFIN WAS A CALIFORNIA SURFER devoted to the sun, ocean waves, and a glorious California horizon. His work – which ranged from the character Murphy in *Surfer* magazine to the masthead for Jann Wenner's *Rolling Stone* – is familiar to many. Rick loved music, be it rock 'n' roll or bluegrass, and even played in a band. With his long blonde locks he was the archetypal hippie surfer, and his psychedelic posters of vivid colors and liquid letterforms set a standard that helped establish the West Coast style and epitomized an era. Sadly, he is no longer with us, but his art certainly is and serves to remind us that in Rick Griffin's world the cosmic wave will unfurl forever onto a golden shore.

THE DESIGNER
Rick Griffin rose to fame with his psychedelic posters for the Avalon Ballroom and the Fillmore West in San Francisco during the late 60s. Jerry Garcia of The Grateful Dead made his acquaintance backstage at one of their concerts.

IDA GRIFFIN:
"The Grateful Dead hired Rick based on his reputation for his concert posters. They told him he could design anything he visualized and was given total artistic freedom. The guys in the band would OK the final artwork, but basically they just loved his style."

MADAM, I'M ADAM
It was Rick Griffin that came up with the title Aoxomoxoa. At the time, he was very much into palindromes – words and phrases that read the same forward and backward.

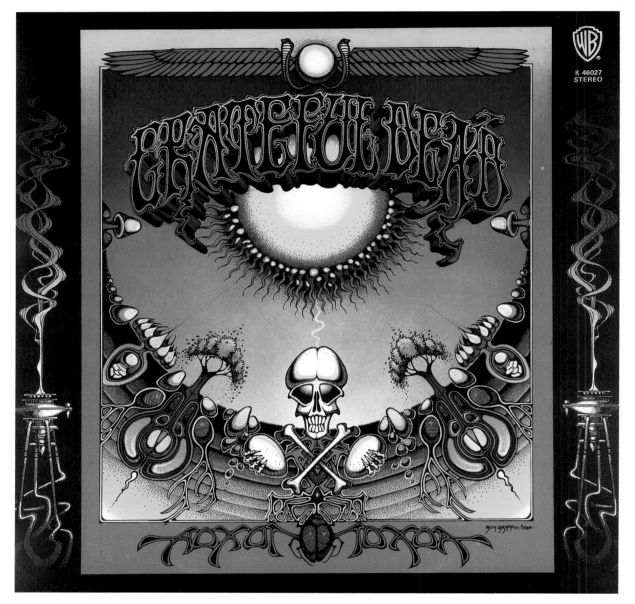

IDA GRIFFIN: "The cover for *Aoxomoxoa* is a surfer's paradise of sunshine, blue sky, and life growing all around. It was during this time in Rick's life that our second daughter was born at home. The cryptic skull and crossbones represented life and

death in a circle of the sun, paradise, the Garden of Eden, and planet Earth awareness. Rick would say that the whole design was "tribal." The lettering was based on an old English style that flowed into liquid edges, through the influence that water and the ocean had on Rick's life."

RICK GRIFFIN

*Rick Griffin grew up surfing, and on graduating from high school he went to work for **Surfer** magazine. He also played in a band called The Jook Savages, moving with them to San Francisco in 1965, where he formed a poster company with Bob Seideman and Louis Rappaport. In 1967 Griffin designed the masthead for Jan Wenner's **Rolling Stone**, and in the late 60s produced his famous psychedelic posters and album art. In the 70s he painted and traveled a great deal, surfed, and exhibited his work. In 1980, a book of Griffin's work was published by Paper Tiger. Rick Griffin was married to Ida Griffin and they had two daughters, Flaven and Adelia. Sadly, Rick Griffin died in a motorcycle accident in 1991.*

HAND COLOR SEPARATION
Instead of making a full-color illustration to be color separated photographically, Griffin used an older and more time-consuming method. By hand, he produced a separate piece of artwork for each individual plate for the four-color printing process of cyan, magenta, yellow, and black. Each plate was registered by hand and the colors printed one on top of the other in sequence to produce the finished art. Although very tedious, this process produced vivid color and great clarity.

MURPH THE SURF
*Murphy, the surfer character who appeared in **Surfer** magazine, was conceived by Rick Griffin when he was just 16 years old.*

SPECIFICATION

• *Artiste*	The Grateful Dead
• *Title*	Aoxomoxoa
• *Design*	Rick Griffin
• *Illustration*	Rick Griffin
• *Record Co.*	Warner Bros., 1969

天晴
あっぱれ

APPARE
The two Kanji characters translate as "Heaven" and "Fine Weather."

SADISTIC MICA BAND, Appare

THIS COVER CLEARLY illustrates a tongue-in-cheek attempt to lessen the cultural divide between East and West. The appeal, similar to the album cover designs of Roxy Music, relies mainly on the seductive image of a beautiful girl, in this case in traditional costume and framed by funky home-grown computer graphics. Very few Japanese bands are capable of making an impression in the UK or US. The culture and language are too different to translate easily into the instant accessibility that results in pop success. The Sadistic Mica Band were an exception, with catchy songs (some sung in English), superb musicianship, and an eccentric image deliberately designed to challenge those at home and initiate those abroad.

THE TITLE *Appare* was thought up during a brainstorming session in the studio by the bass player, Ray Ohara. It means "well done," "bravo," or "splendid." Band founder, Kazumiko Kato, wanted to reflect the word on the front cover. He says: "Okumara's good sense of the abstract in his work made the sleeve odd and eccentric. For me even the cover art is *appare!*"

ILLUSTRATOR
Yukimasa Okumura composed the cover on a Macintosh II using Adobe Illustrator and traditional painting techniques. At the time such a thing was unprecedented. The cover appears to be created using traditional tools, but it is the combination of techniques that makes it special. It was printed as a four-color separation with a fifth plate for the gold ink.

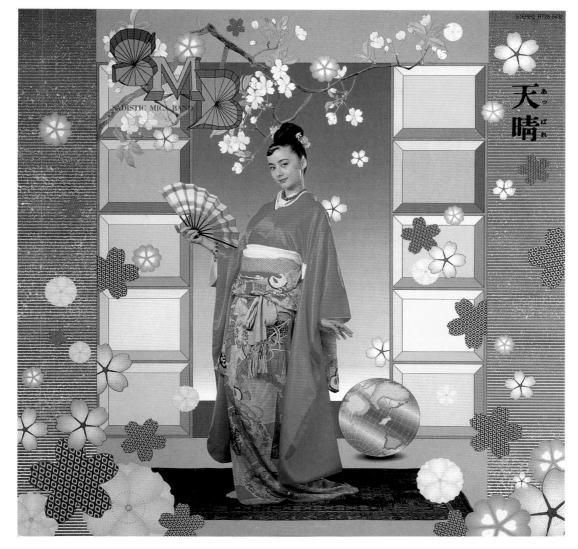

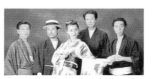

BAND CHANGES
When, in 1989, the band reformed with a new singer, Karen Kirishima, they had not played together for over ten years. The band made a new album and played just one concert in Tokyo, then disbanded again. Yukimasa Okumura, who had designed the first Sadistic Mica Band album cover in the early 70s, discussed his ideas with Kazuhiko Kato, founder member of the band. Kato wanted to have a distinctly Japanese image, but at the same time, something that was cheerful and exotic.

OKUMURA FIRST sketched what he thought the cover should look like with Karen Kirishima on the front and the group dressed in traditional Japanese kimono for the back. Kenji Miura then took the photographs using a 5in x 4in Sinar camera. He shot on Kodak EPR film and lit the set with six strobe lights and an umbrella reflector. He shot against a neutral gray background so that the computer-generated background could be stripped in later.

YUKIMASA OKUMURA
*Born in the Aichi Prefecture in 1947, Yukimasa Okumura learned Japanese brush painting when he was four years old, a family tradition for generations. He studied at the Kuwasana Design Research Institute. By 1979 he had become the art director for The Yellow Magic Orchestra, and designed posters, stage sets, and numerous album covers for them. By 1985 he had developed his own graphic style, influenced by traditional Japanese painting techniques. He has won many awards for his work and was chosen as the artist for the **Daijo-Sai** (the thanksgiving ceremony that is held after the enthronement of the Emperor). Today he continues his work in stage and poster design.*

AFTER WORDS
*Ray Ohara: "I like the cover – it's a kind of Oriental hybrid. We sold 500,000 copies of the record, which for the Japanese domestic market is a lot – so it was **appare**."*
Kazuhiko Kato: "It was successful for us, as an image and as an album. When The Police came to Japan, Sting said 'Hey, Kato, I saw you play at Wembley with Roxy Music – can I have your autograph?' I felt very flattered."
Singer Karen Kirishima called it "My favorite album cover of my career."

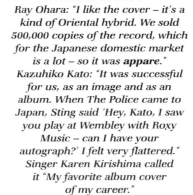

SPECIFICATION

• *Artiste*	Sadistic Mica Band
• *Title*	Appare
• *Art Direction*	Yukimasa Okumura
• *Design*	Mitsunobu Murakami
• *Photography*	Kenji Miura
• *Record Co.*	Toshiba EMI, 1989

THE POPINJAYS, Bang Up To Date With The Popinjays

COUNTERPOINT IS A KEY CONCEPT for a band whose title is *Bang Up To Date* but whose name brings to mind an 18th-century dandy (a popinjay is a "conceited person"). Elements of the design feel as though they date to the 50s or 60s, but the arrangement is modern; the song titles are on the front and not the back, and the logo for a small indie band echoes that of a major conglomerate. Wendy Robinson from the band described the title as a flippant comment. In the same vein as daytime TV, it presents itself as cutting edge despite being the absolute opposite. The Popinjays were being a tad ironic, and the cover needed to reflect that.

THE ARTWORK was constructed using black-and-white components for the type and illustrations. The dome and the woman's face were taken from old magazines. Elements were then individually color-separated; one on the yellow plate, one on magenta, one on cyan, and one on black. The regular yellow and magenta were substituted with fluorescent versions. Silver was also printed as a fifth color. It was all an attempt to be deliberately naive, like 50s sci-fi films.

PINK NIGHTMARES
Replacing magenta with fluorescent pink caused havoc at the printers. It was also difficult for Paul White to visualize exactly what the colors would look like when he was doing the artwork. There wasn't enough time or money to proof it properly.

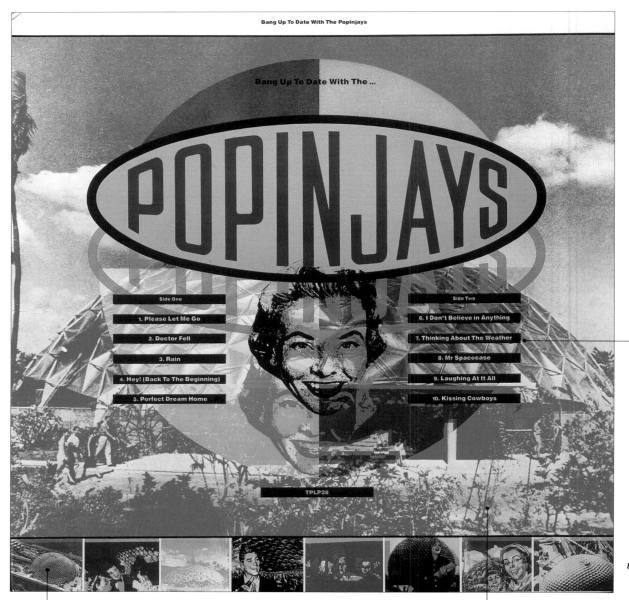

THE APPROACH
Wendy Robinson: "It was a bit scary going to meet Paul White. We thought he'd be an unapproachable, industry-type person, and we were little girlies who didn't know what we wanted. But he was brilliant; he'd listened to our music, gave us some source books and said 'go through them, point out what you like and say why'."

THE IDEA of having the song titles on the cover was to break down the old conventions of album-cover composition, and provide a kind of "bang-up-to-date" perspective in a tongue-in-cheek way.

ASSUMPTIONS
The band weren't going to have pictures of themselves anywhere on the records. They were trying to avoid negative assumptions of "Oh, you're a girl band."

THE DESIGNER and the band spent an afternoon together discussing the sleeve before work started. They talked of memories of growing up in the 50s and 60s. In the 50s, geodesic domes were portrayed as the homes of the future, and everyone assumed that in the future we'd all be living in a biosphere. Paul White remembered a picture of Buckminster Fuller (the inventor of the biosphere) and his dome, with his wife inside looking really uncomfortable.

SPECIFICATION
- *Artiste* **The Popinjays**
- *Title* **Bang Up To Date With The Popinjays**
- *Design* **Paul White at Me Company**
- *Record Co.* **One Little Indian, 1990**

BANG UP TO DATE
"We used samples and a drum machine, which at that time was unusual in indie-style music. For two girls with no technical ability, making the album felt quite space-age." – Wendy Robinson

SURFACE TENSION
Wendy Robinson: "We didn't just want a photo. Then we realized our lyrics related to the woman on the front, who was a bit like both our mothers – women who'd grown up in the 50s when everything had to be just so – keeping it all looking wonderful on the surface, but underneath families were falling apart. Paul had the same kind of upbringing, and he expressed all of our feelings with this dome idea."

THE POPINJAYS LOGO
Designed by White, this was a deliberate rip-off of the logo of US petro-chemical company Dupont. White designed it for The Popinjays when they signed with One Little Indian in 1986.

ITAKURA, KONISHI, SHIGETO, BA NA NA & WAKUI, Bettenchi

TRADITIONALLY, THE JAPANESE ARE VERY GOOD at taking simple objects and placing them in such a way that initially seems unintentional but is, in fact, quite deliberate. This is the basis behind the fine art

of Japanese Zen gardens. And this design for *Bettenchi* is no exception. Within the restricted boundaries of the twelve-inch-square album cover, Kenji Ishikawa has perfectly positioned three elements – a black pitted stone, a piece of coral, and some abstract gold leaf typography. By layering one on top of the other, he has succeeded in creating an almost three-dimensional image. His is a style of natural selection, so is it any wonder he calls his Tokyo studio The Garden? A touch of rural economy, we'd say.

THE COMMISSION
*In 1986 Kenji Ishikawa was an art director at Sony Records in Tokyo. He was given the job of creating the **Bettenchi** album cover by Mr. Fukuoka, the producer. **Bettenchi** is a compilation album of various little-known artists who were making interesting music at that time in Japan.*

THE BLACK STONE
had many small air bubbles in it. Ishikawa found it on the beach at Odawara in Japan. It was probably a piece of volcanic lava that had, over time, been polished into the oval egg-shape by the motion of the sea.

EAST/WEST
Ishikawa used a mixture of European and Japanese styles. He deliberately chose Japanese-style letters, although he hoped that the title graphics would have a cosmopolitan feel about them.

BETTENCHI
*In English, **Bettenchi** means "another world," or a place far from everyday life. The Japanese characters above, reading from the top, translate as "different/another," "sky/heaven/top," and "earth/ground/bottom."*

THE INTRICATE
piece of coral was found by Ishikawa in an antique shop in Tokyo.

ORGANIC LIFE
The Living Field by The Pillows (below) shows more of Ishikawa's fondness for organic shapes and textures.

KENJI ISHIKAWA
Born on January 23, 1956, in Aichi Anjou City, Ishikawa earned an art degree from the Nihon University. After working as an art director for CBS/Sony and Epic/Sony he set up his own design studio, The Garden, in Tokyo in 1992.

FOR THE TEXTURE
within the abstract lettering Ishikawa made up a modeling paste from marble powder. He used this marble paste as a rough base and tore up paper, which he then pressed into it, creating folds and textures. He painted bronze and gold paint onto the texture and inlaid fragments of broken marble. This was then photographed and dropped into the letter forms using photographic masks.

SPECIFICATION

- **Artiste** Bun Itakura, Yasuhiro Konishi, Isao Shigeto, Ba Na Na and Koji Wakui
- **Title** Bettenchi
- **Art Direction** Kenji Ishikawa
- **Design** Kuoko Hayahi
- **Photography** Kaori Hirono
- **Record Co.** Epic/Sony, 1986

A COMBINATION OF TEXTURES
Ishikawa thinks the cover works well because he made a conscious attempt to gather different objects of varying textures and to put them in a pre-determined space – the square of an album cover. By arranging the objects just so, he expressed the intention of the album – one good thing placed next to another good thing – in a pure and organic atmosphere.

ROGER ENO, Between Tides

YOUR AUTHORS HAVE ALWAYS admired the work of artist Russell Mills and his cover *Between Tides* in particular. Both the artist and the musician were interested in the transition from the Dark Ages to the Middle Ages, from insular and suspicious times to the universal and enlightened age that followed. The album echoes the causes and effects of this transitional period and is musically transitional itself. Russell Mills says that the design is based upon the idea of light emerging from the darkness, night becoming day, enlightenment after ignorance. Having derived further information via research, your authors feel the same. They also feel that the explanations in no way dispel their admiration, rather they enhance it. A good piece of art can withstand interrogation and is refined, not cheapened, by analysis… as they might well have said in the Middle Ages.

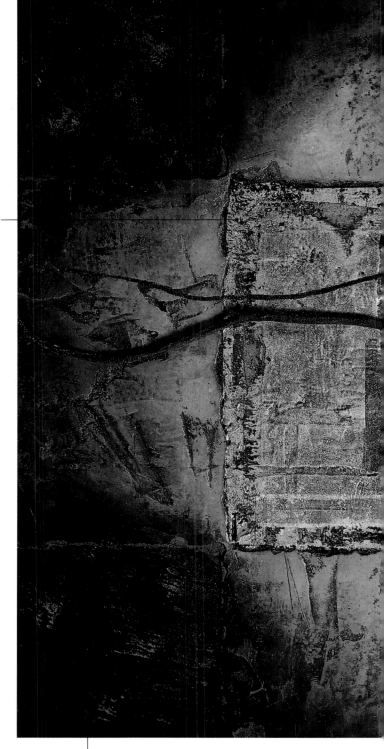

THE BRIEF
Russell Mills: "Eno's interest in the relationship between the Dark and Middle Ages coincided with my thoughts and work at the time. I was reading Umberto Eco's **Travels in Hyper-Reality** *and Hugh Thomas'* **An Unfinished History of the World** *(Mills did the cover art for the latter in 1981), which deal with the cross-fertilizing effects of industrial, religious, cultural, and political changes in societies. These provided valuable triggers toward formulating a conceptually sound visual solution.* **Between Tides** *echoes the causes and effects of the transitional period between the Dark Ages (insular, simplistic, and suspicious) to the Middle Ages (universal, complex, and enlightened) – I tried to reflect this in the cover."*

THE CENTRAL SQUARE
of gold leaf was applied to a bed of cement texture and acrylic paint. It is penetrated by two snaking lines. The top one is a dark crystalized trail of aniline dyes representing gunpowder.

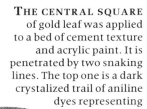

The lower, gentler line is a tree root dusted with black volcanic sand from Lanzarote and blue acrylic paint which represents the gradual refinement of nature imposed by society.

TITLE
The album's title and some track titles were suggested to Eno by Russell Mills in an attempt to summarize concepts behind the album and to evoke the mood of the music.

THE OVERALL
composition is based on a cross. It deliberately plays on all the symbolism that the shape evokes, especially religion as it was perceived in the Middle Ages.

INTEGRATION
Russell Mills doesn't believe in the redundancy of materials. He always uses

A QUESTION OF CHANCE
Russell Mills says "I'm not an abstractionist. I've never felt comfortable or honest in applying paint, texture, etc. with total abandon. Chance is an important procedural tool – a trigger – but it is always

applied in tandem with reason, whether conscious or intuitive. Rigor and discernment governs the use of chance, leading me to work in a reductive rather than additive way."

color for associative or perceptual reasons, for the integration of objects, and for reasons of composition. He hopes that viewers will gain something from the juxtapositions in his work and that it will mean something to them.

THE BACKGROUND is a sheet of lead covered with shellac (a resin varnish) to represent the early science of alchemy. The central gold square represents the alchemist's ultimate goal of turning lead into gold. It also represents the highest personal ideals, the age of discovery, beauty, perfection, and growth.

DAVID COPPENHALL'S LOGO
and type style was a hybrid assemblage of an old calligraphic face and a new font drawn by hand. The title certainly affects the logo and design. David Coppenhall: "I always concentrate on what I term 'appropriate' design. Each decision has to have a contextual base."

RUSSELL MILLS

Russell Mills studied fine art at Canterbury, UK, School of Art in 1971, Maidstone School of Art, from 1971 to 1974, and the Royal College of Art from 1974 to 1977. During the 80s he was the art director and designer at Brian Eno's Land Records. Russell has held numerous exhibitions of his work in the United Kingdom, Europe, the United States, and Japan. He has published several books of his paintings, won many awards, and often lectures in the United Kingdom. He lives in Cumbria, England, with his family.

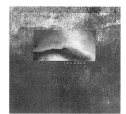

Harold Budd
Lovely Thunder
Land, 1986

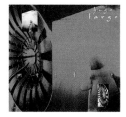

Hugo Largo
Mettle
Land, 1989

TYPOGRAPHY
"David Coppenhall's sensitivity with design and type is rare and sympathetic to my paintings; his contribution is as important and relevant to the music as the cover painting itself." – Russell Mills

THE RED THREAD
cross that embraces the cluster of objects echoes the emerging importance and hold of religion on society.

BOTH LINES lead to a cluster of objects on a fragment of a book cover. The book cover represents Gutenberg's invention of movable type in the 14th century. This led to knowledge being made accessible to the masses through the art of printing.

THE ELABORATELY ENGRAVED watch part represented the appreciation and marriage of arts and science – beauty twinned with usefulness.

ARE YOU HAPPY WITH IT?
Roger Eno: *"Knowing Russell Mills' previous work, his use of found objects, exotic materials, and depth of texture, I gave complete rein to his imagination after talking to him about the ideas behind the music. He encapsulated the music in his use of materials. The cover appears to be a pictogram, and a delightfully apt one at that. It's also a beautiful painting as an individual piece of art."*

YOU'VE BEEN FRAMED
*The cover painting for **Between Tides** was sold in the early 90s for around £1,500 to another artist who, after he bought it, told Russell Mills "All my work is based on ripping off yours." Not surprisingly, Russell Mills is sorry he sold it to him, not least because he hates his style being copied, but also because he couldn't believe the man was so blatant about it.*

SPECIFICATION

- *Artiste* — Roger Eno
- *Title* — Between Tides
- *Painting* — Russell Mills
- *Design* — David Coppenhall
- *Record Co.* — Land, 1988

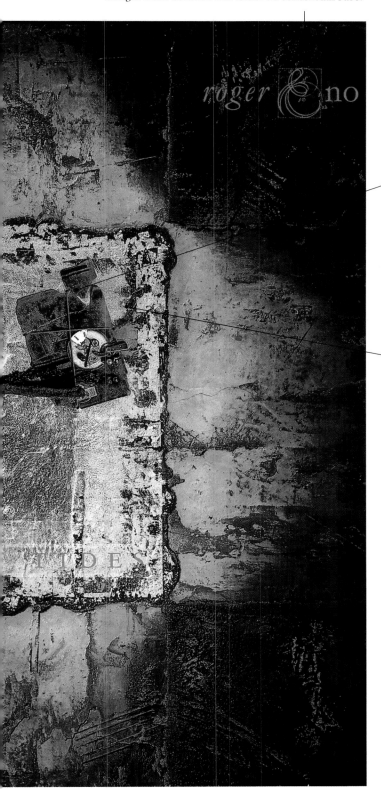

BROKEN CLOCK PARTS and clock fragments represent the acceptance of Arab mathematics (the precursor of computing and double-entry bookkeeping) as well as the greater awareness of time and the sophistication of science, and the conflict this caused with the Church.

ART PRODUCTION
Russell Mills' work of art was a collage of plaster, earth, acrylics, oils, gold leaf, leather, sand, wood, and watch parts on a lead-based board, all put together at his Vauxhall studio in London. The assemblage was photographed and a color transparency produced for the color separations. A mechanical artwork was then made in the traditional way – using art board with trace overlays and a printer's specification markup.

EBB TIDE
Brian Eno's Land Records was part of Opal Ltd, Eno's management and publishing company. In 1991, the recording part of Opal disbanded and all the back catalog was taken on by All Saints Records, started by Dominic Norman-Taylor, who had worked at Land. **Between Tides** still sells well and is regarded as Roger Eno's best record. Dominic Norman-Taylor: *"The cover fits the music and the period in which it was recorded… the name and title creep out at you and are not initially noticeable. The imagery attracts your attention before the name of the artist."*

LAURIE ANDERSON, Big Science

THE TITLE BIG SCIENCE suits the photograph of Laurie Anderson very well. She seems to be in the middle of some scientific experiment that could be straight out of *The X-Files*. Laurie, the lab technician, manually controls the invisible gamma rays that emanate from the visiting Thorgs who have just dropped in from the planet Oberon. No? OK, the atmosphere of the picture is reminiscent of early 60s sci-fi films when plastic picnic plates skimmed at the right angle became, to the camera, acceptable UFOs. (Did you know that 3.5 million Americans believe they have been abducted by aliens?) However, the process of creating this cover could not have been more unscientific. The photograph was taken unintentionally by the producer of one of Laurie's videos. Big science indeed.

BLACK AND WHITE
*Perry Hoberman: "I know we looked at a number of other black-and-white album covers and I'm sure Bowie's **Heroes** was among them. The opaque white glasses were from the performance work* **United States I–IV**, *so was the neon violin bow on the back cover. The photo on the front by Greg Shifrin wasn't perfect, but all attempts to capture a better one failed, so we used it – after some fairly extensive retouching. The cuffs, the shadow of the hand, the wrinkles in the sleeves, the pocket, the tie – just about everything – was retouched. At one point we were obsessed with the shadow of Laurie's left hand – we burned through several airbrush artists trying to get it exactly right."*

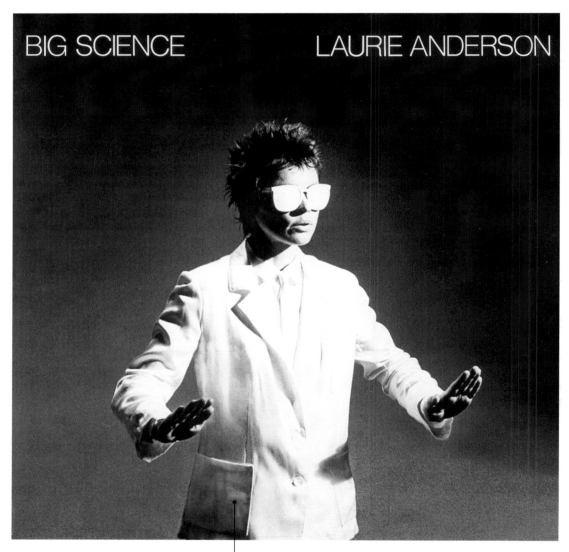

YIN AND YANG
"Conceptually, both the front and back covers were based on a series of oppositions: light/dark, white/black vision/blindness, sight/sound, front/back" – Perry Hoberman.

THE BACK COVER

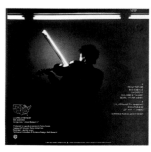

A RETOUCHY SUBJECT
The cover photograph was one of several taken by video producer Greg Shifrin on a sound stage in Princeton, New Jersey, during a video shoot. Several months later, when Laurie was producing the cover for **Big Science**, *she decided she wanted to use a photo almost exactly like the one Shifrin had taken. She restaged the setup and did another shoot with a different photographer to try and get it exactly as she pictured it. It didn't work. She then realized that she could turn the original photo into the image she wanted, and proceeded to heavily retouch the original until it became the one you now see on the cover.*

DEADLINE
Photographer Greg Shifrin has no recollection of any technical details except that he is almost certain it was taken with a 35mm camera of some sort. He says that considering the mind-numbing combination of deadline pressure, fatigue, caffeine, nicotine, and adrenaline under which he was operating, he feels fortunate to have had the presence of mind to put film in the camera.

FOLLOWING LONG discussion between artiste, designer, and art director, and extensive retouching of the photograph, this final version represents a physical impossibility in terms of the light source and the shadow of the hand on the jacket.

TIGHT SCHEDULE
The success of the single "O Superman" was an unexpected surprise, since not many eight-minute songs without guitars, drums, or bass become hit records. With hardly any time and little money to record the album, it meant finding ingenious ways to achieve expensive production effects. It also meant that for the shoot for the cover photo Shifrin had to cram three days of work into 24 hours.

SPECIFICATION	
• *Artiste*	Laurie Anderson
• *Title*	Big Science
• *Art Direction*	Perry Hoberman
• *Design*	Cindy Brown
• *Photography*	Greg Shifrin
• *Record Co.*	Warner Bros., 1981

THE INNER SLEEVE

BLIND FAITH, Blind Faith

IN 1968 SAN FRANCISCO WAS the center of the psychedelic revolution. Bob Seideman was adrift in this milieu photographing Janis Joplin and The Grateful Dead and trying to keep a psychedelic poster company together. When he began to hallucinate that his photographs were coming alive, he got scared. He sold his cameras, and with the proceeds fled to London. His old friend, Eric Clapton, put him up. *Blind Faith* gave him an opportunity to restore his equilibrium and in his own words "create out of ferment and storm, out of revolution and chaos an image of hope and a wish for a new beginning." A classic story of blind faith, hope, and charity.

THE GOLDEN CALF
"Detroit was burning. There was rioting in Chicago, the Love Generation had been kicked to death and I wanted out. I called Eric Clapton in London to ask if he would put me up for a while. He was putting a new band together. It seemed as though the Western world had, for lack of a more substantial icon, settled on the rock 'n' roll star as the golden calf of the moment and the record cover was the place to be seen." – Bob Seideman

PLATE CAMERA
Bob Seideman rented an 8in x 10in plate camera and a studio when he got to London. He shot the girl in the studio against a white background. He then traced around the image of the girl on the ground glass on the back of the camera so that he would then be able to compose the background shot (which he took in Dorset) within the same frame.

THE TWO 8IN X 10IN
color transparencies – one of the girl and one of the background – were taken to a retoucher. He placed them one on top of the other, and using a scalpel, cut the two transparencies at the same time, cutting around the image of the girl. He then joined them together to form the complete image.

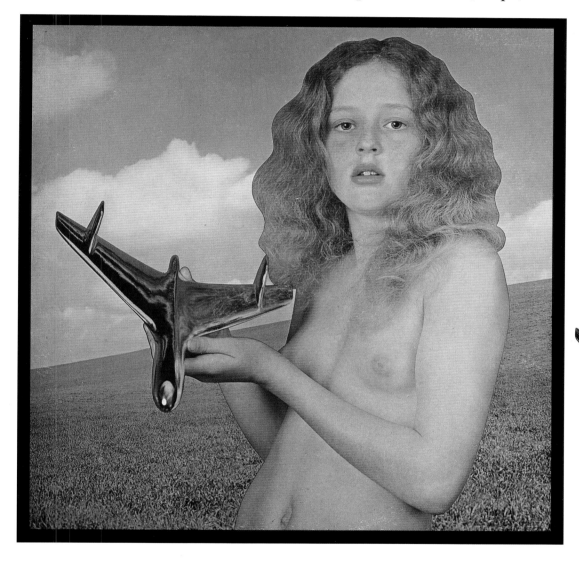

THE CONCEPT
"It was 1969 and man was landing on the moon. I could not get my hands on a concept until, out of the mist, an image began to emerge. To symbolize the achievement of human creativity and its expression through the technology, a spaceship was the material object. To carry this new spore into the universe, innocence would be the ideal bearer, a young girl, a girl as young as Shakespeare's Juliet. The spaceship would be the fruit of the tree of knowledge and the girl, the fruit of the tree of life."

MICK MILLIGAN
had made the spaceship while still a student at the Royal College of Art in London. It was made of wood and the metal was later applied using a technique called "vacuum metalizing." Milligan had just earned himself an MA from the RCA. He was living with an ex-girlfriend of Eric Clapton's called June (later to marry Marc Bolan). Eric called him one day and asked him to come and meet Bob Seideman as they wanted to have something made for Eric's new album cover.

NEIGH, SURELY NOT?
When asked what she thought her fee should be for modeling, Mariora Goschen said she wanted a young horse, but instead she received £40 from the Robert Stigwood Organisation, Eric Clapton's management company. Mariora Goschen: "The nudity didn't bother me. I hardly noticed I had breasts. I was mad about animals and much taken up with family and friends. But now, when people tell me they can remember what they were doing when they first saw the cover and the effect it had on them, I'm thrilled to bits. By the way, I'm still waiting for Eric Clapton to ring me about the horse."

FINDING THE RIGHT GIRL
One day Bob Seideman was traveling on the London Underground when a girl got into the car. Seideman asked her if she would like to pose for the cover of Eric Clapton's new album. She said "Do I have to take off my clothes?" He said "Yes, you do." But she was shy. She had just passed the point of complete innocence, and she wouldn't pose. On the other hand, her younger sister, Mariora, was perfect and really wanted to do it.

NO COVER, NO RECORD
In the US the record company was not happy with the cover, and at one point were even considering not releasing it. But Eric Clapton said, "No cover, no record." An alternative cover was made which featured a handbill from a concert that the group had played that summer in Hyde Park, but it wasn't used.

SPECIFICATION
• *Artiste*	Blind Faith
• *Title*	Blind Faith
• *Design*	Bob Seideman
• *Photography*	Bob Seideman
• *Record Co.*	Polydor, 1969

EMERSON, LAKE & PALMER, Brain Salad Surgery

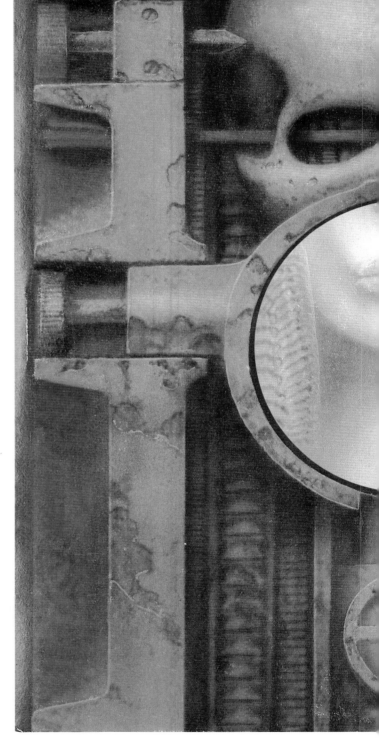

THE SWISS PAINTER AND DESIGNER H. R. Giger is best known for creating the monster in the sci-fi film *Alien*, and the same dark, foreboding elements are evident in this cover for Emerson, Lake & Palmer. A rare combination of heavy machinery and ethereal beauty haunts the viewer, underpinned by latent sexuality and suggestions of torture. Though appropriate for the title, the original cover was altered by record company pressure, and what had been the glans of a penis became a lustrous shaft of light. Art through suffering, pleasure through pain, covers through censorship.

HOW THE JOB CAME ABOUT

*H. R. Giger heard from Emerson, Lake & Palmer's Swiss agent that ELP wanted him to do an album cover. At the time, Giger was in the midst of painting a triptych called **Landscape XIX – Work Z16**, the main themes of which were penises, skulls, and a woman's mouth. Giger was taken aback by the accolades that Keith Emerson laid at his door. It was his first encounter with a famous rock star.*

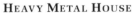

WORKING TITLE

*Keith Emerson: "The working title for our fifth album was originally **Whip Some Skull On Ya**, until it was pointed out that a line from a Dr. John song called 'Brain Salad Surgery' meant the same thing, and was thought more provoking." When Emerson told Giger of the change of title, he was dismayed until it was explained that the new title also referred to oral sex.*

HEAVY METAL HOUSE

*Keith Emerson had been forewarned that Hans Giger was a bit odd and was apparently experimenting with mind-altering substances. When Keith went to visit Giger at his house in Switzerland, Giger immediately struck Emerson as a powerful personality. The interior of his house was overpowering. From floor to ceiling his unique airbrush technique had transformed his house into a bizarre cathedral of horror. His toilet had arms coming out with drip feeds going into them, almost engulfing the sitter. Gas masks adorned the walls. Giger showed Keith part of a triptych of a skull with a woman's pouting lips sandwiched between a metal vice with a protruding phallus. This was Giger's painting entitled **Landscape XIX – Work Z16**. Emerson was both shocked and fascinated. A deal was struck for use of the image on the album cover. Keith says it was dark and very foreboding, and for him it represented ELP's music completely.*

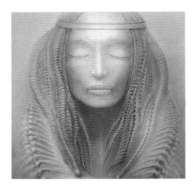

INNER SLEEVE

*This shows the complete woman's head. Close scrutiny shows that her face is adorned with a relief-like patterning, and her forehead bears a design in the form of a Möbius strip. Her flowing Medusa dreadlocks, held in place by a thin headband, are, in true Giger style, scaly, skeletal and snakelike. These elements would be seen in later figures such as the monster in **Alien** (below).*

* * * * * * * *

H. R. Giger later said in an interview that he had read Keith Emerson's description of his house and claimed that none of it was true.

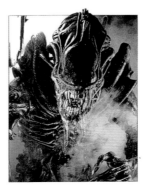

SPECIFICATION

• *Artiste*	Emerson, Lake & Palmer
• *Title*	Brain Salad Surgery
• *Design*	Fabio Nicoli
• *Artist*	H. R. Giger
• *Record Co.*	Manticore, 1973

YOU HAVE NO PROOF

H. R. Giger says he was disappointed with the final printed album cover as, in his opinion, the printers had failed to match the colors to his original painting. No one, it seems, had checked the color proofs, and in some countries the color differences were quite remarkable.

FABIO NICOLI, the art director and designer of the sleeve, decided that the cover should open up like a pair of doors. The center of the sleeve was die-cut, with a circle showing the woman's face through the hole, and the sleeve opened up from the center. Although this was an innovative piece of packaging design, it did mean that the sleeve tore very easily.

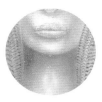

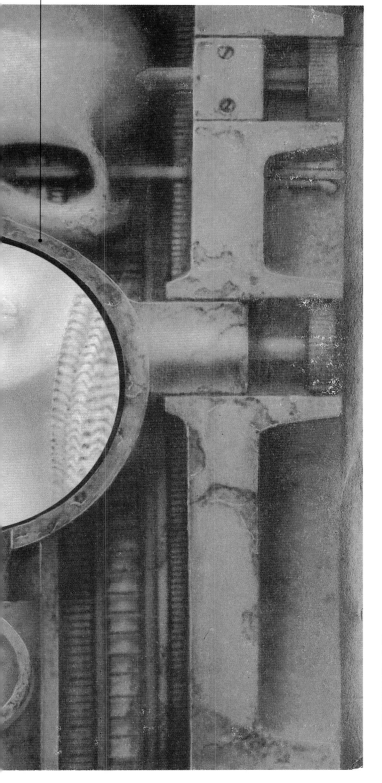

PROBLEMS AROSE with the cover when a woman working at the record pressing plant complained that the artwork was pornographic and the distributors demanded that the penis be taken out. Giger was totally against the idea of changing any part of his masterpiece until he realized that if he didn't comply, the band would have to look for another design, thereby delaying the album release. With delicate airbrushing the offending penis became a shaft of glowing light – although, if you look hard enough you can just about make out where it was!

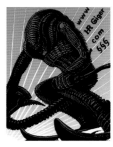

H. R. GIGER TODAY
These days, H. R. Giger is busier than ever producing designs for a variety of projects. He has designed a range of furniture, light fittings, bronze and aluminum sculptures, limited edition prints of his art, and a range of watches. He also has an extensive website on the Internet. There have been several books of Giger's work published. Some are specifically related to subjects such as his work for the **Alien** *movies and his science fiction creatures.*

H. R. GIGER
Hans Ruedi Giger was born on February 5, 1949, in Chur, Switzerland. He was educated in Switzerland, where he studied drawing and had practical training with the architect Venatius Maisen and the developer Hans Stetter. He later studied at the School of Applied Arts in Zurich. In 1973, while living in Zurich and intoxicated by the music of Emerson, Lake & Palmer, Miles Davis, and David Bowie, he painted the triptych entitled **Landscape XIX – Work Z16**. *In 1978, Giger designed, painted, and created the horrific monster for the highly successful sci-fi film* **Alien** *for director Ridley Scott. Giger also contributed designs for the film* **Poltergeist III**. *Today, he continues his design work and lives in Switzerland.*

THE GIGER MUSEUM AND GIGER BAR
Plans are well under way for the opening in May 2000 of the Musée H. R. Giger, Schlossbahn, and H. R. Giger Bar in the little mountain village of Gruyères in Switzerland. The museum will be housed in an old castle, the Chateau St. Germain, which, looking like a castle from some Hammer Studios horror movie, is well-suited to Giger's bizarre taste. The museum and bar interiors are designed by Giger himself, and feature elaborate staircases, fittings, and furniture. The first Giger Bar opened in Giger's birthplace of Chur in Switzerland and was followed by a Giger Bar in Tokyo.

MUSEUM FITTING
Giger's sketches for some of the fittings at the forthcoming Musée H. R. Giger in Switzerland.

TECHNIQUE
The complex painting, Landscape **XIX – Work Z16**, *was executed using an airbrush and paints and took Giger two days to complete – a surprisingly short time for such a detailed piece of work. Further work was later done to the triptych to remove the offending phallus.*

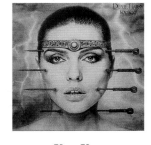

KOOKOO
H. R. Giger designed the cover of Debbie Harry's 1981 album, **KooKoo**. *Giger explained that the four giant acupuncture needles on the cover correspond to the four elements, as do the eyes (fire), nose (air), mouth (water), and neck (earth).*

THE LOGO for Emerson, Lake & Palmer, designed by H. R. Giger, first appeared on *Brain Salad Surgery* and has, like The Doors' logo (page 141) served the band for most of their career. Variations of the logo appeared on later albums, T-shirts, bootlegs, and tour merchandise.

SO, HOW WAS IT FOR YOU, CHAPS?
*Today, Keith Emerson sums up the album and its art: "***Brain Salad Surgery** *marked the peak of Emerson, Lake & Palmer's creativity before we all embarked on our individual orchestral crusades."*

100 BEST ALBUM COVERS

31

BRAIN SALAD SURGERY

PIXIES, Bossanova

WHEN WORLDS COLLIDE, when styles clash, the result can be tremendous. In *Bossanova* for Pixies, retro meets computer, outer space meets inner plastic, kitsch meets class, all wrapped up with taste. Like an old movie logo, Pixies present another world, a Pixies world, a Saturnlike planet of reddened translucency with rings of frosted plexiglass, and interconnecting plexiglass tubes crisscrossing interplanetary space, set against a fiery universe. Corner insets, like the portholes of a retro rocket ship, contain glimpses into Pixies' world with details of their songs. What we see here is the global and the particular, the old and the new, the cheap and the cosmic. A world apart. Pixie world, not Disney world. Bossa nova, not supernova.

OUTER SPACE
Pixies founding member and vocalist Black Francis decided to form a band while on a trip to New Zealand to see Halley's Comet. After seeing a UFO as a child, his obsession with outer space became a key component in Pixies' lyrics.

THE PICTURE of the doll is a representation of Velouria, the central character in a song of the same name, in which the singer speaks of his love for Velouria in another world.

THE INSET pictures were originally photo-graphed for a lyric book that accompanied the first 20,000 copies of the album. The images represent details of the songs.

DESIGNER
Vaughan Oliver recalls saying to himself: "Surely there's room for a Pixies world. I visualized the cover as a make-believe world with the band's logo orbiting around within its Saturn-like rings – it's our version of the *X-Files/Pixies* world."

RETRO-GRAPHICS
"Its about B-movie kitsch, retro-style graphics, such as the lightning bolt of the old RKO wireless adverts. We used retro graphics but it's not a pastiche," stresses Oliver. *"It's a collision of romance and sentiment with retro graphics."*

THE FROG on a fish hook represents a song called "All Over the World," and the mole represents the song "Dig For Fire."

THE BARBED WIRE represents a song on the album called "Hang Wire."

THE PLEXIGLASS RODS that surround the planet were functional as well as graphically stimulating. Chris Bigg: "They're suggestive of communication; but on a practical level, they also held the planet and its rings in place."

HEART-SHAPED HAIR
The inset on the back cover is personal to Vaughan Oliver. The blonde hair on a bed of crushed velvet belonged to an ex-girlfriend. Both partners cut off all their hair together – Vaughan kept hers in a bag. He recalls that some time later he pulled it out, and it was in the heart shape shown on the cover. Next to it is a guitar string, there to represent heart strings.

SPECIFICATION

•*Artiste*	Pixies
•*Title*	Bossanova
•*Design*	Vaughan Oliver and Chris Bigg at V23
•*Photography*	Simon Larbalestier
•*Record Co.*	4AD, 1990

UPSIDE DOWN UNDER
*The globe was custom made from clear acrylic to V23's specifications by the modelmakers, Pirate. The globe is an imaginary world suggested by the **X-Files**-type themes in Pixies' lyrics. The countries visible in the cover shot are America and an upside-down Australia, which represents the semimythological civilization of Lemuria, an Atlantislike culture that some believe was submerged around 14,000 years ago.*

SUPERTRAMP, Breakfast In America

DESPITE BEING A THOROUGHBRED English band, Supertramp relocated to Hollywood in 1977 in a search of the elusive Yankee dollar. The result was the album *Breakfast In America*. The music and lyrics reflect with irony and cynicism the social upheaval of that move. Designers Mike Doud and Mick Haggerty each won a Grammy® for the design, and deservedly so. Rarely has a cover realized the musical intention of a band so deftly. Raise a glass to this design any day.

COFFEE SHOP
The band initially saw the cover as an airbrush illustration, but with the help of some Jean-Paul Goude images torn out of **Esquire***, Mick Haggerty persuaded them to do it as a photograph. The "coffee shop" theme was a gift to a young designer like Haggerty, fresh to the shores of America, and he milked every last drop from it – down to the blue-plate specials and the "Libby" name tag. They originally chose a cheesecake-type model but the band insisted on a more homely one. Mick and Mike joked privately that the whole thing looked to them more like breakfast in London's Stepney.*

LAND OF DREAMS
John Halliwell of Supertramp: "Mike Doud's realization of the cover expressed with wry humor the group's mental and physical place at that time. Although the title song was written years before we went to the US, the imagery appealed to us, living in the 'Land of Dreams and Ambitions.' The image of flying into New York, substituting the English transport café for the friendly diner. We were growing up in a materialist world and had begun some spiritual searchings. It all came together in our music."

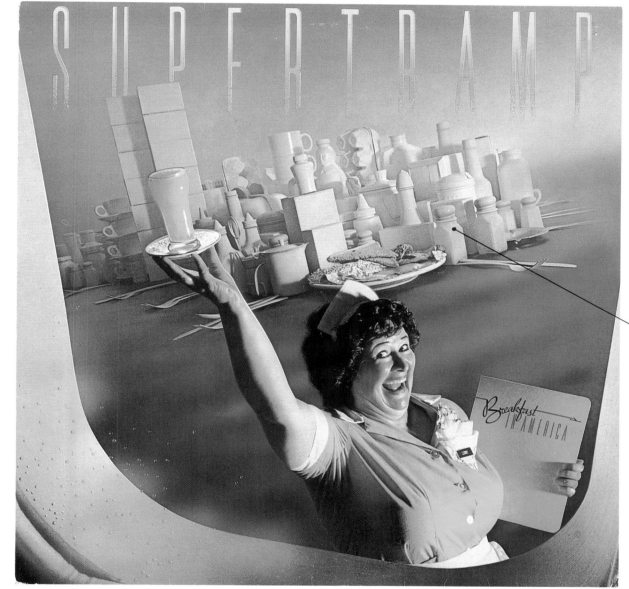

MAY I TAKE YOUR ORDER?
Manager Dave Margereson: "We chose Mike Doud, who was the art director at AGI, a record sleeve printing company. He was a great personal friend and a good person to explore ideas with. The record company gave the band total freedom to do whatever we liked. We had a reputation for our graphics, and Mike Doud brought in designer Mick Haggerty to help."

MICK HAGGERTY created the fake New York skyline using all-white kitchen utensils. The piers are represented by knives and forks

THE WHOLE STORY
The image was shot in four parts: the New York skyline, Libby the waitress, the glass of orange juice, and finally the airplane window.

MIKE DOUD

Born in 1935, Doud was raised on the Yakima Indian Reservation in Washington State. He graduated from the LA Arts Center in 1961 and in 1970 went to London to become art director for A&M Records. In 1973 he took the job of art director at AGI, a Chicago-based printing company. Mike returned to LA in 1976. He was nominated for several Grammys®. He died in 1990.

SORRY HONEY, THAT'S OFF TODAY
Some of the rejected cover ideas were:

1. A striking young waitress on roller skates serving you as if you were seated in a drive-in diner.

2. Neon Park had an idea of a baseball player hitting a home run, and the home run he is hitting is in fact a fried egg in a bit of plastic that moves around the album cover. It was rejected as not being very practical.

3. One of Mike Doud's early ideas was of giant breakfast cereal and milk tumbling down the Grand Canyon.

THE WAITRESS was going to be a classic all-American girl, but the band ended up choosing someone from the Ugly Model Agency. Libby, the model used, went on tour and opened the show!

SPECIFICATION

• *Artiste*	**Supertramp**
• *Title*	**Breakfast In America**
• *Art Direction & Concept*	**Mike Doud**
• *Art Direction & Design*	**Mick Haggerty**
• *Photography*	**Aaron Rapoport**
• *Record Co.*	**A&M, 1979**

Storm Thorgerson

SPECIAL PACKAGING

One of the most enjoyable aspects of album covers is that they are real objects as well as graphic designs. They are 3-D packages that have their own particular physical and tactile qualities. Opening and exploring covers can be a rewarding experience on its own, separate from the visual experience. Though most album covers are simple, straightforward in construction, and broadly the same, there are sufficient idiosyncratic variations to warrant the generic but unedifying title of "Special Packaging." It's hard to show much of their 3-D nature and complexity on a 2-D page of course, but here goes anyway.

Most notable of special packages are the cutouts, where the shape has been changed from the standard square to, say, a circle (*Ogdens' Nut Gone Flake*, page 113), a parallelogram (Traffic's *The Low Spark of High-Heeled Boys*), or even a triangle like Baal Brecht Breuker's *Bvhaast*. Sometimes the cut shape makes the cover look like something else, for instance an art deco TV (Family, *Bandstand*), a cigarette lighter (The Wailers, *Catch A Fire*), a glass of whisky for Rod Stewart's *Sing It Again, Rod*, Cheech and Chong's outrageous giant pill for *Sleeping Beauty*, or even a toilet seat – for Banco Del Mutuo Soccorso, of all people. The die-cut, as these holes in the album cover are officially known, can be rows of windows, as in *Physical Graffiti* (Led Zeppelin), a keyhole, as in *Thunderbox* (Humble Pie), or a set of peepholes with a turning wheel to change the images – *Led Zeppelin III*.

More adventurous constructions include the metal film box for *Public Image Ltd.*, the dry, cynical pharmaceutical package for *Ladies and Gentlemen We Are Floating In Space* by Spiritualized, and Led Zeppelin's *In Through The Out Door*, which was sold in a brown paper bag, despite six front cover variants and a special liner bag – black and white until water or spittle were added, turning it into color like an old coloring book for children.

More provocative but just as ostentatious was *School's Out* by Alice Cooper. This was a cover that looked like a school desk but had a real pair of paper panties attached to each individual cover. Edgar Broughton Band's *Inside Out* was constructed like a Chinese wallet, opening in two different directions, transferring images from the inside to the outside and vice versa. In the same vein but more sophisticated is Pulp's CD *A Different Class*, which comes with interchangeable cards, offering eight different front covers at your discretion.

Whether all the fuss and expense ever justifies the effort, or expense, is highly debatable, especially because there are a host of simple adjustments to standard packaging that can be quite effective, such as the stimulating contrast of outer sleeve and inner liner bag (Heidi Berry's *Love*, page 96) or added inserts like posters or postcards (*The Dark Side Of The Moon*, page 46). The texture of the board or paper can be varied (rough or smooth or patterned), as can the finish (matt or glossy, or somewhere in between). Spot varnish can highlight selected areas, as in 10cc's *The Original Soundtrack* (page 116). Printing on the reverse side of the board to provide subdued tones and a down home feel is a neat trick, as is changing the paper midway though the CD booklet, though this is much more expensive. Printing special colors provides added depth (*Chrome*, page 42), while the use of metallic inks (Pixies, page 32) or Day-Glo (The Popinjays, page 24) adds luster, impact, and a sense of extra levels.

Despite some members of the music public – and album designers in particular – lamenting the passing of the vinyl LP and its large-scale covers, the CD and its minuscule packaging is here to stay – at least until the next technological advance. The LP is not just a "broader canvas," it is in fact a staggering six times the area of a CD! However, the design part of a CD is nowhere near as irritating as the physical part. CD jewel boxes are neat in size only; otherwise they are a complete pain – lots of cheap plastic and an alarming tendency to crack or break at the hinges.

Top left: Alice Cooper School's Out, Top center left: The Small Faces Ogdens' Nut Gone Flake, Bottom center left: Pink Floyd The Dark Side Of The Moon, Bottom left: Baal Brecht Breuker Bvhaast, Top center: Public Image Ltd. Metal Box, Top Right: Led Zeppelin Physical Graffiti, Top center left: Spiritualized Ladies and Gentlemen We Are Floating In Space, Bottom center right: Traffic The Low Spark Of High-Heeled Boys, Bottom right: Family Bandstand

The invention of cardboard constructions called digipaks seemed preferable, but have drawbacks due to a sense of flimsiness, and the permanent attachment of booklets to CD tray. At the time of writing, the Q-pack has some great advantages. It's like a jewel box, but much more robust, and is made of opaque, not transparent plastic, allowing an extra design to be printed on the front. It uses less plastic in its construction… more environmentally friendly, but more expensive. (Logically and politically it should be cheaper, but that's capitalism for you).

One can decorate the dreaded jewel box by sandblasting or by printing some graphic symbol or elegant lettering on the front. Embossing is also possible, as are various colored plastics – opaque or translucent (Thunder, *Behind Closed Doors*). The front spine can also be embossed or made of clear plastic, providing an area for type that is away from the actual cover. Black Grape's rather eccentric CD package had plastic cartoon eyes with floating pupils that could move in a most disturbing fashion. A more discreet but extremely effective improvement to the jewel box is known as the lugless box, pioneered on Pink Floyd's albums, where the removal of all but the two back lugs allows for the easy removal of the CD booklet. No more scrunched-up booklets!

The digipak, however, is a much more flexible beast, since it is made of cardboard. Numerous variations and extensions exist, too numerous and too colorful to describe here, though particular mention should be made of Suzanne Vega's *Days Of Open Hand*. Much more extravagant are the promotional packages made solely for the music industry, given as freebies to radio jocks, journalists, publicity agents, retailers, etc, but not to the likes of you and me. I vaguely recall hearing about Paula Abdul's actual powder compact for *Spellbound*, a complete peepshow device for Bullet Boys' *Freakshow*, and Frank Sinatra's 80th birthday collection which needed – literally – a suitcase (made in China) to carry it all away.

Special packaging in the record business is a thorny issue of cost versus return and of effort versus effect. There is plenty of it to be sure, some of it fun and ingenious, though, conversely much of it is clearly tacky or simply not worth the effort (to explore repeatedly) nor the money (that is spent on producing it). Let me finish this brief survey with a less jaundiced appreciation of three particular examples. First Spiritualized's *Electric Mainline*, a luminous light green plastic envelope-type thing that glows in the dark and stays in the memory. Second, inscrutability epitomized by Ryuichi Sakamoto's *Playing The Orchestra*, which has a package like an old rusty sea chest containing mystic pebbles, which rattle when shaken. And finally, *Pulse* by Pink Floyd, which housed a red, flashing, replaceable, battery-driven LED light in its spine pulsing every second for at least a year, "speaking" to you as it sits on your CD shelf, as live as the music it contained.

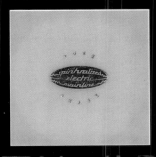

Top left: The Wailers Catch A Fire, Center left: Banco Del Mutuo Soccorso Banco Del Mutuo Soccorso, Bottom left: Spiritualized Electric Mainline, Bottom center: Thunder Behind Closed Doors, Top: Black Grape It's Great To be Straight…Yeah!, Top Right: The Rolling Stones Their Satanic Majesties Request, Center right: Thunder Behind Closed Doors, Bottom right: Pink Floyd Pulse

DEPECHE MODE, A Broken Frame

LADY LUCK SURELY SMILED, or rather thundered, on this cover design for Depeche Mode by providing a magical backdrop against which the action could take place. The sky is the limit, but also the zenith. The clouds really do have a silver lining, an electrical silver lining. But good fortune is not enough in Art, and it required three other distinct elements to make this such an evocative image. First, the original idea, then, the tenacity to keep going when it was hailing and raining and all seemed hopeless, and finally, the consummate skill to add extra lighting, lending the reaper and foreground a dramatic edge, to highlight them, and so match the hand of God in the the sky behind. Some collaboration, huh? Master snapper plus master maker equals masterpiece.

THE WORKERS
When it came to the album cover, Depeche Mode were very open about what they wanted. At the time, photographer Brian Griffin was a fan of German and Russian art – especially Socialist Realism in Stalinist Russia, picturing people reaping grain and working in factories.

IMAGE CHANGE
Martyn Atkins: "Depeche Mode had a 'wimps with synths' image that they were attempting to shed by employing the Russian iconography favored by underground bands of the period."

THE REAPER
figure has her face turned away from the camera. Griffin believed that if you put a human being in a landscape and you have them facing away from the camera, it helps the viewer to picture themselves as that person.

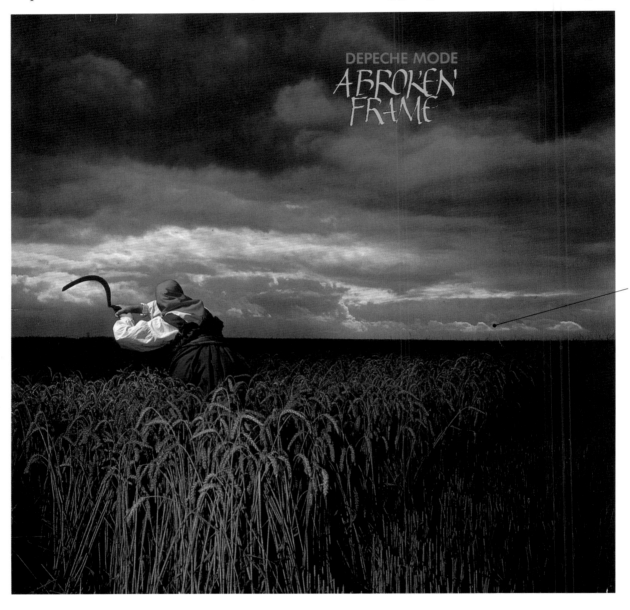

CASPAR DAVID FRIEDRICH
Griffin admired the work of Caspar David Friedrich, a German Romantic painter of the early 19th century. He was particularly interested in how Friedrich depicted death. The lonely figure in the landscape stands next to the wheat, which is life, nourishment, the bread of life.

THE WHEATFIELD
was in Cambridge, England, near Duxford RAF Museum. Martyn Atkins recalls that it was the tail end of the growing season and he spent many hours searching the countryside on his motorcycle.

THE REAPER'S COSTUME was made by stylist Jaqui Frye. Brian Griffin: "She's supposed to look like a Russian peasant reaping wheat with her scythe. It's life and death really, and I think that is what touches people about this image – the impending death, which is inevitable, coming toward you."

BRIAN GRIFFIN always used red so that it would take the eye to the subject. Before he did the shot, he was hoping for a sunny blue sky, but the red against this dark blue is really dramatic and the color draws your eye straight to it.

THE LIGHTING
The wheatfield was lit using three lights – one at the front, one at the side, and one at the top, so the figure and the corn around her were lit to match the sky. Brian Griffin used a daylight exposure with the lighting to bring out the lighter part of the sky.

RAIN AND DARKNESS
The day of the shoot was a very showery autumnal day in September. There were lots of thunder storms. The sky was really dark and it rained torrents and then the dark clouds passed and bright sunlight came through. The design team drove all the way to the location in the rain and darkness. Things didn't look good, but they had to get the photography done that day. It was an expensive shoot – they had a little Winnebago for the makeup artist, the stylist, the model, Brian Griffin and his assistant, and Martyn Atkins. Once they arrived, the rain started to ease off, and eventually the clouds broke up to produce a wonderful sky.

SPECIFICATION

- *Artiste* — Depeche Mode
- *Title* — A Broken Frame
- *Design* — Martyn Atkins
- *Photography* — Brian Griffin
- *Calligraphy* — Ching Ching Lee
- *Record Co.* — Mute, 1982

HAPPY MONDAYS, Bummed

ON THE ONE HAND this design is a picture of the band's lead singer, Shaun Ryder. On the other, it is the epitome of commercial design – full of impact, big and bold, but with plenty of detail to interest the viewer later. Outrageous color in odd places (the eyebrows) like Andy Warhol; bright and unexpected color in close-up like the Impressionists; use of black outline like a child's drawing or a Buffet painting. A complex technique realizing a complex range of expressions, from the suggestive (the tongue) to the sad (the eyes). Garish yet sensitive, up-front but obscure, color on the outside but black and white inside. Beautifully rendered without, crudely presented within. Like a poisonous animal, the beautiful and vivid markings serve both to warn and seduce.

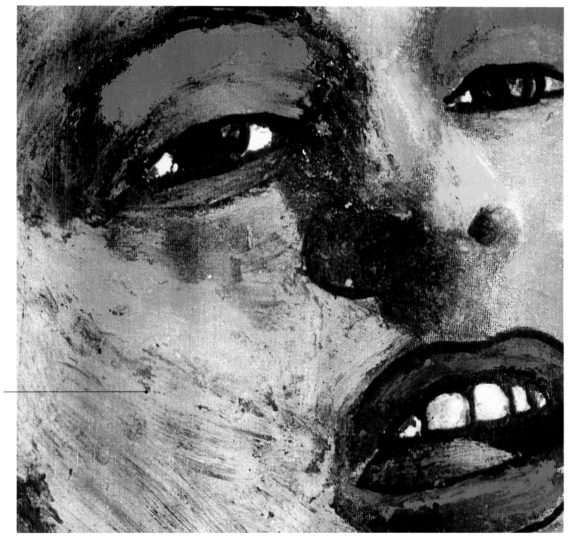

SIMILAR INTERESTS
Central Station Design started up at the same time that Happy Mondays signed a record deal with Factory. "The Mondays came to us originally as we all hung around together and all had similar interests and opinions on the way we wanted to live and work." – Central Station

THE FACE
is a painting of Shaun Ryder. It was painted in oil and acrylic. The reason for the tight crop on the sleeve was to make the image more ambiguous. This worked, because even Shaun Ryder didn't recognize himself.

THE TYPE
on the cover was blind-embossed out of the image. There was no printed type, as the designers felt this would ruin the cover. They were also confident that people would recognize it as a Happy Mondays product. This proved to be the case.

CENTRAL STATION
Factory's Tony Wilson calls Central Station "part of the Mondays' family – Pat Carrol is Shaun Ryder's cousin, and they don't really do much work for anybody else. They did all of the Mondays covers, and were Factory's in-house designers for five or six years."

ARTISTIC CONTROL
*Pat Carrol: "We were never given a brief for any of the Mondays' covers. We had a total free hand to do whatever we wanted. It was a unique position to be in, having complete artistic control. The only obligation was to incorporate the Factory logo somewhere on the artwork. At the time we were working on a series of paintings of TV and radio personalities. These paintings became part of an exhibition called **Hello Playmates**, which opened in 1990 at the Manchester City Art Gallery, eventually travelling down to London to the Pet Shop Boys' Gallery. The painting on the cover of **Bummed** was done in the same style."*

BUMMED
Central Station: "The title came from an expression [meaning being under the influence of stimulants] that was used around Manchester at the time. The band's visual image was left to us as we had already established an image for the band."

SPECIFICATION

•*Artiste*	Happy Mondays
•*Title*	Bummed
•*Design*	Central Station Design
•*Record Co.*	Factory, 1988

THE INNER SLEEVE
"This was one of the most profoundly disturbing inner sleeves in record history," says Tony Wilson. "Ten thousand were shipped over to the US distributors and ten thousand were shipped straight back – no company would handle this level of obscenity, even though it wasn't the front cover. The head of Elektra told me he still got shit for it years later. It really was truly disgusting and horrible – it's the shading and the color quality that makes it seem so desperately obscene and revolting – they are only medium-to-soft porn images from the 50s, but they have an intense quality that people simply couldn't handle."

THE LONGBOX
*In 1988 American record companies were still displaying their CDs in the longbox – an extravagant waste of cardboard that was thankfully done away with in the early 90s. For the **Bummed** longbox, Central Station produced an alternate version of the album cover portrait.*

THE CARS, Candy-O

THE CARS WERE FORMED IN BOSTON in 1977 by front man and songwriter Ric Ocasek. The last to join was David Robinson, the drummer, who also became visual director. He was the one who named the band and took on the task of creating the image for *Candy-O*. He collaborated with Johnny Lee, the art director at Elektra/Asylum, who secured the services of legendary "cheesecake" artist Alberto Vargas, who was 83. "I had lost my wife, Anna May, in 1975 and I didn't know whether I was alive or dead," recalled Vargas in 1979. "I stopped painting almost entirely; but with *Candy-O* the old urge came back and I am now working again the same as I used to." Sexy music inspires an old master painter.

SLAP DASH
Drummer David Robinson was already collecting pin-up art of the 30s and 40s and wanted very much to create a cover in the same style. He loved Vargas' work and thought it would be great to have him paint the cover for **Candy-O**. *They already had the title from one of the songs on the album. He got in touch with a relative of Vargas and visited him at his home. "It was an amazing experience," said David, "There were paintings all over the house, even on the floor. Vargas was chain-smoking with ash falling over the paintings. He was very slapdash about his work, putting coffee cups on paintings and things like that."*

THE CARS LOGO
The band's logo was a carryover from the first album. It was not intended as a brand style. Band and art department fought the record company over printing the title on the front. In the end, aesthetics won and a clear sticker with the logo and title was put on the outer shrink-wrap.

TECHNIQUE
Alberto Vargas painted in watercolor on illustration board. He said: "It's all drawn by hand. There's no airbrush here. There are some artists who work with the airbrush, but that's not you, that's the machine doing it for you. I had been afraid to touch the brush again, but I found that my hands and eyes were perfect."

"WE HIRED a photographer and art directed a photo-session as a reference for Vargas to work from. We photographed a car and a beautiful blonde model called, coincidentally, Candy Moore. I also sketched out a rough layout. When we approached Vargas the only slight problem was his age and the fact that he'd not done anything for years. He didn't want to do it at first; didn't know who The Cars were, or even care. His great-niece loved the group and convinced him to do the painting. The family had a big part in events and attended every meeting."
– Johnny Lee

ALBERTO VARGAS
*Alberto Joaquin Vargas y Chavez was born in Arequipa, Peru, in 1896. He studied in Europe until 1916, when World War I forced him to leave. He moved to New York and began a career in illustration that was to delight millions. The Vargas Girl has since become an American icon carried to all corners of the globe by GI's during World War II. Alberto was decorated by the US Government for his work. From 1960 to 1975 Vargas' work was published monthly in **Playboy**. He passed away in December 1982 at the age of 86.*

NIPPED IN THE BUD
Elektra rejected the first few attempts from Vargas. Johnny Lee had to tell Alberto, who was 83 years of age, that the "hip" record company insisted that he delete the nipples and pubic hair for marketing reasons.

FANTASY GIRL
Johnny Lee thought that both male and female fans would relate to Vargas. For the males, a fantasy girl, and for the females, a sexy fashion image. David told him that fans would dress like the cover girl for their concerts. Johnny visited Alberto every week to check his progress on the cover. Later the band invited him and his family to a Cars concert and presented him with a platinum record for his contribution to the project.

SPECIFICATION
- **Artiste** — The Cars
- **Title** — Candy-O
- **Concept** — David Robinson
- **Design** — Ron Coro and Johnny Lee
- **Illustration** — Alberto Vargas
- **Photography** — Jeff Albertson
- **Record Co.** — Elektra, 1979

HEAVENLY BODIES, Celestial

HERE A MAP, THERE A MAP, everywhere a map map. Here a thread, there a thread, everywhere a thread thread. Layer beneath layer, line upon line, disappearing, re-emerging, interconnecting, inviting us to explore a gossamer world into which we could fall and lose ourselves. Invisible threads, mystic pathways, earth-energy lines; real threads, dream threads, drawn threads, overlaid in both reality and in the artwork, woven together – actually constructed – by the magical hands of the designer David Coppenhall. They represent in part, Coppenhall says, the secret maps of shamans that chart the invisible routes between the everyday world, the underworld, and the celestial world. Maps for those people who know, but a trap for those who do not. This is the Net of Power, seducing all comers with the music of the spheres.

NOT JUST AN IMAGE
David Coppenhall: "I wanted this to be a cover that you could almost fall into, one that you didn't quite understand, but that you might have to try and fathom your way through. I didn't want it to be just an image."

AFTER THE shaman's out-of-body journey to the celestial world, they would usually have their own animal spirit – often a bird symbolizing flight.

THE BLUE is from the painted tissue paper screen where it had split – the color was partly painted and partly lit with gels, so there's a combined set of blues – the underlying one from the background paint on tissue paper, and the others from reflections off the metal rods and light picked up through a light point in the meshes.

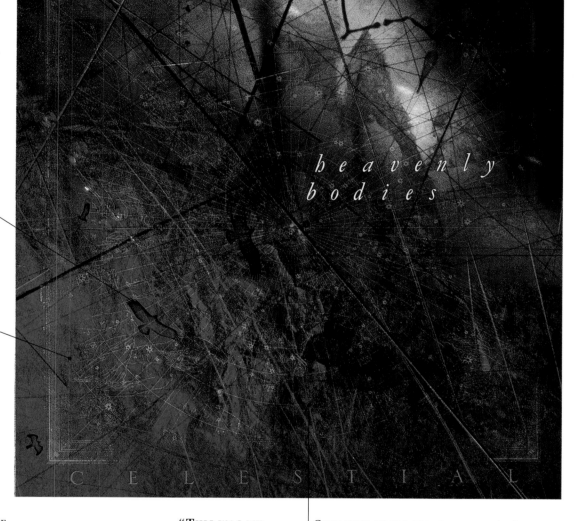

heavenly bodies

CELESTIAL

INITIATION
The Shaman appears in many cultures – as healer, a poet, a seer, a gifted member of the community. Shamans had to go through an initiation of three levels – the underworld, the middle world, and the celestial world. They went through hallucinatory states in order to gain the gift of flight and discover the celestial world.

THE NET OF POWER
In the Shamanic tradition there is a Net of Power, there are celestial maps that chart invisible routes, and there are central axes that cut from the underworld through the middle world, so that one can finally fly into the celestial world and return with the Shamanic gift of healing.

GRANDDAD'S MEAT SAFE
David Coppenhall built some wooden frames and stretched layers of fine transparent thread and fishing line across them. He then fitted these frames inside his granddad's old meat safe and wove between the frames with more thread. Metal rods were also inserted at different angles. A tightly stretched frame of tissue paper was painted with acrylics and doped so much that it split, allowing light to shine through – that's the area in the top right. Lit by various colored gels, the interior of the safe was photographed using a 35mm Nikon camera. It all came together in a series of layered transparencies. With a positional guide for reference, David supplied the transparencies to the printer for scanning. The map and type were supplied as overlays for the printer to drop into the finished image.

"THIS WAS MY grandfather's old meat safe, which was so earthly and opposite to the themes that it made me laugh. It was all a bit too New Agey for me, so it was nice to bring it down to earth." – David Coppenhall

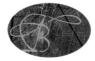

SHAMANS FROM ALL CULTURES had a tradition of documenting their celestial maps – the routes by which they moved into the celestial world and acquired their powers. Though these people came from totally different cultures, they all went through these trancelike states and documented their journeys in a similar way.

SHAMAN TRADITION
Coppenhall used celestial maps on the front, back, and on the vinyl label. The maps came from a book of engravings.

SPECIFICATION	
•*Artiste*	**Heavenly Bodies**
•*Title*	**Celestial**
•*Design*	**David Coppenhall**
•*Record Co.*	**Third Mind Records, 1987**

CELESTIAL

BIG BROTHER & THE HOLDING COMPANY, Cheap Thrills

WONDERFUL ROBERT CRUMB, genius and paranoid, humorist and obsessive. Brilliant penmanship, fertile imagination, little confidence. In retrospect, it seems he spoke for a whole psychedelic generation, but at the time he admits not knowing where he really fitted in. Too scathing for the spiritual heads, and too philosophic for the hedonists. An explosive cocktail of repressed inhibitions spurts on to the page via a dynamic and expressive drawing style, where limbs – particularly breasts and buttocks – are hugely exaggerated; where a colorful hodgepodge of eastern philosophy, naive socialism, and popular psychology is underpinned by a gleeful, sarcastic, and self-effacing humor. Most memorable are the engaging characters Crumb invented, like Mr. Natural, Devil Girl, Fritz the Cat, and himself, as angst-ridden artist. Many of his illustrative qualities are to be found here in *Cheap Thrills*, notably the exuberance of the characters – one-eyed mystics, bawling babies, voluptuous females, and screaming fans – which spill forth from every frame. Frames of fun in a gray life; pools of sanity in a bleak world; crumbs of comfort from the discomforting Mr. Crumb.

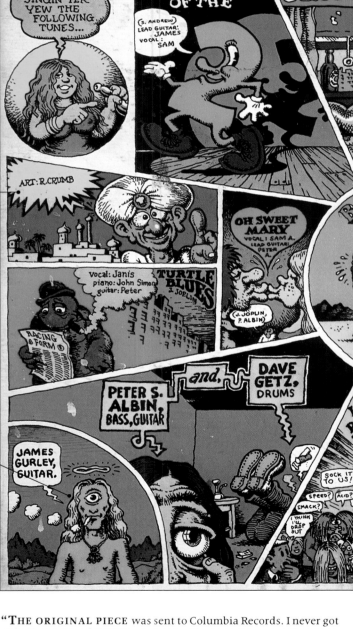

SPEEDY JOB
"Janis Joplin asked me to do the cover for their second album – I think it was in 1967. She'd seen my comics and liked my work. Of course, by the time they asked me they needed it done by the NEXT DAY! I took some speed and stayed up all night to get it done – I remember finishing it well after the sun was up."

HELL'S ANGELS
"Janis and Dave Goetz had talked to me about what they needed. That was about all their input, except that Janis wanted that Hell's Angels seal on the cover. She thought they were 'cool' and hung out with some of those people."

ORIGINAL VERSION
"All I had in mind was to lay it out in comic-strip style and illustrate each of the song titles and the other text they gave me to put on the 'back' cover, which afterwards became the front cover. The original front cover showed a cartoon drawing of the band on stage, using photographs of the members. I cut out the heads and pasted them on, and drew little cartoon bodies underneath the photo-heads, satirizing a motif used often in the 30s, 40s, and 50s to illustrate bands on posters, magazine covers, album covers. I guess the band members didn't get it."

"THE PANEL THAT SAYS 'Art: R. Crumb' was originally intended to illustrate one of the tunes – a raucous put-down of the Hare Krishnas, but this tune was eliminated later, and the lettering 'Art: R. Crumb' was put in by someone in the CBS art department, skillfully matching my style."

"THE FIGURE in the bottom left-hand corner is a static representation of the musician James Gurley as an 'angelic hipster dopehead' with the cyclops 'all-seeing eye' of the LSD visionary."

SPECIFICATION
- *Artiste* — Big Brother & The Holding Company
- *Title* — Cheap Thrills
- *Art* — Robert Crumb
- *Photography* — Elliot Landy & Thomas Weir
- *Record Co.* — CBS, 1967

"THE ORIGINAL PIECE was sent to Columbia Records. I never got it back. I received $600 in payment – a huge sum to me at that time. The record sold in millions over the years – can you imagine if I'd got a ROYALTY deal?!? Oh, well, water under the bridge. Somebody in the band, probably Goetz (the most clear-headed member) told me later that it was rumored that the artwork was lost. Twenty years later the artwork was sold at Sotheby's for a very large sum."

"THE LETTERING at the top was originally done to go all the way across the top… CBS reduced it and moved it over to fit their corporate logo in the top left."

"THE NAME CHEAP THRILLS was the band's idea – all the text on the cover came from them, except for the first panel, where a girl is saying 'Playin' and singin' fer yew…' and a couple of the little asides in some of the panels… yes, I created the lettering used for the title and the band name. I had not used it before, nor since. Jesus, this is beginning to feel like a legal deposition!!"

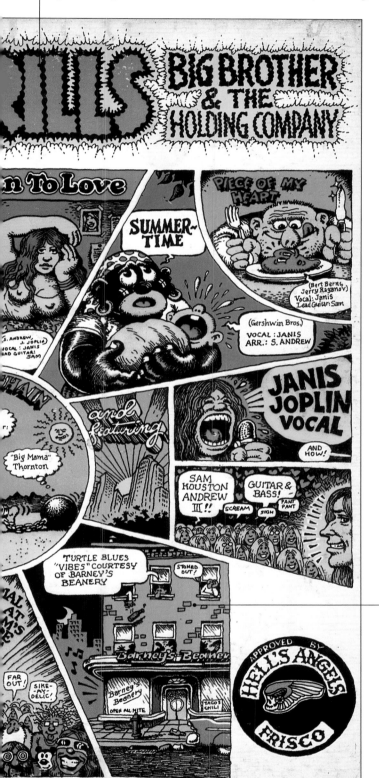

THIRTY YEARS ON

"I was pretty happy with the finished product – it still looks pretty good thirty years later… it's been copied many times for other album covers – the layout and design ideas, I mean. Of course, I was disappointed that they didn't like the original front cover design that I'd done, which at the time I thought was stronger than the 'back' cover. I don't know what I'd think of it if I saw it now… I only have a vague memory of it – the background was deep blue. The figures of the band members were standing on a curved stage which was bright yellow – a cheering crowd in silhouette went across the bottom – there were music notes dancing in the blue background – I don't remember what the lettering looked like. I wonder if that artwork still exists. Maybe Goetz would know."

TECHNIQUE

"Pen and ink on Bristol Board, with Zip-A-Tone color film stuck down and cut out directly over the black line work. There were no prototypes or pencil roughs…."

BARNEY'S BEANERY is a real bar and restaurant on Santa Monica Boulevard in West Hollywood where Janis Joplin liked to hang out and drink.

"THE HELL'S ANGEL'S bit was done after I'd already started the art – Janis called me that morning, or maybe it was late the night before, while I was still working on it, and told me to put that on there somewhere."

A YEAR OR SO LATER, *Janis called me to ask if I'd do some lettering for their next album with CBS. This logo would be printed on the cellophane wrap, not directly on the cover itself. I consented, but told her to tell CBS to keep their money, but I'd do the lettering because I liked her personally. So I did the job, and CBS was only too happy to abide by my wishes and not pay me. Soon after that Janis died."* RC

KEEP ON TRUCKIN' CARTOON
Crumb's design graced every self-respecting hippie's T-shirt in the late 60s and early 70s. Crumb lost a copyright lawsuit for this image in a lengthy courtroom battle.

A **Zap** *comic featuring the hilarious Mr. Natural*

ROBERT CRUMB

Born in Philadelphia in 1943, Robert Crumb had no formal art school training, but began drawing in his teens, producing single-issue comics with his brother in which the infamous Fritz the Cat first saw the light of day. Moving to Cleveland in 1962, he married his first wife Dana and worked at the American Greeting Card Company while moonlighting as an illustrator for comics such as **Help***, where he met one of his greatest influences, Mad co-creator Harvey Kurtzman. Experimentation with LSD led to the creation of the enduring Mr. Natural character, but it was his move to San Francisco in 1966 that really kick-started his career. Working alongside the likes of Rick Griffin and Victor Moscoso, Crumb provided strips for* **Zap Comix** *edition No.1 and became an overnight sensation. The appearance of the incest-based Joe Blow story in* **Zap No.4** *led to Crumb's arrest for obscenity, and he maintained his reputation for high-profile lewdness via the highly successful cartoon movies of his Fritz the Cat character, made by animator Ralph Bakshi. Displeased at the furore, Crumb disowned the films. During the 70s, Crumb toyed with music himself, forming a jazz band, The Cheap Suit Serenaders. He lost a copyright lawsuit over ownership of the iconic Hippy counter-culture strip* **Keep on Truckin'***, and was forced to move to France by a $30,000 IRS tax bill. Crumb has acquired cult status and remains one of the most influential illustrators of his era.*

… And thank you, Mr. Crumb, for permission to quote from your excellent letter.

100 BEST ALBUM COVERS —41

CHEAP THRILLS

CATHERINE WHEEL, Chrome

DANCERS CAUGHT IN ACTION, forming elegant shapes that are captured not so much by the camera shutter as by the surrounding medium. Contradiction is a theme here – aerial, dynamic shapes made not in the air, but underwater. Energetic movements in slow motion, great leaps made easy. Figures floating in ethereal space, ghostly but real, isolated but connected. Lightness of touch for hard music, a metallic title for a gentle image. Catherine Wheel is a girl's name, of course; but it is also an instrument of torture. Catherine was a cruel empress with a heart of stone… fixed like a rock. A wheel is useful and unfixed and likes to roll. Catherine and wheel. Rock and roll.

THIS IS the actual hand of the outstretched arm of the male dancer, just visible above the water, revealed briefly as the lapping pool descends across the lens. The hand represents, almost literally, the tip of an iceberg, which is implied by the triangular formation of the dancers below.

THE LOCATION is London University Students' Union swimming pool on Malet Street. This is the view of the north end – temporarily visible above and below the moving water level.

THE CLOTHES are scanty to convey sensuality and lightweight so as not to drag down the dancers. They are white and shiny to reflect the light and loose enough to flutter in the water, which acts like a filter or net across the lens, lending an ethereal, lustrous quality to the final photograph.

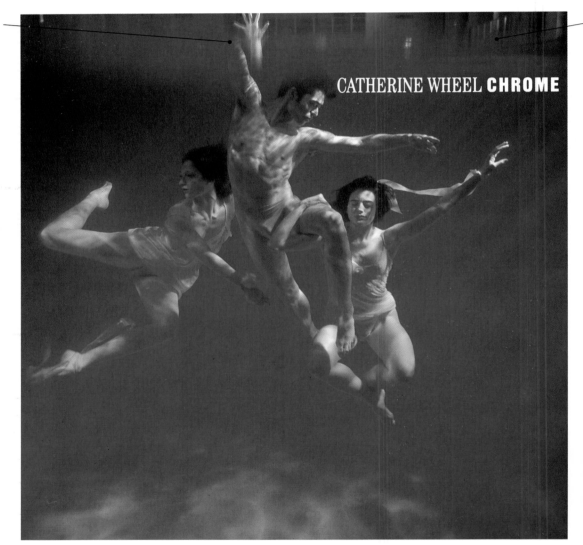

THE CROSS-FADE between underwater and above water is natural, achieved by lapping pool waves passing over the camera lens during a time exposure of between a quarter and one-thirtieth of a second. It is invisible when actually taking the photograph. Its position and extent are uncontrollable: fortuitous in detail, but predictable in principle.

THE FIGURES are ballet dancers recruited from the London Contemporary Dance Theatre by the dancer Chlöe Mason, daughter of Pink Floyd drummer Nick Mason. They needed to be fit and agile to take this formation, to hold it underwater long enough to be photographed, and to repeat it several times. There is no trickery nor manipulation here. It is all one photograph. What you see is what there was.

TECHNIQUE

A single exposure was taken with a Hasselblad camera and a 60mm lens, using tungsten lighting angled down through the water from the side of the pool. The camera was tripod-mounted, and positioned within a small glass fish tank immersed a foot or so into the water near the edge of the swimming pool, providing, in effect, a window at water level. The photographer was positioned flat on the ground and leaned over the contraption to see the depth and pose of the dancers. The procedure was repeated many times to permit both shutter variations and changes in formation.

FLOYD FAN

*Catherine Wheel's manager, Merc Mercuriades, an ardent fan of Pink Floyd, commissioned Floyd designer Storm Thorgerson to design the sleeve for the band's second album, **Chrome**. He and singer Rob Dickinson suggested that there was perhaps more to this band than met the eye. "Tip of the iceberg" was a phrase that stuck.*

THE BACK COVER

The back of the cover shows a figure leaping across the great void and over the credits and track listing. A giant step for mankind, a great jump for Catherine Wheel – an elegant leap of the imagination.

SPECIFICATION

- *Artiste* Catherine Wheel
- *Title* Chrome
- *Design* Storm Thorgerson and Keith Breeden
- *Graphics* Peter Curzon
- *Photography* Tony May and Rupert Truman
- *Record Co.* Fontana, 1993

JOY DIVISION, Closer

THERE WAS A HUGE CHANGE in the spirit of record cover design after 1980. In the late 70s Punk was the anarchic movement that tore everything up, and out of that revolutionary zeal came a new wave of designers specializing in a style known as "deliberate cool." Students fresh out of art school were fed up with the tackiness of Punk and wanted to realize packaging values that were informed by a design and fashion sensibility. Manchester-based Factory Records, along with art director Peter Saville, were exponents of the new style, Joy Division's *Closer* is a perfect example of the work.

GRAVES AND CRYPTS
*Peter Saville: "Joy Division came to me and said 'Is there anything you want to do?' So I showed them some photographs by Bernard Pierre Wolff that I had seen in a French edition of **Zoom** magazine. He had been doing photographic studies of graves and headstones and the sculptures in crypts – the style was a kind of contemporary baroque. I proposed the idea for this cover without hearing any music."*

ART DIRECTION
Closer *was the second album that Joy Division released with Factory Records. As Factory's art director, Peter Saville had the job of designing their covers. Peter Hook of Joy Division: "Inasmuch as Peter Saville is relevant to the group, he listens to the music and we trust him to realize what we are saying in a visual format. We make it for the ears and soul and he makes it for the eyes."*

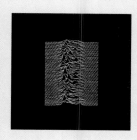

·CLOSER·

NEOCLASSICISM
Peter Saville saw an element of neoclassicism in Wolff's photographs. The biggest inspiration to Saville at that time was the AT&T building that architect Philip Johnson was putting up in New York. Saville wanted to reflect this in his work. He went to Rob Gretton, Joy Division's manager, who thought it was a great idea. Gretton said to him: "Wait till you hear the music – it makes sense."

THE TYPEFACE
is based on the earliest piece of serif lettering ever discovered. It was traced by a German professor of typographic research who dated it from the 2nd Century BC. Saville made this alphabet into a headline font so he could make words out of it. He put *Closer* on the front above the picture and Joy Division on the back.

JOY DIVISION
Joy Division never gave Peter Saville instructions about the cover. There were no credits and the labels said "All songs written by Joy Division." There were never any photographs of the band.

IAN CURTIS
Peter Saville: "Around four weeks before **Closer** *was released the singer, Ian Curtis, killed himself. Not the usual overdose, but because of a romantic tragedy. He stayed at home one night and watched a Werner Herzog movie called* **Kaspar Hauser,** *in which the antihero kills himself. And Ian did the same. He hung himself. He had written a song called 'Love Will Tear Us Apart' about a love affair that went wrong and he went the full way, immortalizing totally this 'teenager in the bed-sit' myth. The group felt that as we had decided on the cover with Ian before he died it should stay the same."*

CLASSIC COVER
"We were very pleased with this cover and I think it is a real classic. It was used on a huge billboard on Sunset Strip in Los Angeles." – Bernard Sumner

ART PRODUCTION
Peter Saville: "I found a very a special paper – an antique board – for the cover. It had a soft kind of etching feel and suited Bernard Pierre Wolff's picture of the tomb. The layout was very simple, with a border and a key line and an inset image and a nicely balanced piece of type and then there is just the monumental type on the back."

THE HACIENDA CLUB
When the album was released it was an enormous success – without any advertising and without being played on the radio. It sold lots of copies, and millions of dollars came in to Factory Records. The money was split between Factory and Joy Division and went toward building The Hacienda Club in Manchester.

SPECIFICATION

• *Artiste*	Joy Division
• *Title*	Closer
• *Design*	Peter Saville and Martyn Atkins
• *Photography*	Bernard Pierre Wolff
• *Record Co.*	Factory, 1980

ROXY MUSIC, Country Life

FROM THE VERY BEGINNING, Roxy Music contrived to make their album covers as sexy as possible. "Sex sells" was the conceit, and it worked. From transsexual Amanda Lear on the cover of *For Your Pleasure* to top models Jerry Hall on *Siren* and Marilyn Cole on *Stranded*, they all graced Roxy Music's sleeves in a parade of camp high fashion that outraged, titillated, turned on, and turned off critics, fans, record company executives, and Christian Fundamentalists alike. All their covers made headlines and that was the general idea. Richard Hamilton — Pop artist, theorist, and creator of The Beatles' *White Album* cover — was one of Bryan Ferry and Nick de Ville's university professor. That he was influential in their respective careers is obvious.

THE LOCATION

Bryan Ferry, fashion designer Anthony Price, and photographer Eric Boman were vacationing together in southern Portugal. Bryan was taking a break from the recording of **Country Life**. They had planned to take some shots of Bryan while they were there. By chance they met two girls, and the idea for the cover was conceived on the spur of the moment.

TOP DRAWERS

Evaline Seeling (left) was on vacation with her boyfriend, Michael Karoli, and his sister Constance Lanterman at their parents house in the Algarve. They met Roxy Music singer Bryan Ferry and his friends at a local bar. One day Bryan and friends arrived at the villa with an idea for an album cover and wanted Constance and Evaline to model for them. Evaline later recalled: "We thought it would be nothing but a holiday snap. Constance and I drove to Portofino to try and find some sexy underwear. We wore the same style because that was all we could find."

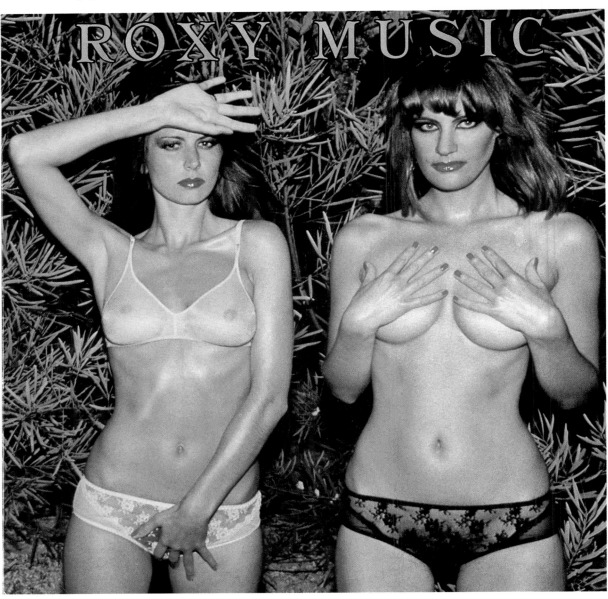

RICHARD HAMILTON

"A product," Hamilton wrote, "must aim to project an image of desirability as strong as any Hollywood star." Roxy Music's covers projected an image almost as outlandish as the band itself.

THE TYPEFACE

for the words Roxy Music was chosen by Nick DeVille. He based it on the logo for the English upper-crust hunting, shooting, and fishing magazine *Country Life*.

SHRINK WRAP

The album cover was banned in the US. It was thought that Constance was a transsexual and that Evaline had her hand in her panties. Initially the record company put the album out in an opaque green shrink wrap; later they used just a different picture of the bushes with no girls at all!

SPECIFICATION

- *Artiste* — Roxy Music
- *Title* — Country Life
- *Art Direction* — Bryan Ferry
- *Design* — Nicholas de Ville
- *Photography* — Eric Boman
- *Record Co.* — Island, 1974

THE SHOOT

Eric Boman shot the photographs in the garden behind the swimming pool at the villa of Michael Karoli's parents. Anthony Price did the makeup beforehand in the bathroom in the villa. Eric Boman: "I shot three rolls of 35mm film, EHB with a Leicaflex SL and a 28mm lens. It was lit by the headlights of our rented car. I remember having to focus the camera on a box of laundry detergent that Anthony held up as the car headlights were pretty dim."

BACK AT THE RANCH

Eric Boman: "When we looked at the film back in London, I got the feeling that Bryan wasn't very happy. I think there was a lack of the slickness that he was used to, but gradually everyone realized that there was another quality, hard to put your finger on, of ambiguity and, as we now call it, 'rawness' that worked. I still think we were all surprised when the cover became such a classic."

ORCHESTRAL MANŒUVRES IN THE DARK, Crush

ONE IS NOT TOO READY to applaud artworks which are clearly executed "in the style of" some well-known artist (and not in the designer's own style), but this painting for the cover of Orchestral Manœuvres In The Dark is different. Firstly, it is lovingly done by illustrator Paul Slater in the style of the American painter Edward Hopper, and is executed openly without embarrassment or sycophancy. Secondly, it is alarmingly evocative, very much like a real Hopper, but of a different mood and setting, recalling memories of love's first encounters. One needs to remember too that the field of commercial graphics is served not only by original custom-made designs, but also by appropriate and elegant solutions, such as this forlorn reminder of teenage passion and impending disappointment. Not quite as Hopper as Hopper, but hipper.

A PASTICHE OR TWO
Paul Slater: "I was commissioned to do this cover by Caz Hildebrand, and by that time everyone had already decided on the Edward Hopper theme. In those days I was known to pastiche the odd painter or two. I hadn't attempted a Hopper look before, though I was, and still am, a big fan of his work."

THE FACES AT THE WINDOWS
Paul Slater: "The composition was left up to me, the only requests being the car, the boy and girl, and to include the group's faces in the windows."

PAINTING STYLE
"The painting was about 14 in x 28 in and painted in acrylics on board. Hopper's style is broad and painterly and my inclination is for more detail, so it was difficult to judge just when to stop." – Paul Slater

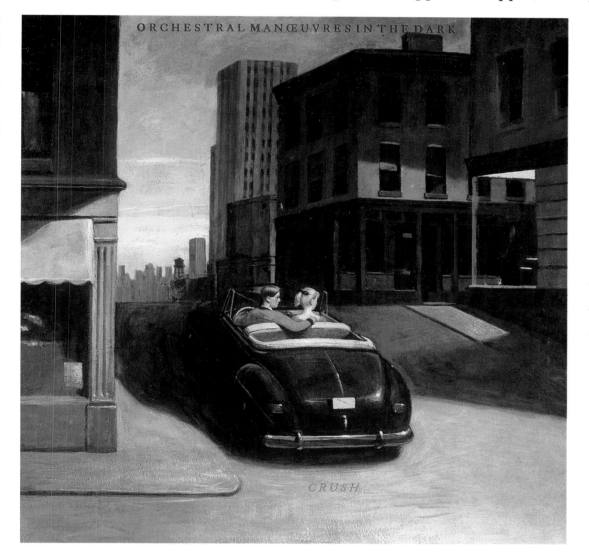

TEEN ROMANCE
Caz Hildebrand: "OMD sent us some tapes and lyrics and we had quite a long meeting to discuss a number of cover ideas. The title **Crush** was already in place and the band explained that they didn't want a violent cover. A cover depicting teen romance was suggested but not treated in a Pop Art way. They wanted a mid-American feel, 'Nowheresville,' quietly evocative of lost, past times."

MELANCHOLIA
Martin Kirkup, manager: "I remember Andy McCluskey telling me the reason he wanted a Hopper-style painting on the cover of **Crush** was that he had always felt that there was a lot of melancholy in the paintings of Hopper and he felt that it matched the melancholy that was in the songs."

WRAPAROUND
As the sleeve is a single sleeve and not a gatefold, it's difficult to view the complete painting.

WHAT DID THE DESIGNER THINK?
Caz Hildebrand: "Hopper was the right feel then, although now it would be a cliché. There is a brooding, particularly un-English feeling about this cover, but at the same time it's not Coca-Cola America either. I think it was a very good pastiche and very different from other covers that were in vogue at the time. It was a good cover in response to an informed brief from the band." Paul Slater: "I think the band liked it, as it didn't come back for alterations.
I must confess though, I've never heard Crush, despite being a fan of OMD. When the album was released, the review in **Harpers & Queen** said that the music wasn't up to the usual standard but the Hopperesque cover was worth a second look."

EARLY SUNDAY MORNING 1930
The Edward Hopper painting that inspired this pastiche was called **Early Sunday Morning 1930**, a quintessential evocation of urban loneliness. Caz Hildebrand: "I found a copy of the original Hopper painting and specified to Paul Slater the position of everything, including the car and the placing of both the band members in the windows overlooking the car. In fact everything in the cover painting was designed before it was painted."

SPECIFICATION

- *Artiste* — Orchestral Manœuvres In The Dark
- *Title* — Crush
- *Design* — Caz Hildebrand at XL Design
- *Illustration* — Paul Slater
- *Record Co.* — Virgin, 1985

PINK FLOYD, The Dark Side Of The Moon

THIS IS ONE OF THE WORLD'S most successful records and most iconic album covers. The group wanted to get away from the pictorial imagery of their previous covers and elected instead to have a cool graphic. They thought that the prism design managed to powerfully represent both the conceptual power of the lyrics and the clean and seamless sound quality of the music. The prism idea also echoed their famous and much admired light show. Pink Floyd felt that the end result was a good match for the album, good enough not to need lettering.

PYRAMIDS
Both as a poster insert and as part of the sticker artwork, the designers included images of the pyramids – symbols of vaulting ambition, greed, and megalomania. These were themes touched upon in the lyrics. The triangular outline of the pyramid also linked it to the shape of the prism on the front cover.

THE DESIGN is derived in part from a textbook illustration of how white light passing through a prism forms a spectrum. This is usually shown as a black line on white paper, possibly with a colored spectrum. The designers changed the background to black because "black is cool." They enhanced the prism to give it depth, and of course heightened the colors of the spectrum as they saw fit.

WHEN WHITE light passes through a raindrop or a prism, it breaks up into seven colors – red, orange, yellow, green, blue, indigo, and violet. Since this cover was a graphic rendition, the designers decided to junk the indigo as it was too close to violet and therefore not easily distinguishable. Art before science, they said.

THE ARTWORK was a tint lay. Areas were drawn in black and white and the separator was instructed to color in with specified percentage tints.

THE PRISM DESIGN
*This motif has resurfaced many times in Pink Floyd's history, none more playfully than on the comic book programs for the 1976 **Wish You Were Here Tour**.*

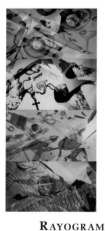

RAYOGRAMS
This set of rayograms was created for the 20th anniversary edition. They are named after the artist Man Ray, and are made by placing the objects directly onto the photographic paper and then exposing them to the enlarger light.

TWENTIETH ANNIVERSARY EDITION

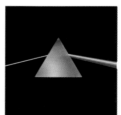

The spectrum for the original cover was done as a mechanical tint-lay in black and white with color instructions. The prism itself was airbrushed black on white, then reversed out. For the remastered 20th anniversary edition the design itself was remastered as a photograph. Tony May shot a beam of white light through an actual glass prism. The colors were clearly visible on the white paper background placed beneath the prism.

SPECTRUM WRAPS
The spectrum stretches across the inner spread, rejoining the first spectrum on the back cover and forming a seamless continuation for shop display. The inner spread spectrum contained graphic heartbeats to echo the audio heartbeat at the start of the album.

OTHER OPTIONS
The prism was one of seven roughs shown to Pink Floyd who spent only three minutes to settle on it, rejecting among others, The Silver Surfer.

SPECIFICATION
- *Artiste* Pink Floyd
- *Title* The Dark Side Of The Moon
- *Design* Hipgnosis
- *Graphics* George Hardie
- *Record Co.* EMI, 1973

BUZZCOCKS, A Different Kind Of Tension

BUZZCOCKS' THIRD ALBUM had a different kind of cover. It broke new ground in design, constructing a bridge between the edginess that had been Punk, and the deliberate coolness of New Wave that was to come. Designer Malcolm Garrett had already produced the first two Buzzcocks' covers, and described the design for *Tension* as a "personal solution." The first had been a compromise with "some great aspects," the second tried to please the band, though they were "less pleased than they should have been," but for *Tension*, he was going to do precisely what he liked. Such personal conviction provided the perfect illustration for the music of Buzzcocks – a band sometimes called the "thinking man's Sex Pistols."

BALANCE
Malcolm Garrett: "I was trying to find the point at which balancing a triangle within a square was neither happy nor unhappy. Balance was central to the whole thing, because though it's unstable visually, a triangle is one of the most stable structures there is. I wanted an end result that, if successful, I wouldn't be sure if I liked it or not."

CONSTRUCTIVISM
Richard Boon (manager) "The graphic came from Russian Constructivist El Lissitzky; it was him in Day-Glo. The lines were construction marks, denoting the center of a circle. The horizontal bars carry information and continue around the spine."

THE BACK COVER
Malcolm Garrett: "I like the back of this better, because it's more graphic and doesn't have the picture to contend with. It's not that I don't like the photograph itself, it's just that I was exploring graphic shapes, so in a way, the photograph compromised that, but it was a compromise that I was then able to make work via the progression."

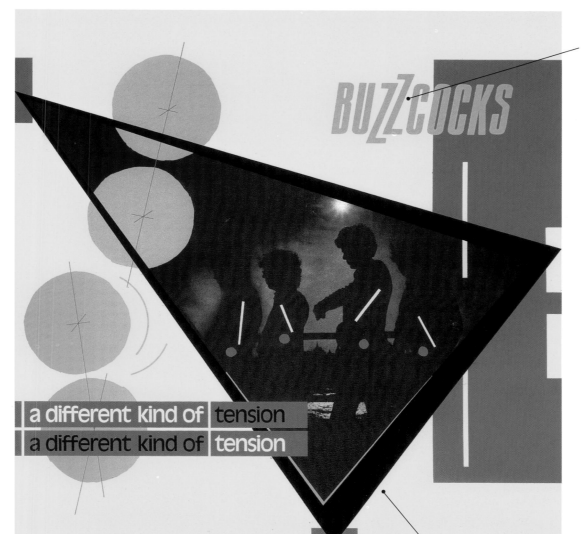

THE LOGO was one of several designed by Malcolm Garrett using various Letraset typefaces, which were photocopied, cut through the middle, and elongated to become semi-original lettering.

THIS WAS the first Buzzcocks sleeve to illustrate the title in terms of color and through the structure of the design elements. Designer Malcolm Garrett was interested in packaging, form, and structure rather than making images. "Choosing colors that don't go together, but sort of do, illustrates the title."

A lot more Garrettski than Lissitzky.

ARTWORK
Traditional mechanical artwork was done on CS10 art board using Rotring pens, pen and ink, and PMTs (photomechanical transfers) on overlays for the type.

SPECIFICATION

- *Artiste* Buzzcocks
- *Title* A Different Kind Of Tension
- *Design* Malcolm Garrett
- *Photography* Jill Furmanovsky
- *Record Co.* EMI, 1979

PACKAGING AND VISUALS
The inclusion of advertising, merchandising, clothes, and stage sets was a considered part of the Buzzcocks project. An attention to detail unmatched in the record industry at the time. Manager Richard Boon: "During the band's early stages, Malcolm Garrett and I spent a reckless night mapping out a whole graphic program for them that emphasized the process toward the product. We released singles marked 'the single from the album' when releasing album tracks as singles was considered against punk 'value for money' ethics. We highlighted the catalog number in the design, and released the previous album in a plastic bag marked 'product.'"

THE COVER SHOT
Taken by Jill Furmanovsky, this was a publicity still for the previous *Love Bites* album and was taken in September 1978 on London's South Bank.

MALCOLM GARRETT
After working with Buzzcocks while at college in Manchester, UK, Malcolm Garrett moved to London and worked as a freelance designer at Radar Records under Barney Bubbles. He then set up his own design company, Assorted Images, and produced work for Duran Duran, Simple Minds, and Peter Gabriel. In 1994, he formed AMX, a multimedia design, publishing, and production company, which then joined Real Time Inc. in 1998.

John Berg

POWER, RESPECT, AND LUNCH

The business of producing cover designs involves quite a few people, but it is the art director at the record company who is often the man in the middle, where the buck stops, and where final decisions are made. The record company art director is usually the arbiter between artistic and commercial requirements, liaising between various factions, between designers and printers, and between recording artistes and company managers. Skill and power varies greatly, depending on the person in question and the company involved. John Berg is a highly respected art director who worked for Columbia Records for twenty-four years. This is his own description of his job — his tasks and experiences.

I came out of a multidisciplined graphic background. First as a high school cartoonist, a college yearbook designer, promotion designer for the phone company, and a packaging and promotion designer for a box manufacturer. I then did some work for some New York ad agencies and eventually became an art director at *Esquire* magazine. This led to some editorial design work at a big "top-shelf" magazine, and I won several design awards before Bob Cato hired me as art director at Columbia Records in New York. Prior to that I had never done a record cover. My first cover was for Andy Williams' *Moon River*, the second was Bob Dylan's debut album, and the third was Igor Stravinsky conducting the music of Don Carlo Gesualdo. In other words, the music was all over the place. Catholic, to say the least. We did album sleeves for polka, country, Broadway, classical, pop, surf music, and a tiny bit of rock 'n' roll.

After a while I managed to cut down the existing art department at Columbia and re-staff to my liking. In later years I built an art department in Los Angeles and another in Nashville to service the two other areas of Columbia's huge music production.

I don't think my era (1961–1985) at Columbia ever had a style *per se*. I have a style and I did a ton of the design, but many of Columbia's staff designers contributed to the workload. We tried to make everything readable (my first criterion), strong, funny (where possible! — the Leningrad Symphony Orchestra cover doesn't qualify), and beautiful. One has to remember, half our product was classical.

I worked hard on winning awards. It was important to me for two reasons — to entice terrific designers and photographers to work for us, but also to get myself a raise. Luckily I was successful on both counts. The list of my compatriots is outstanding.

The monolithic corporation that the art department worked for was CBS. Its chairman was William Paley, who owned Picassos by the yard, with Matisses for backup. The president was Frank Stanton, whose backbone, graphically, was Lou Dorfsman! You don't have enemies in the business with guys like these on top. The jewel of the bosses was Goddard Lieberson, president of the record company, who would defend to the death any creative impulse in his backyard. It's good to have that kind of support behind you.

My personal design premise seems to be storytelling. With illustration or photography or even with type alone. I seem to like to tell stories in tiny, strange, and idiosyncratic ways.

For example, the series of covers for Chicago illustrates what I mean. They are all organic in some way. They are

Top left: John Berg. Center left: Chicago / Chicago XVI. Bottom left: Chicago / Chicago X.
Top Right: Chicago / The Chicago Transit Authority. Bottom right: Chicago / Chicago XI.

all made of something or are objects or crafts (except for the Greatest Hits cover by Reid Miles, which is the only photograph of the band we ever used in the 14 covers that I did). A strange fact is that nobody, to my knowledge, ever realized that the Chicago logo (designed by Nick Fasciano to my layout and request to produce a Coca-Cola rip-off) was always the same size and in the same position on every cover. When the band broke up with their manager and producer, James Guercio, and became a West Coast entity, they had their covers done by our LA art director, Tony Lane, who is one of the best in the business and has a very keen eye for such things. He didn't catch on to what I had been doing for years. He did an illustration of office towers, one of which was shaped like the Chicago logo. I had never produced an illustration for Chicago. Tony put the logo in the wrong place and size and did it in perspective! So much for my subtlety.

I have superstar anecdotes to spare. Months before his motorcycle accident, Bob Dylan turned down a silhouette, backlit photo I later used for his *Greatest Hits* album (which won the Grammy® for Best Album Cover that year). While he was out of action, I used it anyway and it became a smash hit. Several years later, he arrived in my office with a virtual duplicate of that same silhouette photo that I'd used. I reminded him that he had hated that picture before. He shuffled his feet and bobbed his head and did that Dylan shuck-and-jive thing and suddenly we were all happy. It became *Greatest Hits, Vol 2*.

Janis Joplin commissioned Robert Crumb's artwork for the *Cheap Thrills* cover and delivered it to me personally. Clive Davis, then president, hated it and refused to use it. I loved it and had to threaten to quit. I won. It became graphic history.

The first logo that I'm aware of in the record cover business was the Barbra Streisand typography that I used on all her albums until well after she went to Hollywood. After several crash-and-burn typo tryouts she went back to my choice of Century Expanded Italic. Barbra has a reputation of being very difficult or even outright impossible. I loved working with her because she was one of the smartest people I have ever dealt with. We never did great graphics for her, but considering that we were dealing with superstar merchandising, we didn't do anything to be ashamed of either.

The advantage of working as an art director for a giant corporation was power, respect, recognition, clout, first-class seats, and lunch. No trepidation about calling Milton Glaser or Richard Avedon to help out. Management basically and graphically was hands-off. They never bothered us. We won so many awards they thought we were walking on water. In truth, I never had a budget I was aware of. I would spend thousands on some classical non-seller, and twenty bucks on a major pop breakout-smash-hit-blockbuster (which, of course, would pay for the classical product). Nobody in management ever took me to task for our weird misallocations. I guess it all balanced out in the end.

I have been nominated for 29 Grammys®, several times in the same year, which unfortunately dilutes your chances. I've won four, but of course, lost 25 times. I have won awards from the New York Art Directors' Club, Graphis, The Society Of Illustrators, and The American Institute Of Graphic Arts, to name a few. I am currently freelancing covers and book jackets and teaching typography and graphic design at a major New York art school.

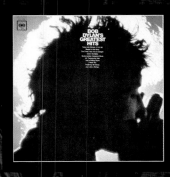

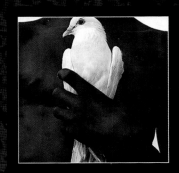

Top left: Chicago Chicago II. Center left: Chicago Chicago VI. Bottom left: Chicago Chicago IX. Top Right: Chicago Chicago VII.
Bottom left: Bob Dylan Bob Dylan's Greatest Hits. Bottom center: Santana Santana's Greatest Hits. Bottom right: Sly & the Family Stone Fresh

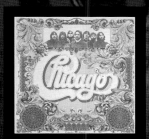

FINGERPRINTZ, Distinguishing Marks

A FEW LITTLE THINGS IN LIFE are intrinsically likable, despite the many that are not. Postcards are one of them, whether sent abroad or back home, or stuck on a corkboard, or resting on a shelf. Postcards are disposable and enduring, bearing slight or meaningful messages and displaying great images from art or cheap photos of the Riviera. We like postcards, so we like this album cover for Fingerprintz. It's not just a collection of 50s magazine illustrations. Lovingly executed by John Stalin, with interesting faded backgrounds and exaggerated expressions separated by bold borders like street markings, it is also perforated to provide real cards for postal use, albeit at the expense of the actual cover. How thoughtful.

PETER SAVILLE: "They were simply humorous images, nostalgic 50s and 60s images you could see a lot at that time in the ICA bookshop in London. I suggested the perforations as a parody on the band's name – introducing some hands-on involvement. There were perforations around each of the John Stalin postcards so that you could, if you wanted, tear up your album cover into 12 postcards."

JIMME O'NEILL: *"John Stalin and I worked through the song titles. My favorites were 'Houdini Love' and 'Yes Eyes,' although they were all brilliant. John was using kitsch drawings and paintings from magazines and books from the 40s and 50s – he was a garage sale, second-hand store freak (as I was), and he mixed them together with modern, medical, sci-fi, and cybernetic images. The overall effect was very modern, post-Punk satire. Perfect for our album!"*

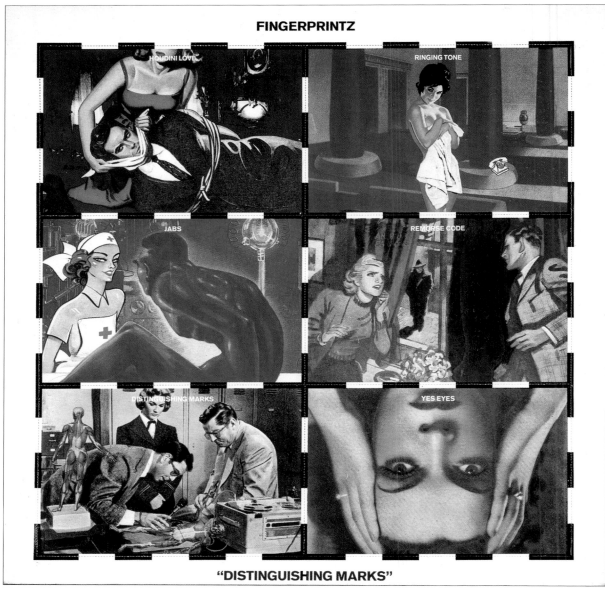

FINGERPRINTZ

"DISTINGUISHING MARKS"

ORIGINS
Jimme O'Neill of Fingerprintz: "Peter Saville was one of a new breed of designers, and I had requested him to design the album cover." Peter Saville: "I was working as the art director for Dindisc at this time and was approached by Simon Valley from Virgin to design this cover."

JIMME O'NEILL: "John Stalin had designed these postcards that I had seen on sale in the King's Road. They were full of quirky, bizarre humor, which was exactly what I was trying to do with my lyrics. I felt his images were street Dada – in other words, Peter Blake updated to Punk. I told Peter Saville how much I liked these postcards, and he agreed they would be ideal. He suggested perforating the cards so that, if you wanted, you could dismantle the album and send it through the mail!"

WINSTON AND JOE
Jimme O'Neill: "I recall there was some tension between John Stalin and Peter Saville. I think that John felt that the design was his and that Peter, as art director at the record company, would end up getting the lion's share of the credit, not to mention the fee. I have had no contact with John Stalin since we collaborated on the cover. He used many aliases – John Churchill being one – Stalin and Churchill – geddit? He once told me his real name, but I've forgotten it now." After extensive enquiries, the whereabouts of the elusive John Stalin are still unknown. Anyone know a John Clinton?

THE POSTCARDS
There are a total of 12 postcards – six on the front and six on the back. Each postcard is a montage of images from a variety of sources. Flat color has been applied to some illustrations in a simplistic style, and the original printed screen dot can be seen in other images. This cover, appearing in 1980, was produced at a time when the crudeness of Punk was giving way to a more deliberate and stylized way of design.

SPECIFICATION
- *Artiste* Fingerprintz
- *Title* Distinguishing Marks
- *Design* Peter Saville
- *Illustration* John Stalin
- *Record Co.* Virgin, 1980

PINK FLOYD, The Division Bell

THIS WAS THE FIRST Pink Floyd studio album for several years, and only the second without Roger Waters. The band felt the album was about communication, or the lack of it, about childhood, and about personal ghosts. Communication was represented by the line of lights between the profile heads; childhood by the location, near Cambridge, England – where Pink Floyd grew up; and personal ghosts by the combined head facing the viewer, which isn't actually there. At first, the band was lukewarm about the idea until they realized the heads were to be huge real sculptures, not drawings – a problem of communication.

COMMUNICATION
The central idea for this cover was communication, or interaction, between the design and the viewer. There are two faces in profile, which form a single or third face looking toward the viewer. Some people see two profile heads, others see one facing head. Field tests proved that the idea worked on several different forms.

SKIES make a big difference to a picture. To capture an evocative sky, photographs were taken over two weeks. What you see is the actual sky behind the sculptures, no trickery, just a lot of patience (and resources).

ELY CATHEDRAL is a spectacular building in the perpendicular style adorned with flying buttresses and soaring spires. It towers over the low-lying fenlands, close to Cambridge, home town of Syd Barrett, Roger Waters, David Gilmour, and the designer.

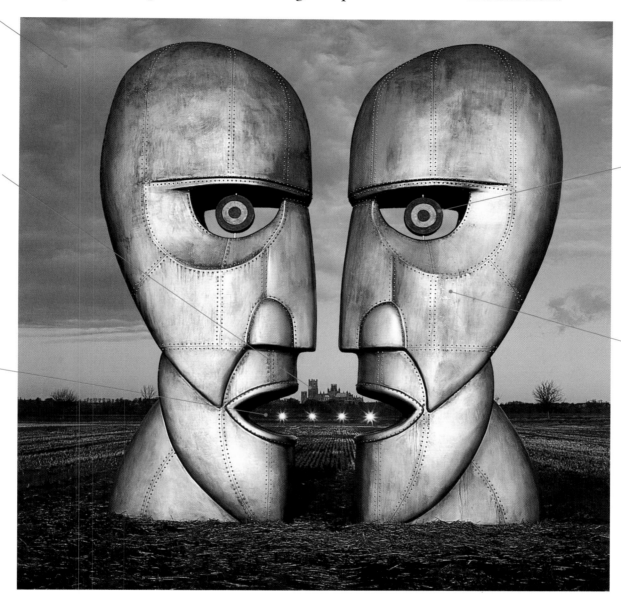

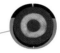

TARGETS used for the eyes provide a penetrating stare while shifting the perspective toward the front and away from the side profiles. The targets resemble airplane roundels.

THE SURFACE of the sculpture was painted and burnished, then distressed to look like the metal "plates" used in airplanes. This is because Pink Floyd are fond of flying… their own planes, of course.

CAR LIGHTS
The lights are real car headlights attached to poles in the ground and run off a battery. They represent the teeth of the single head looking at you, or the communicating lines of the profile heads talking to each other (as in "Keep Talking", one of the songs).

THE VASE ILLUSION
The concept of two heads making one is based on a drawing known as the "vase illusion," where two silhouettes of faces in profile constitute the edges of a white vase. The viewer sees either the faces or the vase, but not both.

THE SCULPTURES
These were based on drawings by designer Keith Breeden and stood 22 feet (seven meters) high; they each weighed half a ton. One gusty night at Streatham just outside Ely, the wind reached gale force six and blew the sculptures over.

THE PHOTOGRAPH was taken with a Hasselblad camera using a 60mm wide-angle lens, regular Ektrachrome transparency film, and available daylight.

ALTERNATE VERSIONS
Two completely different versions of the sculpture were originally designed, one set in metal, one in stone. Owing to the Floyd's perspicacity, or indecision – or perhaps just because they can afford it – both versions were produced. The metal heads appeared on CD and vinyl covers as above, while the stone heads appeared on cassettes. It proved that all formats do not have to be the same in order for a work to be successful.

THE DIVISION BELL

CAPTAIN BEEFHEART, Doc At The Radar Station

DON VAN VLIET, alias Captain Beefheart himself, is responsible for the artwork for *Doc At The Radar Station*, but what can it all mean? We presume that the musician knows, either implicitly or explicitly, the connection to the music since he has created both, but it is nonetheless a most peculiar visual. Looking only at the cover one might ask, who is Doc? A doctor of medicine or philosophy? Or a failed doctor like Doc Holliday? And why would he be at the Radar Station anyway, whatever that is? It's all quite weird, offbeat, esoteric, and magical, like the band and like the music. Quirky, idiosyncratic vocals; quirky, idiosyncratic illustration. A sort of Dutch voodoo, whatever that is. Much of the painting is obliterated by black: a man and a woman whose relationship is presumably much obliterated by fear and disenchantment. An interrupted painting, an interrupted relationship. A disturbance of the normal, an interference, probably electronic. Radar perhaps? A blackness across the painting, a darkness across the land, and a sickness across their love. They need a doctor and his healing hand; we need the Captain and his Magic Band.

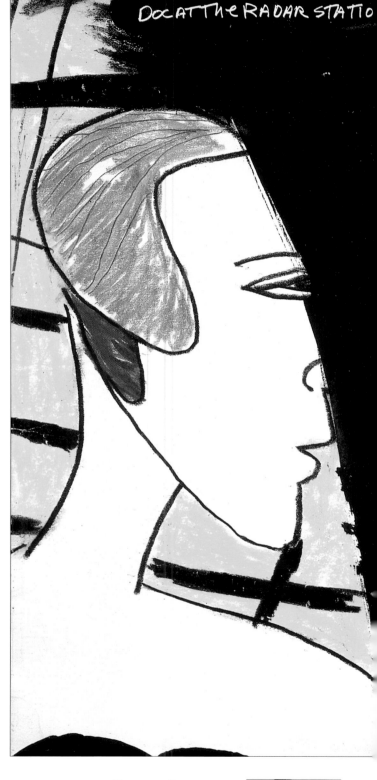

VAN VLIET ON VAN GOGH
"I like painting the most. Van Gogh – whew! I mean really, talk about nerve. I've tried to trace paintings, but I can't do it. It always goes off in another vein. It's the same with music. I couldn't copy anyone if I wanted to. The music just comes out of me. It always has."

MAGIC BAND guitarist and manager Gary Lucas: "This album cover is about the difficulty of a man and woman communicating. It's a theme that runs throughout Don's oeuvre. He took this vision of a man talking to a woman and blacked out a lot of it."

I'M HAVING FUN
Since giving up on making music in the early 80s, Don Van Vliet says he's so happy to be away from concert tours and fans who "get in the way of the work" and critics who feel they have to categorize every artist. "Oh, I've had so much fun since I started just painting, because now I don't have to worry about somebody else. I did that music thing for 20 years, and I tell you, I was a damn fool."

ARTWORK PRODUCTION
Fergus McCaffrey of the Michael Werner Gallery in New York, Van Vliet's representatives: "The cover painting is probably painted on canvas, in which case Don would have used oil paints. He is equally comfortable working in watercolor, with pencils, or even with tea." They have no idea of the whereabouts of the original painting.

Don Van Vliet, Boat And Blue Bodagress, 1984, oil on wood, 122cm x 91.5cm.

CAPTAIN BEEFHEART
*Captain Beefheart and The Magic Band recorded from the mid-60s to the early 80s. Their oeuvre included **Safe As Milk, Ice Cream For Crow**, and **Trout Mask Replica**, which is considered by many to be the group's masterwork.*

SPECIFICATION

- *Artiste* Captain Beefheart And The Magic Band
- *Title* Doc At The Radar Station
- *Design* Michael Hollyfield
- *Illustration* Don Van Vliet
- *Record Co.* Virgin, 1980

PAINTING OR MUSIC?

Don Van Vliet: *"I like painting better than music because I can spend an entire day on a canvas, then erase it. Painting over it is a really beautiful sensation."*

Don Van Vliet, Ghost Red Wire, 1967, oil on Masonite, 71cm x 62cm.

EXHIBITIONIST

Captain Beefheart and The Magic Band made only one more album after **Doc At The Radar Station**. Since then Don Van Vliet has concentrated on his painting and has held over a dozen one-man exhibitions in both Europe and the US. His paintings fetch anything up to $25,000 each.

DOC AT THE WAREHOUSE

The Magic Band signed to Virgin in 1980 after disentangling themselves from a disastrous contract with Warner Bros. However, weeks after **Doc At The Radar Station** was released, the distribution agreement between Atlantic Records in the US and Virgin in the UK was terminated. Virgin's hurriedly arranged distribution deal with RSO applied only to XTC and Gillan, and The Magic Band were left with their record idling in the warehouses, available only to fans in Europe. It subsequently dropped off the **Billboard** charts.

ABSTRACT EXPRESSIONIST

With a steadily expanding reputation in the United States and Europe, Van Vliet may be on the verge of being hailed as one of the better abstract expressionists of his time. *"Don is a very serious painter and a very interesting one,"* said Gordon Veneklasen, director of the Michael Werner Gallery in New York. John R. Hale, the director of the San Francisco Museum of Modern Art said of him, *"He's part of a tradition in American painting that goes back to earlier 20th-century artists like Arthur B. Dove, or to abstract expressionists like Willem de Kooning. I'm very fond of him and interested in what he does."*

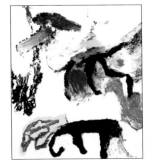

Don Van Vliet, Dreams In The Daytime Colored With Sunshine, 1995-6, oil on canvas, 116.8cm x 87.8cm.

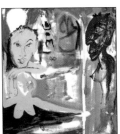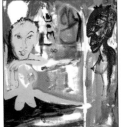

Don Van Vliet, Bezoo, Bezoo, 1985, oil on canvas, 213.2cm x 182.8cm.

CAPTAIN BEEFHEART

"Captain Beefheart came from the beef in my heart about people stealing the land and covering it over; from the beef in my heart about the way people treat animals. It's terrible what we do to animals."

DON VAN VLIET

Don Van Vliet was born in 1941 in Glendale, California. His artistic talents were recognized when he was four years of age by Portuguese sculptor Augustinio Rodriguez, who saw his paintings and declared him a child prodigy. He was soon appearing on local TV, showing his clay sculptures. He was offered a scholarship to a European art school at age 13, but the offer was declined by his parents, who moved the family to the Mojave desert instead. There he met Frank Zappa, assumed the Captain Beefheart moniker, formed the first

Magic Band, and signed with A&M Records. His four-and-a-half octave vocal range cracked a studio microphone during the recording of 1967's **Safe As Milk** album. Disputes over remixes done without his permission prompted a move to Zappa's Straight Records, for whom he recorded the seminal **Trout Mask Replica** in 1969 and **Lick My Decals Off, Baby** in 1970, with a new Magic Band lineup. Though he put out several records in the 70s, Van Vliet's enthusiasm waned, and by 1982 he had retired permanently from the music business to concentrate on painting, moving to the trailer in the Mojave desert where he still lives with his wife, Jan. His first major exhibition was staged in 1985, and he has exhibited his paintings worldwide since then. He was recently diagnosed as suffering from multiple sclerosis.

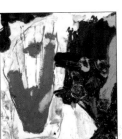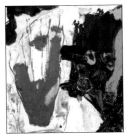

Don Van Vliet, Middle Flower, 1991, oil on canvas, 71cm x 62cm.

DON VAN VLIET ON RECORD COMPANIES

"They have told me that I am a genius throughout my life. They have said the same about my sculptures, too, slapping me on the back; but in the meantime they have taught the public that it is too difficult to listen to my music."

IAN DURY & THE BLOCKHEADS, Do It Yourself

IT'S THE CHEEK OF IT, REALLY. Re-presenting to our gaze something we have seen before, but placing it in a new context. What was once ordinary household wallpaper was being held up as a piece of graphic art; a piece of contemporary packaging for a contemporary music artist. The wallpaper design would normally have been seen as garish and awful but now became strangely attractive. To cap it all the cover was reproduced in several different versions, the selection of covers mimicking the available selection of ordinary wallpapers. This was art made from the ordinary, like the ready-mades of Duchamp, and the lyrical anecdotes of Ian Dury.

EARPAPER
According to Ian Dury, the album was originally going to be called Earpaper because the band wanted to mock the music and suggest that it wasn't very good. The name was the original reason for using the wallpaper. Once the band had decided on the paper, they changed the title to Do It Yourself.

THE HOLES
in the type were designed to look like rivet holes, in keeping with the DIY theme.

RHYMING SLANG
The inner label states "Any resemblance to persons living or dead is not meant to be unkind to men in syrups" (Syrup of Figs is Cockney rhyming slang for wigs).

CROWN WALLPAPER
allowed the band to use the wallpaper on the cover for free on condition that they print the catalogue number (P87554) on the front for potential purchasers.

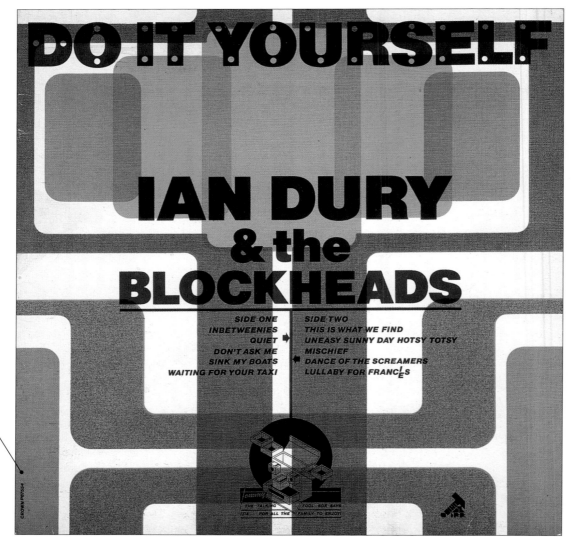

TOMMY THE TALKING TOOLBOX
Designed by Barney Bubbles in collaboration with Ian Dury, Tommy the Talking Toolbox graphic (who tells us the album is "for all the family to enjoy") fitted in with the title. The idea was suggested to Barney Bubbles by Ian Dury, who recalls that "Leb [Lebanese hashish] had a lot to do with it – Tommy was the result of many evenings of rambling, stoned thoughts that Barney interpreted visually, and the fans loved it – we'd even get letters addressed to the toolbox."

ART DECOR
To promote the album, a team of people went out and literally wallpapered London with wallpaper – given free by Crown. They papered buildings, poster sites, windows, lampposts. The music papers' offices were also wallpapered – desks, phones, typewriters, directories, the lot. Melody Maker was OK about it, they thought it was funny, but the New Music Express called the police – and didn't print the story either.

BARNEY BUBBLES

Brought up in suburban London, Barney Bubbles studied at Twickenham School of Art before getting a job at the Conran Design Group at the age of 23. After substituting the rather plainer moniker of Colin Fulcher for Barney Bubbles, he worked on underground magazines Friendz and Oz based in London's Portobello Road. Moving into album cover design, he produced sleeves for Hawkwind and Glastonbury Fayre before becoming full-time graphic designer at Stiff Records. His work there and at the Radar and F-Beat labels has proved hugely influential. Sadly, Barney Bubbles committed suicide in 1983.

LINE FOR A SONG
The back cover shot was taken outside a wig shop on Baker Street. Permission to photograph the wig shop window had not been granted, so the band turned up in the middle of the night, did the photo, and disappeared again. Ian Dury wanted everyone lined up in single file looking like a bunch of sailors preparing for shore leave, and instead of contraceptives, they're lining up for wigs. The smiling man on the right is Fred Rowe, who was the Blockheads' bodyguard. He was the only person with no hair, which is why he is not wearing a hat.

WHAT'S IT ALL ABOUT, IAN?
Ian Dury: "Barney was a genius – I loved the cover. If I hadn't liked it, it wouldn't have been used. I had full control. Still do. Mind you, there's a deeper meaning to this cover, but I'm not telling anyone what it is."

SPECIFICATION

• Artiste	Ian Dury & The Blockheads
• Title	Do It Yourself
• Design	Barney Bubbles
• Photography	Chris Gabrin
• Record Co.	Stiff, 1979

JEFFERSON STARSHIP, Dragon Fly

THE MID-70S was the golden age of airbrush art. It was a medium used by a number of well-known artists, including Peter Max, Alan Aldridge, Kelly & Mouse, Michael English, and Robert Grossman. Peter Lloyd was a popular choice with rock stars for his own particular brand of airbrush work. He was from California and obviously had a thing about legs straddling wide-open spaces. Compare *Dragon Fly* with the cover of Rod Stewart's *Atlantic Crossing*, painted a year later. By the 80s, digital paintbox effects were beginning to replace the traditional craft. Nevertheless, the talents of artists like Peter Lloyd, and illustrations such as this, place real paint head and shoulders above digital pixels.

KANSAS
*Peter Lloyd's cover for Kansas' 1975 album **Song For America**.*

KOSH: *"I worked as art director with Peter Lloyd on Rod Stewart's **Atlantic Crossing** album in 1975. He was probably one of the best airbrush artists working in Los Angeles at the time, and I chose him because of his skills."*

ACY LEHMAN: *"In 1971, we presented Jefferson Airplane with an idea for their new album, **Fresh Today**. It was a picture of a fish wrapped in paper. They took the fish and put false teeth in it and changed the title of the album to **Bark**. So you can see the communication between the record company and the band was not exactly straightforward."*

DRAGONFLY
According to Bill Thompson, the manager of Jefferson Starship at the time, Grace Slick, lead singer of the band, was lying by the pool one day soaking up the California sunshine when a dragonfly landed on her. This prompted the title of the album. What is odd, though, is that it is spelled as two words and not one.

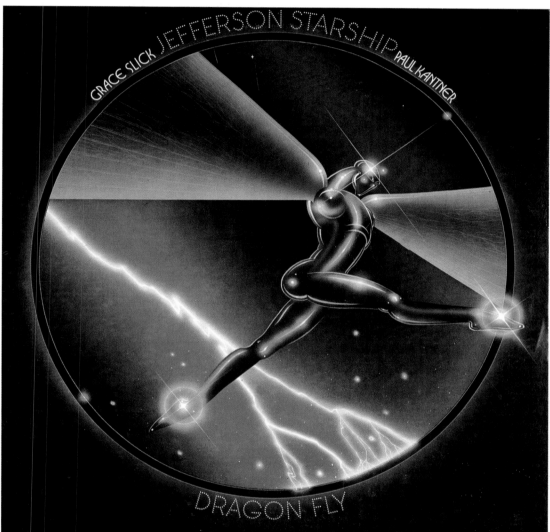

ACY LEHMAN:
"I was the art director for RCA working out of New York when this job came in. I put Frank Mulvey, our art director in Los Angeles, on the case. With Jefferson Starship, we generally sent them a bunch of ideas. In this case, we looked for an artist that we thought appropriate. I think we found Peter Lloyd out of an illustrators annual. He hadn't worked for Jefferson Starship before. He had a very good airbrush style that was quite fashionable then."

LACKADAISICAL
The Starship sometimes seemed indifferent about their covers. Lehman remembers going to the Airplane House in San Francisco for a photo shoot for another of their albums. Having flown from New York, he turned up with a photographer on a Monday morning. Grace Slick came to the door and said the band weren't ready for the shoot and could they come back on Thursday.

SPECIFICATION

- *Artiste* — Jefferson Starship
- *Title* — Dragon Fly
- *Design* — Acy Lehman & Frank Mulvey
- *Illustration* — Peter Lloyd
- *Record Co.* — Grunt, 1974

THE ART OF THE AIRBRUSH

*The airbrush was developed around the turn of the 20th century by companies such as Devilbis in England and Paasche and Badger in America. It was originally intended for hand-coloring and retouching black-and-white photographs. Looking somewhat like a fountain pen attached to a hose, the airbrush is propelled by air from a power-driven compressor. Through accurate control of the nozzle, the airbrush atomizes paint or colored dyes like a miniature spray-gun. A skilled airbrush artist can produce the most beautiful graded effects and, with the use of masks made from low-tack adhesive film, can build an illustration up in layers from the darker shades through to the white highlights. This technique can easily be seen in Peter Lloyd's illustration for **Dragon Fly**. The base color for the sky background was applied first, followed by the body color of the dragonfly figure. The wings and blushed crescents of pinks and green then followed, and finally the stars, lightning bolt, and starburst highlights were applied.*

LITTLE FEAT, Down On The Farm

WHAT STRANGE AND MISCHIEVOUS imagination is at work here? The paintings of Neon Park seem to defy analysis, smiling at you with humor and weirdness. They are friendly yet sinister, and often feature ridiculous characters in ridiculous situations. The paintings seem to have assembled themselves as much by chance as by design. Neon Park felt that part of the joy of his art was that he never knew how it was going to turn out. His first meeting with Little Feat was equally spontaneous. It is said that one day Neon was driving on an errand in the rain in LA when he picked up this guy with a guitar (Ivan the Ice Cream Man), who took him to a friend's house. The friend turned out to be Lowell George, vocalist and guitarist with Little Feat. From that point onward Neon Park did every cover for Little Feat, and after *Sailing Shoes*, his first, he became spiritually part of the band. Lowell George insisted that Neon be given total freedom. He always got it and he always deserved it.

DOWN ON THE RANCH

*Little Feat Guitarist Paul Barrère recalls: "**Down On The Farm** was the last record we made while Lowell George was still alive. In fact he died in the middle of the project, sadly, from a drug-induced heart failure. The title came from the song 'Down On The Farm,' which was written by my father and myself. We recorded most of the album out at the Paramount Ranch, part of Paramount Studios in Los Angeles. Needless to say, this was not a farm but there was plenty of "wildlife" on the property! Where and how Neon came up with the idea for the duck doing her nails by the pool is anybody's guess but when we saw it, it made perfect sense to us. If you've seen any of Neon's other work you know he had a fondness for ducks."*

AND THE TIGER? The tiger is the duck's lover. He is watching from the other side of the pool and is as languid as she is. A perfect couple. A perfect day... down on the farm.

THE FARM WOMAN (DUCK) sort of rules the place, on an odd-ball farm in LA. It's only natural that on this farm she should be sitting by the pool.

NEON PARK XIII

Neon Park XIII was born Martin Muller in Oakland, California on December 28, 1940. His mother agreed to pay for painting lessons for six months and he set off with a sketchbook to learn how to draw. Berkeley was the place to be, and this was where he would sit in the Café Piccolo and draw the beatniks. He was a self-taught painter, and a painter is how he saw himself, not a designer. Berkeley was

an exciting place for him both for the art scene and the radical elements of the early 60s. He loved Mouse and Kelly's work, and Moscoso, Virgel Finlay, and Rick Griffin. Neon Park produced covers and graphics for the albums of Frank Zappa, Little Feat, Dr. John, The Beach Boys, David Bowie, and many more. He designed opera sets for UCLA, painted backgrounds for cartoons on Saturday morning TV, and optical effects for a small film company. He spent the 80s in Mexico. In January 1993 he died of Lou Gehrig's disease.

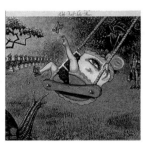

SAILIN' SHOES, 1972 *This was Neon Park's first album for Little Feat. The slice out of the cake represents the cake's sexuality – that she is free.*

WAITING FOR COLUMBUS, 1978

HOY-HOY, 1981

A SPECIALIST APPEAL

Little Feat always received critical acclaim and were greatly admired by other musicians, but their record sales never reflected this. Lowell George was a much sought-after musician and songwriter and contributed to many other albums, including those of The Mothers of Invention, Carly Simon, The Doobie Brothers, and Robert Palmer.

FOR LITTLE FEAT, the record company usually hired someone else to work with the lettering. Sometimes Neon would do it if it was an integral part of the painting. Regrettably, the type for this album was done by the record company.

THE 60S BUTTERFLY chair adds a hint of dated style to the scene – a sort of kitsch taste in character with the farm woman/duck.

Neon Park had been painting lots of sexy ducks. He thought they would sell like hotcakes. They were part of an ongoing series – **Betty Duck**, **Jane Duck** and **Marilyn Duck**. These three were based on famous images of three female film stars of the 40s and 50s: *Betty Grable (left), Jane Russell (below), and Marilyn Monroe (below, centre). Neon Park had respect for women but perhaps not for vampires: he painted a picture of a vampire duck, which he entitled* **Duckula**.

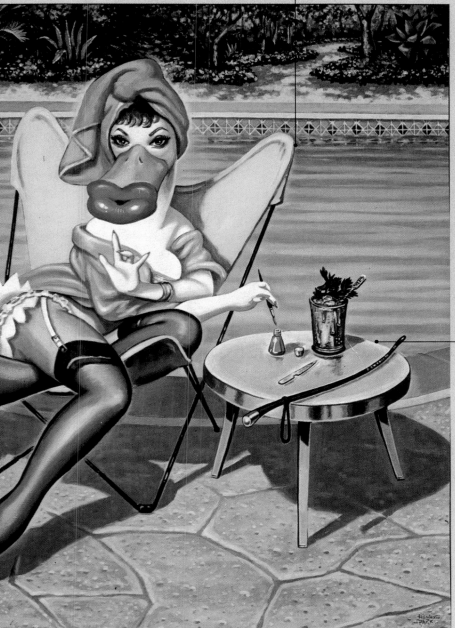

TECHNIQUE
Down On The Farm is painted in acrylics on Masonite board. Park was a master in acrylics and preferred to paint his own way. Although acrylic paint dries incredibly fast, he learned to overcome the problem. He drew the work straight onto the board not necessarily knowing the end result. "If you know what it's going to be, why do it?" he quipped.

THE DUCK'S self-indulgent primping, the drink, and the whip show her state of mind. The whip may be part of some game she and her lover play, or perhaps it's a weapon to warn the viewer not to intrude or make judgements.

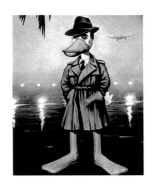

HOW MARTIN MULLER BECAME NEON PARK XIII

Martin Muller and his wife Chick were visiting friends in Mendocino in the heart of the California redwood forests. Stoned out of their minds, they speculated on how the local kids would react to being taken to a rock 'n' roll concert at the Fillmore in San Francisco. "Well," someone said, "they'd have to be prepared." Then Martin said, "Well, we could asphalt one of those clear-cut places out in the woods and hang up a bunch of neon lights and call it Neon Park." The next day Martin wrote a letter to the Canyon Cinema News declaring that he would subsequently be known as Neon Park. The XIII after his name stands for M, the thirteenth letter of the alphabet, which was used as a code for marijuana among the zoot-suiters of the 1940s.

SPECIFICATION

- *Artiste* Little Feat
- *Title* Down On The Farm
- *Design* Neon Park
- *Record Co.* Warner Bros, 1979

CREATIVE SOUL
Park's idea came to him as he worked, sometimes from found images picked up from the gutter. Paul Barrère: "We hardly ever told Neon what to paint. He'd listen to the songs and come up with his own ideas, and they were always great. I believe it was all the work of Neon and his wonderful creative soul."

EDGAR WINTER, The Edgar Winter Band With Rick Derringer

WHAT DO YOU DO when you're writing a book and no one wants to cooperate? You either make it up as you go along, or play detective and look for clues, that's what you do. The cover for *The Edgar Winter Band With Rick Derringer* received the thumbs up in the one hundred selection and yet the lack of information has made it a difficult final choice. However, it is sufficiently brilliant to warrant its inclusion, and it has always been a memorable and admired piece of photography. It was a brave decision to put this particular piece of esoteric art on the album cover of a band whose famous rock 'n' roll hit at the time was entitled "Frankenstein." Was this cover a deliberate experiment, a lucky choice, or was it all just a shot in the dark?

BLUE FLOYD
When the band saw the unexpected cover were they, perhaps, so stoned that they thought it was, well, cool and freaky? Perhaps they thought it wasn't for them at all, but the next Floyd sleeve? A blue cover for Pink Floyd.

TOTAL UNRECALL I
When Edgar Winter's manager was approached about the cover, he said that Edgar couldn't recall the album art and could we send him a photocopy. How many albums can one man make in a lifetime? Anyway, no reply was ever received.

CRAWLING KINGSNAKE
Maybe the "thing" is a California Kingsnake that is all aglow because it's become radioactive due to too many atom bomb tests in the Nevada desert.

LOCATION
This could be one of three possibilities: the salt flats near Salt Lake City, Utah; or perhaps China Lake, a dry lake bed off US 395 near Ridgecrest, California; or our hot favorite, White Sands, New Mexico – mile upon mile of rolling white dunes of pure gypsum.

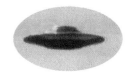

THEY'RE HERE!
Perhaps this was not really the intended sleeve at all, and by some quirk of fate this happened to become the front cover. Did a young crazy creative late one Friday night in the record company art department succumb to temptation and swap the rather boring group shot for a photo of a glowing UFO hovering in a blue desert that he'd been studying for hours?

TOTAL UNRECALL II
The photographer, Hiro, was equally mysterious. His studio in New York faxed a letter stating that he too could not remember the picture and that he was too busy to go through his archives to check it out. However, his studio did supply his biography, and as the cover photograph is credited to him, we must assume that he took the photograph. Now, how many times does a man photograph a piece of glowing washing-machine exhaust pipe in his lifetime?

HIRO
*Born in the Far East, Hiro was educated in Shanghai, Beijing, and Tokyo before moving to New York in 1954 to study photography with Richard Avedon and legendary art director Alexey Brodovitch. Within three years he was working exclusively with **Harper's Bazaar**. Moving freely between Eastern and Western cultures, Hiro developed a startling, graphic style – in fashion, portrait, and beauty photography – for which he is renowned. In 1990, Hiro published a book of his work, **Fighting Fish/Fighting Birds**, and a monograph and exhibition of his work are planned for the near future.*

EDGAR AND JOHNNY
A possible clue to the cover is that Edgar Winter and his brother Johnny, Texas blues boys from Beaumont, Texas, are albino. Is the white light emanating from the translucent tubing a symbol for the embryonic glowing albino?

FLOOR LIGHT
In the 70s, a light made from industrial flexible hose was all the rage. Was this what Hiro used for his luminous serpent asleep in the desert?

SPECIFICATION

• *Artiste*	Edgar Winter
• *Title*	The Edgar Winter Band With Rick Derringer
• *Photography*	Hiro
• *Record Co.*	Blue Sky, 1975

RICHIE HAVENS, The End Of The Beginning

BY THE MID-70S, albums were selling in unprecedented numbers. To sell five million albums was not unusual for a popular band. Album cover budgets went up, and so did the quality of the commissioned photographers and designers. One of the classiest of them was Moshe Brakha. His clean, aesthetic, colorful style, combining natural sunlight and flash photography with an imaginative sense of composition, made him one of the most sought-after photographers by the major record labels. His sophisticated portraits of Boz Scaggs for *Silk Degrees* (left) and Richie Havens, illustrated here, are a sign of the times. Shortly after, Punk arrived with its lick'n'stick anarchic stance, trashing this clean-cut style of album sleeve. The beginning of the end?

MOSHE INSISTED on no cropping and no retouching to the photograph, so the compostion worked around it. Designer Junie Osaki kept the photo large, left in the black film frame to show the "through the lens" composition, and left herself a very small space for the typography.

THE GIRL running across the back of the picture was Richie Havens' girlfriend at that time.

PHOTOGRAPHY
Moshe Brakha used a Hasselblad with Ektachrome 64 ASA and a basic Norman flash. He shot a couple of rolls before the police turned up, saying he needed permits to take photographs on a freeway. They were pretty hostile until they realized it was Richie Havens.

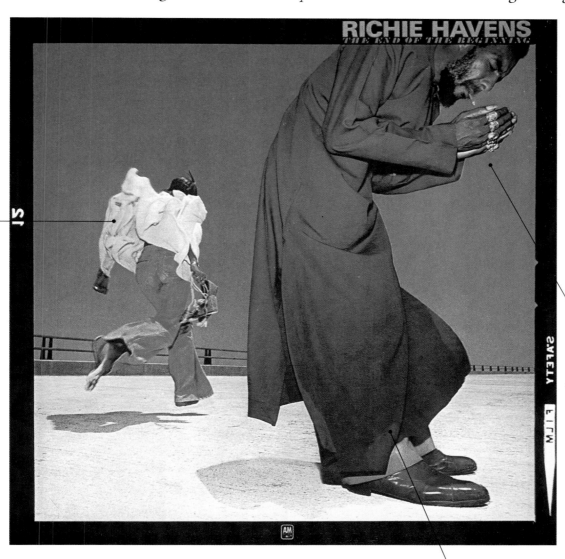

FATHER FIGURE
Moshe Brakha: "I was straight out of the Arts Center School in LA and Roland Young had been one of my teachers. He called me and asked me to photograph Richie Havens for this cover. I loved Roland, he was a nice guy, a legend, a father figure. I don't remember any brief. I just turned up for the shoot with no expectations. Richie Havens is a wonderful spiritual man and I bonded with him very quickly."

"WE BEGAN TO take pictures on different levels. Moshe handed me a pack of More cigarettes and I turned from the wind to light one… He said 'Hold it'… the young lady that was with us was told to run past and the photo was taken. There are people, still to this day, who don't believe that it really was a cigarette. With the highway crisscrossing behind me, and the edges of the roads… roads to nowhere… end of the beginning… magic."
– Richie Havens

MOSHE BRAKHA

*Moshe Brakha, a native Israeli, graduated from the Art Center in Los Angeles and began his career photographing album covers. He worked for **Rolling Stone** magazine, documenting the LA punk scene and photographing celebrities such as Arnold Schwarzenegger and Steven Spielberg. His print work ranges from Airwalk to Remy Martin, and appears in **Details**, **Harper's Bazaar**, **Arena**, and on covers for **Newsweek** and **Entertainment Weekly**. Moshe has shot commercials for clients such as Martini Rossi, Miller Lite, Candies, and Vespa. He has won numerous awards for both his television work and his print photography.*

THE PHOTO SESSION
Richie Havens: "We had made a very early morning appointment to do the shoot since we had to drive a long way south. It was a typical LA day and we wanted to beat the morning rush of traffic. When we were about a quarter of a mile from the site Moshe said 'There it is!'… I looked straight up the highway and I could see this incredible complex of elevated highways crisscrossing the one we were on. There were about seven layers, all twisting through each other. I could see that none of them went anywhere. They were part of a matrix of new highways that was to be built but was abandoned. They all ended either in midair or descended into the cornfields on either side of the freeway. It was like something out of sci-fi movie… highways for UFOs."

RICHIE HAVENS brought along some of the things he wore on stage, which were mostly long caftans or long Chinese coats. Moshe liked the coats and had Richie put on his favorite, this maroon one.

SPECIFICATION

•*Artiste*	Richie Havens
•*Title*	The End Of The Beginning
•*Design*	Junie Osaki
•*Photography*	Moshe Brakha
•*Record Co.*	A&M, 1976

PRODIGY, The Fat Of The Land

LIAM HOWLETT TAKES PRODIGY'S IMAGE very seriously. As the producer and main songwriter he has invested a great deal of time, effort, and faith in designer Alex Jenkins' ability to create the band's visuals. With aggressive hit titles such as the controversial "Firestarter" and "Smack My Bitch Up," the need for some sophistication in the art department was essential if Prodigy wanted to appear to be in earnest. For many of us the crab is deeply etched in our subconscious as a symbol of fear from paddling in seaside rockpools during the vacations of our childhood. Armed with that knowledge, Howlett and Jenkins have succeeded in creating a confrontational and frightening cover without resorting to the predictable pictures that might have accompanied an album entitled *The Fat Of The Land*.

THE ANT LOGO was Liam Howlett's idea. The ant is a small and powerful creature – like the band – and first appeared on the "Fire-Starter" single. Howlett wants to keep the ant as a symbol that will be easily recognizable by the fans.

"THE TITLE came via the fact that we were getting quite a lot of stick from fans that we were living in the country. They felt a raw, urban band like us should be in the city. So, to take the piss out of the country, I came up with the title *The Fat Of The Land*." – Liam Howlett

BRANDING TOOL
The crab is a strong metaphor for the band – colorful, full of energy, coming at you with two fingers stuck in the air. It captures their attitude. To our knowledge, a crab on a record cover had never been done before and seemed quite off the wall. It was unique, incredibly striking, and beautiful – a great worldwide branding tool for the album.

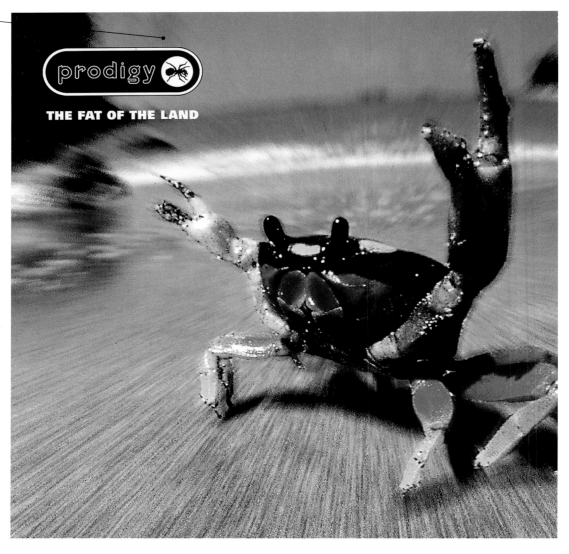

METAMORPHOSIS
Designer Alex Jenkins: "I liaise with Liam Howlett, the writer and producer of Prodigy, on all artwork. The creative process involves us both coming up with different ideas that tend to metamorphose into other ideas in pursuit of a final cover concept – a kind of 'ideas tennis match'!"

ALEX JENKINS says that a crab was chosen for the front cover because a crab is a creature that comes out of the sea to enjoy the spoils of the land. He loved that connection with the title. Alex suggested the crab idea quite late on in the design of the album packaging. The artwork was designed and completed in around three weeks. As Alex was the sole designer, this was a massive task.

WASTELAND
The back cover and liner bags use photos of the band standing against industrial wasteland, truck parts, and packing cases. The typography is scarred and distressed.

CONGEALED FAT
Alex and Liam messed around with a lot of images before settling on the crab. They considered a big V8 American tractor – converted into a hotrod – tearing through the countryside, and a big, fat pig wearing makeup, lipstick, and eyeliner. They took one concept to completion – a lamb kebab on a skewer, branded with the album title. They hired a kebab shop, a photographer, and a model-maker for the evening. The shoot lasted about eight hours – staring closely at this disgusting lump of congealed fat put them all off kebabs for life!

DIGITAL MANIPULATION
The photograph of the crab is a stock library shot taken in Costa Rica by Konrad Wothe/Silvestris, courtesy of Images of Nature. The image was manipulated on an Apple Mac, with the crab temporarily removed from the background and the background given a zoom effect using Adobe Photoshop. The finished artwork was put together using Adobe Photoshop, Quark Xpress, Adobe Illustrator, and Streamline. Other tools, such as a photocopier, were also used. The finished project was given to the color separator on a 1GB Iomega Jaz cartridge.

SPECIFICATION

• *Artiste*	Prodigy
• *Title*	The Fat Of The Land
• *Art Direction*	Alex Jenkins and Liam Howlett
• *Design*	Alex Jenkins
• *Photography*	Konrad Wothe/Silvestris
• *Record Co.*	XL Records, 1997

TALKING HEADS, Fear Of Music

THE LIFESTYLE BUZZWORD OF THE 70S was high-tech, when everybody started buying factory lights and rubber flooring for the kitchen. As a New York act that prided itself on punchy lyrics combined with almost gentle music, originality was an essential ingredient if they were to compete with the raw, brash emotion of other local groups like The Ramones or The New York Dolls. Talking Heads' cover art reflected their determination to buck traditional trends and communicate a different set of values. Were they qualified to do their own sleeves? Jerry Harrison studied architecture at Harvard and the other three met at the Rhode Island School of Design. The band were often in contention with the record company over their ideas but, as they might say, unfamiliarity sometimes breeds contempt.

THE VINYL LIMIT
The cover corresponded quite well with the dark nature of Talking Heads' music. At first, the art director at Sire didn't know what to make of the idea. Jerry Harrison had hoped that they could use actual vinyl flooring for the cover. He called the president of the company who made the material and told him he had an order of potentially a million square feet (a million albums), which got his attention! They talked about making it quite a bit thinner to try and get the price down, but eventually it proved to be too expensive, and he was afraid that thinning it down would jam the machines which made the rolls of vinyl.

DAVID BYRNE of Talking Heads came up with the lettering by typing on an IBM Selectric typewriter and enlarging the type to show the ragged edges of the letters. He thought that the justified type would go well with the industrial quality of the deck plate.

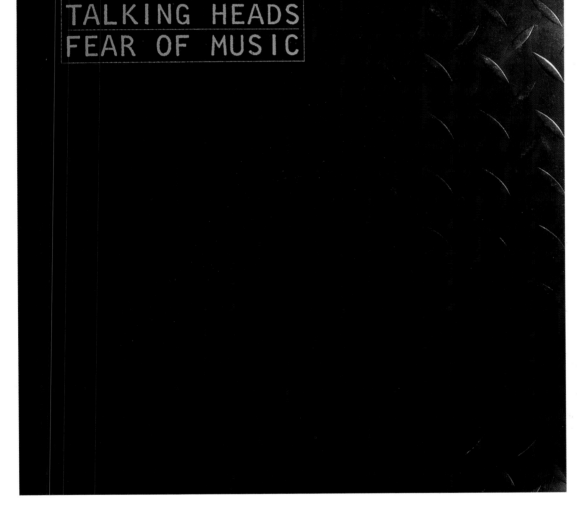

THE IDEA FOR the cover came from the vinyl floor covering that Tina Weymouth's brother, Yan, an architect, used in the kitchen and bathroom of his Long Island home. The floor covering was a vinyl version of deck plate, or diamond plate – seen on metal doors, elevators, loading dock floors, and on trucks and trailors. The raised pattern is an anti-skid pattern, but to Jerry Harrison it was just beautiful shapes.

VINYL EFFECT
Richard Roth, Executive Vice President of Queens Litho: "The whole band came out to Queens and brought some mock-ups. They really wanted the cover to be in the vinyl material. But I explained how impractical that would be and also how very expensive. So I created the same effect on a card paperboard with an embossed pattern and a matt coating. We made proofs and they proved to be very successful."

SPECIFICATION

- *Artiste* — Talking Heads
- *Title* — Fear Of Music
- *Design* — Jerry Harrison
- *Photography* — Jimmy Garcia
- *Record Co.* — Sire, 1979

HIGH TECH IN THE DARK
*When designing Orchestral Manœuvres In The Dark's first album cover with architect Ben Kelly, designer Peter Saville said: "In my opinion the Talking Heads' **Fear of Music** cover is the first definitive high tech sleeve. The OMD sleeve is the UK version of the same thing. It is a perforated sheet metal pattern cut out of cardboard. It is the moment at which fashion comes in to play on design. Very clever, that cover."*

THE INNER SLEEVE
__Fear Of Music__'s inner sleeve included a heat-sensitive thermograph portrait by Jimmy Garcia, courtesy of Dr. Phillip Strax. It's hard to say exactly who it is. Answers on a postcard.

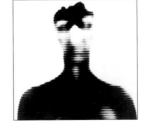

EVEN HIGHER TECH IN THE LIGHT
Jerry Harrison also wanted to do an album cover that lit up. There would be a tiny camera battery in there, and when you squeezed the corner of the sleeve, the whole cover would light up. At the time the idea proved impossible to execute.

FEAR OF MUSIC
The album was nominated for a Grammy® for Best Album Package in 1980.

TECHNIQUE
The cover was printed in solid black with a specially mixed green ink for the type. It was then blind embossed with the floor pattern on a printing press called a Big Planetta. The finished cover was finally coated with a matt UV varnish.

FREE, Free

THIS DRAMATIC DESIGN presents an unexpected set of contrasts, obviously expressing the title, but also exhibiting precision and restraint. The silhouette, embodying the concept of free movement, stretches diagonally from corner to corner, leaping gracefully through the air. Stars are contained within the woman's shape – heavenly bodies within a heavenly body – night dividing the day. The image consists of simple elements, but viewed from an unusual angle, both graphic and erotic, looking up into the clouds, up at the stars, and also up into her secret garden. This whole ensemble speaks of controlled freedom, free, but beautifully organized, free to rock and roll.

CLOUDS AND STARS
The image of the cloudy California sky came from Raffaelli's own stock collection of photographs, taken from the rooftop of his studio in Hollywood. He used a Celestron telephoto lens to shoot a night-time star field from a location outside of the city. Raffaelli shot the star field specifically for this album.

RON RAFFAELLI:
"The model was an young 18-year-old girl named Linda Blair. I shot the picture in my studio. I stacked some wooden boxes about four feet high and leaned a ramp on the top box. I then placed about a dozen pillows six feet from the ramp and boxes. I aimed my strobe lights at the ceiling and laid down on my back between the boxes and pillows. The nude model made a ten-foot run, then went up the ramp and leaped across the six-foot gap as I shot her silhouette before she landed on the pillows. I made this poor girl repeat this death-defying jump about 20 times, until I was sure I had captured the feeling of freedom that I wanted."

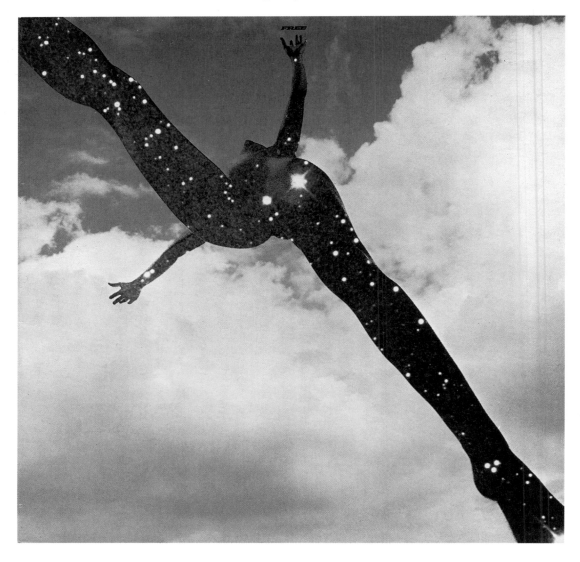

***Purple Haze**, Ron Raffaelli's portrait of Jimi Hendrix.*

MAKING MASKS
Raffaelli shot the model on 35mm Tri-X B&W film. Placing the negative in an enlarger, he exposed a sheet of 8in x 8in high contrast litho film. This gave him a black silhouette of the model against a clear background. Next, he sandwiched the positive litho film with another sheet of litho film and exposed it to create a negative (a black opaque background with a clear image of the model). He then used these two masks to create the finished image.

"I USED THE CLEAR mask of the model to expose the stars on to a 8in x 10in sheet of color transparency film. I used the litho film with the clear background to expose the clouds on to the same film. By using the litho films as masks in registration I was able to create the image of the star field girl jumping against a cloudy sky."

RON RAFFAELLI

*Ron Raffaelli was born in Hollywood in 1943. His career in the music industry started when he was asked to show his portfolio, not to the art director of the record label, but to the recording artist at his home in Beverly Hills. It was there that he met the star who acted as his own art director... Jimi Hendrix. Since then, Raffaelli has photographed many legends of rock 'n' roll, but he is best known as a romantic erotic photographer. He has had five books of his work published, his most well-known being **Rapture**, published by Grove Press in 1974, which ran to seven printings with sales of over half a million copies. He is currently working on a new book featuring erotic fantasies created entirely on a computer using 3-D ray-tracing technology.*

THE INNER SPREAD
"I made 4in x 4in prints of the band members and glued them to wood blocks. Using the same model as the front cover, I drove out to the Mojave Desert. I dug a hole and placed the blocks as if they had been buried in that hole. I posed the girl to look like she had just uncovered a buried treasure. I placed some metallic sparkles on the top of Paul Rodger's block and had the model blow them off. The idea was that she was blowing his mind." – Ron Raffaelli

SPECIFICATION

• *Artiste*	Free
• *Title*	Free
• *Design*	Ron Raffaelli/The Visual Thing Inc.
• *Photography*	Ron Raffaelli
• *Record Co.*	Island, 1969

GAMMA, Gamma 2

ONE CAN SEE WHY disturbing the safety of a suburban back yard might appeal to both designer and musician. For the latter, it is the job of rock 'n' roll to threaten suburban values, just as the sharks are menacing the figures on the chaise lounge. For the designer, there is the surrealistic cuteness of sharks operating in the wrong medium, and the strong graphic shapes – diagonally, yet naturally, positioned in an uncluttered setting. There are other allusions to savor: the shark-infested music biz, references to two-ness, and a cutting sense of humor. One has to applaud these sharks for their tenacity – not letting the absence of a little seawater deter them from their purpose – sharp, hungry, and powerful – like the music.

JEFFREY SCALES:
"It's saying 'There's sharks in the water, baby!'"

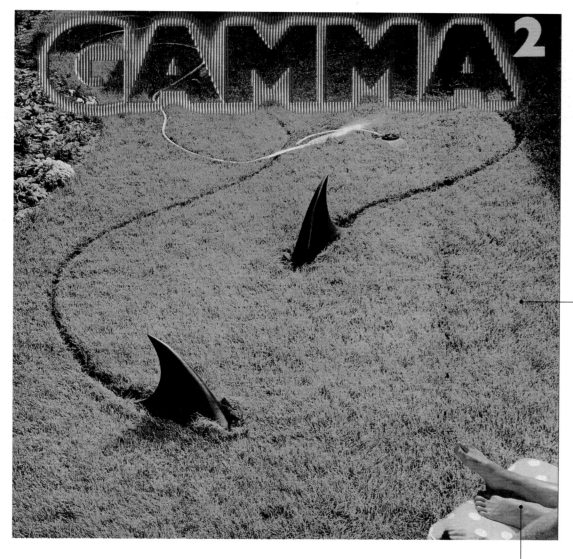

TECHNIQUE
Jeffrey Scales: "We went back and re-shot the chaise and had it mechanically stripped-in. We took the transparency, put it inside the 10in x 8in camera, matched it exactly with the chaise and re-shot it against a white background. The light was different, though. It had been overcast when the original was taken, but there was bright sunlight when we went back."

MICK HAGGERTY:
"The image was improved by the strip-in, not only by un-intentionally expanding the "2" theme, but with the addition of the cigarette adding a touch of sexual innuendo."

"THE COVER IMAGE came out of the subversive surrealism that was in the air at a time when album graphics offered the opportunity to use a more subversive style of imagery which advertising just couldn't offer," says Mick Haggerty. "Unexpectedly disturbing that sense of small-town tranquillity was very satisfying for me – sharks are big and black and dangerous – and they float just under the surface."

"MICK AND I did location shopping and looked at several different lawns in LA. The one we used belonged to a friend of Mick's. We chose it because it was nicely groomed and fresh-looking, and the owner didn't mind us digging it up." – Jeffrey Scales

JEFFREY SCALES

*Born in San Francisco in 1954, Jeffrey Scales' photographs have been exhibited all over the world. He has also contributed a great many images to books and to magazines such as **Rolling Stone**, **People**, **Esquire**, **Time**, **Life**, and **Newsweek**, as well as numerous record covers. Robert De Niro, Denzel Washington, Spike Lee, Michael Jackson, Charles Bukowski, Wim Wenders, and Martin Scorsese have commissioned him for portrait work. He is currently employed as photo editor at the **New York Times**.*

NUMBERS
*Like **Gamma 1** and **Gamma 3**, **Gamma 2** was loosely based on the number of the album, in this case, 2. A straight photograph with one added strip-in, the cover features two land sharks, two people, and a garden hose sliced in two.*

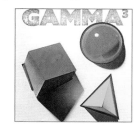

SHARK FIN SUIT
Haggerty thought of having the fins slicing through a cheese sandwich or a concrete floor. Also mooted was his shark suit idea (top right).

SPECIFICATION

• *Artiste*	Gamma
• *Title*	Gamma 2
• *Design*	Mick Haggerty
• *Photography*	Jeffrey Scales
• *Record Co.*	Elektra, 1980

THE COVER originally featured only female feet on the chaise. An innocuous idea, you might think, but Haggerty recalls that the image of a vulnerable woman being attacked by sharks was deemed inflammatory by Elektra Records, who feared the cover would spark protests similar to the roadblocks and pickets staged by women's group WAVAW (Women Against Violence Against Women) over a promotional billboard on Sunset Strip for The Rolling Stones' *Black And Blue*, which depicted a bound and beaten woman. Imagining angry demonstrators disturbing their executive tranquillity, Elektra asked Haggerty to alter the cover, and suggested a man and woman together on the chaise.

Design: Storm Thorgerson and Peter Curzon
Photography: Tony May and Rupert Truman
Computer Manipulation: Jason Reddy

Storm Thorgerson

DESIGNING A COVER

Catherine Wheel's music could be loosely described as a mixture of contemporary rock and indie, a shade on the heavy side, with lyrics that are obsessive and contrary, though they would probably resist any such label (they all do). Herewith are the stages in designing their cover – stages that are probably similar, but not identical, to the designing of other covers.

THE COMMISSION

The first stage in designing an album cover usually starts with a phone call. The manager, Merck Mercuriades, asked me to think about Catherine Wheel's next album, their fifth, probably called *Adam and Eve* (titles are such a nightmare). A commission (getting the job) is the all-important act in a freelance life. This may come via a recommendation, through PR, or by someone seeing something else you've done: by showing your portfolio, by luck, or by being connected to the band, etc, etc. In this instance, we'd done their previous three album covers.

THE BRIEF

All designers need information. I start by talking to the lead singer and songwriter, Rob Dickinson, to find out what he feels about the album. I request some lyrics (incomplete), some music (unfinished) on cassette or CD, and then receive a pep talk from the manager. These sundry ingredients constitute the brief for the job, quite detailed in this case, though less so in other instances.

THE ROUGHS

Coming up with an idea is the difficult part. With my colleagues Peter Curzon and Sam Brooks, I listen to the music, read the lyrics, study the notes from the lead singer, then we talk. We scribble little pictures, or doodles, occasional words or phrases. We talk some more, and then go our separate ways. We reconvene, and listen again to the music. Always the music, often in the background, seeping slowly into our minds. Odd ideas, fragments of image, certain words or phrases begin to emerge, appear, reappear, and evolve into definite ideas. Another colleague, Finlay Cowan, illustrates these ideas as figurative roughs. The content is usually clear, but not the mood, nor the lighting, nor the characters, nor what the meanings might be – I'll explain these verbally in the presentation. We might accumulate between five and ten ideas, stopping only when summoned to present them to the band.

THE PRESENTATION

These rough designs are then attached to large viewing boards and also copied onto actual CD-size cards, and taken in person to the band – to Rob and Merck the manager. I present the visuals, placing the boards around the office like a mini art show. This moment is exciting but nerve-wracking. What happens if they don't like anything, even in spite of my persuasive patter?

A week or so later – horror upon horrors – they don't really like anything. All that effort up in smoke! So much for my persuasive patter. The manager and singer ask me to try again, suggesting that "I be more experimental, not so like myself." "Break new ground," they say, "be different." Why don't they hire somebody else, I say. How can I design unlike I design? But we try again with a redefined brief. We repeat the process described before and resubmit. This time they accept two ideas, not one, and pat themselves on the back for having pushed me and extracted more than I thought possible (ha bloody ha).

THE SHOOT

One of the two accepted ideas is an experiment involving two actors improvising a couple having a bad day in Paris. They know things are over, but can't seem to say it out loud. We followed them with a photographer (Paul Postle) taking stills like fragments of a movie. It does not work that well, but was quite stimulating to do, and was used later for a single bag. The other idea, which appeared on the finished album cover, showed naked figures, male and female, in confined boxes, forced into

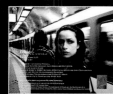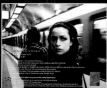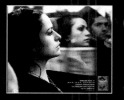

uncomfortable shapes. Loosely speaking, it was an attempt to indicate contrariness, free but trapped, elegant but contorted, together (adjacent) but separate (compartmentalized)… as we are in life. Though photographed for real, it is in fact a metaphor since the boxes are "open" (front and back) and only "graphically" closed.

The front image was photographed in a studio with tungsten lights (better for modeling) against a chroma-blue background with a Hasselblad camera and color transparency film pushed 1/3 stop in processing. The boxes were specially made to size and laid on top of each other. The final image was composited in a computer selecting the most interesting shapes – and then placed in finished rows. We turned the finished picture on its side, to confound both gravity and expectations.

THE ARTWORK
Peter Curzon then deployed all the elements in various enlarged detail to form the basis of the CD booklet and label design – incorporating, in crisp, elegant fashion all the lyrics and the credits for the album, including variations for different formats – cassette and double vinyl in this instance. (The front lettering and the boxes were changed for the UK version. Though it is not uncommon for us to make alternate versions, these were extreme and caused acrimony. Lots of bad blood with the manager, but we're friends again now). Peter used an Apple Mac system to do the artwork and supplied it on disk to the record company's printer. The transparencies for the front and for the booklet illustrations were separate, and added by the repro house to the combined artwork, following Peter's instructions (see below).

The more the artwork materializes, the more one can comment and improve things. Input from the band and manager is also taken into account. This interactive process between designer and client is sometimes painful, owing to the vagaries of human nature and circumstance, but with Catherine Wheel it is by and large constructive and friendly… but not without some heated debate.

THE PRINTING
This process of manufacture (mass production) involves separation, printing, production (cutting, folding, binding, packing), and distribution. The first two processes involve us. Since the normal "printing process" works in 4 colors, not 400 or 4,000, but only 4 (cyan, yellow, magenta, and black), via a procedure of dot-screen films out of which combinations of all other colors are produced, the overall process is fundamentally reductive. Quality gets worse. This seems to be an intrinsic property of mass production. Despite these enormous limitations it is truly amazing that we get the printing quality we do.

But back to the matter in hand. The separator combines our artwork into one whole, single entity by "separating" the original images into their four color constituents and recombining them, then providing examples (proofs) of his endeavors. These proofs are passed by us. Or in this case, not passed. The repro house (New York) tries, and we reject again. Release dates require immediate production and our beloved, indifferently "separated" cover goes off to be printed in its thousands. (In the UK, we could personally oversee these procedures.)

THE AFTERMATH
The finished printed copies of *Adam and Eve* were a disappointment. Tears are shed. Catherine Wheel are distraught, and so are we. But we are men and life must go on, especially in relation to art and business. These now demand design and artwork for allied pieces such as single bags, poster, and press advertising (and of course the proverbial T-shirt). These items require different text and different design, yet are related to the principle image. After that we have a beer and wait a long time to be paid.

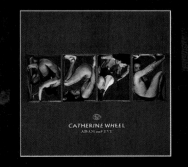

WORLD PARTY, Goodbye Jumbo

SAY GOODBYE TO THE OLD MILLENNIUM and hello to a new one. It's time to celebrate. It's time for a world party. Eco-warrior, Green Party activist, and musician Karl Wallinger says the album title "just came to him." After seeing a photograph of Tim Buckley in a gas mask to combat the LA smog, the elephant concept evolved as his way of animating such a bizarre title. The destruction of the environment has been a frequent theme of Wallinger's songs and the message here is that he is scared. Why else would he carry his huge elephantine ears in such a threatening way? Why else would he be breathing through his gas mask trunk on such a fine, sunny day? Why else would he be challenging us through a window frame of corporate junk? Because if someone doesn't, it will be goodbye Jumbo, we're off to the elephant's graveyard.

IN-HOUSE ARTIST
When Karl Wallinger rented The Old Rectory on the Woburn Estate in England to record his album, he discovered that the house came with Edward Durdey, it's own artist-in-residence. Durdey was commissioned to make the elephant ears. Says Karl: "They were really beautiful. He made them out of plaster of Paris and they had an incredible elephantine texture."

THE GOLD STARS for the band name were printed in gold as a fifth color.

THE EARS were positioned face-on rather than naturally flat against the side of the head. This angle signifies that an elephant is alarmed and may be about to charge.

EDWARD DURDEY'S art often includes small gold containers like these, which are vessels for holding one's spirit, or soul, and for keeping dreams in. They are also for decoration, as are the corded tassels which Durdey had seen on processional elephants during a trip to India.

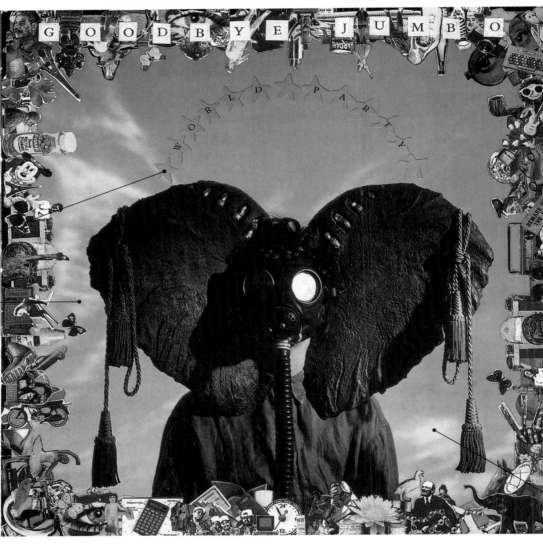

THE GAS MASK
*Karl Wallinger: "I sat in a brainstorming session one night with Stephanie, Michael, and Tony Nash. I'd been looking at the cover of Tim Buckley's album **Greetings From LA**. The front cover is a postcard shot of Los Angeles shrouded in a veil of thick brown smog and on the back is a photo of Tim Buckley wearing a gas mask. He was making a point, and I saw a way of playing with that idea and making the gas mask an elephant's trunk. It's also a symbol of Green politics because we're all aware of the environment. And on the cover, because I've got the mask on, I'm in danger."*

THE IMAGE WAS photographed in the studio against a painted backdrop of a bright blue sky. The cloud's V-shapes formed a false perspective. The set was lit to represent natural daylight. The elephant ears were built on a stand – Karl Wallinger squeezed in between them wearing the gas mask.

*"**THE COVER** is like a chocolate box. You want to pick all the things up and play with them, taste everything. You want to pick up the vitamin bottle and take them all." – Karl Wallinger*

THE WHITE ALBUM
*In as much as the front cover has a certain **Sgt. Pepper**-ish feel about it, the back cover and inner sleeve have a very deliberate tongue-in-cheek homage to the insert poster in The Beatles' **The White Album**, designed by Richard Hamilton.*

COLLAGE OF ART
After they had done the cover photo, Stephanie Nash felt that it needed a frame, so she assembled a rough collage of people and objects that represented World Party and the songs on the album. Karl then added some personal pieces of his own. "It works when you put it next to the music because the music's a bit like this. As John Lennon said: 'We're just reporting on what's happening to us,' and I've always felt that's exactly what I'm doing." Most of the collage came from trashy pictures in catalogues such as *Innovations*. Some of the corporate items had to be removed later and the cover reprinted.

SPECIFICATION

- *Artiste* — World Party
- *Title* — Goodbye Jumbo
- *Design* — Karl Wallinger and Michael Nash Associates
- *Photography* — Steve Wallace
- *Elephant Ears* — Edward Durdey
- *Record Co.* — Ensign, 1990

HANK MOBLEY, Hank Mobley

THIS COVER DESIGN FOR JAZZ TENOR sax Hank Mobley by Tom Hannan has been selected for a number of reasons. It was one of the first Blue Note covers that brought together crisp, dynamic layout with an evocative photograph of the recording artiste. It was also one of the early batch of cover designs that used space, rather than content, to reflect the music, counterpointing size and angle of type with image area. It was one of the precursors of a whole style and approach that lifted cover design from mere packaging to a fine art. It uses a portrait photograph that is more about mood and character than about vanity or adulation. And to cap it all, it is economic in both its use of color and the number of elements deployed.

THE SHOTS
Francis Wolff used a Rolleiflex camera for all his shots – usually taken at Blue Note studios. Michael Cuscuna of Mosaic Records: "Frank was never precious about his work, using any old film and sending the prints to a photo service to be developed. However, he always had square negatives made up."

THE SHADES
Like everything else about the sleeve, the shades say jazz, modern, cool. The style, which inspired the mod(ernist) movement in Britain in the 60s, is neatly encapsulated here. The overall style of the piece draws heavily on the "Swiss style" – the look of higher concept advertising design during the late 50s.

THE TYPEFACE
used for the title is Franklin Gothic. Designed at the turn of the century and now a basic staple of the typographer, it was very much in vogue during the 50s and early 60s.

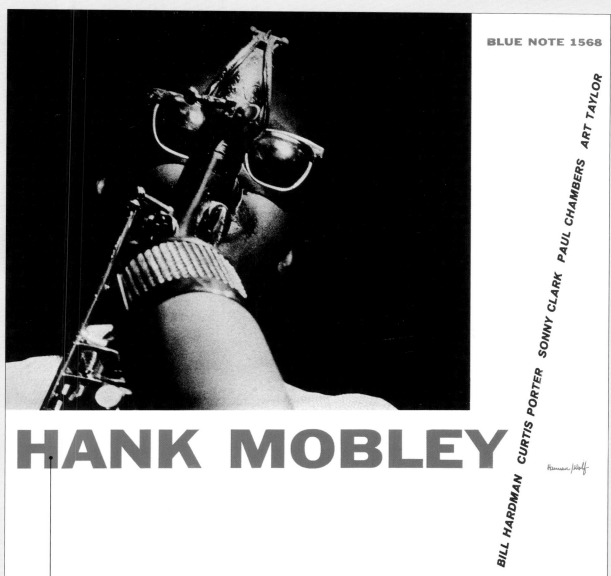

BLUE NOTE 1568

HANK MOBLEY

BILL HARDMAN CURTIS PORTER SONNY CLARK PAUL CHAMBERS ART TAYLOR

CREATIVE SOLUTIONS
Tom Hannan contributed to perpetuating the Blue Note house style with this Hank Mobley cover. The house style (see Hannan sleeves above and below)

was very much about design impact, especially in the context of short turnaround times. During the halcyon days of Blue Note, records were released so frequently that severe economies, in terms of budget and time, were imposed on the designer. Here, as is often the case, greater restrictions encouraged more creative solutions.

SPOT RED is used here as a dynamic counterpoint to the black-and-white photography.

EVERY COVER that Hannan and Wolff produced together included their signatures on the front.

SPECIFICATION

- *Artiste* — Hank Mobley
- *Title* — Hank Mobley
- *Design* — Tom Hannan
- *Photography* — Francis Wolff
- *Record Co.* — Blue Note, 1957

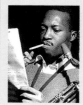

BONE & BARI
Another Tom Hannan/ Francis Wolff collaboration was the cover design for Curtis Fuller's album **Bone & Bari.**

HANK MOBLEY

Born in 1930, tenor saxophonist and composer Hank Mobley recorded 25 albums for Blue Note, playing alongside every jazz luminary in the book and providing a meaty foil to some of the genre's more energetic instrumentalists. Once described as the "middleweight champion of the tenor," Mobley's clipped, precise playing first attracted attention while working with Max Roach and Dizzy Gillespie in the early 50s. He went on to become an original member of the Jazz Messengers and played with Miles Davis in the early 60s, but retired from music in the mid-70s due to ill health. Hank Mobley died in 1986.

HAPSHASH AND THE COLOURED COAT, Hapshash…

HAPSHASH FROM THE HORSE'S MOUTH… Michael English: "There was a concept behind making the record, and the project was intended as a complete experiment. We hired EMI Studios overnight and used an anchor group of musicians we named The Heavy Metal Kids after William Burroughs' book *Nova Express*. We invited everybody on the scene to come – well-known celebrities and musicians and lots of UFO club hippies who we credited as The Human Host – and left musical instruments lying around so people could just come in and make music. When we felt something interesting was happening, we'd start taping. The next day, we worked with Guy Stevens, Procol Harum's producer, on the editing – and there was very little to do as it had all been done during the recording, really. There was singing, wailing, all sorts of strange sounds which sounded great when you related them to the steady beat of the band. When we'd got it all edited, we went into designing the cover, which of course was very important to us." And here it is.

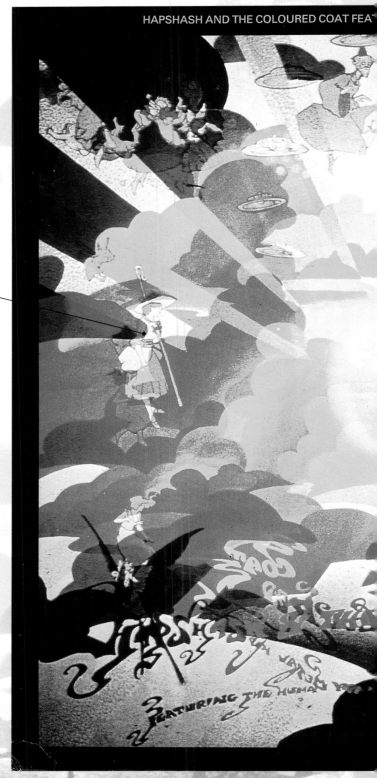

HAPSHASH AND THE COLOURED COAT FEA

GRANNY TAKES A TRIP
Guy Stevens of Island Records, who had produced Procol Harum's "A Whiter Shade of Pale," suggested to Michael English and Nigel Waymouth that they make an album. Already well-known within the psychedelia

circuit for the poster and clothing designs sold at their King's Road, Chelsea, boutique, Granny Takes A Trip, Hapshash felt that it seemed only natural that they should then make a record.

UFO COMING
This Hapshash poster was for the Liverpool Love Festival of June 1967, with Soft Machine and The Crazy World Of Arthur Brown.

NIGEL WAYMOUTH drew the figures of Little Bo Peep and friends around the edges – "They're 'very Nigel'," says Michael English – as well as the dots around the edges. English drew the clouds, the rays of light, and the lettering. He recalls that "I did the artwork of the clouds with just a white shape in the middle. Nigel did separate drawings of the characters which we cut out and stuck onto the artwork. Then we took a photograph of a Maya deity and merged it into the white of the middle to put it all together."

THE SAVILLE
Hapshash produced several posters for Brian Epstein's Saville Theatre in St. Martin's Lane, London.

THE INTENTION
Michael English: "If I use the words that are current now – and they weren't the words we used then, but the meaning is the same – it was to do with putting out a good energy, an incredible energy of love and power and light and color and peace, and turn the whole planet into a radiant ball of good energy. We wanted to communicate that good energy, spread it out, and make contact with new beings; so that in a way, the whole universe would be pulsating with this energy – which it is anyway, as we know. That thinking was so revolutionary, so incredible, and it was virtually ignored by the established fine art world, which continued its fascination with Pop Art; and Situationist art. They didn't want to hear about what we were talking about because it was dangerous, it undermined their system."

SPECIFICATION

- *Artiste* Hapshash And The Coloured Coat
- *Title* Hapshash And The Coloured Coat Featuring The Human Host and the Heavy Metal Kids
- *Design* Michael English and Nigel Waymouth
- *Photography* Ekim Adis
- *Record Co.* Minit/Liberty, 1967

"LITTLE BO PEEP – she's all silly and feminine. The cherubs at the top are just silly little boys. Of course UFOs had to go in because UFOs were everywhere then. And the tropical butterflies were there because they represented the feminine, while the Maya face is masculine. It's about playing, interplaying the child with the adult. The Maya face in the center is totally adult." – Michael English

THE ARTWORK is a combination of photomontage, gouache painting, and airbrush work. The artwork was produced as a collaboration between English and Waymouth, who each illustrated the parts that they felt motivated to do. "I'd do a bit, and he'd do a bit," says English. "It was rather like a tapestry where the personalities of those working on it are interwoven, and you can detect each person's input if you know their style of work."

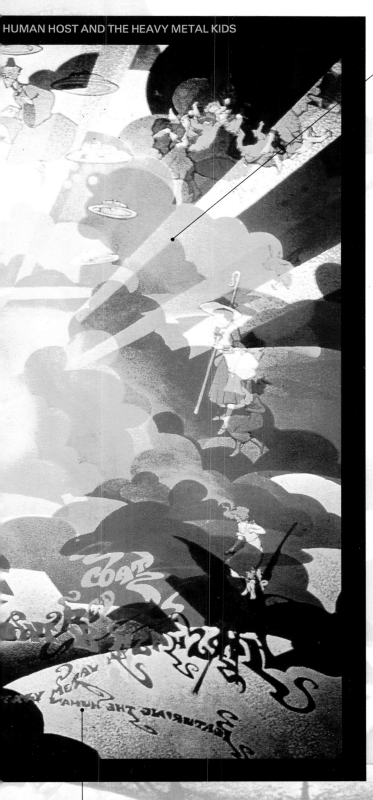

HUMAN HOST AND THE HEAVY METAL KIDS

THE FACE IN THE MIDDLE was a photograph of a Maya carving. It was used, says Michael English, because "At the time, we all imagined that Mayas were these wonderful, fantastically spiritual people; but we know a lot more about them now, and they were far from that – pretty horrific people in fact."

THE RAYS OF LIGHT "all come from the center energy," says Michael English. "X marks the spot. X is the center, and almost all my work has a center point of light that radiates outward."

FLIPPED OUT
Two identical transparencies were taken of the artwork. One was flipped over and laid on top of the other, and the combination was then rephotographed to form the final artwork. Incidentally, the cover was photographed by the mysterious "Ekim Adis" – a pseudonym adopted by a London fashion photographer (English can't remember his real name) who used this moniker because he didn't want to be identified. So, working backward, let's hazard a guess that his first name was Mike.

MANDALA
Michael English: "It is basically a mandala, about symmetry of matter, time, and space – symmetry in terms of the way the word is used in new physics. The universe is in symmetry, everything is in symmetry with everything else – symbiosis. I know now that this was what we were doing, but we didn't know it then. Holding the two transparencies together just looked absolutely wonderful to us on the light box – we thought 'with a black border, that is it!' It was fantastic."

I CAN SEE FOR MILES
This poster featuring The Who was one of several beautiful posters designed by Michael English and Nigel Waymouth as Hapshash and The Coloured Coat and published by Osiris Visions.

SOUND AND VISION
Michael English: "With the album, we wanted to expand outward from visual expression into sound, and the cover was a way in which the visual expression was made more accessible. You saw a poster and heard the music that went with it at the same time. We were not about drugs – people think anything to do with hippies was drug-related, but Hapshash wasn't about that. We just wanted to create mythical images and communicate the idea that there is an incredible beauty in the world, on the planet, and that this is something amazing, wonderful."

RED VINYL
Hapshash wanted the record to be pressed on clear red vinyl, but Island Records refused to foot the bill. Guy Stevens offered the project to Liberty, who paid Island for the tapes and agreed to press the record on red vinyl. The album is available again having been recently reissued – but sadly, not on red vinyl.

HIS SATANIC MAJESTY DECLINED
After the album came out, Hapshash decided to put on a concert at the Royal Albert Hall and approached Mick Jagger to help finance the show. Michael English recalls visiting Jagger "in this massive place off Marylebone Road where he lived with Marianne Faithfull. We played him the album and explained how we'd recorded it, and he said 'Great, but I don't want to invest.' No one else was interested, so that was the end of that. When The Stones' next album came out I thought that one track sounded similar to a track on our album which had been released just before theirs. We weren't cross about it – it didn't matter. The Stones were doing what we couldn't do because we didn't have the fame – sending our idea out to millions of people. But our album cover was better than theirs!"

MICHAEL ENGLISH
Born in Oxfordshire, England, English studied at the Ealing School of Art. He was heavily involved in the British hippie movement, and became Britain's best-known psychedelic poster artist, as well as painting storefronts such as Granny Takes A Trip in the Kings Road, Chelsea. In 1969, he abandoned posters to concentrate on super realism, producing limited-edition prints which were later mass-produced and gained worldwide exposure. By 1973, he had begun painting the detailed canvases which have formed the main body of his work ever since. He has exhibited in New York, London, Tokyo, Paris, and the south of France, and now divides his time between painting, art directing for television, and illustrating for advertising. He recently designed an image overhaul for Swissair.

THE LETTERING at the bottom with the band and musicians names was done by Michael English, who did all the lettering on Hapshash designs because he just loved doing lettering. It is easy to see where the transparencies have been overlaid in the lettering.

JONI MITCHELL, The Hissing Of Summer Lawns

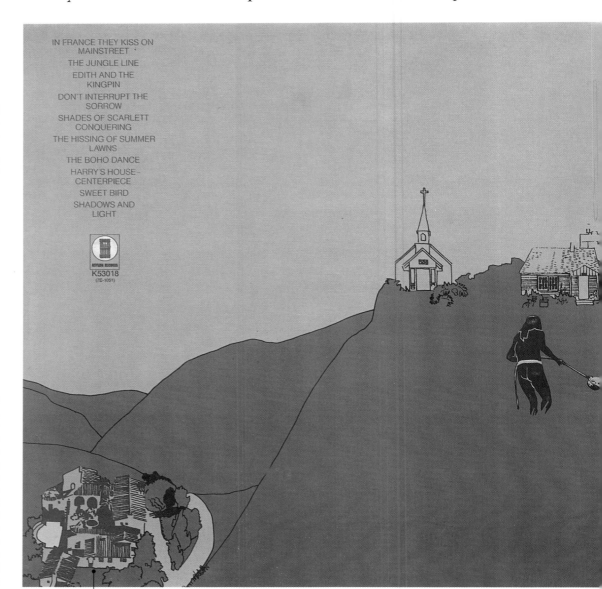

THE TERM RENAISSANCE MAN, or Renaissance woman, refers to those fortunate enough to be accomplished in more than one area of the arts. Bob Dylan, Captain Beefheart, John Lennon, Cat Stevens, and Paul McCartney all compose and paint and have used their skills to illustrate their music. Joni Mitchell plays guitar, writes poetry, sings her own songs, and paints her own album covers. Painting came first in her life and then she discovered music, so perhaps it's only natural that after becoming a successful recording artiste the reverse followed suit. Her painting has always been influenced by the overall themes expressed in her music and lyrics. The cover painting for *The Hissing Of Summer Lawns* represents precisely these themes.

IN FRANCE THEY KISS ON MAINSTREET ·
THE JUNGLE LINE
EDITH AND THE KINGPIN
DON'T INTERRUPT THE SORROW
SHADES OF SCARLETT CONQUERING
THE HISSING OF SUMMER LAWNS
THE BOHO DANCE
HARRY'S HOUSE - CENTERPIECE
SWEET BIRD
SHADOWS AND LIGHT

ASYLUM RECORDS
K53018
(7E-1051)

KEEPING BOTH CAREERS ALIVE

Joni Mitchell has painted nearly all her album covers. This cover is no exception. Joni: "I was a painter first. I trained as a commercial artist, as well as a fine artist. So when I began to record albums, I thought art was a great way to keep both careers alive."

THE RANCH ON THE HILL

The inspiration for the cover illustration almost certainly came from the first verse of "The Hissing of Summer Lawns":

"He bought her a diamond for her throat
He put her in a ranch on a hill
She could see the valley bar-b-ques
From her window sill
See the blue pools in the squinting sun
And hear the hissing of the summer lawns."

© John Guerin and Joni Mitchell. ℗ 1975 Warner Bros. Music.

BOTH SIDES NOW

*Brian Hinton, in his excellent book **Both Sides Now**, says of the cover: "The album title refers to water sprinklers on the lush lawns of suburban Los Angeles – a city resting perilously on what was once desert – and how they sound like a huge snake rustling ominously through the undergrowth. The city on the front cover of the album is New York, crossed with Saskatoon (where Joni lived as a child), while the mansion on the back cover, viewed from the air, is the singer's own home in Bel Air. The blue of the swimming pool matches the blue of a house on the front, the only other colors in Joni's drawing being the gray for the sky and a kind of olive green for the vegetation – maybe Central Park – maybe the suburbs – across which black and white natives drag a giant snake, apparently towards a church."*

SPECIFICATION

- *Artiste* — Joni Mitchell
- *Title* — The Hissing Of Summer Lawns
- *Design* — Joni Mitchell with Glen Christensen
- *Illustration* — Joni Mitchell
- *Photography* — Norman Seeff
- *Record Co.* — Elektra/Asylum, 1975

JONI MITCHELL'S Spanish-style house in the hills of Bel-Air, painted, unlike the other houses, from a bird's-eye view and with its swimming pool on the left-handside of the house.

THE JUNGLE LINE

Another song on the album, entitled "The Jungle Line", talks of "a poppy snake in a dressing room… it slithers away on brass – like mouthpiece spit." The song also refers to the detailed jungle paintings of Henri Rousseau:

"Rousseau walks on trumpet paths, safaris to the heart of all that jazz.".

© Joni Mitchell. ℗ 1975 Warner Bros. Music.

HISSING AND BOOING

*In 1991, **Rolling Stone** voted the album No. 11 in The Best Album Covers Of All Time. However, when it was released in 1976 they said it was one of the worst albums of the year. It was, by the way, accidentally reviewed in black music magazines to rave notices, which was unusual for Joni Mitchell.*

THE CITYSCAPE IN THE DISTANCE is a strange mixture of architectural styles. Supposedly the city is an amalgam of New York and Saskatoon in Canada, although the clapboard houses in the middle foreground look more like the ranch-style houses of Laurel Canyon in the Hollywood Hills than Alberta. And why is the one on the far right painted green?

SLEEVE NOTES
Joni writes in her sleeve notes, which are laid out like a poem around her body floating in the pool: "This record is a total work conceived graphically, musically, lyrically and accidentally, as a whole."

THAT HISS OF SUBURBIA
Joni Mitchell talking to Cameron Crowe in 1979: "The basic theme of the album was just any summer day in any neighborhood when people turn their sprinklers on all up and down the block. It's just that hiss of suburbia. People thought it was very narcissistic of me to be swimming around in a pool. It was an act of activity as opposed to sexual posturing, which runs through the business – nobody ever pointed a finger at narcissism there."

THE INNER SLEEVE
Norman Seeff, photographer: "I went to Joni's house, where we hung out and took some pictures. I suggested some shots in the pool, which turned out to be very evocative and sensuous. It was probably by accident, rather than design, that they appeared on the cover at all. The photograph is in monochromatic color, shot with a Nikon camera using Kodachrome film in natural daylight."

MINGUS
The album package for **Mingus** *consists of three paintings by Joni Mitchell of Charlie Mingus. When they began their collaboration Charlie Mingus was ill, paralyzed and in a wheelchair, and he had never heard her play. She told Leonard Feather in an article for* **Down Beat** *magazine that she particularly liked the cover because it was done for commercial reasons yet suited the music. The music, she said, seemed "painterly, with lots of white canvas and very brash stroky interactions."*

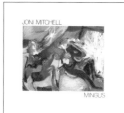

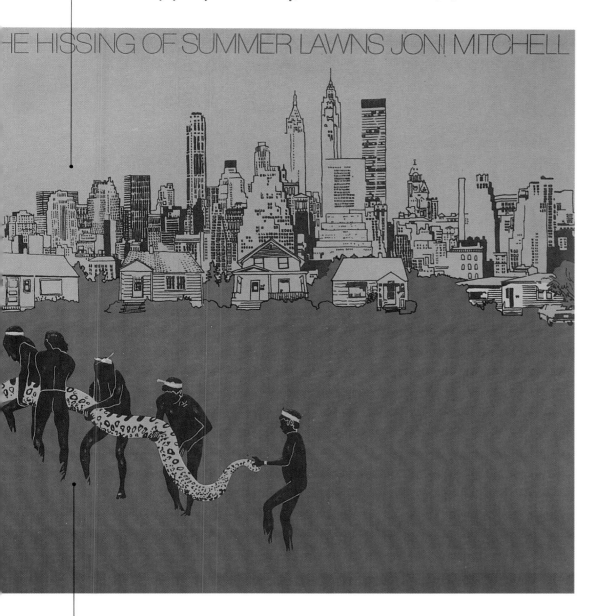

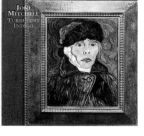

TURBULENT INDIGO
The cover for **Turbulent Indigo** *won Joni Mitchell an award for Best Album Package in 1995 at the 38th Annual Grammy® Awards. The cover painting is an accurate pastiche of Vincent Van Gogh's* **Self-portrait with Bandaged Ear**, *with Joni as Vincent.*

ON FIRST PRESSINGS of the album the snake and the figures carrying it are embossed. In a later interview with *Rolling Stone*, Joni commented: "At that point my stock was up. The record company let me do all sorts of expensive things in terms of art. I think back now to an album like *The Hissing Of Summer Lawns*, when we did all this fancy embossing for the cover. Even Madonna couldn't get embossing these days."

ZUMA
Brian Hinton: "In 1976, the same year as **The Hissing Of Summer Lawns**, *Neil Young released an album called* **Zuma**. *On the album there is a song called 'Stupid Girl,' supposedly about Joni Mitchell. It's sung in sorrow rather than anger. Verse two of 'Stupid Girl' seems inspired by the inner sleeve shot with Joni as a beautiful fish, 'flopping on the summer sand, waiting for a wave'."*

FIRST ALBUM
Joni Mitchell's, **Ladies Of The Canyon**, *with a cover painting by Joni.*

JONI MITCHELL

Joni Mitchell was born Roberta Joan Anderson on November 7, 1943, in Fort MacLeod, Alberta, Canada. In 1952, at the age of nine, Joni contracted polio in the same epidemic that also struck Neil Young. While she was in the hospital she painted and wrote poetry, and as she grew older painting became more important. In high school she studied figurative art and later, in 1963, she attended the Alberta College of Art. It was during this period of her life that Joni Mitchell began to develop both as an artist and musician and started to write her own material. In 1965 she moved to the US and soon after released her first album, **Ladies Of The Canyon**, *on Reprise Records, to critical acclaim. Today, Joni is still constantly recording and touring.*

HIS NAME IS ALIVE, Home Is In Your Head

IN MANY INSTANCES of cover design a particular attribute contributes the lasting quality. It can be the idea or the image, the attitude or the typography, the photograph or the illustration. *Home Is In Your Head* is a striking example of all the ingredients combining to produce a collective effect. The background, the typography, the image, and the colors all seem to connect fluently, contrasting and complementing each other in turn. The eye can find different elements to favor when visiting the design again. The lines of lyrics are decorative yet informative, fragments of the songs within. They look as if they have been etched by the tip of the hanging squid – half-quill, half-alien – hanging within a scratchy void made of metal brush strokes, or bits of flowing hair, or perhaps silvery seaweed. Elegant but huge type, restrained and classic in vivid purple, contrasts with the weird, big-brained, squelchy squid. The entire design is crisscrossed with lateral lines of type and scratches and with vertical lines of title type and suspended squid. And all this on the front cover before the rest of the package and the rest of the story!

WHAT'S IT ALL ABOUT?
The cover was inspired by the music: an attempt to reflect the mood and the atmosphere of the music in the manner of Kandinsky and Klee. The scratches, for example, represent the scratchy guitar sounds and the nervous energy and tension of the electronic sounds. Vaughan Oliver: "It was my train of thought at the time, my surreal word associations, and it made sense then. It's all an organic relationship – the pod gave birth to the maggots that grew in the squid." Dominic Davies: "The band's biggest input was not having an input. I was free to do what I felt was right for the music." Warren Defever of the band: "There is a concept, so I've been led to believe, as it's been explained to me enough times. First you have a squid, then you have a green pod, and finally there are maggots, or maybe that's backward. Anyway, it works with the lyrics."

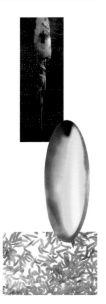

VAUGHAN OLIVER says he is always keen to play with typographic formats. Lyrics are normally on inner sleeves, but he liked the idea of putting them on the cover instead. It illustrated a feeling of nervous energy. Whole songs are not printed – just snatches that were chosen by him simply for the shape of the lines – they link to the scratches brushed on to the steel background.

FOR THE FRONT COVER photograph, Dominic Davies froze the squid into several different positions, and recalls that he "probably got through three or four of the little devils" during the course of the photo session. The photograph was taken using a Mamiya 645 camera.

DOMINIC DAVIES

After taking an art foundation course at Horsham Art School, UK, and a Higher National Diploma in photography and an advanced diploma in media production at Bournemouth College of Art and Design, Dominic Davies was commissioned to take photographs for Virgin Classics, 4AD, EMI, and Decca. He still works as a freelance photographer from his London studio.

"THE IMAGES CAME from the music; it's quite intense, with lots of feedback sound. *Home Is In Your Head* conjures up images of schizophrenia, so I thought 'What does madness or schizophrenia look like?' It felt internal, like in *Alien* where there's something inside you that you can't control. I needed to visualize the feeling. A squid from Brixton market seemed perfect because it reminded me of those tiny sea creatures that live at great depths, swimming around and noone's ever seen them before, and it seemed quite a good symbol for schizophrenia."

TECHNICAL ITCH

The background is a piece of sheet metal that has been scratched. Dominic Davies' builder had left a piece of metal outside his house, so he scratched it up and double-exposed it on top of the squid, which gave it a certain rawness – they didn't want anything too polished. There had to be an itch; the general feel was "oddness" and "itchiness."

NUMERICAL CODE

Dominic Davies recalls that the numbers on the back cover photograph came from the London Underground. Some work was being done at his local station and they were using a numerical code to put all the bits back in the same place – little dots all over the ceiling with "171, 172, 173" written on it. He photographed a section of ceiling and incorporated it into the back cover image.

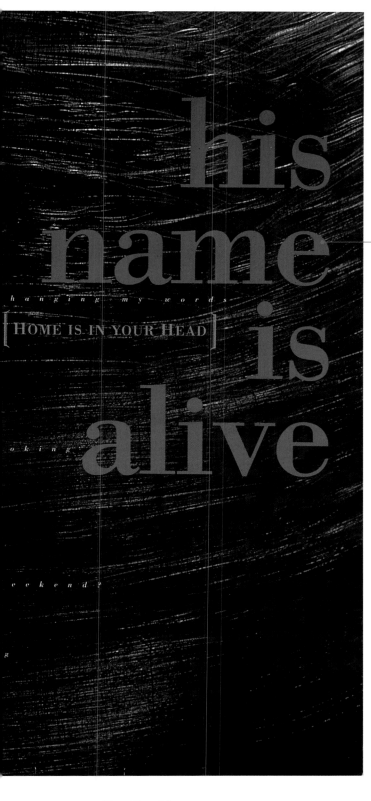

name

THE ARTISTES' name and the album title are in Bodoni, a classic typeface. Vaughan Oliver wanted something very "establishment" and he liked the juxtaposition of the weirdness of the images and the incongruity of lyrics on the cover, which make the type look even more normal.

WORKING THROUGH THE NIGHT
Trying to come up with ideas for the inner sleeve, Dominic Davies laid out some maggots on his light box to photograph them. Around 3am he fell asleep at his desk exhausted and was rather surprised to wake up in the morning to a room thick with flies. The heat from the light box had hatched the maggots. Undeterred, he felt this was a good thing because it had a feeling of metamorphosis.

THE DESIGNER
Vaughan Oliver: "I'm really happy with it. I think it's unusual. I like the avant-garde photographic approach juxtaposed with the establishment type, offset by the odd imagery. I like the horror and the beauty of it all."

THE ARTISTE
Warren Defever: "I can't remember what I felt seven years ago, but I am currently of the opinion that it's terrific."

THE RECORD COMPANY
Founder of 4AD, Ivo Watts-Russell: "At the time I felt the cover got a bit confusing because of all the type. I would've liked to have seen more room for the image to breathe. But with the passage of time, the cover has come to seem more appropriate, an inseparable part of the music which evokes all the details within it. But the squid doesn't mean a damn thing to me."

THE INNER SLEEVE
This is photograph of a potato that Dominic Davies sprouted in a cabinet. Originally, he wanted to put song titles or lyrics at the end of each sprout, but Vaughan Oliver said he preferred the potato as it was.

SPECIFICATION

• *Artiste*	His Name Is Alive
• *Title*	Home Is In Your Head
• *Design*	Vaughan Oliver at V23
• *Photography*	Dominic Davies
• *Record Co.*	4AD, 1991

THE TAX MAN
Dominic Davies claimed for the squid on his tax return. The tax authorities called him up and said: "You're a photographer, you can't claim for fish." So he showed them the album cover and claimed his legitimate business expense.

FIDDLING THE SQUID
Vaughan Oliver had a free hand to do what he liked for the cover. He knew Dominic Davies had been "fiddling about with squid" and wanted to use them. Vaughan wanted Davies' "fish" photography to be exploited commercially. He felt that giving him the opportunity to work on our cover might help him to come to terms with his peculiar obsession.

PATTI SMITH, *Horses*

PHOTOGRAPHER ROBERT MAPPLETHORPE'S friendship with Patti Smith survived illness, suicide attempts, his revelations of homosexuality, and her increasing fame. In 1975 Mapplethorpe's photographs had never received national exposure before, but when *Horses* was released in November 1975 his photographs of Patti Smith were in every major magazine. "We always dreamed of becoming successful together," Smith said, "it was all part of our grand scheme." And they did, though perhaps not quite in the way they imagined. Wild horses for wild courses.

THE DAY OF THE SHOOT
Mapplethorpe and Smith spent several hours at the Pink Teacup in Greenwich Village. Suddenly Mapplethorpe looked at his watch. "Let's get out of here," he said, throwing change on the table and running from the café. Patti Smith had no idea what was happening but she followed him as he sprinted down the street. "The light," he called out, "we can't lose the light." Mapplethorpe lined up her body so that the tip of the triangle of light jutted from her collarbone, like an angel's wing. He knew he'd taken a good picture before he saw the contact sheets.

AMBIGUITY
What Patti Smith needed was a photograph that captured her intriguing ambiguity, and while she could have selected almost any photographer for the job, she asked Robert Mapplethorpe to take the picture. Robert and Patti talked about the cover endlessly. They'd just go on and on about it… Should it project a **Vogue** *and* **Harper's Bazaar** *quality? Or was that too glamorous? Then they'd argue about what "glamour" was. He had much more conventional ideas than she did, but ultimately she didn't pay him a lot of attention.*

NATURAL LIGHTING
Mapplethorpe was far from a professional photographer, and was intimidated by technical equipment. He didn't do any of his own printing and his negatives were developed for him at a local photo lab. He didn't even have supplemental lighting, so he was confined to shooting his pictures in daylight. As a result, he was always looking for interesting light and shadow effects.

OTHER ALBUMS
Mapplethorpe photo-graphed Patti Smith again, for her album **Dream of Life***, shortly before he died.*

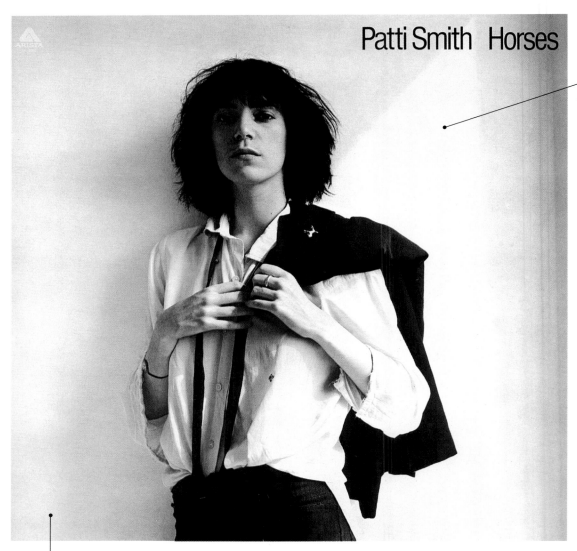

ARISTA RECORDS
art department wanted to change Smith's hair into a bouffant. She told them: "Robert Mapplethorpe is an artist. He doesn't let anyone touch his pictures." He probably wouldn't have minded – but Patti Smith would have.

WHEN SMITH had signed her deal with Arista she had been given complete artistic control of her albums, and she refused to change the cover, even declining to airbrush out her mustache. She said it would be "like having plastic surgery or something."

UNRULY HAIR
"Don't you even want to use a comb?" Mapplethorpe asked Smith, but she refused. Instead she flung an old second-hand jacket over one shoulder in a Frank Sinatra pose and imagined that she was the French actress Anna Karina being filmed by Godard.

LOCATION: Sam Wagstaff, Mapplethorpe's benefactor had just bought a penthouse on Fifth Avenue in Greenwich Village. Since it was bare and painted white, Mapplethorpe sometimes used it as a photographic studio. He noticed that the afternoon sun formed a perfect triangle on one wall, and decided to use it for the *Horses* cover.

ROBERT MAPPLETHORPE

Robert Mapplethorpe was born in Floral Park, Long Island, in 1946. He studied painting and sculpture at the Pratt Institute in Brooklyn. In 1976, he held his first exhibition at New York's Light Gallery. These pictures included his favorite subjects: erotic scenes, flowers, and portraits. During the 80s Robert Mapplethorpe photographed for **Vanity Fair**, **House & Garden**, **Stern**, **Splash**, **Interview**, **Harper's**, **Geo**, *and* **Elle***. In 1988, the Whitney Museum of Modern Art, New York held a retrospective. Robert Mapplethorpe died of AIDS on March 9, 1989.*

THEY SHOOT HORSES, DON'T THEY?
The record company didn't share Mapplethorpe's enthusiasm for the cover. In fact, they were appalled by it. An unwritten rule of the record business was that "girl singers" were supposed to look pretty and feminine. Not only was Smith wearing a man's shirt and tie, but she hadn't even bothered to put on makeup.

SPECIFICATION

- *Artiste* Patti Smith
- *Title* Horses
- *Design* Bob Heimall
- *Photography* Robert Mapplethorpe
- *Record Co.* Arista, 1975

ABC, How To Be A Zillionaire!

SHEFFIELD POPSTERS ABC wanted to get away from their previous albums *Lexicon of Love* and *Beauty Stab*, and so created *How To Be A Zillionaire!* – less guitar-based, more electric and hip-hop. For the entire promotion – video, publicity, and album cover – they invented new characters, loosely based on animated cartoons and club fashions of the time. These caricatures were pure inventions – extreme versions of themselves. The album cover features these cartoonlike characters, set against a cartoon background and surrounded by a specially designed typeface. Nothing substantial here except the art.

CARICATURE

Martin Fry: "We didn't want to repeat **Lexicon of Love** *and at the time there were only two of us, myself and Mark White, so we drafted in David Yarritu, this diminutive guy who had come to a gig in Austin, Texas. Then there was Eden (Fiona Russell Powell), who was a writer for* **The Face** *magazine. They weren't musicians and were just used as visual tools for the cover characters. They were visually two very extreme people and as a group we had decided we wanted to become like* **The Archies** *– a Hanna-Barbera cartoon – and to caricature ourselves."*

PLASTIC FANTASTIC

ABC said that as the record was musically synthetic, they wanted their image and clothes to be synthetic too. The clothes were designed by Elm Huseyin and two men called Mark and Murray, who were inspired by London club Taboo and performance artist Leigh Bowery. When it came to the graphics, they were influenced by the **Loony Toons** *and* **Tom & Jerry** *cartoons, and by the new 3-D video arcade games such as* **Xaxon.**

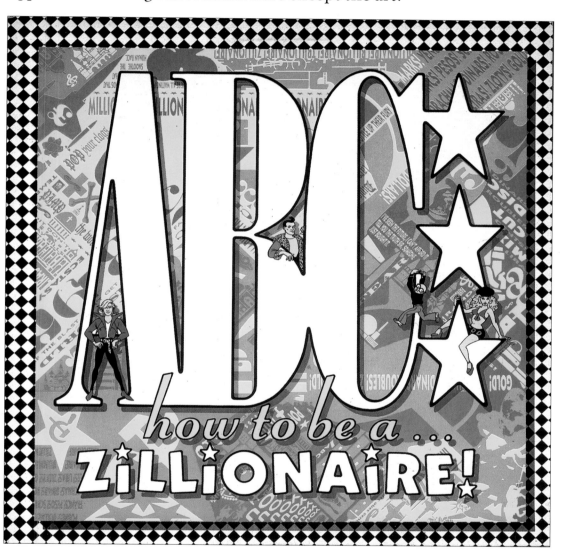

THE DESIGNER

ABC chose Keith Breeden to design their album cover. Keith was a painter and sculptor who they had worked with on **Beauty Stab**. *They felt he wasn't a "yes" man and that he understood what they were trying to achieve.*

CARTOONS

"Martin and Mark wanted to create a pop cartoon world. They had already commissioned an animation video and this gave us four characters. We tried to imagine an immediate, brash, and colorful world for ABC to inhabit. Martin and Mark's lyrics talked of love, ambition, money, fear, fashion, and of a city. That gave us all the creative information we needed." – Keith Breeden

WHEN PORSCHE COMES TO SHOVE

"When it came out we got a lot of antagonism – people reacted against the images. They defaced the posters in Britain. They did not like the change of image. We wanted to create something that summed up the time – there were all these young people with insane **Dynasty** *aspirations – people believing you had to have a Porsche to survive – and we were saying: 'We can see the future, and you can't afford it.' It was getting ridiculous. That is why we called the album* **How To Be A Zillionaire!**" *– Martin Fry*

ARTWORK

The sleeve was drawn up as a black-and-white line artwork which, considering the complexity of the illustration, was a very long and laborious process. The individual colors were specified as color tints and indicated with film overlays and dropped in by the color separators.

DEE-LITE

In 1990, New York based trio Dee-lite took inspiration from ABC and employed the same pop-star/cartoon theme. They scored an international hit with "Groove is in the Heart."

SPECIFICATION

- *Artiste* ABC
- *Title* How To Be A Zillionaire!
- *Design* Keith Breeden/Design KB
- *Illustration* Keith Breeden
- *Record Co.* Phonogram, 1985

LED ZEPPELIN, Houses Of The Holy

BY 1973, LED ZEPPELIN WERE the biggest band in the universe. Their reputation for great, hard-driving music, laced with soaring, poetic vocals was matched by a tough business reputation and a dark private side. Not a band to be trifled with. When Jimmy Page phoned Hipgnosis and asked if they'd done *Argos* for Wishbone Ash and might they care to do a Zeppelin cover and could they come to a meeting, the answer was a very definite yes. Would Hipgnosis like to design an album cover for the heaviest band in history? Well, who wouldn't? The *Houses of The Holy* album cover was born, therefore, in suitable deference and awe. The children clamber across the rocks towards some cosmic dawn, as inevitable and awesome as Led Zeppelin themselves.

PRINTING PROBLEMS
The album's release date was delayed for months due to printing problems with the cover. The children came out purple and the rocks glowed a luminous orange. Manager Peter Grant ordered Hipgnosis "to make sure that it's printed perfectly." A dozen more proofs were rejected until he demanded that Atlantic Records pay for the designers to stay in New York to see the project through. Days of luxury at the Plaza Hotel beckoned. A tough job, but someone had to do it.

HIPGNOSIS HAD previously experimented with many forms of photographic trickery, including hand-tinting. The black-and-white finished collage was re-photographed and printed in a light sepia brown and then Philip Crennel imparted a subtle array of rainbow colors. The water-soluble colored dyes were applied layer upon layer by brush and airbrush until the desired effect was achieved.

THE SHOOT
At 4.00 am every morning for a week, three adults and two children were sprayed silver and gold from head to toe and driven from the hotel to the location to await a glorious sunrise that never happened. "It was wet and cold" Samantha Gates recalls, "and I've never been a Zeppelin fan!" Mark Sayer, one of the adult models remembers: "A nightmare. Hot coffee, brandy, Mandrax [tranquilizers], freezing rain, turpentine (they had to use car paint as the makeup had run out), tepid baths, bad food, boredom, damp beds, and misery. And then they didn't use me and shot it in black-and-white. Anyway, I got paid £100."

CHILDHOOD'S END
*The idea for the cover comes, in part, from Arthur C. Clarke's book **Childhood's End**. At the close of the story all of the world's remaining children gather together and fuse into a tower of mental fire and "leave" Earth. Hipgnosis meant to use a family, but during the shoot decided that the naked children alone made for a more evocative image. In a recent interview Clarke said he was flattered that his book had stimulated the image for **Houses Of The Holy** and that Led Zeppelin was one of his favorite bands.*

LED LOGIC
*Strangely enough, the title song didn't even appear on this album; it appeared on the following one, **Physical Graffiti**.*

SPECIFICATION
- *Artiste* — Led Zeppelin
- *Title* — Houses Of The Holy
- *Design* — Hipgnosis
- *Photography* — Hipgnosis
- *Record Co.* — Atlantic, 1973

THE OBI
*The finished cover was ringed by a band of paper known as an **obi**, a Japanese kimono sash, upon which was inscribed the Celtic-style title (designed by Bush Hollyhead). This meant that no lettering appeared on the cover itself. Each album was pristine, as the **obi** had to be broken to get the record out. The **obi** also hid from view the naked bottoms of the little children, which some people considered offensive.*

THE LOCATION

The photograph was taken at the Giant's Causeway in Northern Ireland. Robert Plant had suggested the Isle of Staffa off the coast of Scotland, which has the same octagonal rock formations but is very inaccessible. The Giant's Causeway is the other end of the "staircase under the sea," which leads to Staffa. When Po went to take the picture he was impeded by British Army road blocks, bad weather, and a watchful mother.

THE PLAIN OF NAZCA

Hipgnosis had arrived nervously at a small office in London's Oxford Street. Peter Grant, Led Zeppelin's manager, dominated the room. Physically massive, he was suspicious, aggressive, and enthusiastic all at the same time. They talked through their presentation from notes scribbled on the back of a cigarette pack. No elaborate roughs or sophisticated presentations. One of the ideas presented meant plowing up the sacred Plain of Nazca in Peru (right) with the ZoSo symbol, and another involved a family, painted in silver and gold, heading towards a magical power source photographed at dawn in an amazing location. Peter Grant and Jimmy Page were unanimous: they liked both ideas. Robert Plant was excited about the rock formations on Staffa in Scotland for the location: "We're off to tour Japan so do whichever one you think will work best." Hipgnosis had never been given such **carte blanche**. Slightly daunted by offending archaeologists worldwide and also by spending a lot of money on a trip to the foothills of the Peruvian Andes, Hipgnosis settled on Northern Ireland instead. Irish mysticism was just as powerful as Peruvian mysticism and more pertinent to Zeppelin's Celtic inclinations – it was also closer to home.

LOCATION photographs are heavily dependent on evocative skies. Since the weather was foul and the sky dark gray, and Hipgnosis had promised the band a glorious sunrise, it was decided to fashion an imaginary sky. Vivid peach was the unexpected result.

THE GEOMETRIC nature of the rocks hid the edges where different photos of the children, taken individually, were joined together to make the finished collage.

NUDITY

The possibility of any pedophilic overtones never entered the designers' minds. The liberal 60s had spilled over into the 70s and the innocent atmosphere

*of experimental work had not yet been poisoned by political correctness. Children were chosen to represent future innocent souls, nakedness to represent vulnerability. The children were real brother and sister, Samantha and Simon Gates. They were chosen because they had already appeared nude in Japanese photographer Hajime Sawatari's version of **Alice In Wonderland**. The Houses Of The Holy cover was banned across America's Bible belt and in Franco's Spain*

THE INSIDE SPREAD

The inside of the album cover was photographed near the Giant's Causeway at Dunluce Castle. The appalling weather required instant decisions, so the shot took approximately five minutes. The photograph was printed in black and white and then hand-colored.

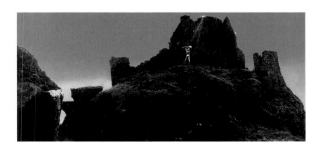

HIPGNOSIS

*At the time of the album, the Hipgnosis design studio in London consisted of Aubrey Powell, known as Po, and Storm Thorgerson. They were friends from Cambridge and had first worked for Pink Floyd, who also came from Cambridge. Hipgnosis usually designed in the photographic medium, often in association with graphic designers and illustrators. Though they had previously created album covers for a variety of other bands, this was their first design for Led Zeppelin. The relationship continued for several years (**Presence**, **In Through The Out Door**, and **Coda**) and Po was later helpful in assisting the formation of Page & Plant in the 90s with the film **No Quarter**.*

FREDDIE HUBBARD, Hub-Tones

IT'S OFTEN SAID THAT WE DON'T NOTICE THINGS under our own noses. Genius might exist right in front of us, but we fail to appreciate it, especially at the time. In the jazz era of Jimmy Smith, John Coltrane, and many others, the music reached our ears (and touched our souls), but the covers did not catch our eyes. Yet it's not too late to acknowledge the unremitting brilliance of Reid Miles. If one man were said to have started album cover design, then it was Reid Miles at Blue Note. Along with photographer Francis Wolff, Reid took album art by the scruff of the neck and hauled it from the mediocrity of workaday packaging to new and dizzy heights, to its special and idiosyncratic status. He did this by being continually bold and intuitive, despite his own declared indifference to jazz, preferring instead classical music. He extracted the essence of an album from Blue Note founder Alfred Lion and then worked with just an expressive photograph of the musician and the title of the record. Despite, or perhaps because of, economic constraints, he often worked with black and only one other color. Despite, or because of, the quantity of work, he generally executed it fairly rapidly. Bold but sensitive strokes, large yet appropriate block areas, forceful yet delicate lines dominated his style. Invariably the images were accompanied by an interesting and dynamic use of typography. All of this was woven together with panache and an unerring sense of design, as seen in this *Hub-Tones* cover for the legendary Freddie Hubbard. Repeated vertical bars visible from across the street, black against white, regular except for one depressed bar drawing the eyes down to the title and the small red photograph of the artist – red to counterpoint the black and white – and representing the keys of a piano perhaps, or more suitably the valve of a trumpet. The one bar out of sequence suggests not discord so much as improvisation, it's odd, "jazzy" even. And all so simply done it's amazing. Reid, you were the best, by miles.

james spaulding/herbie han

DUOTONES

Wayne Adams, assistant to Reid Miles: "Often, Blue Note didn't have the budget to do the regular four-color printing on the sleeves. Reid used this constraint in his designs – having just two colors was deliberate for the pureness of the look. Black-and-white session photos would be printed as duotones of black and red or black and blue or whatever, and this splash of color added real depth to the design."

TWO FOUR ONE?

Reid Miles: "It didn't mean you had to have full color – two colors didn't hurt the product at all. The few full color covers I did were not as strong as the ones with black, white, and red."

SPECIFICATION

- *Artiste* Freddie Hubbard
- *Title* Hub-Tones
- *Design* Reid Miles
- *Photography* Francis Wolff
- *Record Co.* Blue Note, 1962

A KIND OF IRISHNESS

Freddie Hubbard: "Frank Wolff would take the pictures at the Blue Note Studio in Englewood, New Jersey. He never asked me to pose – he just took them while I played. Then he'd show me the pictures from the sessions, and we'd decide which we liked. I felt that the theme behind the album was a kind of Irishness, the mechanicalness of Irish dancing, but I couldn't really have an Irishman on the cover, so they put in this little one of me."

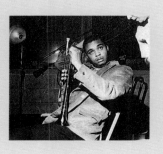

"THERE WAS no standard place for the Blue Note logo to go; no pattern. Reid just worked it in to the cover wherever it suited the design." – assistant Wayne Adams

THE DEPRESSED BAR not only suggests improvisation in terms of the music – that is, not all bits are the same, expect the unexpected – but it also suggests depressing a valve on a trumpet, the instrument that Freddie Hubbard played.

FREDDIE HUBBARD

Born in Indianapolis in 1937, Freddie Hubbard is widely credited as one of the greatest jazz trumpeters of all time. His long and varied career has seen him play with John Coltrane, Sonny Rollins, Ornette Coleman, Art Blakey, Max Roach, and Herbie Hancock, as well as leading his own quintet in the late 60s. Still performing and recording today, Hubbard has played on nearly 60 albums, 20 of which were for Blue Note.

IT'S TIME!
Reid Miles' occasional use of dynamic graphics – bold, repetitive, insistent – is also well displayed on a Jackie McLean album, **It's Time!** *It seems to suggest "what a nerve" – a design consisting of only one element repeated several times, turning it into a pattern or flag. A black flag for Blue Note.*

A BLANK WHITE space would often be left at the top of Reid's design so that when people were going though record bins in the stores, they'd have to stop and pull the record out to see what it was. It was just a way of making people notice the covers. Reid had plenty of tricks up his sleeve to tempt people into buying the record.

A SPECIAL LABEL
Freddie Hubbard feels the covers really helped to sell the Blue Note records. "They were a real special label – everything was done so well, they cared about every aspect of your record, and the covers were very striking and appealing to the average person. Jazz isn't really geared toward sexy covers so you have to come up with something really well-designed in order to get people's attention, and that's what this is. I'm glad people like it, and I'm amazed people still remember it so well."

DAMN FUNKY
The modernity of Reid's design is indicated by its use as a flyer in the 90s by the Jazz Café in Camden, one of London's premier jazz night spots. Imitation as the sincerest form of flattery?

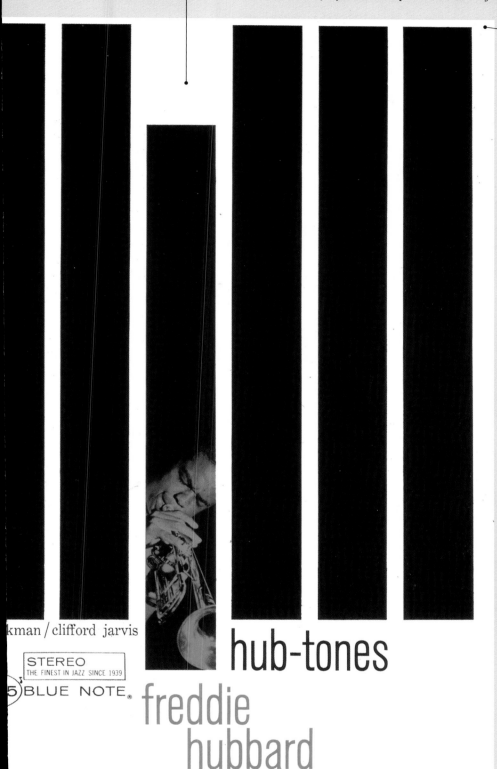

kman / clifford jarvis

STEREO
THE FINEST IN JAZZ SINCE 1939

⑤BLUE NOTE.

hub-tones

freddie hubbard

REID MILES

Born in Chicago on July 4, 1927, Reid Miles turned to design after an unhappy stint in the Navy, where he chauffeured for a captain before being sent to Alaska as punishment for stealing tires. Honorably discharged, he headed for LA and enrolled in the Chouinard Art Institute. He graduated and, armed with his portfolio, he left for New York, where he landed the job of art assistant to designer John Hermansader, whose clients included Blue Note Records. Taken with the innovative designs Reid Miles produced, label bosses Francis Wolff and Alfred Lion offered Miles the Blue Note account in 1956, when he left Hermansader to work for **Esquire** *magazine as a pasteup man. Miles was soon elevated to art director, but the position was short-lived. For nine years, he designed for various agencies and magazines while continuing his Blue Note commissions, having stipulated that he could continue to design for them in every contract he signed. During the next 15 years, he produced nearly 500 sleeves for the Blue Note label. In 1967, he put his faith in his 35mm wide-angle lens and left to become a photographer. By 1971, he was making 25 trips a year between the east and west coasts, and had moved back to LA to set up a studio in Hollywood. His photographs and television commercials for the* **Los Angeles Saturday Evening Post**, **Look**, **Esquire**, *Kelloggs, Honda, Kawasaki, Raleigh, DuPont, Dole, and Polaroid made his reputation as the creator of his own distinctive version of Americana. Reid Miles continued to work until his death in 1993.*

REID MILES WAS EXPERIMENTING with the use of heavy lines, and this cover represents the pure design element of his work. It is simple and effective. He took Francis Wolff's photo of Freddie, put it in a block of lines, and recessed the line that the photo was in, playing with the "horizon" of the design. The line points down to Hubbard's name, and the use of a strong color like red gives further immediacy to the design.

THE ART OF NOISE, In No Sense? Nonsense!

THE COVER DESIGN for *In No Sense? Nonsense!* by The Art of Noise is an odd mixture of awkwardness and elegance, humor, and style. The girl's face is beautiful but distorted. Her expression is cool and aloof, yet she is doing something rather silly and frivolous. The lettering for the band's name is a strange combination of both very small and very large characters, and is positioned perhaps too close for comfort to the girl's forehead. The end result is charming – both fashionable and naive – and like the music, laced with humor. All of this is epitomized by the party noisemaker, an arty image that made noise. The Art of Noise.

QUIRKY
Art director John Pasche wanted something quirky, something sophisticated that related to fashion but with a bit of a twist. There was a lot of humor in the music. The band was much taken with odd sounds. They experimented enthusiastically with the Fairlight sampler and recorded the noises made by objects dropped on the floor. Any interesting results were incorporated into the music in a wry and incongruous way.

FASHION
John Pasche commissioned Alan David-Tu, who had recently arrived in London from Holland, to do the photography. His work was then very fashionable. John saw it as "very impressive; fresh and different, which connected to the fashion element I wanted to bring into the cover."

STRANGE STUFF
"I was doing strange stuff, and John let me get on with it and do my own thing. The shot was based on ideas I was already working on, but was taken specifically for the cover." – Alan David-Tu

MANNEQUIN
The cover image is a manipulated photographic montage of a mannequin, taken with a Linhoff Supertechnica camera. David-Tu's style was to photograph an image, distort it in the printing, then montage the hair on, at the same time cutting it into a particular shape. No computers were used. It was purely montage with photographic and printing techniques.
Alan found a mannequin as a subject, masked off portions of her face and hair, and photographed her. He then cut up the shot, rearranged it and re-photographed it.

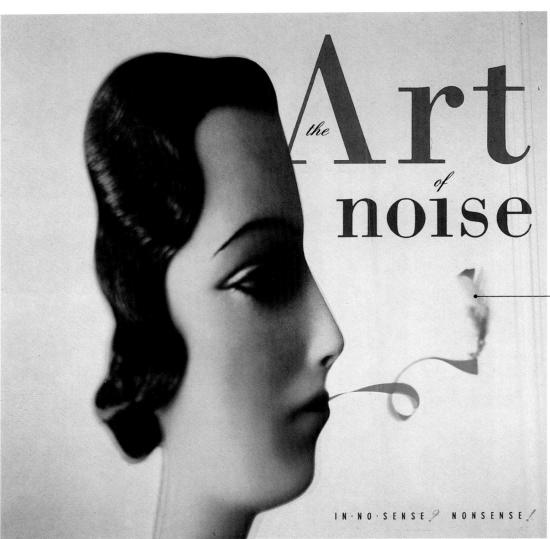

DID YOU KNOW
that *The Art of Noises* was the title of an Italian Futurist manifesto, written by Luigi Russolo in 1913, advocating the use of everyday sounds? The Futurists also pioneered "wild" typography – years before the experiments of the Dada movement.

"THE ONLY thing coming out of her mouth was a piece of colored acetate and a feather made to look like one of those twirly, noisy things you blow at parties. I also experimented with an iron cog-wheel and a trumpet. They were supposed to represent noise – a play on the band's name – and the party popper thing seemed the right kind of twiddly noise." – John Pasche

THE ART OF NOISE LOGO
*Printed on the back cover in a clear spot varnish, the logo was visible only when the light caught it. The logo was designed by John Pasche when the band first signed to Chrysalis, and was used as the basis for the sleeve of the 1986 album **In Visible Silence**.*

JOHN PASCHE
*John Pasche studied at Brighton College of Art, UK, and then the Royal College of Art, gaining an MA in Graphic Design in 1970. In 1971, John designed the famous tongue logo for The Rolling Stones (see page 139). During the 70s he was an art director at Benton and Bowles advertising agency and later for United Artists Records. In the 80s he became creative director for Chrysalis Records and won several **Music Week** awards for his album cover design work. In 1994 he became creative director at the Royal Festival Hall and the Hayward Gallery Design Studio.*

SOPHISTICATED MARKETING
Derek Green, owner of China Records: "We wanted to market the band in a very sophisticated way. They're called The Art of Noise, after all. We were absolutely delighted with the album sleeve."

SPECIFICATION

• *Artiste*	Art of Noise
• *Title*	In No Sense? Nonsense!
• *Art Direction*	John Pasche
• *Typography*	Roland Williams
• *Photography*	Alan David-Tu
• *Record Co.*	China/Chrysalis, 1987

EDWARD VESALA/SOUND & FURY, Invisible Storm

ON THE ONE HAND, the world is rushing by; darkness is descending, fast and furious, spreading across our view from right to left. The sound is humming, whistling, screaming across the darkened countryside; all will be consumed in a blurred range of sound and fury. Soon it will cover the land and all will be blackness! On the other, lighter, hand, this design is simple and elegant, consisting of muted colors, soft defocused streaks running horizontally, steady and regular; the mood is abstract and tranquil, softly heralding the comforting night. Alternatively, this photograph is of passing trees taken from a moving train in the early morning light, an everyday event transformed by its presentation. Whichever way you look at it, this cover design for Edward Vesala is very atmospheric, cleverly using a slight phenomenon to imply something monumental.

Invisible Storm Edward Vesala Sound & Fury

ECM

PHOTOGRAPHER *and designer, Sascha Kleis: "At 16, I wanted to become a musician; and yet I started to collect ECM records, initially not for the music but for the fascinating sleeve designs, which incorporated work of some of my favorite photographers, such as Joel Meyerowitz and Christian Vogt. Before long, though, the sounds inside the sleeves exerted a similar fascination, and my discovery of ECM was complete."*

"IN 1989, at the age of 23, I opened a photographic studio in Wuppertal, Germany. One day I had the spontaneous idea to visit ECM in Munich. I took the train at six o'clock in the morning and brought along my camera and a few pictures to show. Somewhere to the south of Cologne I leaned out of the train window as the sun came up and took some photos with a slow shutter speed – maybe one second – and a wide-angle lens. The film was Ektachrome 100 Plus. I didn't know it then, but my collaboration with ECM was to begin with these images of blurred trees and landscape racing past." – Sascha Kleis

SASCHA KLEIS: *"Music and photography were parallel interests, but after I bought my first camera, the clarinet began to fade into the background. Enthusiasm for ECM remained, and by the time I began to study photography and design some four years later I had the complete collection of the label's releases. I used to call ECM to enquire about forthcoming albums."*

OLD FAVORITE *"I'm told that Edward Vesala was pleased with the cover. It's an album I still like to look at and listen to myself."* – Sascha Kleis

SPECIFICATION

- *Artiste* Edward Vesala/Sound & Fury
- *Title* Invisible Storm
- *Design* Sascha Kleis
- *Photography* Sascha Kleis
- *Record Co.* ECM, 1992

"WHEN PRODUCER MANFRED EICHER was looking for imagery for Finnish drummer Edward Vesala's *Invisible Storm,* he selected this picture and asked me to design the cover. I put the artwork together myself using an Apple Macintosh computer. Although I'm principally a photographer I have designed many covers for ECM." – Sascha Kleis

DESIGN PHILOSOPHY
"Its difficult to put into words the philosophy behind cover design at ECM. When a photograph is used it's with the intention of providing a kind of visual counterpoint to the music, perhaps also connecting in an oblique way with the album title – as I think it does in this case. Photography is never merely 'illustrative' at ECM. The idea is that it should work with the music in some symbiotic manner, yet also be able to stand by itself." – Sascha Kleis

Right: Edward Vesala's **Ode To The Death Of Jazz.** *Design and Photography by Sascha Kleis.*

EDWARD VESALA

progressing ("If we miss this release slot, all our jobs are on the line" – or words to that effect). We would respectfully inform him/her that despite many reminders we were still awaiting "label copy."

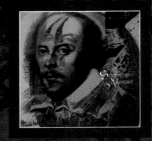

This would comprise a definitive track list with accompanying author, publishing and copyright details, catalog numbers, production credits, lyrics, and the artist's personal thanks to their particular god and a dozen others lower down the evolutionary pecking order. Handwritten pages would begin their trek around the city via a fleet of motorcycle couriers, arriving at our studio just in time for many telephoned corrections to arrive.

Some poor soul would then collate this mess of words and figures into something resembling legible copy, typed, double-spaced, in readiness for the "type markup." Duly smothered in red ballpoint hieroglyphics, the sheets of copy would be photocopied and dispatched by motorcycle to our typesetters. Bit by bit, the "line" artwork would be assembled on board with a combination of scalpel, ruler, and sticky finger.

The'"real" artwork would have been created separately, sometimes over a period of months (sometimes minutes!). Photographs would have been planned and taken, retouched, and assembled, illustrations and graphics prepared and pasted in position.

Many classic album covers of our time were prepared thus – the finished gloss of the Pixies' *Doolittle* (23 Envelope) and DKB's sleeve for Scritti Politti's *Cupid & Psyche 85* were both examples of how this quaint Rube Goldberg system of production turned ugly duckling pasteup into beautifully plumed works of art (We did some nice ones, too).

This was the way things were for the few years following the photolithography revolution. Then another revolution arrived, known as the fax machine. Back in 1987, our typesetter's hopeful suggestion to buy a fax and thereby save a fortune on couriers presented itself as something resembling a choice – how foolish we were to see this unbridled, rampant technology as an option, and not an inevitability.

Then when the budget allowed, we ventured into computer imaging via the high-cost Scitex/Quantel/Crosfield resources of wealthy prepress specialists, while manufacturers were putting computer design on the desktop. Eventually we took the leap and bought…an Apple Mac. Just the one, a tentative step into the new age, which took center stage in our relatively capacious studio, a veritable Captain Kirk's bridge, part microchip genius, part Trojan horse.

Digital typography allowed fonts to be created and played around with in an apparently limitless variety of bug-ugly options – the doors were opened to a new age of accessibility for the designer. We had arrived in a generation where the near-impossible was not just within reach, it was bleeping, flashing, and spewing out colorful hard copies on our own desks like the wish lists of Bell, Waddington, Caxton, Morse, and Disney coming back from Santa with bells on. Now we could take photographs without film and feed the images straight onto our hard drives, scan our butts and our lunch bags, grab video frames, re-invent the creations of great type designers – and, most amazingly, lay some sort of personal claim to the results. We could seamlessly pervert the truth of photography and create

Top left: Pixies Doolittle*, Center left: Scritti Politti* Cupid & Psyche 85*, Bottom left: Carl Cox* Fact
Top right: Diesel Park West Shakespeare Alabama*, Bottom right: Danielle Dax* Tomorrow Never Knows

worlds of unimaginable fantasy. No more the endless corrections and messy artworks of previous days…we entered instead the clean promise of digiland.

The difficulty with this new technology was in exercising the self-discipline to respect the computer as the means of solving visual problems and not to revere the infernal machine as the solution itself.

The enormous contribution made by the developers of creative software in turn dictates style; witness the multi-layered and deconstructed typography of the early 90s, the pseudophotographic *Myst*-style texture mapping, the chrome and blur styling of the jungle era, the kind of illustrated three-dimensional "realism" previously rendered by airbrush and discredited as cheesy, only recently revived by the arrival of the hard-edged PostScript design of the 80s. Every little improvement to a software package would inevitably feed the insatiable desire of the end user, enabling them to exploit each new capability more or less "because they could."

In the way that a computer game system can deprive the player of a true sense of time, creative computer software could diminish the designer's visual integrity; the sheer ability of being able to "do," overshadowing the importance of deciding whether one wants to. "Technique over content," "style over concept." Great self-control was now required to avoid falling foul of the technology trap.

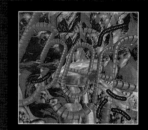

The computer has not replaced the pencil and paper any more than MIDI and the drum machine have replaced the guitar. The computer represents another vehicle for self expression, one which has the ability to turn the most humble mouse-pusher into a new breed of commercial artist while it struggles to convince the canvas-stretching classes of its credibility as a fine art medium. No matter, this is the age where money drives the machine, and if you can combine man and machine with the wind blowing in the right direction, this particular machine can come up with the goods time after time.

On balance, my favorite sleeve designer is one Colin Fulcher, who hid behind the post-Hippie/pre-New Wave nom-de-Punk of Barney Bubbles. The fact that Barney is no longer with us will save him the embarrassment of being labeled one of the godheads of the sleeve-designing fraternity. His designs for artists as idiosyncratic as Ian Dury and Elvis Costello showed his extraordinary capacity to demonstrate personality – his own, certainly, but more importantly, the artists. He knew how to convey both the psychedelic, astral exploration of Hawkwind, and the plaintive urban poetry of Billy Bragg, the gig on two legs. There's not a computer in the world that can do that for you.

To ensure that you don't misunderstand me I'll state here and now: "I LOVE MY COMPUTER." I type letters on it, check the weather and Charlton Athletic's Football Club's League position. I keep a bunch of databases, toy with trial versions of new software, access pictures from Photo CDs, email my otherwise forgotten friends abroad, listen to KCRW live from Santa Monica – oh, and I use it for design. I'm not the Luddite I romantically considered myself to be 15 years ago. The fact is, I think I've got it under control. I think I've got the balance right. I'm long since back from my Apple Mac honeymoon and my relationship with the gray boxes on my desk is something close to healthy. The scalpels, paint, pencils, and paper still have a home in our studio, thereby permitting the hand skills (that also know the pleasure of making a real cup of tea) to continue.

Barney Bubbles died in 1983, the year before the Apple Macintosh was born. Shine on, Barney. Keep the upgrades coming, Apple.

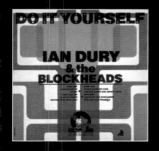

Top left: Xymox. Center left: Elvis Costello & The Attractions Armed Forces (back). Bottom left: Ian Dury & the Blockheads Do It Yourself
Top Right: Intrance Mosquito. Center right: BEF Family Affair. Bottom right: B-Zet Everlasting Pictures

IT'S A BEAUTIFUL DAY, It's A Beautiful Day

RENAISSANCE MAN GEORGE HUNTER – musician, designer, furniture maker – is responsible for this iconic and perfectly appropriate cover design. The picture feels just like the title (which is also the name of the band). The viewer can sense the gentle breeze against the woman's face, the open sky, and the scudding clouds; hear her say so pleasurably to herself: "It's a beautiful day." Even the type style feels sunny, affectionate, like a banner proclaiming again: "What a beautiful day." This image is unashamedly nostalgic, recreated lovingly (and painstakingly) from turn-of-the-century sources, down to the old Columbia logo. Even if one were to question, albeit fleetingly, the use of nostalgia, Americana, or borrowed images, such criticism is blown away by the fresh summer breeze of *It's A Beautiful Day*.

THE LETTERING was done by George Hunter, who borrowed the style from a piece of turn-of-the-century sheet music called "My Daddy Knows," which also had curvy yellow lettering against a dark blue background.

ORIGINS
George Hunter concedes that the cover was inspired by illustrator Maxfield Parrish and Americana. Nevertheless, he says that this cover is a straight appropriation of a cover from a turn-of-the-century housekeeping magazine. George asked local painter Kent Hollister to faithfully reproduce the cover, which he did using acrylic paints on plywood. "It's an exact copy, but we extended the blue sky at the sides to fit in with the square dimensions of an album."

ART PRODUCTION
The finished painting was photographed, and the lettering drawn in pen and ink in black and white. The cream color of the lettering was added in as a tint by the printer.

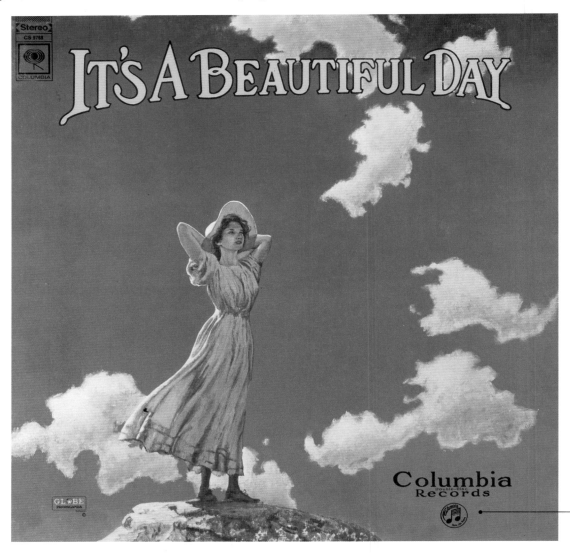

HAPPY TRAILS TO YOU...
Happy Trails by Quicksilver Messenger Service, another San Francisco band, also featured a cover by George Hunter and Globe, with lettering by Kent Hollister. The sleeve featured a Pony Express rider waving "adios" to the girl in her straw hat and white dress.

CALIFORNIA WEATHER
It's A Beautiful Day were one of the leading San Franciscan bands. Their name was inspired by the weather on the day they formed. David LaFlamme recalls that they were "riding around on a sunny day and my wife Linda said 'It's a beautiful day' and right away our manager listed it as a possible name."

POSITIVE EXPRESSION
Band member David LaFlamme says that the album title "spells out the meaning of the cover. It's about freedom, expression. It's very positive, very California. It's about innocent dreaming. The cover stands on its own, and I have to say that it's stronger than the music has been!"

GEORGE HUNTER
Globe Propaganda was a moniker for the design work of George Hunter, the lead singer of fellow Bay Area psychedelic band The Charlatans.

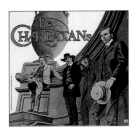

AMERICANA
George Hunter: "The significant thing about this cover is that it is uniquely American. It celebrated Americana at a time when this wasn't yet popular. We were all focused on British rock music then, and most people were just rehashing Beatles, Stones, and Dave Clark Five covers. It's A Beautiful Day celebrated American identity, and it was a driving force of the Americana graphic realm of the early 70s."

THE COVER was required to display the Columbia logo. Hunter used the old Columbia "music note" logo instead. "I didn't want it to look modern – it needed to look old, with a turn-of-the-century feel."

UP FOR AUCTION
The painting was put up for auction by Kent Hollister. George Hunter: "I tried to stop it, because really, it's mine. He'd cut it down to magazine proportions. In the end, Hollister didn't auction it – he left it in a house and the landlord took it in payment for rent."

SPECIFICATION	
• *Artiste*	It's A Beautiful Day
• *Title*	It's A Beautiful Day
• *Design*	George Hunter at Globe Propaganda
• *Record Co.*	Columbia, 1969

SLAMMIN' WATUSIS, Kings Of Noise

SLAMMIN' WATUSIS SOUND WILD ENOUGH to call their album *Kings Of Noise* and then secure a rampaging mishmash of paint, collage, and indefinable junk thrown up by the deranged subconscious mind of art director and designer Steve Byram, probably over a short period high on weird yogurt, coffee, or lack of sleep, furiously ordering the chaos around him into a riot of shape and color, staccato edges, and lots of pointy bits, like the tips of a crazy crown worn, of course, by the King of Noise. Phew!

COLLAGE
"Kings Of Noise was a good title for the music," says Steve Byram. "Lots of loud noise seemed to be a big deal for the band and choosing to do a collage came from that. I was into pre-Renaissance art, which was mostly religious in meaning, and I felt that the piece had the same kind of look, a Biblical image with a vulgar meaning. I wanted it to be an updated version of a religious painting done for a rock 'n' roll cover, as I liked the idea of mixing three vastly different things."

Shades Of Bud Powell, The Herb Robertson Brass Ensemble. Cover by Steve Byram.

SLAMMIN' WATUSIS were familiar with designer Steve Byram's work as a painter and asked him to do the cover art. He was an art director for CBS Records at the time. Byram was given the album's title, and with this in mind he immediately decided on a figure of a king for the main image.

BYRAM WOULD clip words out of newspapers and put them in cups to use at random. Both the teeth and the stream of texture coming out of the mouth were there to represent noise. He was interested to see whether the words had any meaning when put together like this, but there was no *intended* meaning to it.

Sanctified Dreams, Tim Berne. Cover by Steve Byram.

"SLAMMIN'" is just Byram's shaky handwriting. For "Watusis" he cut letter shapes out of paper and pasted them down.

THE CHAIR was made by using a picture of a crowd of people as the back and painting on the legs. The texture of the people makes it look as though the chair has been cut out of the background and folded down. Steve says it's a joke about the space of things – it makes a 2-D image appear 3-D.

THROUGH DESIGNING *for Tim Berne, Steve Byram became involved with Munich-based jazz label JMT. He left CBS/Sony in 1990 to concentrate on his work with JMT artists. He recently established the Screwgun label with Berne and continues to design album covers.*

THE ALBUM TITLE was made by taking old type letters from a book and photo-copying them several times to distress the letter shapes and achieve a rough effect.

MIXED MEDIA
The cover is a combination of collage and painting. Not one to meticulously plan every aspect of a piece, Byram asserts that while working, he tries not to think too much. "I 'do' rather than consider." He worked on the piece in the evenings after work at CBS. It took a week and a half to complete, by which time he says felt utterly deprived of sleep.

SPECIFICATION

- *Artiste* Slammin' Watusis
- *Title* Kings Of Noise
- *Design* Steve Byram
- *Photography* Tony Soluni
- *Record Co.* Epic, 1979

Byram: *"I commissioned myself really, so I also got to OK it. I thought it was pretty good, though the record company didn't think it was commercial enough. But as it was a strong record, I guess they felt they could leave it alone. I consider it one of the smoothest things I've done. It was good to work for a fringe band as there were fewer layers of people to please and I was able to do what I really wanted without being constrained by the marketing men."*

CLOSE SCRUTINY of the painting reveals parts of a Watusis sticker; various scraps of newsprint discussing an artist, his gallery, and Picasso; a loudspeaker cone for the king's neck chain; and scraps of cloth for the king's headgear.

VARIOUS ARTISTS, The Last Testament

WITH A HEAVY HEART and very appropriate timing, this is the last introduction the authors write. The idea of a fish about to be caught – the little fish and the big hand – clearly demonstrates a sense of impending doom. In many walks of life, smaller entities exist at the mercy of larger ones; be it individuals, companies, or even entire nations. The little fish could be swallowed up when the whim or appetite is so inclined. These fateful dynamics are strongly represented in the positioning of elements – the thrusting diagonal hand pursuing its quarry toward the corner. The layout of the design is bold and clear, but the finer details are more ambiguous, as in many of life's processes. Fetish – the little fish – is about to be grabbed by the hand of big business, by conglomerate record companies, robbing it of its soul, its independence, and its very existence. The primitive quality of the artwork echoes the home-grown, free-spirited independence of smaller labels such as Fetish, but, alas, it was to be no more. This is the last record Fetish released: the last testament to a small label, betrayed by greed, circumstance, and inefficiency; subsumed and destroyed by ruthless big business. It is also the last testament to Fetish founder Rob Pearce, who was murdered in Mexico in 1997. This page is dedicated to his memory.

KEEPING THE FAITH
*Neville Brody: "There's a sort of weight implied by the title. **The Last Testament** obviously has religious connotations, and Rob Pearce had a very real belief in the label and faith in the design, and I think, in time, that people will look back on this era of independents, dig out the stuff, and appreciate what was going on."*

THE LAST TESTAMENT
This was the only sleeve that Brody did for the label in full color. "Everything else was done in two colors because of the budget, which forced us to be very creative. Using full color gave the project a sense of completion. There's a sense of calmness – the anger is subdued a little by the color."

THE SCREEN DOT effect was produced by enlarging the drawing of the fish and exposing it on camera using a halftone screen. This image was then enlarged so that what would normally be tiny dots were hugely magnified.

NEVILLE BRODY

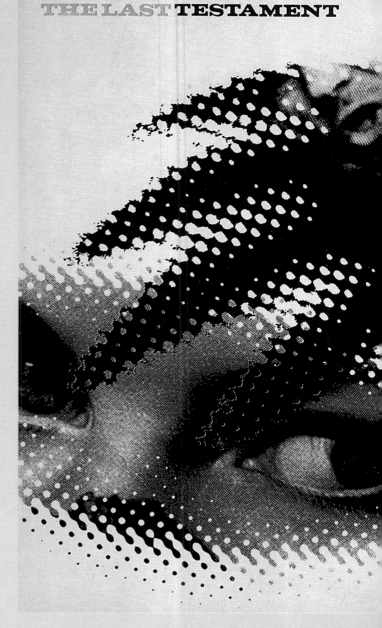

THE LAST TESTAMENT

BRODY SAYS that he was heavily influenced by Russian constructivism at the time, and these characters represented an authority and an anger. They seemed fairly appropriate.

SPECIFICATION

- *Artiste* — Various Artists
- *Title* — The Last Testament
- *Design* — Neville Brody
- *Illustration* — Neville Brody
- *Record Co.* — Fetish, 1983

NEVILLE BRODY
Brody was introduced to London-based independent label, Fetish by 23 Skidoo's singer, Tom Heslop, with whom he was sharing an apartment and a job doing dishes at the Peppermint Park restaurant. Heslop introduced him to the label's founder, Rob Pearce. They got along extremely well, and Brody then produced all of the sleeve designs for his friend's label.

ON CLOSE SCRUTINY, the edges of the fingers become extremely abstract and textural. This is the effect of the halftone screen used with the repro camera.

THE SOLID BAND
above the title was supposed to suggest weight, to represent the weight that had been carried by Fetish Records, trying against all odds to succeed, producing some great music, but in the end, having to go under.

AMENT

A SAD SLEEVE

"It's about the death of the independent record movement, where, for all your innocent enthusiasm, there is little hope. You can be swimming free, but there will always be somebody trying to exploit and control that freedom. This was a sampler album of all the acts that Fetish had worked with and it was the only opportunity I had to use four-color process. Really, it's not even about losing innocence – you're fished out and eaten before you get to that point. It's about the destructiveness of cynicism, but it also reflected the demise of Fetish...." – Neville Brody

OTHER FETISH SLEEVES BY NEVILLE BRODY

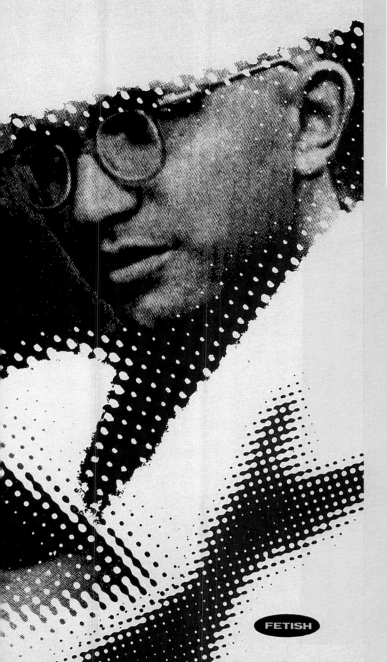

23 SKIDOO
"23 Skidoo was designed in the context of an environment where most design and communication was based around advertising language. Most record companies had pictures of singers on covers with good or bad haircuts. That was the sort of project that didn't interest us, and so this was a reaction against all that. In those days, to do a record cover without putting a picture of the artist on was considered radical and uncommercial, and a major label would never have done something like this. It was about getting in touch with the human spirit, about raw, human power and getting away from the mechanized process." – Neville Brody

CLOCK DVA
Neville Brody: "Most DVA sleeves were paintings that I'd done, so the feeling was very much about being handcrafted, an anti-corporate look. They were a band from Sheffield [England] with a lot of energy, and this was really about innocence, and the loss of it, in a sophisticated and exploitative environment. At the time, a lot of my work (such as the sleeves for Cabaret Voltaire) was about the struggle for identity, and the struggle to maintain a sense of self in a technologically tooled world that is intent on exploiting your interests. That was also very much part of the raison d'être of the musicians." The tribal wood carvings were also done by Brody.

THE FETISH RECORDS LOGO
was designed by Neville Brody specifically for this release. He recalls that "we more or less changed the logo for each record... and that's the difference between a major and an independent label – you can just alter your image whenever you feel like it."

NEVILLE BRODY
*One of the most influential graphic designers of his generation, Neville Brody studied at the London College Of Printing before immersing himself in the early 80s independent music scene as art director for Fetish Records. His innovative styling of **The Face** magazine between 1981 and 1986 and his work for **City Limits** and **Arena** revolutionized magazine graphics. Since establishing Research Studios in 1986, he has produced work for Nike, The Body Shop, BA, Swatch, Sony, Armani, BMW, and United Artists among many others, as well as interactive film sequences for **The Avengers**, **Hackers**, **Heat**, and **Mission Impossible**. Brody is partner and cofounder of Font Shop International in Berlin and FontWorks in London, with whom he launched the experimental type magazine **FUSE**.*

THE COVER ARTWORK was produced on a repro camera, which worked like a photo enlarger by using a powerful light to reflect an image on to a piece of photographic paper. This was repeatedly exposed using different images – in this case, pictures of fish and hands that Brody had drawn by hand.

TROUT TICKLING
Although Neville Brody had never heard of trout tickling and didn't have the fishing technique in mind when he designed the cover, in a way it was trout tickling. The tickle was the financial lure of major label money that enticed independents to sell out, enjoy the brief rush of cash, and then be swallowed up (eaten) by the major label's corporate concerns. We reckon anyway....

THE LAST TESTAMENT

FREDDIE HUBBARD, Liquid Love

LIKE A MERMAID, half-woman and half-fish, this cover was half-in and half-out, not of the water, but of this book. It nearly didn't make it into our selection because back then the record company decided – in their infinite wisdom – that the album required lettering as big as a bus and just as ugly. Purists may disagree with the inclusion, but the luxuriance and the sheer delight of the image saved the day. Like a Busby Berkeley dance routine (it's the forest of limbs that does it), the exuberance makes it work. Serene and exotic, she glides through liquid love, her sunburst hair waving in the dappled waters. The magical mermaid survives despite our technological times and despite the lettering.

ORGANIC PROCESS
The cover idea was Lou Beach's interpretation of **Liquid Love**. *As with so much of his collage work, the images at hand dictated the outcome… it was a very organic process. At the time Beach was also creating fantasy women made up of wildlife and flowers, so the fish motif fitted right into that scheme of things.*
"The meaning is nothing deeper than an attempt to wed the image to the title in a surreal, and hopefully appealing manner."

ART PRODUCTION
Lou Beach: "All the images for the collage came from sources other than my own photography… old books and magazines – the trash heap of disposable printed matter that abounds in our culture. Why these? Why not these? The package was put together in the conventional pasteup method – mechanicals and a transparency. There were no roughs or sketches… straight from the addled brain to the art board."

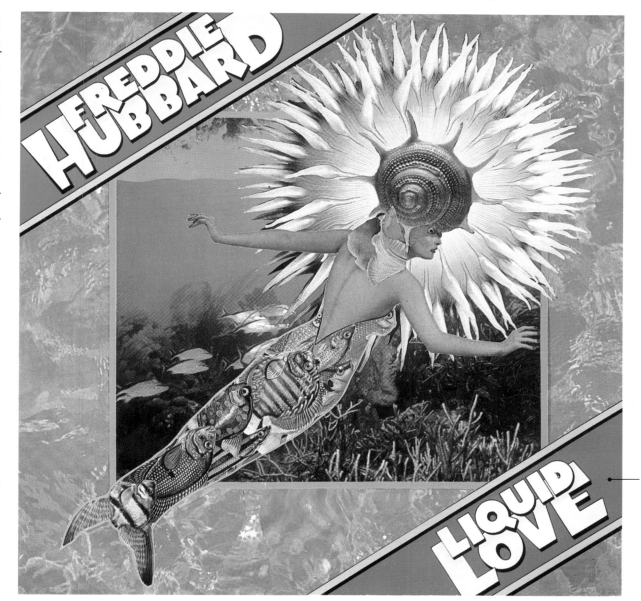

HOW THE JOB CAME ABOUT
Lou Beach: "I believe it might have to do with the fact that I was dating one of the art directors, or perhaps that I was a fresh, new talent at the time."

THE COLLAGE was made from a variety of sources. The head and torso of the mermaid was a turn-of-the-century illustration found in a magazine. Her elaborate headdress is a strange sea shell. Lou Beach gave her a mask "just to add some intrigue to the picture."

THOUGH NOT responsible for the typography, Lou comments: "I don't like the type treatment at all… it is incongruous and overwhelms the sea maiden."

SPECIFICATION

- *Artiste* Freddie Hubbard
- *Title* Liquid Love
- *Design* John Brogna
- *Illustration* Lou Beach
- *Record Co.* CBS, 1975

TECHNIQUE
The collage was produced at Beach's studio, in Culver City, California. Lou Beach: "The difficulties were minor – finding the right images, using sharp blades, and trying not to inhale too much spray adhesive. I guess it worked at the time – it's a very dated image to me – a bit stiff. As I haven't looked at, or thought about, this particular piece in years, I have to think of it in the context of the time it was made. In which case, I think it's a fine image."

DOVER SOUL
Freddie Hubbard says that he loved the cover and found it very striking. "It fitted in with the jazz fusion style that I was experimenting with on the album. It's one of the few fusion covers that really caught your eye. Most people would just have an attractive girl in a bikini, so this was different. The fish and the water thing fitted right in with the title – it wasn't much to do with me, because I'm an Aries, not a Pisces. The figure did remind me very much of my wife, and she was a very lovely lady."

THE COLLAGE KID
Lou Beach is known for his bizarre collages. This is **King Tut At Breakfast**.

THE BEASTIE BOYS, Licensed To Ill

THIS IS A SHOCKING COVER. It penetrates deep into our psyches. In the hectic world of rock 'n' roll the subject of aeronautical mishaps is a particularly taboo subject, and most pop stars take their method of air travel very seriously. Extreme caution is taken in the choice of pilot, plane, or helicopter, and not without good reason. Lynyrd Skynyrd, Ricky Nelson, Buddy Holly, Stevie Ray Vaughan, Otis Redding, and John Denver have all made the obituary pages by way of a plane crash. The glamour of the private tour jet adorned with the band's logo and festooned inside with bars, beds, discos, and obliging hostesses palls once the turbulence gets going. Admit it or not, even for the rest of us humble folk, once the doors of the packed commercial flight close, that "could this be the one?" feeling can sometimes surface. The cover is irreverent, like the image of The Beastie Boys themselves, and because it's a brave, yet dangerous, image to flaunt, it's fascinating. Life's not all "plane" sailing.

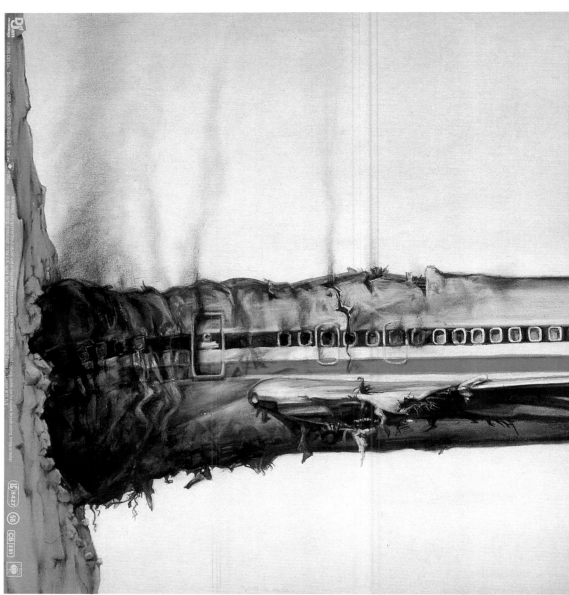

HAMMER OF THE GODS

Rick Rubin, record producer: "At the time, I had just read **Hammer Of The Gods***, a wild biography about* *Led Zeppelin's rock excesses. In the book there is a photograph of the Led Zeppelin private jet and the idea of this cover came from that. The Beastie Boys were just a bunch of little guys and I wanted us to have a Beastie Boys' jet. I wanted to embrace and somehow distinguish, in a sarcastic way, the larger than life rock 'n' roll lifestyle."*

THE STARSHIP

Hammer Of The Gods *author, Stephen Davis: "The Starship was a converted Boeing 720B jetliner owned by the former producer of The Monkees TV show. It had been redesigned as a 40-seat luxury plane, decorated in Las Vegas lounge style with a long bar, video screens, plush chairs, and bedrooms with fake fireplaces, and showers. There was even an organ."*

THE CONCEPT

Steve Byram: "The idea came about when I was flying back from LA with Rick Rubin, producer, unofficial member of The Beasties, and part owner of Def Jam Records. I was an art director at CBS, which distributed Def Jam. I was given the job as I was considered the 'weirdo' in the creative department at that time."

SPECIFICATION

- *Artiste* The Beastie Boys
- *Title* Licensed To Ill
- *Design* Steve Byram
- *Artist* World B. Omes
- *Record Co.* Def Jam, 1986

ART PRODUCTION

For the album cover image Steve Byram contacted an old art school friend called David Gamboli, who goes by the unworldly name of World B. Omes and whose speciality is collage. His technique is making an image from a collage of various photographic elements and then drawing over and hand-coloring with water soluble crayons. He says it makes the image "imperfectly perfect."

REASSEMBLAGE

Dave Gamboli collected piles of photographic images of airplane parts, enlarged them up to the right size, and reassembled them to reconstruct the plane crash. It started off as a black-and-white collage and then he added color on top with semitransparent colors using water-soluble colored crayons.

THE PACKAGE ALSO INCLUDED *a monster 33in x 42in full-color poster of The Beastie Boys showing a plane with their logo taking off over their heads. What is strange is that the poster appears to have been printed back-to-front so that the writing on a T-shirt and milk carton is a mirror-image, although the writing on a ring is not. Was this a clue for working out the back-to-front 3MTA3 on the tail?*

FROM AA TO BB

American Airlines wrote to the record company complaining that they felt the Beastie Boys' plane looked uncannily like one of theirs, but they never took any action.

3MTA3

The plane's identification number on the tail actually reads "Eat Me" if you hold the sleeve up to a mirror.

INSPIRATION

Rick Rubin: "Inspired by Led Zeppelin and their album covers designed by Hipgnosis, I wanted this cover to be a gatefold sleeve. I wanted it to look surrealistic, like a painting, but when you get up close to it you realize it is a collage."

HAVE A NICE TRIP

Rick Rubin wanted to reflect the excesses of the rock 'n' roll lifestyle and the destruction it causes. Hence, the front cover looks safe enough – the tail plane of a luxury executive rock 'n' roll jet – but when the cover is viewed as a whole, we see the plane has crashed into the side of a mountain. There are also some phallic implications. According to Rick Rubin, if you look at the cover sideways it looks like a penis with pubic hair.

THE BEASTIE BOYS LOGO

Stacey Drummond, another art director at CBS, had already designed the band's logo for a 12-inch single. It was supposed to resemble the Harley-Davidson logo.

THE INNER SPREAD

AFTERWORDS

Rick Rubin: "I am very proud of this cover, although I don't think it works as a CD cover. I do remember showing the cover to the band for the first time in a Chinese restaurant in Manhattan, and I got a very mixed response at first."

Steve Byram: "I think it is really cool, and it did realize my intention to reflect the screwed-up persona of the band."

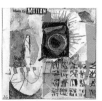

Poinciana by Ahmad Jamal (left) and Monk In Motian by Motian (right). Design and art direction by Steve Byram.

RICK RUBIN

Successful record producer Rick Rubin has worked with such bands as The Red Hot Chili Peppers, Run DMC, AC/DC, and Tom Petty and The Heartbreakers. He was nominated for a Grammy® for Producer of the Year in 1995. In 1996 he produced Unchained, an album for Johnny Cash that won a Grammy® for Best Country Album.

A VIEW TO AN ILL

Steve Byram says that they had to incorporate the irreverent attitude of the band and the title of the album into the design. The title refers to James Bond's "license to kill" and to the word "ill," which means cool. The Beastie Boys were basically licensed to outrage.

STEVE BYRAM

Steve Byram arrived in New York in 1979 with the aim of practicing graphic design in the music business. By the early 80s he was Assistant Art Director at RCA records, then moved to CBS, where he was Art Director for seven years, producing sleeves for Living Colour, Tim Berne, Ahmad Jamal, and Slayer, amongst others. Through designing for Tim Berne he became involved with Munich-based jazz label JMT, and left CBS/Sony in 1990 to concentrate on his work with JMT artists. He recently established the Screwgun label with Berne, and continues to design album covers.

JOHNNY COLES, Little Johnny C

FOR A MAN WITH A DECLARED INDIFFERENCE to jazz music, designer Reid Miles still managed to say a lot about it, and in the simplest and most elegant of ways. The juxtaposed shapes and the improvised typography suggest the genre itself – the improvised and sometimes irregular rhythms of jazz. The big "c" is an enormously enlarged little "c" straight off the typewriter, adopting visually the same procedure as jazz does when it takes a simple melody and expands it through variation. The contours of the "c" are now exposed as an elegant wavy shape on its own, not just a letter. The emphatic playing style of Johnny Coles himself is mirrored in the arrangement of block shapes, sharp corners, and strident colors. The elements are joined together with a sense of humor evident in the photograph of a grinning Johnny Coles. An impish sense of fun, a huge "c" for a little Johnny. A high "c" note for his trumpet, a big "c" note for under his hat band.

WAYNE ADAMS, Reid Miles' assistant: "This is a very pure design; taking the 'C' of the artists name and the title and enlarging it. The leading has also been manipulated; it's obviously a lot less than it normally would be. The 'e' and the 'y' are lined up so that the text becomes part of the whole design."

TYPOGRAPHY
Reid Miles: "I think typography in the early 50s was in a renaissance period anyway. It happened especially on album covers because they were not so restrictive as advertising."

THE ENORMOUS C is a typewriter "c" that Reid Miles copied and blew up in size so that the character came into its own and showed all the shapes and irregularities only visible at that size.

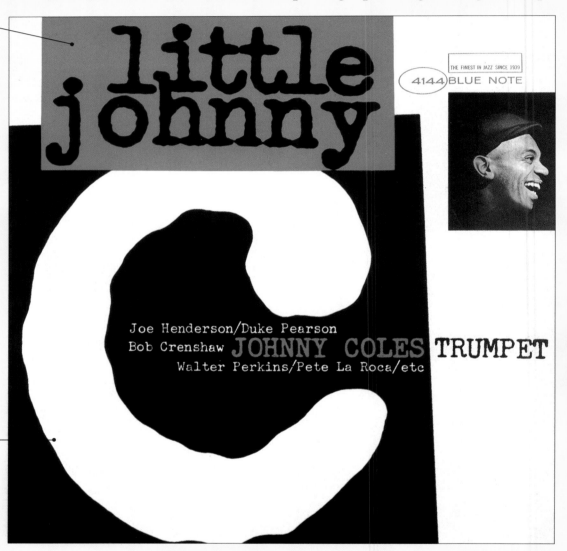

REID MILES: "I would say that ninety percent of Frank Wolff's photos were taken at the recording sessions. I got the pictures from him and I integrated them with the design of the moment." Blue Note founder Alfred Lion: "Frank tried to get the artist's real expression … the way he stood. Reid was more avant-garde and chic but the two together worked beautifully."

REID MILES ON PHOTOGRAPHY:
"You can't just photograph garbage without restyling it. I think any designer, illustrator, or first-rate photographer knows this. That's a matter of design, control, playing one shape against the other. But how many guys know that? Ten guys in the country realize how important that is."

PURE TRUTH
There was a lot of truth and simplicity in Miles' work. The music came through in the design, even though he didn't like the music himself.

BIG C, LITTLE C, AND TOP C
Reid Miles would often mix giant and small typefaces. He had fun with the entire design – even though he didn't like jazz. It was almost as if he were playing with those irregular jazz rhythms and beats, bringing them into his design work for Blue Note.

JUST MY TYPE
Wayne Adams, assistant to Reid Miles: "Reid loved to play with type – he felt it was as important to design as the image itself. He saw type as absolutely a part of the complete image rather than an afterthought."

JOHNNY COLES
Born in 1926 in New Jersey, self-taught trumpeter and aficionado of the Hard Bop style Johnny Coles was one of the unsung heroes of jazz. Though fame in his own right eluded him, his distinctive, emphatic style led him to play with John Coltrane, James Moody, The Gil Evans Orchestra, Art Blakey, Charlie Mingus, Duke Pearson, Ray Charles, and Duke Ellington. Johnny Coles died in 1996.

SPECIFICATION

•Artiste	Johnny Coles
•Title	Little Johnny C
•Design	Reid Miles
•Photography	Francis Wolff
•Record Co.	Blue Note, 1963

JOE JACKSON, Look Sharp!

LOOK SHARP IN A SHARP-LOOKING COVER. Look sharp in a natty pair of pointed white shoes. This arresting image for Joe Jackson's debut album just goes to show that the old adage – you can tell a man by his shoes – was still appropriate then, if not today. One might have expected Joe's face to be on the cover, but nobody expected him to make a statement with his shoes alone. As art director Mike Ross puts it: "Those shoes in that shaft of light say more about Joe Jackson than a picture of his face could ever say."

THE PHOTO SESSION
Mike Ross: "The photo session took place on the morning of Monday, November 20, 1978, at the South Bank in London. It was a low-key, low-budget affair. By chance we came across a pointed shaft of light, and with Joe standing in position it made it look as though the shoes themselves were the light source." Brian Griffin: "I only had a 35mm camera back then (an Olympus) and I used black-and-white Ilford film."

PHOTOGRAPHER Brian Griffin described the shaft of light as "a spiritual force, like those religious paintings with the heavenly lights. When we came around the corner and saw this shaft of light I just pointed the camera down at Joe's shoes. It was a rare and magical moment."

THREE'S A CROWD
Mike Ross: "The US single sleeve for 'Is She Really Going Out With Him?' borrowed Joe's shoes and recreated the shot to include a pair of girl's shoes standing next to a pair of extremely scruffy suede boots. My reaction was of horror – good grief, how could you? – but I guess it was a compliment."

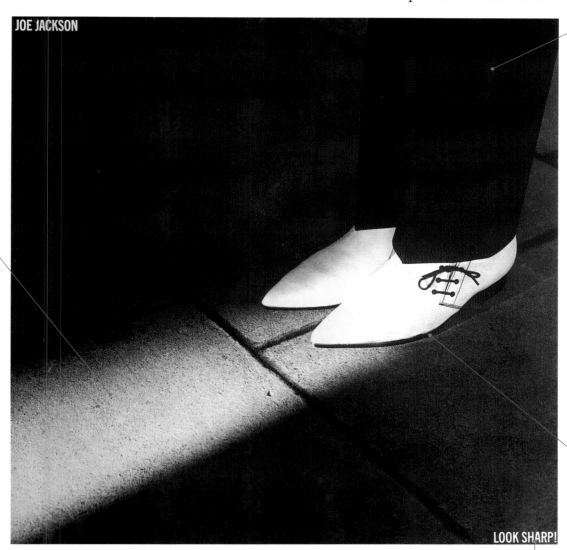

JOE JACKSON took himself fairly seriously back then. He had sharp creases in tapered black trousers, a pin-stripe jacket, and a black-and-white polka dot tie — the "spiv look."

THE WHITE SHOES
Joe Jackson: "I'd just bought these white shoes. At the time I wanted everything to be in black and white. Anyway, it was Brian Griffin's idea to take a picture of the shoes. I think my first reaction was 'You must be joking', closely followed by 'Oh, all right then, what the hell!' I'm not sure if I ever particularly liked the cover or thought that it represented the music. It's hard to be objective about these things. You make a record and you put it out and then it's like a teenager leaving home – it has to make it's own way in the world and it belongs to everyone."

"THE ERA was Post-Punk New Wave. I remember Joe saying he was excited about his Denson shoes and wanted to wear them for the photo session." – Mike Ross

MICHAEL ROSS

Mike Ross was born in Galashiels, Scotland, and studied graphic design at Kingston College of Art. He was art director at A&M Records from 1977 to 1986 in London, where he subsequently became director of visual arts with additional responsibilities for music videos and commercials. Joe Jackson's Look Sharp! was nominated for the highly prestigious Grammy® Award for Best Album Package. Ross now directs music videos, commercials, and corporate films, and has worked on a variety of design projects, including album sleeves for clients such as Elton John, Sting, Bob Geldof, Paul McCartney, and Kiri te Kanawa.

THERE WAS disagreement about the size of the type. The record company wanted it a bit larger – but Mike Ross (A&M's art director at the time) had learned to anticipate that sort of response from record companies and had deliberately made it smaller than he thought he would get away with, to allow for a little enlargement.

A SHARP PAIR OF ASHTRAYS

SPECIFICATION
- *Artiste* **Joe Jackson**
- *Title* **Look Sharp!**
- *Design* **Michael Ross**
- *Photography* **Brian Griffin**
- *Record Co.* **A&M, 1979**

THE CLASH, London Calling

BY 1979 THE CLASH were already established as one of the most talented and politically outspoken groups to emerge from the London Punk scene. However, following a lucrative recording contract, they began to face accusations from hard-core fans of "selling out." Their third album was originally called *The New Testament*, but was changed to *London Calling* amid fears of being labeled pretentious. The Clash's consistent punk attitudes are well illustrated by their album cover. They seemingly satirized one of rock's most revered images – Elvis Presley's first LP sleeve. However, it turned out that it was actually an homage to the unknown graphic pioneer who had created an immortal cover for The King. Who said pink and green should never be seen?

THE 1979 CLASH US TOUR
Pennie Smith and Ray Lowry accompanied The Clash on their tour of the United States in 1979 as house photographer and illustrator respectively. "The Clash were a law unto themselves and always encouraged other talents," declared Smith.

PINK AND GREEN LETTERING
Ray Lowry: "The first rock 'n' roll graphic image that I remember is the strange potency of the pink and green lettering and the sheer vibrancy of the Elvis picture. The Beatles made no secret of the sources of their inspiration, so that it was easy to see the flame being carried through and beyond the hippie daze. The Sex Pistols and The Clash were the first bands that I saw in the 70s who embodied and communicated a similar level of raw excitement."

COLONEL TOM PARKER – ART DIRECTOR?
The cover photo for Elvis' first album was taken by William S. Randolph (aka Popsie) during a performance in Tampa, Florida, in July 1955. It was supplied to RCA Records by Elvis' manager, Colonel Tom Parker. According to Todd Morgan, director of communications at Graceland, that was the Colonel's usual modus operandi. "Colonel Parker would generally provide a photograph to RCA Records – for a fee, of course – and be acknowledged as the album cover art director."

HOUND DOGGED
"The sleeve has dogged me ever since, with most informed observers understanding that it was intended as a genuine homage to the original, unknown, inspired genius who created Elvis Presley's first rock 'n' roll record and that it was not a calculated rip-off."
– Ray Lowry

RETURN TO SENDER
Ray Lowry: "The obvious thing to do seemed to be to bring it all back home and make plain the obvious sources of all our insanities by dovetailing it into the grand design. I had picked up a battered old copy of Elvis's album in Chicago and I did a couple of roughs in various hotel rooms before doing the finished artwork for the lettering in the CBS Records' art department in Los Angeles. I finished the artwork and the back sleeve (which is a bit of a mess, frankly) at the CBS Records' art department in London, where the staff were aloof, listened to Radio One all day, and were designing a Shakin' Stevens' album cover at the time. No secret about their priorities there."

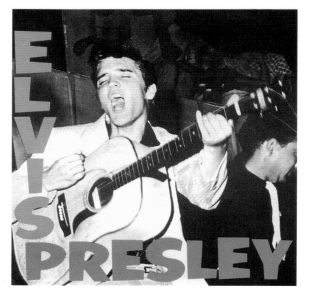

SPECIFICATION

• *Artiste*	The Clash
• *Title*	London Calling
• *Design*	Ray Lowry
• *Photography*	Pennie Smith
• *Record Co.*	CBS, 1979

SPECIFICATION

• *Artiste*	Elvis Presley
• *Title*	Elvis Presley
• *Art Director*	Colonel Tom Parker
• *Photography*	Popsie
• *Record Co.*	RCA, 1956

"**THE SHOW** had gone quite well that night, but for me, inside, it just wasn't working well, so I took it out on the bass. If I'd been really smart I would have got the spare bass out, as it wasn't as good as the one I smashed up. When I look at it now I wish I'd lifted my face up a bit more." – Paul Simonon

NO PRESENT LIKE THE TIME
When Paul Simonon smashed his bass guitar he also smashed his watch by accident. Afterward, he gave it to Pennie Smith as a keepsake.

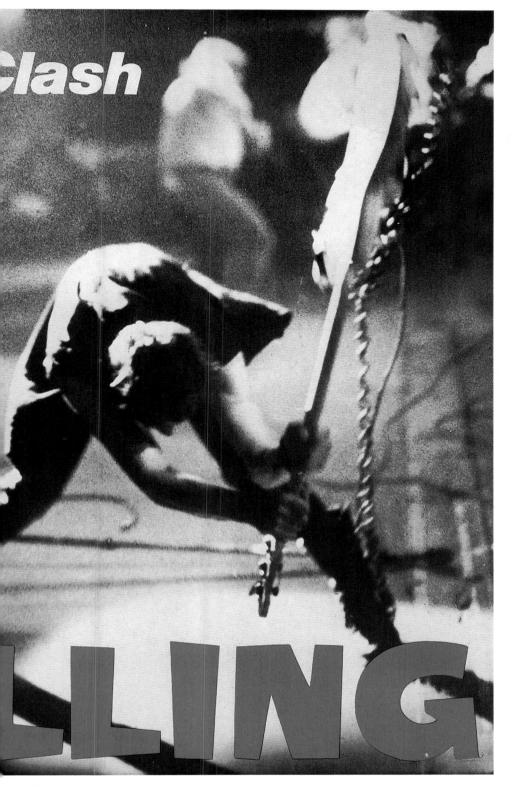

THE CLASH
1977

GIVE 'EM ENOUGH ROPE
1978

CITY ROCKERS
*The Clash got together in 1976 while living in a squat in Shepherd's Bush, London. Originally titled **The New Testament**, London Calling, reached number 11 in the UK charts.*

BACK COVER
*Ray Lowry thinks that the back cover of **London Calling** "is a bit of a mess, really."*

RAY LOWRY

*Ray Lowry began working as a cartoonist and illustrator in the late 60s, contributing to such publications as the **International Times** and **Oz** magazine. In the early 70s he began a long association with the music press, most notably the **New Musical Express**, where he worked as a cartoonist and illustrator for most of the 70s and 80s. The occasional record review led to a two year link with **The Face** as a columnist. In 1979 he was invited to accompany The Clash on their groundbreaking tour of the United States, illustrating the band's progress and sending visual reports back to the **NME**. Lowry then worked for a short time with grunge rock band Gaye Bikers On Acid, putting together a promotional film for their album. Lowry continues to produce cartoons and illustrations for **Punch**, **Private Eye**, **Time Out**, **The Observer**, **The Guardian**, **The Independent**, **Mojo**, and many other publications. He had two collections of drawings published – **Only Rock and Roll** and **Space To Let**. A forthcoming publication is entitled **Ray Lowry – Ink**. He recently illustrated **A Riot Of Our Own**, an account of the rise of The Clash.*

PENNIE SMITH wasn't technically prepared for Paul Simonon being so close to her when she took the shot. She still had a wide-angle lens on her camera – hence the photograph wasn't completely sharp. Pennie shot the photograph on a Pentax ESII and she used TR1X 400 ASA film pushed to 1600 ASA.

BLURRED VISION
Because the photograph was out of focus, Pennie tried to talk the band out of using it but they were quite adamant that it was the shot they wanted for their front cover.

PENNIE SMITH

*Pennie Smith was born in West London and studied graphic design and fine arts at Twickenham School of Art. After graduating from art school she set up her own studio in a disused railway station in West London. Her first, and nonpaying, job was for **Frendz** magazine, where art director Barney Bubbles persuaded her to take up photography. Having learned her craft and photographed many bands for **Frendz** she moved on to **NME** in the early 70s, where she photographed the majority of covers from 1975 until 1982. She left **NME** when the format changed to color and published a book of her photographs of The Clash entitled **Before & After**. She has since worked on band tours, album covers, books, and magazine features. Pennie Smith continues to work freelance and specializes in black-and-white reportage photography.*

DESIGN TREATMENT
*Elvis' album covers never really improved after that classic first album. Further albums sported mundane sleeves, usually with "pin-up" pictures of Elvis and some rather crude lettering. It's safe to say that for most of his career, apart from **Elvis Presley**, he never had a decent cover on any of his records. Not until **Elvis 56** was released in 1996 did the King begin to get the design treatment he deserved.*

HEIDI BERRY, Love

LIKE THE ELEGANT SIGNATURE from the pen of a great writer or philosopher, it is the calligraphy that draws one into this cover design for Heidi Berry. The flourish of the angled strokes coupled with filigree side-swishes and blotterlike patches give the impression of both class and passion, beauty and craft. The stamp of authority is sustained by the metallic coloring of gold and brass. The overall style, however, is unmistakenly modern, as in the solarized folds of material below and the unexpectedly bright colors of the insets. A cool, semimetallic exterior (the cover) concealing a hot, organic interior (the liner bag). A hard, unforgiving outside, a soft, enveloping inside. A more durable, truer love perhaps.

THE GOLD sheen was a fifth color added to the four process colors to soften the cover and to pull together and enhance the individual images.

EXECUTED BY Chris Bigg, the calligraphic scribbles in the top panel were a reaction to the jacket – Chris wanted to express a knotted-up intensity through very expressive calligraphy. He used black Quink ink and splashed it with household bleach.

KEVIN WESTENBERG was experimenting with photographic techniques and hit on the idea of placing the flowers in what he calls a "glass sandwich." He placed flowers with colored oils and gels between three panes of glass, lighting the ensemble at five different angles and trying to make sure that the petals didn't get totally squashed as the oil and gel sluiced around and the lights heated it all up. Some flowers were out of focus in the background, others were very sharp.

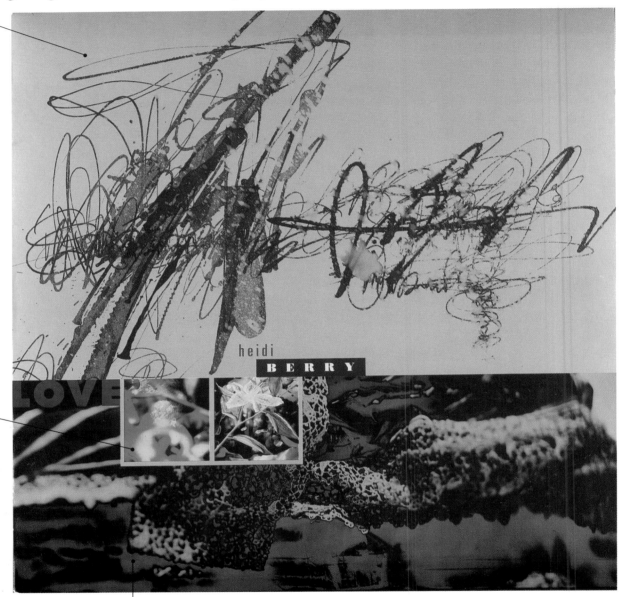

THE BOTTOM PANEL is a sideways close-up of the jacket, which Kevin Westenberg subjected to a process called solarization, in which negatives are prematurely exposed to light so that light areas become dark and vice versa.

SPECIFICATION

- *Artiste* Heidi Berry
- *Title* Love
- *Design* Vaughan Oliver and Chris Bigg at V23
- *Photography* Kevin Westenberg
- *Record Co.* 4AD, 1991

HEIDI BERRY
While Westenberg was photographing the flowers, Heidi Berry came into the studio. He photographed her in black and white because it went well with the highly colored cover.

SIMPLE BRIEF
Vaughan Oliver was given a very straightforward brief by Heidi Berry: "Listen to the music, and use flowers and my father's Victorian jacket." As an ex-art teacher, Berry had a good visual awareness. Vaughan felt that she wanted the jacket on her cover for purely sentimental reasons.

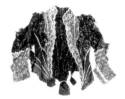

LILY THE PINK
Referring to "Lily," one of the album's songs, the flowers were a passionate reaction to the somber browns and greens of the Victorian jacket. The pockets of color seem to echo the intensity of the music.

THE TYPEFACES on the front cover are Bodoni and Univers Condensed, chosen, say the designers, because of the juxtaposition between the moods and differing extremes of serif and sans-serif type.

THE COMPLETE PACKAGE
Bigg and Oliver hoped that their design made the album a nice, pleasurable object to hold. It's a complete package that continues on to the back and the inner cover – a flower-smothered, hot-pink-dominated glass sandwich shot that reveals itself in an almost sexual way when you remove the record. It's very sensual.

PRINCE, Lovesexy

WHEN JEAN-BAPTISTE MONDINO began the *Lovesexy* photo session he must have thought that he was dealing with a case of "the emperor's new clothes." Circumstance had not permitted him and his client to discuss how intimate the pictures were going to be. When Prince arrived there was some confusion over whether he was to pose nude for the portrait because the studio contained a wardrobe full of costumes for him to wear. The question was finally resolved, and the result is a very daring and sensuous portrait. The pose is feminine, yet the flower stamen suggests ideas of ambiguous sexuality. Was it all just a case of barefaced chic?

THE COMMISSION
When Mondino was staying at Prince's Paisley Park studios in Minneapolis while working on a video project, Prince asked him if he was still taking photographs and would he be interested in doing the cover.

TANTRIC SEX
Lovesexy was already the name of the album when Prince commissioned Mondino to photograph the cover. Mondino felt the title reflected Prince's spirituality, as well as his lyrics about love and sex. *Lovesexy* also feels like a Tantric word, and Mondino wanted the stamen of one of the flowers to represent a small phallus.

OFF OR ON?
Prince wanted the photographs taken in Los Angeles and told Jean-Baptiste Mondino that they could discuss ideas on the flight. Unfortunately, Mondino was unable to get a seat on the plane next to Prince, so they were unable to discuss anything. The next morning (the day of the photoshoot) Mondino suggested to Prince that he would like to shoot him naked.

JEAN-BAPTISTE MONDINO
The French fashion photographer and video director Jean-Baptiste Mondino is best known for his graphically composed, color-saturated images. His photographs are renowned for their subversive and sexual imagery. He has directed videos for artistes such as Madonna, Neneh Cherry, and Björk.

PHOTOGRAPHY
Mondino shot one roll of Kodak Ektachrome film using a Hasselblad camera. Later that day he met Prince at his hotel and showed him the contact sheets. Prince chose one shot for the album cover and the rest were destroyed.

SPECIFICATION
- *Artiste* Prince
- *Title* Lovesexy
- *Photography* Jean-Baptiste Mondino
- *Typography* Margo Chase
- *Record Co.* Paisley Park, 1988

STRANGE SPELLING
Before he gave up his original name and became simply ♀, Prince's love of unconventional spelling was evident on **Lovesexy**, *with titles such as "When 2 R In Love," "I Wish U Heaven" and the one below:*

THE QUANTEL PAINT BOX
At the time of this album digital paint boxes were still a thing of the future. None existed in the US, so Mondino flew to Paris where his friend Kiki had a demonstration model. Mondino played around with the photograph for a couple of days, and when he was satisfied he called Prince, who flew over to Paris with his bodyguard. They all sat squashed into Kiki's tiny kitchen, with Kiki's kids playing around them, and examined the cover. Prince's initial response was that he didn't like it. For two hours they played around with it some more until Prince concluded that he preferred what he had seen at the beginning.

LOVESEXY

BRUNO WALTER, Mahler – Symphony No. 9

DIVERSE elements are drawn together here by the adroit use of perspective lines and the monochrome color. This combination provides for a harmonizing of the more conceptual concerns in Mahler's music with the more humanitarian. Mahler was obsessed with both form and technique, with complexity and juxtaposition, but also with the ordinary emotional preoccupations of life, and with simple and evocative melodies from Austrian folk songs. He was known as an avant-garde composer and the last great Romantic symphonist, bridging the gap between the old and the new, composing on a grand scale but expressing universal truths.

FOLK SONGS
Some of the main sources of inspiration for Mahler's orchestral work were the simple folk melodies of the Austrian countryside, represented here by the mountains and the glacial lakes in the landscape.

THE BLACK-coated figure is a smiling symbol of death. At the time the ninth symphony was composed, Mahler was suffering from a prolonged heart condition and knew that he was going to die.

THE DESIGNER
John Berg: "When I was art director at CBS James Cook was an in-house junior designer. He was from Canada and was influenced by Norman Seef, with whom he shared an office."

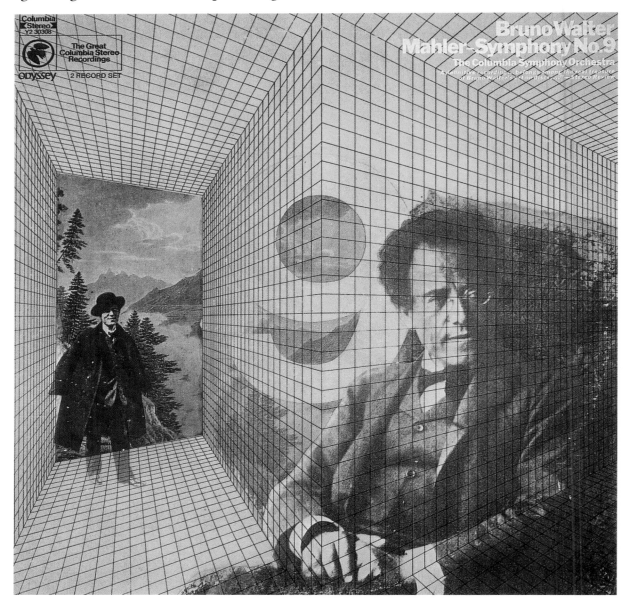

THE GEOMETRIC
background may refer to the complex musical structures of this symphony including extreme chromatisation, polyphony, juxtaposition of major and minor, recurring crescendos, and complex solo instrumentation.

THE NUMERAL
nine obviously, refers to the number of the symphony, but the work was originally published as the Tenth Symphony, due to a super-stition among classical com-posers for avoiding ninth symphonies. The ninth was the last work of several great composers, and like the 13th floor in a building, they came to be seen as a sign of impending death.

ANOTHER SOURCE of inspiration to the designer was the complex structure of Mahler's music, represented here by the geometric design and its corridor connecting the contemplative seated figure of Mahler with the doorway into the landscape.

SPECIFICATION

- *Artiste* The Columbia Symphony Orchestra conducted by Bruno Walter
- *Title* Mahler – Symphony No. 9
- *Design* James Cook
- *Record Co.* Columbia/Odyssey, 1978

GUSTAV MAHLER

Born in 1860, Austrian composer and conductor Gustav Mahler was the son of a Jewish shopkeeper. He later converted to Catholicism, but suffered anti-Semitism during his career. Educated at the Vienna Conservatoire, he was very talented as a child, but various intrigues led to resignations during his later career. His symphonies four to eight were written in Vienna; the rest were composed during summers in a villa in the Worthersee in the beautiful province of Carinthia. In 1907 he went to America, but shortly afterward returned to Vienna and died in 1911 from pneumonia and blood infection. During his lifetime his symphonies were sometimes criticised in the press as "too long, too loud, and too discordant." It is also said that he brought the Romantic era to a "culmination by virtue of the expansiveness of his emotional expression and the grandiose design of his musical structures."

KAZUMI & THE GENTLE THOUGHTS, Mermaid Boulevard

DURING THE TECHNOLOGICAL AND ECONOMIC growth experienced by Japan in the 70s, western culture was being imported at an alarming rate. Japanese youth wanted to break free from the constraints of a formal society and could finally afford to do so. This cover demonstrates the traditional, minimalist approach influenced by Japan's exposure to modern American painting. Pop Artists such as Andy Warhol, Claes Oldenberg, and Roy Lichtenstein had been respectively utilizing Campbell's soup cans, inflatable doughnuts, and comic strips in bold, bright shapes and colors, and had found a place in eastern culture. This painting is a mixture of both styles – the old and the new – Japanese tradition with a liberal splash of American Pop Art – all neatly contained in a box.

KOICHI SATO

*Koichi Sato was born in Takasaki in the Gunma Prefecture in August 1944. He graduated from Tokyo National University of Fine Arts and Music. In 1986 he held his one-man exhibition, **About Box-2**, at the Ginza Graphic Gallery. Since then his posters have been in most of the great museums around the world. He has won many prestigious awards and is director of the Japanese Graphic Designers Association. He is also a professor at the Tama Art University.*

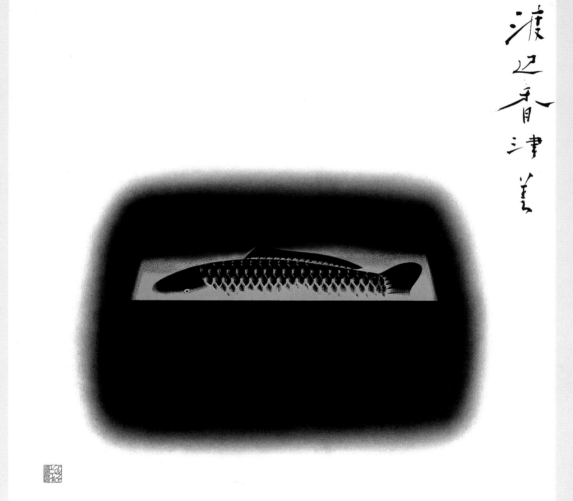

PAINTING STYLE
Koichi Sato: "This picture is one of my best works. At the time I was going through many changes. I had started my own design company. I got married, I was becoming 'westernized' – this influence was particularly prevalent in Japan in the 70s and I was wondering if I could paint in the style of western Pop Art. My mentor was Tadanori Yokoo (see pp.20–21). In the end I discovered that I was most interested in my own traditional culture and began to paint Japanese objects such as green tea, or rice, or soybeans – but in my own style."

POSTER
After Koichi Sato had painted the picture he was asked to make it into a poster for a music festival. He hand-printed it by silk-screen. Later on, it was chosen as one of the top 100 Japanese posters and was reprinted by traditional offset litho.

EKIBEN
Japanese fast-food lunch boxes (ekiben), are sold at train stations throughout Japan and have become an art form in themselves. Each station will often feature its own unique box.

ALL DRAWN TO SCALE
"I was young and unknown when I painted this picture. I was trying to find my own style. I started out by painting simple box shapes and tried to create two- and three-dimensional images on flat canvas. I put water in the boxes and tilted them to make interesting tonal graduations and perspectives. These experiments made me study Japanese traditional skills very carefully, such as calligraphy, flower arranging, and scroll painting. One day I heard that the ex-Japanese Prime Minister Tanaka had carp in his pond at home. I couldn't get this out of my brain for some reason. So, I bought a carp and put it in one of my boxes. I wanted to paint the carp traditionally like Hokusai, but I couldn't get the scales right. I placed a piece of paper and cut it out in the shape of the carp and stuck it directly on the canvas over my first attempt. If you peel back the paper from the painting you can see the original underneath. I then painted the fish my own way, and I was pleased" – Koichi Sato

SPECIFICATION
• Artiste	Kazumi & The Gentle Thoughts
• Title	Mermaid Boulevard
• Art Direction	Aijiro Wakita
• Illustration	Koichi Sato
• Photography	Hiroshi Seo
• Record Co.	Alfa, 1978

Richard Evans

BOX SETS... WITH ALBUMS TOO!

Now before we go any further with this, I'd like to say that I've always thought the correct term should be "boxed set." It's a boxed set of albums, after all, isn't it? But it's a bit late in the day for that. Like trying to explain to someone that 2000 really is the last year of the 20th century, and not the first of the next. But "box set" it is and "boxed sets" is what they will always be. Well, they certainly started out that way. But in today's box sets you can expect to find more than just a set of albums in a box. They quite often come with the customary full-color book, telling you more than you've ever wanted to know about your musical heroes, and every marketing device known to man, including peel-off stickers, decals, T-shirts, badges, photographs, doodads of all shapes and kinds and, of course, the obligatory bonus CD with unreleased, unrehearsed, and sometimes under-par tracks, hoping to entice punters to shell out anything from $30 to $300. A couple of years ago, a big fish in one of the major labels in Los Angeles said to me, "You know, with a huge back-catalog such as we have, we're basically a repackaging company these days."

What he meant was that with the birth of the compact disc, a whole new market had opened up. If, like me, you had been buying LPs since you were a pimply teenager, by the time you got to my age you could well have a sizeable vinyl collection. (Unless, of course you'd sold it along the way to buy a secondhand VW Bug or that long-promised hippie trip to Rishikesh). Either way, people began to replace their scratchy old albums with new, digitally remixed, and digitally remastered CDs. And so the "replacement buyer" market came into being, and the record-buying age group stretched overnight from "teens to thirties" to "forties and fifties" and even older. Established record companies such as EMI, Polygram, RCA, Warner Bros., Capitol, and MCA realized they were sitting on gold mines. And once they had re-released all their classic back-catalogues on CD, the public still craved more. Enter the box set.

The box set started life as a grand overview of an artiste's work. Those who didn't want to buy all the individual albums could buy the box set and have an artiste's career skimmed down to a mere four or so CDs. Forget all the bum songs and the filler tracks. What you got was five hours of wall-to-wall quality material with, perhaps, the odd previously unreleased track or three thrown in for curiosity value.

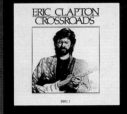

Of course, there had been box sets back in the 60s. Usually they were confined to the classical market, from companies such as Deutsche Grammophon, where you might find a triple-album set of, say, Smetana's *Mà Vlast* or Bach's *St. Matthew Passion* in a big square box with full libretto but not much else. The first genuine rock 'n' roll box set that I can remember was in 1970 – George Harrison's *All Things Must Pass*. Modest by today's standards, it's true, but you did get three albums of brand-new material, special liner bags with all the lyrics, and a BIG poster of George in his wellington boots. But after that, box sets pretty much died out until 1986, when Columbia released the four CD/cassette/vinyl set of *Bruce Springsteen & The E Street Band Live*, followed by Polydor with Eric Clapton's *Crossroads* box set in 1988. All things certainly did pass, and today the box set is a natural progression in any artiste's career. The choice of material is vast and the packaging is exciting, varied, and innovative.

The temptation to disguise the box and make it something else, for example, has always been very strong and has produced some real gems over the years. One of the best of this genre was also one of the first. Jeff Beck's *Beckology* box set not only looked just like Jeff's old battered guitar case, but when you opened it up there was his red Strat lying on the cover of the booklet. And best of all was the inside of the box lid, printed to look just like red crushed velvet, with the impression of the guitar strings in the cloth – just as they should be.

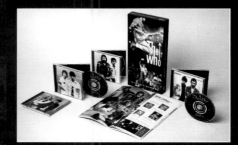

Top left: *Boston Symphony Orchestra, Smetana: Mà Vlast, Center left: Bruce Springsteen & The E Street Band Live.*
Bottom left (both): *Jeff Beck Beckology Top Right: Eric Clapton Crossroads, Top center right: Miles Davis & Gil Evans The Complete Columbia Studio Recordings.*
Bottom center right: *Led Zeppelin The Complete Studio Recordings, Bottom right: The Who Thirty Years Of Maximum R & B*

The Who were always known for their strong visual appeal, and over the years a huge fan-base evolved which collected and traded items of Who memorabilia and Who bric-a-brac. When I set out to design *The Who: Thirty Years Of Maximum R&B*, my intention was to create a treasure trove of Who material — a 30-year celebration of the band, an exhibition in a box, if you like. I wanted fans to open the box and wade deep in the stuff we'd dug up for them, to wallow in the newspaper cuttings, old badges, T-shirts, engagement calendars, backstage passes, unpublished photographs, and bits of gossip. If you weren't there the first time around, well, you could be now. Inside the lid was a montage of ads from their early days to the present. The booklet cover was a HiWatt amp, torn, battered, and still smoldering as if Townshend had left the stage only moments before. And the band themselves were seen at their best, and at their worst, in true Who style.

Similarly with *The Doors Box Set*, my aim was to invite the fan to be a part of The Doors' private world, to make them feel as if they had stumbled on something personal and private. The booklet was designed to look like one of Jim Morrison's notebooks — a red imitation leather cover (just like the real thing, according to Ray Manzarek) and printed on uncoated paper to give that "literary" touch. Examples of Morrison's handwritten lyrics, William Blake illustrations, and hand-marbled paper all added to the true portrait painted of an "arty" band fronted by a now-dead poet.

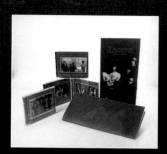

Shine On, the gargantuan celebratory box of seven classic Pink Floyd albums, is a fine example of "box setting". Designed by Storm Thorgerson and Stylorouge, it was far from modest in the packaging department. For a start the box itself was twice the size of a regular box and it was black…everything was black. It contained eight custom-made opaque black CD jewel boxes, a beautiful hardcover book covered in black cloth and silver embossed, a pack of postcards, a CD slipcase, and a bonus digipac CD of all the early Pink Floyd singles.

By way of contrast, but no less classy, Led Zeppelin's *The Complete Studio Recordings* was a little chest of drawers with a fold-back lid that held all eight Zeppelin studio albums, repackaged as hardcover books with the original sleeves and lots and lots of matt black. Very dark, very chic, very Led Zep. And more arty still was Yoko Ono's *Onobox* from Rykodisc. A hefty slab of a box with beautiful black-and-white graphics inside and out, six CDs, and a book. This box set was also available as a limited edition "Ultracase" in white plastic with metal corners and hinges and included a signed, numbered glass sculpture by Yoko. An edition of 350 and a bargain at $300! I'll take four.

Over the next few years box sets become so elaborate that by 1994 a special category was made for them at the annual Grammy® awards, and in 1996 art directors Chika Azumi and Arnold Levine deservedly scored one for their Miles Davis/Gil Evans package of *The Complete Columbia Studio Recordings*. The spine of the chunky book was even made of brass-like metal and was engraved with the same scroll design as that on Miles' own trumpet.

Rhino Records, on sunny Santa Monica Boulevard, discovered what a rich and lucrative seam box sets are, and over the years have produced some of the finest examples. Their compilation boxes, on subjects as varied as western music, beat poetry, surf music, and 60s British beat groups, carry some of the most innovative and clever packaging around. *Cowabunga! The Surf Box* looks and feels just like a real wedge of surf board, waxed up so well that the spot varnish has been applied to look like tiny beads of water on the surface of the board. But hold on! This was upstaged in 1999 by their *Hot Rods & Custom Classics: Cruisin' Songs & Highway Hits*. Looking like a Revell-style model box this went way over the top and included a book on custom cars, interviews with hot-rod racers and customizers, several car decals, a keychain, a copy of Tom Wolfe's legendary *The Kandy-Kolored Tangerine-Flake Streamline Baby*, a custom accessories catalog, and a pair of fluffy dice to hang from your rearview mirror. Oh, and I nearly forgot in all this excitement, four compact discs.

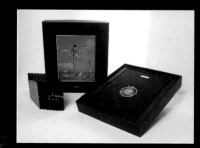

Top left: The Who **Thirty Years Of Maximum R & B** *booklet, Center left (both): Yoko Ono* **Onobox**. *Bottom left: Hot Rods & Custom Classics: Cruisin' Songs & Highway Hits*
Top Right: The Doors **The Doors Box Set**. *Center right (all): Cowabunga! The Surf Box. Bottom right: Pink Floyd* **Shine On**

BLUR, Modern Life Is Rubbish

THIS COVER WAS TONGUE-IN-CHEEK and not to be taken too seriously. It was meant as an ironic slant on 90s life, celebrating Englishness and postwar optimism while asking what this had amounted to. "Blur were into quirkiness," says designer Rob O'Connor, "those little things that made Britain special, like pints of beer, dog racing, and flocked wallpaper, rather than simply being nostalgic. Blur's lyrical fascination with Englishness was the main brief." O'Connor made up a "style book" of ideas: pictures and images on the theme of the British postwar period – an Austin Mini, 50s advertising, pictures of Royal Guardsmen, the Coronation, the Flying Scotsman train, and a Spitfire. They decided on a train because people at that time were proud of the railways and "really got into locomotives." Life was great then, but modern life is rubbish. Or is it?

THE BLUR logo is reminiscent of Bodum or Bounce-style corporate logos. It wasn't the designer's favorite, but the record company thought it would endure.

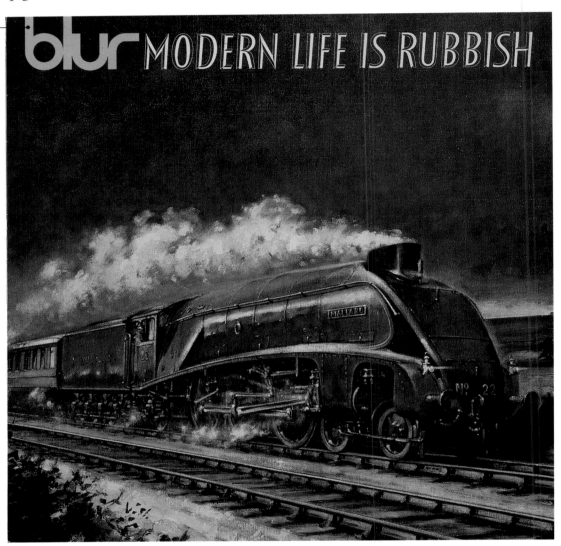

THE IRONIC HORSE
Rob O'Connor wanted to use a painting by Terence Cuneo, a famous painter of locomotives, but once Cuneo heard the title, he wanted nothing to do with it, wouldn't accept that it was ironic, or that he could be paid quite a lot for a picture that was just sitting in his files. Chris Thomson felt that Cuneo was a bit of a snob about record covers and didn't like the title's implication that his work might be rubbish. Soon after the rejection, however, O'Connor discovered Paul Gribble's oil painting of Mallard on a greetings card in his village shop, and the problem was solved.

DESIGNED BY
Sir Nigel Gresley in homage to the cars of Emilio Bugatti, the Mallard became the fastest steam locomotive in the world five months after its completion – its 126 mph on July 3, 1938, has yet to be bettered. An A4 locomotive with a four-wheel bogey leading six driving wheels, the Mallard is an icon of British design, combining fine engineering with beauty and style.

NO ONE REALLY liked *British Image No. 1*, but it was the only title forthcoming and gave Stylorouge something to work with. It became *Modern Life Is Rubbish* after Blur's singer, Damon Albarn, saw the phrase written in huge letters among graffiti near London's Marble Arch.

IF THE CAP FITS...
Rob O'Connor: "These 'tacky' designs came about because neither Stylorouge nor Blur have ever been constrained by considerations of taste, and that's deliberate. I pride myself that I've got quite a sophisticated visual sense, but the Blur attitude is one of not playing the normal game. The first album cover (above) was perverse, showing a portrait as per record company preference, but not in this case of the band but of someone totally irrelevant!"

ROB O'CONNOR AND CHRIS THOMSON
*Rob O'Connor studied graphic design at Coventry and Brighton and did his first design work for Polydor Records. Established in 1981, his company Stylorouge has produced sleeves for Tears For Fears, Squeeze, Maxi Priest, Simple Minds, George Michael, Catatonia, Lighthouse Family, David Bowie, Kula Shaker, and Jesus Jones, as well as coming up with the promotional posters for the hit UK movie **Trainspotting**. After a stint at Stylorouge in the early 90s, Chris Thomson and co-designer Richard Bull formed Yacht Associates in 1996. The pair have continued to design Blur's covers as well as numerous dance music sleeves and the fearfully stylish design and fashion magazine **Blag**.*

BRITPOP
Although Blur were at the forefront of Britpop at the time, the actual phrase had yet to be coined. Blur were poking fun at a kind of Englishness and indicating that there was something underlying it that was actually quite sinister.

SPECIFICATION

•Artiste	Blur
•Title	Modern Life Is Rubbish
•Design	Rob O'Connor and Chris Thomson at Stylorouge
•Artist	Paul Gribble
•Record Co.	Food/EMI Records, 1993

THE DAMNED, Music For Pleasure

COLIN FULCHER, AKA BARNEY BUBBLES, aka serious Kandinsky fan, is here at full throttle and in full exuberance mode, presenting an entirely new and obscure rendition of that exhausted notion – a band portrait on the front cover. Find and identify them if you can (and they are there). Not to mention a glorious Kandinskyesque lettering of the band name, large enough this time for record company officials, but more or less illegible until you know it's there. This design feels like a genuine tribute from a great designer to a great painter – a vivacious and audacious amalgam of several Kandinsky motifs, especially from the 20s, presented with panache for the nefarious world of rock 'n' roll, and album art in particular. Not only music for pleasure, but also visuals for pleasure.

ALTHOUGH BARNEY Bubbles' painting looks like a straightforward parody of Kandinsky it is obvious that it has been done very tongue-in-cheek and with great humor. Hidden among the lines, curves, squiggles, and circles are not only the name of the band (look hard, it's at the top), but also portraits of the band members – you'll have to look even harder for them. Clue: this is Dave Vanian, vocals, below.

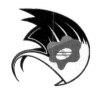

KANDINSKY TRIBUTE
Stiff founder Jake Riviera says that he thought of the ideas for the cover. **Music For Pleasure** *was intended as a spoof/ tribute to the painter Kandinsky. "The band didn't really have any input – they just let Barney and me do what we wanted."*

MATCH THIS!
Chris Gabrin also stage-managed concerts at the Roundhouse in London, so he'd met the bands in their working environment and got a good idea of what they were about. Whenever The Damned played, Rat Scabies would promise faithfully that he wouldn't to set fire to his drum kit, and every night the lighter fuel would come out and the drums would go up in flames.

THE STIFF ALBUM VOUCHER
Barney Bubbles couldn't resist adding quirky little graphics to his Stiff Records sleeves (see Tommy the Talking Toolbox on page 54). On The Damned's back cover you'll find the Stiff Album Voucher – a fun bit of graphic nonsense.

AN HOMAGE
Photographer Chris Gabrin calls the cover an "homage" rather than a "rip-off," pointing out that Kandinsky never took things this far in terms of graphics. Barney Bubbles took Kandinsky's work as an inspiration and did his own thing.

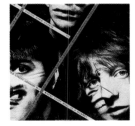

SPECIFICATION

- *Artiste* The Damned
- *Title* Music For Pleasure
- *Design* Barney Bubbles
- *Photography* Chris Gabrin
- *Record Co.* Stiff, 1980

TIME-CONSUMING PROCESS
"Barney wanted to give the back cover a slight twist, so I did straight portraits of the band in my studio in Camden and did layered, multiple prints with different negatives so you got an eye in the middle of a face etc. It was a lot of trial and error in the darkroom." – Chris Gabrin

ON BARNEY BUBBLES
Chris Gabrin: "Barney was the ultimate publicity-shy person. His name never went on anything. He was the most talented person I've ever worked with, but he had trouble dealing with real life. He wasn't really interested in money; he'd always insist on getting paid something for a job, but he didn't know what to do with it once he'd got it."

THE LINER BAG
The liner bag photos were taken in Gabrin's London studio on a Hasselblad using a flash and long exposure. Gabrin remembers that "Barney had found this old Mondrian-style vinyl floor covering in Shepherds Bush Market and wanted to use it as the backdrop. It ended up on the kitchen floor of my studio for the next ten years. The band were great posers. They'd become instant idiots whenever you pointed a camera at them, and because one was a static shot, Barney deliberately put it out of register (not lined up properly during the printing process). Barney was continually asking printers to do what they spent their entire working lives trying desperately to avoid."

BEF, Music of Quality and Distinction, Volume 2

COMPUTER ART IS RELATIVELY NEW and therefore difficult to assess in terms of any lasting qualities. Computer art is also like fashionable clothes – initially attractive, but later, a bit generic and shallow, possibly forgettable. Will we still love it tomorrow? This design for BEF, however, incorporates many computer elements in a dynamic and integrated fashion. Here we find layered busyness, precision, unexpected perspective, defocused background, globular shapes, and a mixture of drawn, photographic, airbrush, and graphic styles all woven together with ease and verve. An innate sense of design (of shape and of proportion) has managed to harness the virtues of the computer without being taken over by them. At the same time this cover represents both the apparent electronic nature of the recording artistes, and the industrial logo-styled imagery suitable for the ironic title of this album.

MUSIC AS PRODUCT
Designer Malcolm Garrett was inspired by the generic acronym BEF and its connotations of industry and commerce. "I wanted the logo to represent a kind of futuristic virtual musical 'institution.' Like Martyn, I have always been interested in the notion of music as product, and have often explored the extent to which a corporate image can be modified to account for incremental changes in visual style."

THE LETTERING was drawn digitally, initially in two dimensions, following a loose geometric grid, then passed to Olaf Wendt at Zapfactor to break it into a series of 3-dimensional separate elements which could be rendered in many different ways and viewed in virtual space from an infinite number of angles. In this way, each time the logo was used for separate single releases from the album, Garrett could modify the way in which the "corporate" flavour was represented. The 3-D surface of the lettering was also "texture wrapped."

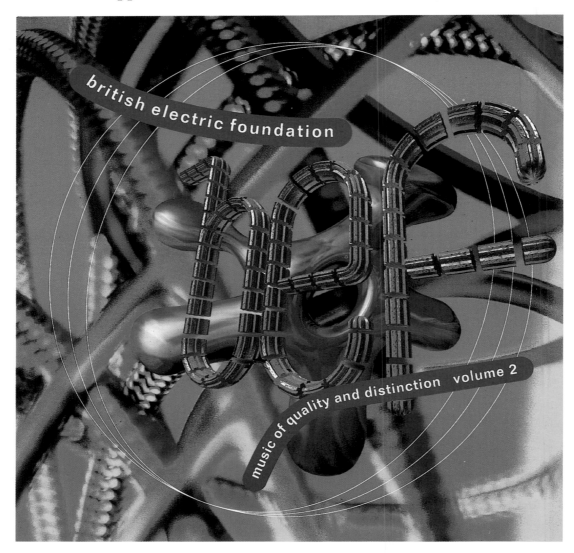

BRITISH ELECTRIC FOUNDATION
The project was devised by producer Martyn Ware to record some of his favorite singers performing some of his favorite songs. **Volume 1** *was released in the early 80s, and featured, amongst others, David Bowie and Tina Turner.* **Volume 2** *consisted of soul classics updated for the electronic generation. Malcolm Garrett decided to use the then fairly new Macintosh computers – against the prevailing industry wisdom at the time – believing that his working future lay in the domain of the computer screen, not the drawing board or the photography dark room.*

THE BACKGROUND
Malcolm Garrett: "The BEF logo hovered against a background of objects which were photographed by Kevin Westenberg. I had wanted to capture a number of ordinary objects quite close up, lit with saturated color gels, allowing parts of the image to go out of focus in order to create an environment in which the corporate logo could always re-invent itself in a visual world that was hyper-real, aesthetically stunning and psychedelically space age. The imagery on the album sleeve is actually coiled metallic power cables. They were hung from the ceiling and lit from many angles. Other objects featured in this piece included plaster cherubs and some pages from a novel."

ARTWORK PRODUCTION
Apart from the initial photography session, the entire project was composed on Apple Macintosh computers to create, modify, develop, and compile the elements for the various sleeve formats, and then to output finished color separation films for printing.

SPECIFICATION

• *Artiste*	British Electric Foundation
• *Title*	Music Of Quality And Distinction, Vol. 2
• *Design*	Malcolm Garrett for Assorted Images
• *Photography*	Kevin Westenberg
• *Record Co.*	Ten Records, 1991

ROD STEWART, Never A Dull Moment

NEVER A DULL MOMENT could not have been closer to the truth for Rod Stewart at the time. He struck gold with a simultaneous number-one single in the UK and US taken from the album entitled *You Wear It Well*. A title that is an ironic comment on the mood of the cover. The sleeve shows a grumpy Rod slumped couch potato style in a middle-class drawing room, wearing a tacky suit reminiscent of a 30s magazine advertisement. Well, that's exactly what it was – a modified Athlete's Foot advert with Rod's head collaged on. As the original slogan said: "Someone else walked away with the bonus money." That someone was Rod Stewart.

HEAD SHOTS
Jim Ladwig needed photographs of Rod so that John Craig could strip his head on to the image from the advert. Ladwig commissioned photographer Ed Caraeff to take some head shots. They flew to Florida with Rod but he wasn't very cooperative. One minute he was growing a beard, next minute he got sunburned. Nevertheless, they had great fun, went deep sea fishing, but didn't get much work done. So they followed Rod to Puerto Rico where he was playing a concert. After the gig, the promoter ran off with all the concert money and there was a riot with local people brandishing machetes. The two were lucky to come out alive, but they did get their head shots.

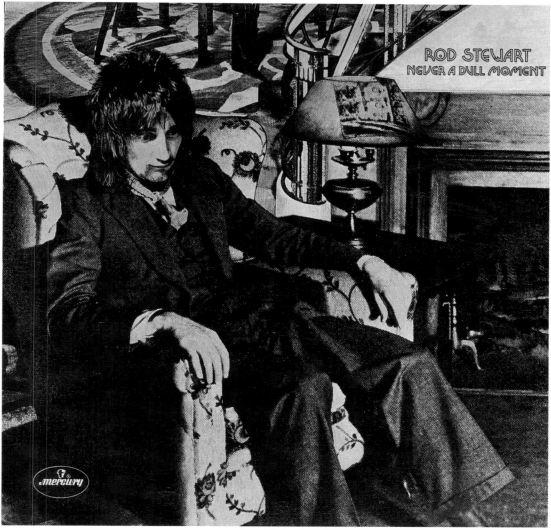

THE BRIEF
Jim Ladwig was given the title and decided to employ designer John Craig to create a collage of a "very dull moment" based on some old 30s press advertisements. It was also decided that the cover would hinge from the top. Rod came up with the ideas for the inside of the album, which included a shot of Rod and his musicians photographed in a soccer goal.

"I STRIPPED Rod's head on to an old advertisement for Athlete's Foot medication and added the background, which came from an Art Deco portfolio of interiors." – John Craig

DIRECTION
*John Craig was given little direction other than the title **Never A Dull Moment**. He says he probably didn't hear the music, which is usually how it was when he worked for Mercury Records for a while in the late 60s. As for the sleeve today* he says: "It still has the same mood that it suggested then, so it still works for me. I'm sure it could have been rendered and produced better, but then there is some charm to its rough technique."

JOHN CRAIG
*Educated as a printmaker at the Rochester Institute in Chicago, Craig took a job at one of the last commercial wood engraving companies in Chicago. Craig turned to making collages from the wood engravings he found in old books and catalogues. In 1972, after a stint as an assistant art director at Mercury Records, he and his wife moved to the wooded rolling farm country of southwestern Wisconsin, where they raise sheep and pursue their separate arts. His otherworldly assemblages have appeared in **Time, Money, US News & World Report, The New York Times**, and on the cover of a recent Smashing Pumpkins CD.*

PHOTO COLLAGE
Designer John Craig made a black-and-white pasteup from photocopies and then made a copy of the collage onto photographic paper. Using a sepia toner photo product, he soaked the black-and-white print in his bath. After this was dry he hand-colored it with Dr Martin's photographic dyes and colored pencils. This was the same technique that he used for Rod Stewart's *Every Picture Tells A Story* and The Faces' *Ooh La La*.

SPECIFICATION

• *Artiste*	Rod Stewart
• *Title*	Never A Dull Moment
• *Design*	John Craig
• *Photography*	Ed Caraeff
• *Art Direction:*	Jim Ladwig
• *Record Co.*	Mercury, 1972

THE SEX PISTOLS, Never Mind The Bollocks…

PUT ASIDE THE PRELIMINARIES, dispel the hyperbole, and get to the point. And the point here is to say "bollocks" to an introduction and let the designers tell the story behind this famous sleeve. But as they say, there are two sides to every story….

NEVER MIND THE RUNES
Malcolm McLaren's version: "Jamie Reid and I were at Croydon Art College together and became friends – at the time, I didn't like his art at all – it was all ancient druid symbols painted on pebbles and frankly, it annoyed me. Years later his girlfriend Sophie became my assistant when we signed The Pistols. I wasn't into graphics then. The first single, "Anarchy In The UK" was released in a black plastic sleeve, but I realized that the record company would demand something for the album. Jamie was doing some remarkable work on the Suburban Press, which was a magazine publishing essays by lefty French philosophers, so I asked him to do The Pistols sleeves."

"THERE'S A LOT of misunderstanding around the origins of this cover. At the time, I was living with an old friend of mine called Helen Wellington Lloyd. I was doing lots of leaflets to promote the Sex shop and Pistols gigs, and as Helen didn't have anything better to do, she'd help me with them. She couldn't be bothered to go to the shops and buy Letraset, so she descided to cut out newspaper letters instead and made the band's name look like a ransom note. It just goes to show that the best ideas are not always consciously formed. It fitted the anticommercial attitude of the band perfectly. "

… BUT MIND THE LOGO
Malcolm McLaren:
*"Helen's newspaper logo fitted so well – it stuck with the group from then on. Once Jamie and I realized just how wonderful it was, we took it on as their logo, and when the time came for him to do **Never Mind**, he had no choice but to carry it through."*

"I NEVER WANTED a picture of the band. I saw head shots as part of the cult of personality – very, very naff, but at the same time I wanted the album to be seen very much as a product but to make fun of that product at the same time. The colors were meant to make it look like a packet of washing powder – no better, no worse, just disposable rubbish."
– Malcolm McLaren

MALCOLM MCLAREN

Born and bred in London, infamous impresario Malcolm McLaren studied at Croydon College of Art, leaving in 1972 to open a shop at 430 King's Road with his then-partner, designer Vivienne Westwood. Variously named Let It Rock, Too Fast To Live Too Young To Die, SEX, Seditionaries, and World's End, the shop sold the clothes that embodied Punk and New Romanticism. Though he's worked with a host of bands and is credited with helping to bring rap music to the masses, McLaren is best known as manager of The Sex Pistols. After they disbanded in 1978, he created Bow Wow Wow, replacing Adam Ant as singer with Annabella Lwin, a 14-year old of Burmese origin whom he discovered singing in a dry cleaners. He is currently writing his autobiography.

"WE USED *The Times* newspaper for a lot of it. It was never meant to look straight and correct. The polished look of Letraset type was never what we would have wanted. It needed to look hard, a Luddite look that needed to have a physical input so that it looked do-it-yourself, not straight but irregular. The back was to be the same – Jamie copied the kidnap/ransom lettering."
– Malcolm McLaren

MALCOLM MCLAREN: *"I was in a pub in Tottenham Court Road in London with Steve Jones (The Sex Pistols' guitarist). We'd just signed to Virgin, and I was feeling very anxious as they were demanding an artwork for the album and we hadn't even come up with a title. Steve just said 'Never mind all that bollocks' and that was it – it was perfect, it was in sync with the whole disposable rubbish element. It was clever in that it was so simple."* "Bollocks" is the English street slang equivalent to "bullshit" in the States.

THE WORD "BOLLOCKS" ON THE COVER was seen as sufficiently indecent and offensive for shops to refuse to stock the album. Malcolm McLaren was subsequently taken to court for indecency and public order offenses. Virgin boss Richard Branson defended the cover, the album was kept in the news and the label won. Jamie Reid adds that the victory "proved that 'bollocks' was in fact a fine Anglo-Saxon word to be proud of," and recalls that "I left the court in Nottingham to hear a newspaper vendor shouting 'BOLLOCKS NOW LEGAL!' above the noise of the traffic."

SO IT WASN'T HELEN?
Jamie Reid: "The visual origins of this particular sleeve came from the work I was doing at the Suburban Press, an early 70s, Croydon-based printing and publishing collective that put out anarchist/Situationist-inspired posters, flyers and the shit-stirring magazine **Suburban Press**. *At the time, we had to produce cheap (no money), fast and effective visuals, so collage was the dominant look; things cut out from papers and magazines – photos and lettering – which was the so-called 'blackmail punk' look, which looked great. Doing our own printing, we realized that these collaged images actually gained effect – becoming more grainy, etc., – through the printing process. Some of these early images were actually used for The Pistols – such as the buses on 'Pretty Vacant' and a drawing on the back of 'Holidays in the Sun'."*

"**THE COLORS** were influenced by a Suburban Press series of 'This Store Welcomes Shoplifters' stickers from 1972 that were done to flypost on department store windows to look like sales offers. They were gaudy and fluorescent – pink and yellow Day-Glo in your face." – Jamie Reid

MEANWHILE BACK IN THE HEBRIDES...
Although both Malcolm McLaren and Jamie Reid agree that they met at Croydon Art College in the riotous year of 1968 and were heavily involved in student sit-ins and the anarchist/Situationist upheaval that occurred at the time, according to Reid their memories of how they came to work together on this cover differ sharply. Reid recalls that "Seven years after leaving Croydon, while I was crofting (farming) on the Isle of Lewis in the Outer Hebrides, I received a letter from Malcolm asking me to join him on the Pistols project. So I returned to London."

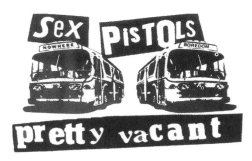

JAMIE REID
Jamie Reid was born in 1946. He attended Wimbledon Art College and later Croydon Art College, where he met Malcolm McLaren. From 1970 until 1975 Reid worked at the Suburban Press. He met up with McLaren again who, with his then girl-friend Vivienne Westwood, was running Let It Rock, and later Seditionaries. McLaren asked him to come and work on graphic images for The Sex Pistols. In 1980 Jamie Reid began collaborating on work with Margi Clarke. He continued to work with people such as avant-garde dancer Michael Clark and in 1987 published **Up They Rise: The Incomplete Works Of Jamie Reid**. *Reid has exhibited all over the world from the Parco Gallery, Tokyo to the Musée National d'Art Moderne, Centre Georges Pompidou, in Paris.*

GOD SAVE THE QUEEN
The publicity campaign for this single was timed to coincide with the Queen's 1977 Silver Jubilee celebrations. Jamie Reid designed a cover incorporating an official portrait of the Queen by Cecil Beaton. The cover was banned by A&M. When The Pistols signed to Virgin two months later, a slightly different cover was used.

SITUATIONISM TO PUNK
Jamie Reid: "This style is a continuing part of 20th-century collage agit-prop art, including early Russian Revolutionary artists, John Hartfield's anti-Nazi work, various Dadaists/Surrealists sifting into Situationism and into punk, to hackers and plunderers on computers and websites."

THE ALBUM TITLE
*Unsurprisingly, Jamie Reid provides another version to Malcolm McLaren's: "We had tried many titles and sleeve formats – **God Save The Sex Pistols**, etc – but to no satisfaction. I was running through the options with Steve Jones and John Varnom (the marketing director at Virgin). Unimpressed by these suggestions, Steve said 'Never mind the bollocks', to which we said 'That's it!'"*

SPECIFICATION
- *Artiste* The Sex Pistols
- *Title* Never Mind The Bollocks Here's The Sex Pistols
- *Art Direction* Malcolm McLaren
- *Design* Jamie Reid
- *Record Co.* Virgin, 1977

"Rock'n'roll is over. Don't you understand? The Pistols finished rock'n'roll. They were the last rock'n'roll band." – John Lydon, 1986

NIRVANA, Nevermind

WHAT A GREAT DESIGN for Nirvana's album *Nevermind*, so full of poetry and cynicicm it makes the viewer wince and smile at the same time. The image of a sweet and innocent baby, floating in the blue yonder, is perhaps proclaiming the virtues of water birthing and swimming lessons. But nice little baby is also intent on pursuing a dollar bill. Is it all part of an insidious training program? More likely a cutting critique of contemporary society, which is preoccupied with money and all its materialistic concomitants. Is our society so indoctrinated that even a baby chases after money, like a Pavlovian dog – conditioned response rather than a considered reaction. Our society may be corrupt but, never mind, worst things happen at sea. Or in the pool.

MONKEY BUSINESS
Kurt Cobain wanted to do a cover with a baby being born underwater or, alternatively, something with a monkey. He showed Robert Fisher a picture of a monkey that he'd created himself and wanted to appear somewhere in the package. He was a little bit shy and reluctant to push any particular ideas forward. Fisher pursued the baby underwater suggestion and put the monkey picture on the back.

THERE IS A *hand print where the baby's dad was holding him just before he passed him to mom.*

"WE DID A photo shoot at a swimming school in Pasadena and had several parents bring their babies down – both boys and girls. The parents took turns passing their babies back and forth in front of the photographer under the water. When I got the photos back, one stood out as the perfect shot. The lucky baby's name was Spencer Elden, and it was his first time swimming." – Kirk Weddle

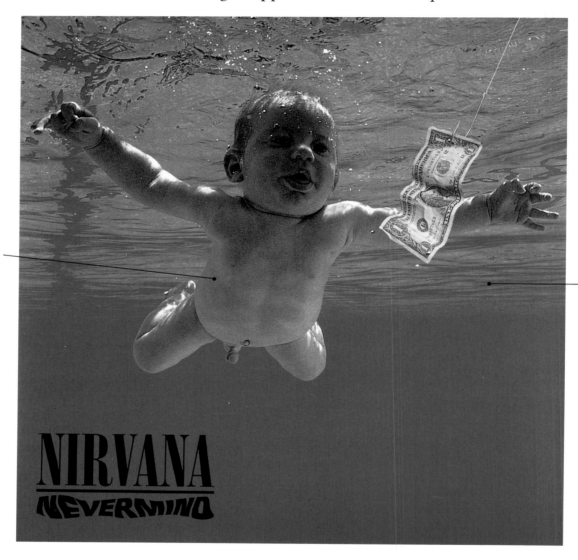

FIRST CHOICE
*"I'd seen Nirvana play live and liked their first album, **Bleach**. So when they were signed to Geffen I requested to work with them. This was the first cover that I was allowed to do on my own. The band came in and we had an initial meeting. They were still rather innocent about the business and welcomed any advice that I could offer up. In fact Kurt Cobain could not have been nicer." – Robert Fisher*

TECHNIQUE
The photograph was shot on 35mm with a camera locked in an underwater housing unit. Robert Fisher made a composite of the photograph, adding the hook with the dollar bill. He designed the rest of the package and sent it to Seattle for the band's approval.

ROBERT FISHER

*Robert Fisher was born in Los Angeles in 1962. He was raised on a diet of Led Zeppelin, Yes, and Pink Floyd, and spent many hours listening to their music and staring at the album sleeves. Inspired, he started art classes in middle school and even made his own black ceramic obelisk in deference to the album cover for **Presence** that Hipgnosis had designed for Led Zeppelin. He gained a Bachelor of Fine Arts degree in Communication Design from Otis Parsons College in Los Angeles in 1989. He then landed his dream job at Geffen Records, where he worked as an art director for 10 years. He now runs his own design studio in Los Angeles.*

"I RESEARCHED PHOTOGRAPHS of underwater births but found them way too graphic for an album cover. Although the shock value was good, Geffen would never have approved it. I found a picture of a baby swimming under water that I liked. I showed Kurt the baby picture and he liked it but felt it needed something more. We threw all kinds of ideas around and at one point Kurt half joking suggested a fish hook. We spent the the day thinking of all the things you could put on a fish hook; there was meat, a CD, a fish. Someone suggested a dollar bill and that won. Kurt was intellectual and deep-thinking about his work, and although he never gave a rationale for the contents of the design, I must assume that the naked baby symbolized his own innocence, the water represented an alien environment, and the hook and dollar bill his creative life entering into the corporate world of rock music." – Robert Fisher

BACK COVER
The monkey photo on the back cover is credited to Kurdt Kobain. The singer used this different spelling of his name for any artistic work not related to his music. The photograph apparently shows a monkey tied up with wires.

SPECIFICATION

•*Artiste*	**Nirvana**
•*Title*	**Nevermind**
•*Design*	**Robert Fisher**
•*Photography*	**Kirk Weddle**
•*Record Co.*	**Geffen, 1991**

GRACE JONES, Nightclubbing

IT IS SAID THAT MANY ARTISTS need their muse, and photographer Jean-Paul Goude discovered his in the statuesque and eerie beauty of Miss Grace Jones. This telling portrait expresses the sexual ambiguity which Goude found so inspiring. Grace Jones is both sensuous and scary at the same time. She wears a male-styled jacket, but with exaggerated female shoulders; she sports a male crew haircut on a decidedly female head; an open V but a flat chest; severe contours, yet moist lips. Black skin with white cigarette. Is this man, or woman, or somewhere in between? Would you even dare to find out?

MANIPULATION
In his first images of Grace Jones, Jean-Paul Goude used the same techniques he had employed with earlier black subjects: cutting up photographs and changing body shapes to exaggerate his ideal fantasy of the female figure – buttocks were enlarged and made to protrude far enough to support a champagne glass, legs were lengthened and nipples and breasts perked up. The end result of these manipulations was then made into a C-type photographic print and painted over with oil paint applied with a brush. Impossibly contorted and exaggerated human forms were given an eerie appearance of reality.

GIRL/BOY/GIRL/BOY
When Grace Jones dressed in conventional female attire, she looked somewhat masculine. But if she wore male attire, the femininity of her features was immediately enhanced. The same went for the haircut. The flat-top is a traditional US Marine hairdo, and for the same reason, Grace's beauty was enhanced by such a masculine hairstyle.

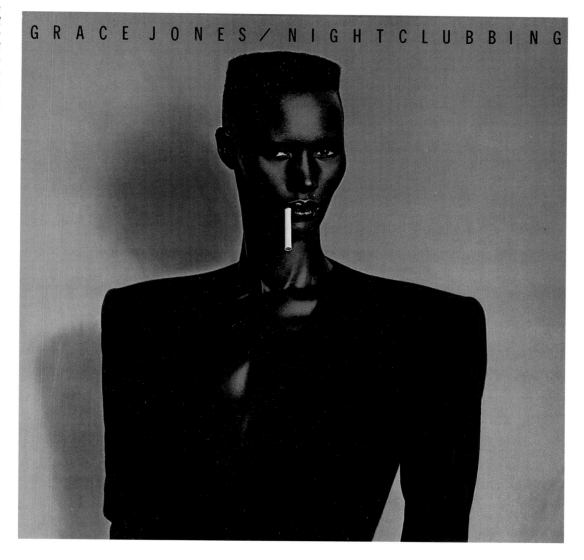

MUSE
Artist and photographer Jean-Paul Goude first saw Grace Jones at a New York gay club called Les Mouches. Intrigued by her bare-breasted performance of 'I Need A Man' to an audience of ecstatic men, he says that she was "exactly what I had been looking for all these years – not just a pretty model, but a fresh face, a demi-goddess, black, shiny, her face something more than just pretty. It was more like an African mask."

EXTENDED PLAY
Transparencies were cut and rearranged so that limbs were extended, accentuating Grace's form.

CHILDHOOD FANTASIES
"Any attempt at portraiture involves a certain amount of exaggeration. I take what is there and dramatize it. If painting Grace Jones blue-black was a way to come to terms with my own childhood fantasies about the mysteries of Africa, it's ironic that once transformed, her image would suggest a strange menacing alien when all I had wanted to do was sublimate her African roots." – Jean-Paul Goude

JEAN-PAUL GOUDE
Goude designed two other album covers for Jones – **Warm Leatherette**, 1980, and **Living My Life**, 1982.

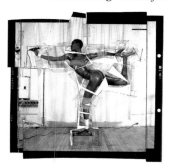

SPECIFICATION

- *Artiste* Grace Jones
- *Title* Nightclubbing
- *Design* Jean-Paul Goude
- *Photography* Jean-Paul Goude
- *Record Co.* Island, 1981

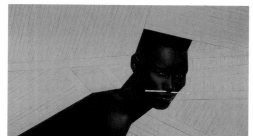

WAYNE SHORTER, Night Dreamer

SHADES OF BLUE, SHADES OF NIGHT, shades of meaning. Squiggly light-trails crisscross the dark screen behind a lone figure. All is blurred, all is dreamy. All is abstract. More graphic than photo, but still photographic. Such defocused technique predates modern computer obsessions with accuracy. A time exposure of about half a second with moving lights or moving camera provide the blur and the curvy light shapes. Different blues in the lettering (i.e., varying tints of the same blue) complement the blue/black duotone of the photograph. So simple, so evocative. Silent urban car lights etched dreamily on the blackness of night behind a lonely traveler, behind a lonely Night Dreamer.

JUST A JOB
Graham Marsh, co-author of **The Cover Art of Blue Note**: "The Blue Note sleeves were just a job to Reid Miles – he did them like a production line. He wasn't precious about them, and he preferred classical music anyway."

CLICK
Reid Miles: "I went to art school because of a girl I was going with and because of the GI Bill, and it was nice to be close to her and go to an easy art school. The girl didn't work out, but three months later, it just clicked."

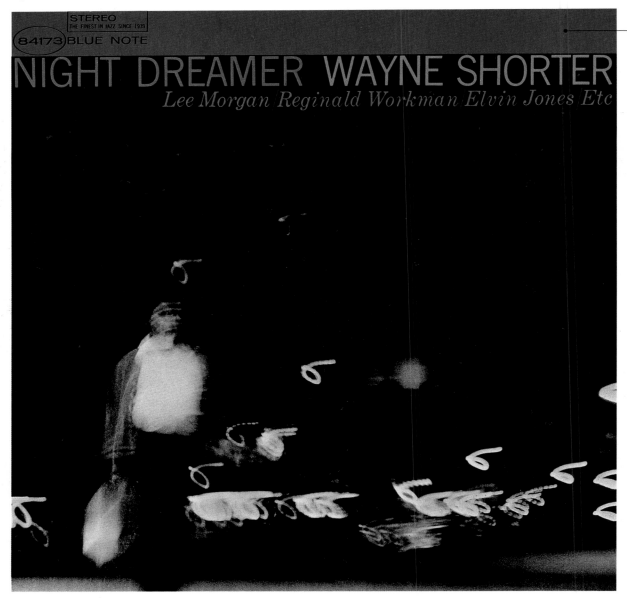

"**THE BLUE**
color is part of the whole scheme of the title, it ties in with night-time." – Wayne Adams

MUGSHOTS
As Blue Note embraced the musical changes of its recording artists, so designer Reid Miles caught the slipstream, creating sleeves that transcended the mugshots and mysticism of other genre's sleeves.

COOL NOTES
"Reid Miles made the cover "sound" like it knew what lay in store for the listener: an abstract design hinting at innovations, cool strides for cool notes, the symbolic implications of typefaces and tones." – Felix Cromley

MOTION IN THE PHOTOGRAPH
Wayne Adams: "Reid loved to work with motion – he felt it brought an inanimate object, such as an album cover, to life."

FRANK OR REID?
Reid's assistant, Wayne Adams, thinks that this might be a Reid Miles photo rather than a Francis Wolff: "Reid was fond of motion shots, Francis wasn't, and practically all of his Blue Note covers were session shots of the artists. The grainy film, combined with the motion and subject of a man with a grocery bag in the street, gives the image the look of a Reid Miles photo. Francis wouldn't have used a motion shot at all, he just did session shots."

PURE DESIGN
Wayne Adams: "Reid Miles' Blue Note work redesigned the way album covers were designed. They became art, pure design rather than just packaging."

SPECIFICATION
- Artiste — Wayne Shorter
- Title — Night Dreamer
- Design — Reid Miles
- Photography — Francis Wolff
- Record Co. — Blue Note, 1964

WAYNE SHORTER
Saxophonist and composer Wayne Shorter was born in Newark, New Jersey, in 1933. His intense, tough tones on the tenor tax and his innovative approach to the soprano sax have been very influential, and many of his complex compositions have become jazz standards. He has played with Art Blakey's Jazz Messengers and the Miles Davis Quintet, and formed Weather Report alongside Joe Zawinul and Miroslav Vitous in 1970, leaving in 1985 to pursue solo projects. He recorded thirteen albums for Blue Note.

Wayne is still shorter, but sadly, Reid is no longer.

JANE'S ADDICTION, Nothing's Shocking

NOTHING IS SHOCKING in culture any more. We are anesthetized by overexposure. Nothing is shocking in rock 'n' roll in the wake of its torrid history of excess. Nothing is shocking compared to man's inhumanity to man. Have we lost the ability to be shocked? Are Jane's Addiction going to do it via a cover design? In an uncertain atmosphere of double meanings, anything is possible. Jane's Addiction – nice girl, nasty habit. Addicted to love, or sex, or marijuana. A girl's addiction, a boy's band. Led by Perry Farrell, previously Bernstein, reborn as a play on peripheral, Perry-pheral, creeping up on one, up to no good. Or even Perry Feral, the untamed creature of the night. Well, it works. We were shocked. A dream, albeit a turbulent one (and a nightmare for the record company). Keep at it, Perry Farrell, enfant terrible. Wild thing. Perry Feral.

PERKS

Then head of Warner Bros. Creative Services, art director Kim Biggs (née Champagne) says that getting the job was "one of the perks of working in-house," and adds that "the idea was totally original – it was Perry's baby…. It was not like anything I'd ever seen before. It was a bit naive and awkward, but very visually arresting – shocking even to show two Siamese twins on fire."

JUST CHILL OUT

Nothing may be shocking, but the American public found the cover less than palatable – nine national record chains refused to stock it. It was left to Perry Farrell to defend his work to an uneasy record label: "How do you convince Warner Bros. to just chill out and release it as it is? Luckily, I was so naive I wouldn't give in."

THE LINER BAG

The cover's nudity theme is carried through to the pictures of the band on the liner bag – Perry Farrell's shot features his own naked form reflected in his sunglasses.

SPECIFICATION

- *Artiste* — Jane's Addiction
- *Title* — Nothing's Shocking
- *Design* — Perry Farrell with Kim Champagne
- *Photography* — Perry Farrell
- *Record Co.* — Warner Bros., 1988

PROTECTIVE

Kim Biggs: "Perry Farrell didn't really trust me to do too much – he was worried about what I'd do with the retouching and wanted to keep tight control over it. He was great to work with, very interesting, but sometimes difficult. He was very suspicious of the label, very wary of the corporate machine, and so he was apt to be very protective over his work. It was a great experience though."

ORIGINALLY, PERRY Farrell wanted to sculpt Niccoli out of clear glass and light the figures from within. The idea fell through when he discovered that "the glass blower I had talked to had said he was better at his job than I was." Undaunted, Farrell decided to switch to plaster.

BACK COVER

Photographer Kevin Westenberg was called to do the photo for the front cover. On the day of the shoot, Westenberg recalls, "Perry and I fell out. He said someone at Warner Bros. had told him that my pictures weren't very good, and that he was going to do them himself. Later, I was surprised to find my picture of the band on the back cover. Perry and I made up again soon after."

THE NEXT BIG THING

Kim Biggs: "Perry had a layout worked out in his head, and I helped him fine-tune it. The band were a very big signing. There was lots of hype at the time and they were marketed as the next big thing. Perry was presented to the Warner's creative department as this creative force – an artist as well as a musician. He needed someone to act as a technician, to assist him with layout and the like; and that's what I did."

FLAMING HEADS

At his Venice, California home, Perry Farrell built two life-sized Siamese twins that he modeled in plaster, using his then-girlfriend Casey Niccoli as the model. Once complete, the sculptures were doused in gasoline and lighter fuel and set alight. Kim Biggs recalls that Farrell "had a hard time getting a good-looking flame. It wasn't as simple as just building them and setting fire to their heads – he had to experiment until he got it right."

BECK, Odelay

IS IT A RUG? IS IT A MOP? Is it a dog? Well, yes, it's a dog, and a very hairy one at that. Beck's cover caused quite a stir when it first appeared as no one was quite sure what the picture was all about. This was precisely the intention that Beck had in mind when he picked it out in a last minute decision to avoid his album being delayed. The only comment the record company could make about the cover was one of relief when they learned that the album would be released on time. Art for art's sake. Money for dog's sake.

THE TITLE ODELAY had been decided during the recording of the album. Beck was originally going to call it *Andale!* which is Spanish for "Get going!" However, one of the tape operators misspelled it on the tape box as *Odelay*. Beck thought this was amusing and decided to make it the title. The album was running a bit late, and at Geffen Records it became known as *Over Delay*.

SKY LIMITS
The print in the dog breed book was not the right size or shape, so they cloned the edges and added in some extra sky at the top using an Apple Mac computer with Adobe Photoshop.

ROBERT FISHER, the art director, found the typeface in an old Western woodcut typography book.

THE INNER SLEEVE
For the the inner sleeve montage Beck used some images of his grandfather's, the beatnik artist Al Hansen. There were also some paintings by Italian artist Manuel Ocampo.

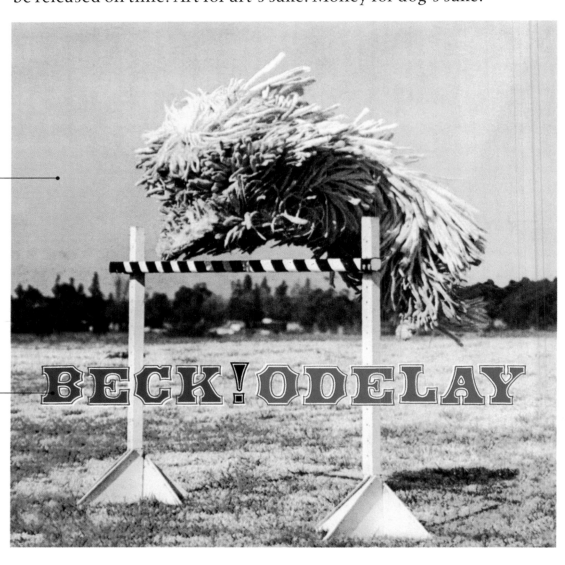

CREATIVE CONTROL
*Robert Fisher, art director, Geffen Records: "I'd worked with Beck before on the cover for his **Mellow Gold** album and we got along pretty well. He came into my office with tons of images, and we started to throw ideas around. He's kind of hard to pin down and has lots of his own ideas, and just when you think he'll love something he has a change of heart and throws it out. He has complete creative control over his career, so he decides his own image."*

HURDLES TO CROSS
Beck's girlfriend Lee was an avid collector of old postcards and provided a lot of the material for the album package. It was she who found the photo in a book of dog breeds. By the time they discovered the picture the album was right on the deadline, and almost out of desperation Beck settled on the cover just to get it done. However, it turned out to be a good choice. The record company were just relieved that it was finished.

ODELAY, HERE BOY!
Robert Fisher: "Once we had found the picture of the dog I set out to see if we could obtain the original transparency. The photo was taken by a famous dog photographer called Ludwig who just happened to live a few blocks from the office. She was in her late 70s, I think, and was enthusiastic to have someone come visit her. Her garage was filled with boxes of dog pictures and after hours of searching I couldn't find it and so I ended up scanning the image directly from the book. The quality wasn't so great but it did give the cover a certain look that I liked. Beck felt that it was kind of ambiguous, unrelated to the music, and was chosen almost at random. The viewer could read into the cover whatever they wanted. Odelay also sounded a bit like a dog command."

THE KOMONDOR
The Komondor, or Hungarian sheep dog, is a large dog with an unusual white coat consisting of tassels of hair called cords. It is believed to be a very ancient breed. It probably moved to the Danube Basin (present- day Hungary) with the nomadic tribes who settled there in the 9th century. These early Komondors were used to guard sheep, goats, and cattle from predators, which included wolves, bears, and humans. The dogs often had to make their own decisions in the absence of a shepherd to guide them. Thus they developed into a very intelligent, independent and strong-willed breed.

SPECIFICATION

• *Artiste*	Beck
• *Title*	Odelay
• *Art Direction*	Beck Hansen & Robert Fisher
• *Design*	Beck Hansen & Robert Fisher
• *Photography*	Ludwig
• *Record Co.*	Geffen, 1996

THE SMALL FACES, Ogdens' Nut Gone Flake

THE SMALL FACES WERE four chirpy young Cockneys who had risen to fame in 1965 during the infamous battles between Mods and Rockers in Brighton and Southend. In 1967 they finally turned on to the peace and love generation, and in the immortal words of singer/guitarist Steve Marriott: "Life is just a bowl of All Bran, you wake up every morning and it's there." The cover was based on an existing tobacco tin, and is very representative of a traditional working class symbol – the hand-rolled cigarette. The cover design neatly joined together the old with the new – hand-rolled ciggies with hand-rolled joints.

THE SMALL FACES
They were small in stature but large in reputation and they were "faces" or "tickets" – flash mods from London's East End. Their career lasted less than four years, from 1965 to 1969, but in that time they made a huge impression on the UK charts with a succession of hit singles: "Tin Soldier," "Itchycoo Park," "What Ya Gonna Do About It," "Lazy Sunday," "All Or Nothing," and "Sha La La La Lee." Their finest hour was creating England's first rock opera, **Ogdens' Nut Gone Flake,** *predating Pete Townshend's* **Tommy** *by a year. Recording took over 12 months (unheard of in 1967). They introduced their hero Happiness Stan through eccentric comic Stanley Unwin as the storyteller. Who else could begin a rock opera with the words: "Once a polly tie tode, when our young worle was fresh in univerbs and Englande its beauty garden, a young lad set out in the early mordee, to find it deef wisdom and true love in flower petals arrayed...."*

HOW DID SUCH A COVER COME ABOUT?
Glyn Johns, engineer: "The idea mainly came from Ronnie Lane. It was very much his thing." "We were at a loss as to what to call the album," says Kenney Jones. "On the table in front of us was a tin of tobacco, Ogdens' Nut Flake, which we always used to roll joints and that was it, that was our cover. The tin was round so our cover was round."

THE ROUND COVER
Although the circular record cover sounded like a good idea it caused a lot of problems. Record shops found that when they tried to stack them they warped or rolled off the shelves. Eventually they had to put the circular cover into a square clear plastic sleeve to cure the problem.

THE MEDALS
Four gold medals show profiles of each member of the band. The first one, Steve Marriott, is inscribed "The Phantom Sheet Whistler." The second, Kenney Jones, is "George The Cleaner XVIII." Ian MacLagan is "Maximilian III," and lastly, Ronnie Lane, is "Leafy Lane."

ORIGINAL PACKAGE
The vinyl package opened up to reveal a psychedelic illustration of a pointy-eared elf smoking a long clay pipe, surrounded by leaves of many kinds (see top of page). Facing this was a photograph of the inside of a tobacco tin. The tin had opened to reveal a pack of cigarette papers that looked like Rizlas but were branded SUS – popular East End slang – "a bit sus" – a bit suspect. Opening the sleeve further revealed individual portraits of the band members.

I'M OUT OF ME BOX, MAN!
Ogdens' Nut Gone Flake *was the first ever concept album with narrative, words, and lyrics. The Small Faces wanted to suggest that the album would be good to listen to accompanied by the smoking of a joint. "We called it* **Nut Gone** *because your nut's gone if you smoke that stuff."*

PROMOTION
Immediate Records ran a series of adverts incorporating a parody of the Lord's Prayer:

Small Faces
Which were in the studios
Hallowed be thy name
Thy music come
Thy songs be sung
On this album as they came from your heads
We give you this our daily bread
Give us thy album in a round cover
As we give thee 37/9d
Lead us into the record stores
And deliver us Ogdens' Nut Gone Flake
For nice is the music, the sleeve and the story
For ever and ever.

Following a deluge of complaints from readers, Immediate withdrew the ad.

SPECIFICATION
- *Artiste* — The Small Faces
- *Title* — Ogdens' Nut Gone Fake
- *Design* — The Small Faces
- *Illustration* — P. Brown
- *Record Co.* — Immediate, 1968

THE ORIGINAL TIN
The original Ogdens' Nut Flake tobacco tin ceased production in 1983. A limited edition of the **Small Faces** *CD comes in a tin.*

Jon Wozencroft, Touch

HOUSE STYLE

A house style means an overall visual approach for a particular set of graphic items, i.e., album covers for a record label or a part of a label, or for a series of specific recordings, or even the covers of a particular artiste. 4AD Records in London had an elegant nonspecific house style (developed by Vaughan Oliver), as did Blue Note under Reid Miles. ECM jazz records possess a very cool conceptual approach while the band Chicago used a very distinctive logotype devised by John Berg and designed by Nick Fasciano. Charley Records, Arista Freedom, Wyndham Hill, and the Cruisin' album series have more genre-oriented house styles. The following text outlines the motives and criteria for one example of house style, namely Touch Records, an independent avant-garde outfit based in London.

The music is the principal thing — music that is truly alternative and about change. You rarely get to hear it on the radio. Its profile in the megastores is negligible. There is no advertising budget, no magazine coverage. But it's music that you're passionate about, so cover design becomes even more crucial for small labels as a way of getting "difficult" music heard. Hopefully, if you produce consistently good work, someone who buys one CD will keep buying subsequent releases. It's trust that makes the first narrative, and a mark of respect to the musician(s) and to the buyer that great care goes into the design.

Touch started in 1982. Until 1986, it came in magazine form, publishing new music alongside specially commissioned work from artists, writers, photographers, and graphic designers. Our first CD came out in 1988, *Ignotum Per Ignotius* by The Hafler Trio, packaged in a custom-made slipcase, in a twilight period before the collapse of Rough Trade distribution, the retailer colossus, and the onset of obligatory barcodes.

Acts of resistance against the CD format have been long and various, not only because plastic jewel cases are so tiresome – making more of the print medium is a way of expressing the contrast between analog and digital. But wallets, slipcases, posters, and pouches become an increasingly costly affair. As a result, the product ends up having to be assembled at home. Reprints are a nightmare. Not only is there the tabloid conservatism of retailers and distributors to contend with, but the print quality and attention to detail of CD pressing plants leaves a great deal to be desired. Even a change of paper stock from the regulation issue is to ask for trouble, usually compounded by the fact that you have paid handsomely for the bother of being different. Better mastering technology and the digital origination of film are big steps forward, but the eye for detail of the master printer is disappearing.

So the Touch "house style" is first of all to get the best out of this process. With Touch covers, the main ambitions are to suggest the emotion and the atmosphere of each particular recording, usually choosing images that form a lateral relationship to the music and its title. For me, photography is a more resonant medium than computer-generated or graphic design: it is better at expressing qualities of light. The images are about the thirst for beauty. Actually, I don't like to say anything much about this: the images must speak for themselves.

If anything, the covers follow a minimalist aesthetic and, over a period of time, become distinctive by virtue of what they avoid. If the music is somewhat ahead of its time, the last thing you want is design-as-fashion statement. The titles never invade their space, so set alongside the photograph, there is a fine balance between the vivid and the understated. The subject matter of the images can be strong to the point of being iconic, but a sense of movement and surprise comes from the intriguing relationship between what the front image actually is and how it might

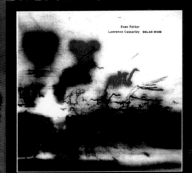

Top left: Mesmer Variations, Center left: Hilmar Örn Húmarsson Children Of Nature, Bottom left: Evan Parker & Lawrence Casserley Solar Wind
Top Right: Mark Van Hoen The Last Flowers From The Darkness, Center right: Mika Vainio Onko, Bottom right: Scala Hold Me Down

relate to the music – expressing the potential of complex and intuitive meanings is a simple, modernist device which underlines the critical nature of the work. (The documentary film of Chris Marker, *La Jetée*, Gysin & Burroughs' *The Third Mind*, and the film opening title sequences of *Saul Bass* are among the many points of reference…). This tension between the singular image and the richness of meaning that comes from the contents inside has turned into a litmus test to set against the computer world's claims for "interactivity."

Once you accept their obvious deficiencies in size and tactility, CDs do have an advantage over record covers in that they allow you to create a dynamic interplay between front/back/tray card/label/booklet and centerfold. Each transition can be treated like a film edit. Playing around with the aspect ratio of 35mm, TV, and widescreen is also a way of breaking the square frame of the CD format. And all the stock information that you have to put on the package can simply be small print, designed around the barcode. This too should always be as small as possible.

These CD covers are fragments of a much larger work; in themselves, they by no means tell the whole story. In some cases, the front image is not even the most "active" within the overall design. The jumbo jet of *Dark Continent* opens up to reveal a flare of sunlight and an eye in close–up; the saturated cityscape on the front of *Beauty Nowhere* is contrasted with, among other images, Scala's singer Sarah Peacock in front of a shopping mall window, a line of vodka bottles in a duty-free shop, an empty bus careering across the runway at Porto airport, and, on the back of the booklet, the first man in space strapped into his space suit.

In terms of the elusive qualities of emotion and atmosphere, hopefully a narrative emerges out of the unpressured observation of pictures that suggest personal moments of rapture and their primacy amid all the entertainment out there. Every aspect is invested with a kind of sublimation. It is idealistic work that tries to create a field of generosity and space for contemplation – to want to look again, each time you listen.

Top left: Touch Sampler 3. Bottom left: The Hafler Trio & The Sons Of God Resurrection (Front and open)
Top right: Sandoz Dark Continent. Right center: Scala Beauty Nowhere. Bottom right: Scala Hold Me Down (back)

10cc, The Original Soundtrack

FOR A ROCK 'N' ROLL BAND it's an ironic name, 10cc: either some self-deprecating reference to their lack of phallic bike-power, or conversely an indifference to such trifling matters as size and strength. Or were they initially a 10-piece commune band living by the sea, or ocean? *The Original Soundtrack*, their third album, is also ironic. It describes music for a film that didn't exist. The score had been recorded first, and the film would then be created around it, as opposed to the reverse procedure in normal movie-making. Many of

the individual songs have filmlike references, hence all the film editing equipment. The sparkling wordplay of 10cc, and the richness of idea and allusion in their work, determined the "busyness" of the design. The quality of the sound – close, immediate, and detailed – suggested that the representation should be more than ordinary photography; more real somehow, like the hyper-real art of Humphrey Ocean. Humphrey Ocean and 10cc – a marriage made in Hull.

IN BOB DYLAN'S *John Wesley Harding* album cover, The Beatles' faces can be seen, upside down in the bark of the tree. Humphrey has drawn a similar image of 10cc – hidden in the reflections of the equipment.

HOW DID THE COVER COME ABOUT?
The first job Humphrey Ocean was given by Hipgnosis was a drawing for the album sleeve of a band called Jail Bait. Unfortunately the band split up so the album was never released. On the strength of that drawing he was commissioned for this cover.

KEVIN GODLEY'S THREE STEPS TO HEAVEN
How do you make a band that sounds like four wackos from Hollywood, but are in fact from Manchester, England, appear cool?

1. *Call for the man with a sea in his name.*

2. *Invite him to interpret Hipgnosis' photographs of a film editor's Steenbeck in pencil.*

3. *Sit back and sell shedloads of albums.*

TECHNIQUE

Humphrey Ocean: "It is a pencil drawing started at the top left-hand corner and finished bottom right. I approached it like a painter, not a graphic designer. There is an intensity to it. If I had been a graphic designer, I think it would have been more slick, whereas I feel it's a bit clunky. It is ten times harder to do a drawing from a photograph and not the real thing because it is a flat image. You get a series of shapes that are put together that are second-hand, dull, lacking in information."

A WORK OF ART
Graham Gouldman of 10cc: "I liked the cover right away – it was part of what we were about – wanting to create pictures in people's minds. I regarded the drawing as a work of art, rather than an artwork, standing in its own right, not just an album cover. In retrospect it is still intrinsically linked to the music and the songs – as it always will be."

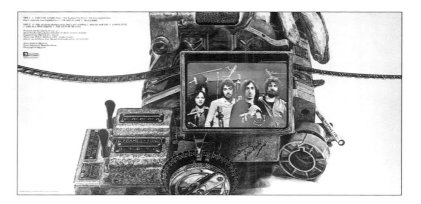

SPECIFICATION

- *Artiste* 10cc
- *Title* The Original Soundtrack
- *Illustration* Humphrey Ocean
- *Art Direction* Hipgnosis
- *Record Co.* Mercury, 1975

ANYTHING AND EVERYTHING

The golden rule of writing and recording for 10cc was to try anything and everything. A great explosion of conflicting ideas. Lots of them obsessed with film. "What I really wanna do is direct!" was the subtext of most Godley and Creme songs on this record and the probable origin of its title. Not surprisingly, both Kevin Godley and Lol Creme have gone on to be successful directors.

STILL LIFE DOCUMENTARY

Kevin Godley of 10cc: "Back then I thought Humphrey Ocean's drawing was just a great drawing, but looking at it again, after so long, I'm mostly struck by the mess of tools and junk piled around the editor's screen, correctly suggesting 95 percent industry – 5 percent inspiration. It also reminds me of the Pompidou Centre. All the guts on show, servicing the perfect, surprised cowboy looking at God-knows-what behind him. In one rich, detailed pencil drawing he summed up the twitchy faux Gershwinisms of 'Une Nuit A Paris,' the panoramic end titles wash of 'I'm Not In Love,' the Eurovision tat of 'The Film Of My Love' and the spirit of every word and note in between. Somehow Humphrey not only captured the sheen of the finished product but the chemical reaction that made 10cc combust. To me this cover is less a drawing, more a still-life documentary of what made the sick tick."

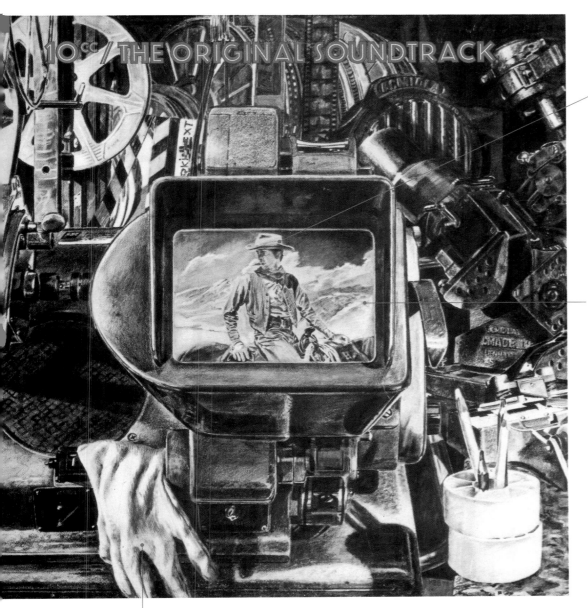

THE ORIGINAL plan was to have a die-cut hole in the Steenbeck screen where the image of the group would show through from the inner spread. Humphrey had a white space in his drawing and he just thought, as it's going to be cut out anyway, he'd put Anthony Perkins in there. The image is a still from the movie *Lonely Man* that he found in his collection of film annuals.

THE ORIGINAL vinyl cover had the Steenbeck screen with the image of the cowboy as a spot varnish, while the rest of the cover had a matt finish.

HUMPHREY OCEAN

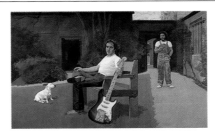

Creme, Godley, Gismo & Jack *1978*
Acrylic on Canvas. 182.8cm x 295.8cm. Courtesy of the artist.

Humphrey Ocean was born in 1951 in Pulborough, England, and studied at Canterbury School of Art. He became bass player for Kilburn & The High Roads with Ian Dury in 1973. He left the band to pursue the life of a painter. Humphrey won the Imperial Tobacco Award in 1982 and has five paintings in the National Portrait Gallery in London, including portraits of Paul McCartney, Philip Larkin, Tony Benn, and William Whitelaw. After the 10cc cover, Humphrey was commissioned by Lol Creme of 10cc to paint a portrait of him and Kevin Godley with their invention called a Gismo (see above). Humphrey thought of Holbein's painting **The Ambassadors** *in London's National Gallery and convinced Kevin and Lol to pose for a similar painting.*

"PO AND STORM of Hipgnosis used to give me the good guy/bad guy routine. Everything else had gone really easily but I had a lot of trouble with the form of one of the gloves. Typically, when I brought in the completed drawing, Storm noticed this straight away."– Humphrey Ocean

ARTWORK PRODUCTION

Humphrey Ocean: "I have always preferred to draw things from life but I had to do this from a photograph. The photography of the Steenbeck and related film equipment was set up in a Soho basement. I did rearrange things a bit from the original. I used to get up early in the morning and work right through and it took me about three weeks to draw. I would put the radio on, and it was an ideal existence."

ORCHESTRAL MANŒUVRES IN THE DARK, The Pacific Age

MICK HAGGERTY'S IDEA FOR THIS COVER came to him after reading a book set in the South Seas. There is, however, more of a sense of the romantic in the cover than was necessarily intended by Orchestral Manœuvres through the music. The concept of the album referred to the socioeconomic explosion of the Pacific Rim countries and its political implications for the rest of the world. Haggerty's cover design, on the other hand, with its native, wood-cut art of pastel-rich letters surrounding a symbolic yin and yang centerpiece of sun and moon, strikes a harmonious chord with its charming naivety. It's a rare skill to create visual simplicity from a subject so complex.

DAWN CHORUS
During the recording of the album, Andy McCluskey of OMD played his manager, Martin Kirkup, a song that was to become the title track – "The Pacific Age." They all knew the moment they heard the song that it was the emotional center of the album. The song expressed the dawn of a new age in the Pacific… the opening-up of the Pacific Rim. Kirkup called designer Mick Haggerty. He knew him very well, as they had worked together at A&M Records in LA.

CONTRAST
Martin Kirkup: "OMD are best known as an early electronic band, so there was this fabulous contrast between the synthetic sound of the music and this wonderful tactile, homemade feel of the album cover, with the subtext of the Pacific as its theme."

NOA-NOA
*When Mick Haggerty was asked to come up with some cover ideas he had just returned from a three week trip to Baja in Mexico, where he had completed a series of woodblock prints for Condé Nast Publishing. He had also recently discovered **Noa Noa**, Paul Gauguin's journal of his visit to Tahiti, so the idea of doing a completely handmade sleeve seemed a natural solution.*

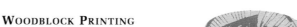

FROM LA TO PARIS
OMD were recording the album in Paris, so Mick Haggerty had to fly from LA to show the band his ideas. They loved every idea and ended up using them all. There was a design for the cover, the inner sleeve, singles sleeves, and even ideas for a logo, badges, and T-shirts –

in fact an entire package. Mick was relieved that they liked everything. He didn't fancy doing too many 11-hour flights from LA to Paris.

TO FURTHER the "homemade" feel, the sleeve was printed on the reverse side of the board, so that the shiny side was inside and the rough, uncoated side was on the outside. The sleeve was then left unvarnished.

WOODBLOCK PRINTING
Mick Haggerty produced the artwork using traditional woodblock printing techniques. First of all, he drew out his design on thin paper, then pasted his drawing face down on to a block of wood so that it appeared as a mirror image. Then, using chisels and gouging tools, he carved the design out of the wood in five stages – one stage for each color (pink, yellow, green, blue, and red). By rolling ink on to the woodblock he produced a five-color print of his finished design.

SPECIFICATION

• *Artiste*	Orchestral Manœuvres In The Dark
• *Title*	The Pacific Age
• *Design*	Mick Haggerty
• *Illustration*	Mick Haggerty
• *Record Co.*	Virgin, 1986

THE REAL THING

Rock 'n' roll stars are normally quite vain, desperately wanting to appear better to the public than they really are. It says a lot for Peter Gabriel's character that he was prepared to undergo "distortion," even within artistic terms. After all, he's not a bad-looking chap.

SLIGHTLY USED IDEAS

Peter: "I had always liked Hipgnosis' work and Storm is a very amusing man. It's always fun when you first start meeting with him. He's got this box of slightly used ideas that he tries to palm you off with. Only the difficult sods get the original creative things and everyone else gets the stuff that's been rejected. But that is a part of the game and I used to enjoy it as well."

PETER GABRIEL called his third solo album *Peter Gabriel,* which was the same title as his two previous albums – more a wry comment than lack of imagination. The title was put in under pressure from the record company. Peter would have been happy to have no title on the front.

THESE STREAKS are actually the front edges of the stairs behind Peter, which led up to Hipgnosis' studio, and are there to provide graphic contrast to the painterly technique of the rest of the cover.

TECHNIQUE

An ordinary Polaroid contains the developing chemicals between two pliable layers. On exposure, chemical processes are triggered and the image begins to appear. Pressure can be applied to the surface with a blunt instrument, and the developing chemicals will move around. At the same time, the developing image can also move – hard edges are blurred and whole areas flow into one another, creating a paintlike effect. This process was pioneered by Les Krims and the results were known to Hipgnosis as "krimsographs."

POLAROIDS

A poster was later designed using 30 different polaroids, all manipulated, some by Peter himself, with added captions of humor and interest. Peter made this suggestion on seeing all the rejected polaroids on the floor. It seemed such a pity to waste them.

PETER GABRIEL, Peter Gabriel

FOR HIS THIRD SOLO ALBUM Peter Gabriel continued a theme of self-effacing portraiture: covers with pictures of himself which were neither too clear nor too cosmetic. He was familiar with Hipgnosis' design studio, but was taken aback when they suggested that as a result of a dream one of them had had, he should appear with a dripping, melting face. This dream related to Peter's music in general, not necessarily to this specific album. He subscribed to the power of dreams, but told Hipgnosis that he didn't mind being in their dreams so long as they were not in his.

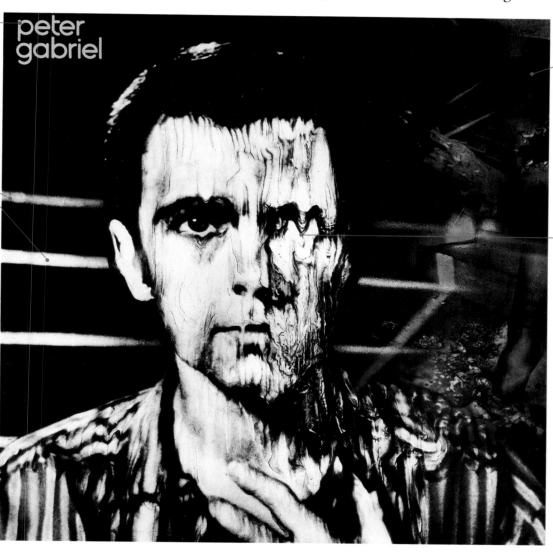

HIPGNOSIS thought the background too dull and added "dreamlike" superimpositions, including various shoes… fragments of a story only half told.

THE DEFORMED or smeared nature of the "krimsograph," or enlarged polaroid, as this technique was known, was essentially fluid and painterly, if not a little grotesque – as seen in the dripping eyes.

SINGLE DESIGN *As is often the case in music design, the central theme expressed on the album cover is extended to other peripheral items such as single bags. This design for "No Self Control" contrasts the melting face with the real one. Hipgnosis felt half satisfied with the end result of the album cover, preferring the poster and single bag in the end.*

THE ARTWORK

The original image was a color polaroid. To make the finished piece different it was re-photographed in black and white. In turn, the negative was "sandwiched" with other negatives of the images on the right-hand side to provide a finished, superimposed black-and-white print. Hipgnosis were indebted to Paul Maxon for this procedure.

car/scratch/melt

SPECIFICATION

- *Artiste* Peter Gabriel
- *Title* Peter Gabriel
- *Design* Hipgnosis and Paul Maxon
- *Record Co.* Charisma, 1980

Peter Gabriel: "There's a lot of gumph talked about identifying images. I think if you respond to an image emotionally it is likely that it will relate to the things you respond to emotionally inside the music."

DAVID BOWIE, Pin Ups

WHEN DAVID BOWIE released *Pin Ups* in 1973 it was an about-face from the previous creative work of *Aladdin Sane* and provoked the suspicion of the pop pundits. All the songs on the album were reworkings of oldies selected from the 1964–67 pop scene. The concept appeared to be rather too lightweight and not what the fans of David Bowie had come to expect from him. It was rumored that he had released this album as a contractual obligation to his record company. Bowie's career plunged into a period of uncertainty that was highlighted by the announcement of his retirement from the music business at a concert at the Hammersmith Odeon, London, in July 1973. Bowie's retirement proved to be short-lived. Unlike the careers of real pin-ups, this is a cover that does last.

VOGUE SHOOT
*Justin de Villeneuve: "Twiggy and I were in Los Angeles when **Aladdin Sane** had just been released. We heard Twiggy's name coming over the radio in David's song 'Drive-In Saturday.' I had just photographed a couple of **Vogue** covers and I thought it would be a good idea for David to*

*be on the cover with Twiggy. He would have been the first man ever on the cover. I called him in France. He loved the idea, and we arranged a photo session. When Bowie saw the finished picture he asked if he could use it for his album sleeve. I said to him, 'I've just flown to Paris for **Vogue** especially to do their cover.' Then I asked, 'David, how many albums do you sell?' He said 'about a million, hopefully.' **Vogue** would sell about 80,000 copies in the UK. I owned the picture, so I decided to let him have it. I was a little arrogant then! **Vogue** didn't talk to me for years after, they were very angry...."*

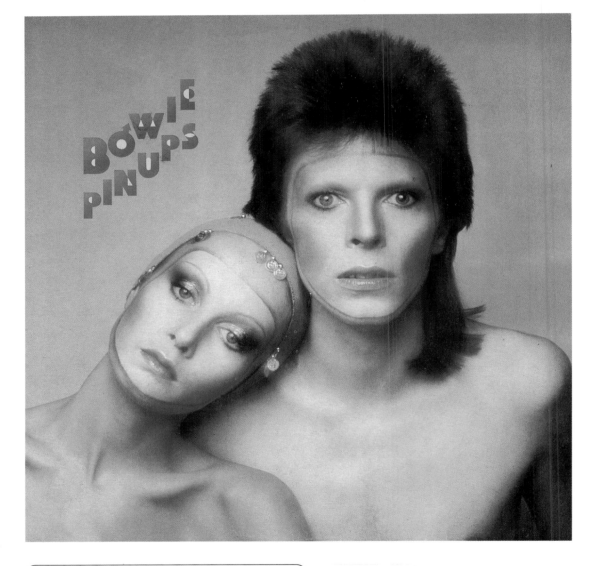

TWIGGY AND BOWIE
were sitting next to each other when de Villeneuve suggested they do a shoulders shot – then he realized how ludicrous they looked. Twiggy was tanned, as she had just returned from a vacation in the Bahamas, and David looked like the Thin White Duke with a fake studio tan. De Villeneuve and Bowie's makeup artist, Pierre Laroche, had the idea of giving them masks. It was pure makeup. He made Twiggy's face white like David's and David's face brown like Twiggy's body.

THE BRIEF
*De Villeneuve had been commissioned by Bea Miller, the London editor of **Vogue**, to photograph a cover of Twiggy and Bowie. De Villeneuve and Twiggy flew to Paris, where David Bowie was recording an album of his favorite 60s songs at Le Chateau. It was not called **Pin Ups** at that point.*

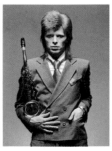

A photograph from the back cover

<div>

JUSTIN DE VILLENEUVE

Born Nigel Jonathan Davies in the East End of London, he was evacuated to a Shropshire manor house during World War II. Justin de Villeneuve is a man of many masks... he has been a boxer, a villain, a hairdresser (under the grandiose name of Christian St. Forget), interior decorator, manager, photographer, and poet. He is always reinventing himself and has made and lost many fortunes. Justin collaborated on pictures with Klaus Voorman, Peter Blake, and Alan Jones, and had his portrait painted by Peter Blake. He photographed Lartigues in 1968, and photographed the infamous Marsha Hunt "silhouette" poster.

</div>

TECHNIQUE
Justin de Villeneuve did the first shot on a Polaroid and knew then that that was the shot he wanted. He gave David Bowie a Polaroid, then shot the rest on a Rolleflex with Kodak 6cm x 6cm color transparency film.

Justin de Villeneuve: "I knew I'd made the right decision giving David the photograph when months later I was driving in Los Angeles and I saw a 60-foot-billboard of the album cover on Sunset Boulevard."

SPECIFICATION

• *Artiste*	David Bowie
• *Title*	Pin Ups
• *Photography*	Justin de Villeneuve
• *Masks*	Pierre Laroche
• *Lettering*	Ray Campbell
• *Back Cover*	Mick Rock
• *Record Co.*	RCA, 1973

LOS LOBOS, La Pistola y El Corazõn

IT'S VERY DIFFICULT for ethnic songs to break into the mainstream US Top Ten. A few have managed the crossover, and some more than once. The original Ritchie Valens 50s hit "La Bamba" is the exception. Los Lobos' version, released in 1987, boosted their career and gave them an opportunity to explore their cultural heritage with pride and conviction. Deliberately avoiding the commercial prerequisites of the record company that normally follow a hit, Los Lobos conceived an album of regional Mexican music, with a Spanish title. A brave and romantic notion depicted brilliantly by the painting on the front cover. Border crossing? Music and art transcend the north/south divide.

MEXICAN MUSIC
Los Lobos' Louis Perez: "After our huge number one success with 'La Bamba' we thought it would be a great opportunity to record an album of regional Mexican music. It would give Mexican music worldwide exposure. We explained our idea to the president of Warners Bros. who thought we were crazy – but said if that's what we really wanted to do, OK, go do it. We decided to write an original song in the same traditional style as the others and this became 'La Pistola y El Corazõn.' George Yepes, the painter, was a childhood friend of mine from East LA and he was the perfect choice for the cover art."

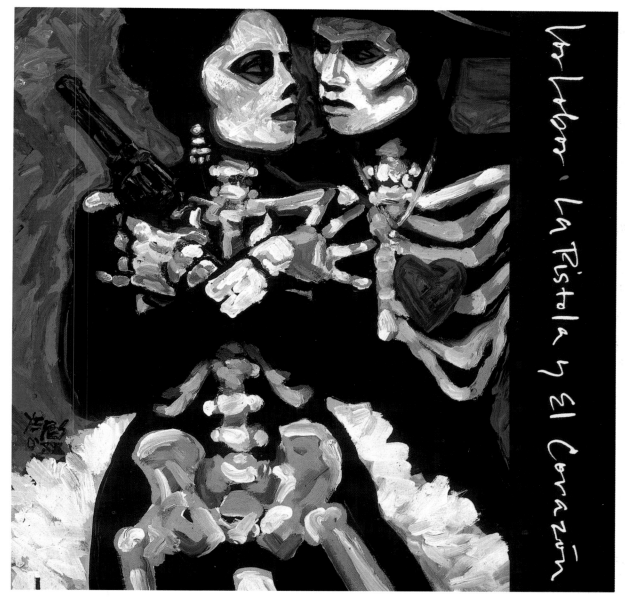

ACRYLIC PAINT
The painting was done in acrylic paint on artist's canvas sized approximately 20in x 30in. The artwork was put together in the traditional way. First, full-size roughs were created with color photocopies, Pantone papers, and PMTs. Then the finished artwork was constructed with film overlays, positional guides, and type.

TITLE SONG
"La Pistola y El Corazõn" was an original song telling the story of lost love… Mexican cowboy style. The title translates as "The Pistol and the Heart."

LOUIS PEREZ:
"The lyrics of the title song were influenced by the writings of Louis L'Amour – popular adventure/romance novels of the American West – [it is] a love story with the guy riding off into the sunset. I also wanted to make the cover more Mexican by adding images from the Day of the Dead."

THE TYPOGRAPHY
was based on Jeri Heiden's handwriting. The lettering is fluid and complements the style of the painting.

THE DAY OF THE DEAD
Falling on November 1 each year, The Day of the Dead (El Dia de los Muertos) is when Mexicans visit cemeteries to decorate the graves of family and loved ones with flowers, food, and photographs.

JERI HEIDEN
Jeri Heiden is senior vice president of creative services for A & M Records in Hollywood. She was formerly vice president of creative services at Warner Bros. Records. Heiden has received three Grammy® nominations for her album package design.

SPECIFICATION
- *Artiste* — Los Lobos
- *Title* — La Pistola y El Corazõn
- *Design* — Jeri Heiden
- *Artist* — George Yepes
- *Record Co.* — Slash/Warner Bros., 1988

GEORGE YEPES
George Yepes was born in East LA. He grew up as a neighbor and friend of band member Louis Perez. He worked in the financial world, but in his spare time became a member of Los Streetscapers, a group of muralists in LA. They went on to receive many corporate commissions. George received critical attention from this cover and it invigorated his art. He concentrated on his painting more and got himself an agent and a gallery. It is believed that he is still a painter, but his whereabouts today are unknown.

BJÖRK, Post

IT WOULD BE CHURLISH to exclude from serious artistic consideration all portraits of recording artists. In most instances the portrait appears on album covers because it is deemed relevant, glamorous, satisfying to performer's egos or so-called commercial criteria, and can therefore be safely passed over. One looks instead for qualities that render the portrait more universal; then it doesn't matter who the subject actually is. For Björk's album *Post* the designer Paul White and photographer Stephane Sednaoui have captured at least three aspects that raise it above the norm. There is a wistfulness and softness to the artist's expression that suggests vulnerability and maybe even an unspecified longing or sadness. There is by way of contrast the unexpected choice of

garish colors, (the orange/pink/puce spectrum is notoriously difficult to carry off), and it is both eccentric and brave to use them, adding further depth and mood to Björk's character. There are blurred but interesting details behind her, which the inquisitive mind is invited to explore – not intrusive, nor deflecting our gaze from her face, but surrounding her and affording presumably a glimpse into her private or inner world. And then there is a dash of humor in the airmail edging to her jacket, as if she were herself ready to be "posted." These aspects are welded together with unusual but stylish typography to provide not just a portrait of Björk – bizarre singer musician-type person and elf-lunatic from Iceland – but also a moving and curious image.

THE BRIEF
Björk doesn't get too involved in the creative process of her cover designs. Once she's sure that her feelings toward each project are invoked in the essence of the designer's idea, she trusts them to go ahead and do it. Paul White has never heard her say "this should go here" or "move that" or "change that font." She believes in allowing the designer to contribute their own ideas, whatever it is that they do.

WISH YOU WERE HERE
*The motivation behind the cover for **Post** was Björk's desire to be surrounded by her possessions from home. She felt very isolated from everything in Iceland while recording the album, and this came through strongly in the music and lyrics. She was away from her friends and family and communicating with them via messages. There was no one-to-one contact. **Post** was about her state of mind – a sense of isolation, of posting her feelings. It was about remote communication by mail, and a sense of awe and surprise at the changes and activity in her life after the success of her first album.*

ONE LUMP OR TWO?
As one of the founders of One Little Indian and the label's main designer for their early releases, Paul White's working relationship with Björk stretches back to her stint as vocalist with The Sugarcubes. He had designed their cover artwork and continued once she went solo. They first met at a party in Iceland in 1987, and became firm friends. Paul White confesses they have "a special relationship – she has faith in my work."

AFTER DECIDING ON a cover shot of Björk surrounded by her possessions, she and Paul White spent an afternoon at her house looking at her things, pulling bits and pieces out that they felt they could use. The items were intended as symbols of her isolation, things from home that were important to her. However, driving home, Paul White hit upon the idea of building an environment around her that would be a kind of house of cards made from postcards – these would represent her messages to others, the symbols of her communication in isolation. It was then decided to scrap the possessions idea. They selected images for the house of cards and decided that this background was to be static, while Björk was to be moving. On the day of the photo shoot, it was decided that it would be more effective for Björk to remain static while the objects moved around her.

THERE ARE many interesting details hidden in the background of the cover – this strange child-like face, for example.

SPECIFICATION

- *Artiste* Björk
- *Title* Post
- *Design* Paul White at Me Company
- *Photography* Stephane Sednaoui
- *Record Co.* One Little Indian, 1995

APPLES AND ORANGES
The cover photograph was partially manipulated and re-touched on an Apple Macintosh using Adobe Photoshop. Color saturation adjustment in Photoshop was used to amplify and intensify the colors. Paul White says he wanted it to be lush and rich with lots of orange, because he felt that this color matched the personality of the album.

BJÖRK'S LOGO
For Björk's logo and the text, designer Paul White chose to use a computer-modified version of DIN, the typeface used for German road signs, because he says it has freshness, cleanness, and a sense of honesty about it.

LOCATION AND PHOTO SESSION
The photographer, Stephane Sednaoui, was chosen by Björk. Stephane decided that the photo session should take place outdoors. A city street near the Bank of England in London was cordoned off with vans and trucks. The house of cards and personal possessions were hung up around Björk so that they would flutter in the breeze.

FIRST DAY COVER
*The first 50,000 copies of the **Post** CD were issued in a clear plastic wallet that Paul White likens to a "little girl's purse" (see left). A poster was also included, which had the cover photograph on one side and more of the lavish orange and pink lily pond shots (incorporating flowers modeled by Martin Gardiner) that appeared in the CD booklet and on the back of the vinyl cover. Paul White included these extras because "at Me Company, we believe in the importance of the package as a whole – we wanted to give the buyer something special, something tactile and interesting in the tradition of Barney Bubbles' work for Hawkwind and Hipgnosis' **Wish You Were Here** package for Pink Floyd."*

ICELANDIC GEISHA
*Paul White at Me Company also designed the cover for Björk's album **Homogenic**.*

SHOOTING THE BREEZE
A wind machine was used to create a breeze to ruffle Björk's hair and to make the suspended cards and objects move.

THE JACKET ON THE SLEEVE
Designed by award-winning, London-based clothes designer Hussein Chalayan, Björk's white jacket with its red, white, and blue "airmail braiding" was the final touch. In effect, Björk was posting herself through the cover and the music.

PAUL WHITE
Paul White began his career as a freelance designer and was one of the founders of the record company One Little Indian. Paul produced all the design work for One Little Indian before starting Me Company in 1986. Initially he worked exclusively for the music business, but he has since diversified into advertising (Nike and Diet Coke), producing store concepts for Apple and Mercedes, corporate identities for Fuji TV in Japan and for Unilever. Paul has recently produced a video for Björk.

NEW ORDER, Power, Corruption & Lies

JOY DIVISION HAD AGREED to change the name of the band should any member leave. With the death of Ian Curtis they reinvented themselves as New Order. The direction of the band began to change, techno dance rhythms were introduced, the single "Blue Monday" from *Power, Corruption & Lies* went on to sell more than a million copies. Despite their commercial success, they continued to communicate an identity that was both subversive and intriguing, through the visual language of art director Peter Saville. Techno Flower-Power, corruption, and lies.

SOMETHING SINISTER
*A chocolate-box painting of roses combined with the title **Power, Corruption & Lies** – it's so perverse: behind those flowers there must be something more sinister. There had been Flower-Power in the 60s, but since then flowers hadn't really figured in pop culture at all, and Peter Saville thought it was time that they did.*

THE CODE APPEARS
on the front of the cover giving the catalog number FACT 75. Running the length of the inner sleeve is a strip bearing the words "Power, Corruption & Lies" and "New Order."

THE BRIEF
*Peter Saville: "The band decided on the title **Power, Corruption & Lies** and I quite liked it. I wanted a kind of Machiavellian image for the cover, as I was reading about the Borgias at the time. I continued with the postmodern ideas of Joy Division and chose a piece of classicism juxtaposed with the computer technology aesthetic of the album's music."*

THE COLOR CODE
*Peter Saville created a color code for New Order's "Blue Monday" single sleeve and used the same code on this album. He turned the alphabet into colors and worked out nine sets of color tints. He assigned colors to letters and combinations of colors to letters and numbers, then spelled the words out. On the back of the cover there was a color wheel made up of the process colors used to print the sleeve – the rose colors. Around the outside were 26 subdivisions of tints. Fans of the group figured out that it represented the alphabet. The **NME** received two letters pointing out spelling mistakes on the cover.*

THE NATION'S ART
Peter Saville picked up a postcard of Henri Fantin-Latour's floral still life at the National Gallery in London. When he phoned the gallery to get permission to use it, he was told it would be fine to use the painting as long as he didn't overprint any type or crop the picture in any way. The gallery then called back to say that they had lost the transparencies of the painting and would not be able to let him photograph the picture as it was out on loan. There was no way they would be able to give Peter the material he needed for the artwork. Weeks passed. Deadlock.

Finally, Factory Records boss, Tony Wilson, called the National Gallery. Brick-wall bureaucracy met brute determination head on. Unfazed by their stonewalling, Wilson asked the gallery representative just who owned the painting? "The British public" was the reply. "Well, the British public want to use it on a New Order album cover." It worked.

IRRELEVANT TITLE
*Steven Morris of New Order usually gave the band a list of song and album titles that had nothing to do with the songs. **Power, Corruption & Lies** was one of his suggestions.*

PETER SAVILLE
Peter Saville was born in Manchester, England, in 1955 and graduated from Manchester Polytechnic in 1978 with a BA in graphic design. He was a founding partner of Factory Records and collaborated with interior designer Ben Kelly to create The Haçienda Club. During the 80s, Peter established Peter Saville Associates. In 1990, he became a partner at Pentagram Design in London and, in 1993, creative director at Frankfurt Balkind, Los Angeles. Peter established a London office for German agency Meire und Meire in 1995. His clients have included Joy Division, New Order, Roxy Music, Ultravox, Paul McCartney, George Michael, Suede, Pulp, and Goldie. He has also worked for Christian Dior, Estée Lauder, Jil Sander, and on the "smart car" for Swatch/Mercedes Benz. He is now a guest speaker for the British Council, promoting the best contemporary British design.

IN ON THE SECRET
A psychological observation on cult music fans – an article entitled "The Mass-Produced Secret" – was published in The New York Times. It described how fans pride themselves on being in on a secret, even though the product may have been produced in huge quantities.

SPECIFICATION
• *Artiste*	New Order
• *Title*	Power, Corruption & Lies
• *Design*	Peter Saville
• *Painting*	Henri Fantin-Latour
• *Record Co.*	Factory, 1983

LED ZEPPELIN, Presence

THE DESIGN FOR *Presence* was inspired by the power of the music, but fueled by a particular anger. The power was not nameable – dark and intense, and capable of submerging the listener. Not to be represented in corny fashion with light beams from the sky or by loud images of tanks or cathedrals, gushing floodwater, or massive airships. Instead, something more persuasive and more ubiquitous. A contained power object seen in all walks of life, exposure to which sustained the very essence of being. A cosmic mind battery, recharging and controlling our lives. This insidious scheme was given shape and form by a loathing of borrowed images, usually from the past and not originated for the music. Hipgnosis vented their spleen by contaminating such old pictures with a foreign object. A black power object, no less.

EVERYONE NEEDS Led Zeppelin's music. Everyone needs a black object. At work and in the home. An object, in fact, from the past, often found in old pictures. So powerful that it exists in the memory, and is no longer needed in the flesh. So powerful it doesn't need to be actually there. An object which was in fact a hole. An object-shaped hole. An absence, not a presence.

THE OBJECT
George Hardie made a prototype out of cardboard and black velvet, but this initial design was rejected by Jimmy Page as being too ordinary. George then redesigned it and gave it a slight twist. The final object was made by model-maker Crispin Mellor. Only twelve objects were ever made, each was numbered on the base and made from a hard resin material.

PRESENCE
The title came after the design and referred to the overwhelming presence of Led Zeppelin's music, the presence of the black object in everyday life, and an ironic play on the fact that, technically speaking, the object is absent. The type on the cover is embossed, hardly present at all.

THE BACK-GROUND
was The Boat Show, held annually at Earls Court, London. The family was photographed separately in Bow Street Studios, London.

DEPTH CUE
Close scrutiny of the edges of the so-called object reveal an absence of shadow or light variations, implying it has no solidity. However, the object shape is altered in some instances, as seen on the inner spread, to coincide with objects or hands placed in front of it, suggesting it is behind them… and so has solidity after all.

HEADS ROLLED
As a publicity exercise of grandiose proportions, one thousand black objects were going to be placed simultaneously, and secretly, outside locations such as 10 Downing Street and the White House. On March 6, 1976, the day before the proposed event, the cover was featured in Sounds, scuppering the whole plan. Cronies of manager Peter Grant hammered on the front door of Aubrey Powell's house at 4.00 am demanding the artwork. It was, thankfully, in New York at Atlantic Records. The culprit at Atlantic Records' press office who had leaked the cover design was dismissed the next day.

DELIBERATELY DATED
The photograph is a composite (a dye transfer strip-in) of two pictures, one of the family, shot in a studio, and the other, the background, shot on location. The style is deliberately dated, the mood informal yet stilted. All the ingredients were carefully rendered to look like a photo-library picture from the past, an old photograph which was then "messed up" by painting the black object shape directly on the finished photoprint. It was shot on a Hasselblad camera with a 50mm wide-angle lens using normal color transparency film with flash lighting.

SPECIFICATION
- *Artiste* Led Zeppelin
- *Title* Presence
- *Design* Hipgnosis and George Hardie
- *Photography* Aubrey Powell and Peter Christopherson
- *Record Co.* Swan Song, 1976

A DREAM HOTEL
One night, Aubrey Powell of Hipgnosis dreamed that he was summoned to meet Jimmy Page in a tall, black-glass building. He awoke in a cold sweat thinking his wife had turned into a goat. Later, he went to Munich to present the album cover roughs to Led Zeppelin. They were staying at the Hilton Hotel – it was a tall, black-glass building.

THE 13th FLOOR ELEVATORS, The Psychedelic Sounds Of...

THE OUTRAGEOUS EXPLOSION OF COLORS, shapes, and unreadable lettering that visually characterized the psychedelic events of the mid-60s does not always last so well. Many of the psychedelic album covers were not so great – the posters were generally more interesting – and some were eminently forgettable. But not this one. A dynamic amalgam of clashing colors (red and green eye-blasters), childlike shapes, powerful, wavy diagonals, and mystic ingredients raise this cover above most others. It is wild at the edges, yet still and focused in the center. Painted with the verve and flourish that epitomize the era, it speaks, or rather shouts, for the music, for a generation, and for an ideology. It says so in the sleeve notes.

JOHN CLEVELAND
Clementine Hall, wife of band member Tommy Hall, recalls that designer John Cleveland was a close friend who they met at the University of Texas. Hall says "I asked John Cleveland to do a painting that might be used as the cover, but I had no input at all into the art."

MENTAL STATES
Tommy Hall is responsible for this perception-altering text on the flip side of the cover: "Recently, it has become possible for man to chemically alter his mental state and thus his point of view (that is, his own basic relation with the outside world, which determines how he stores his information). He can then restructure his thinking and change his language so that his thoughts bear more relation to his life and his problems, therefore approaching them more sanely. It is this quest for pure sanity that forms the basis of the songs on this album."

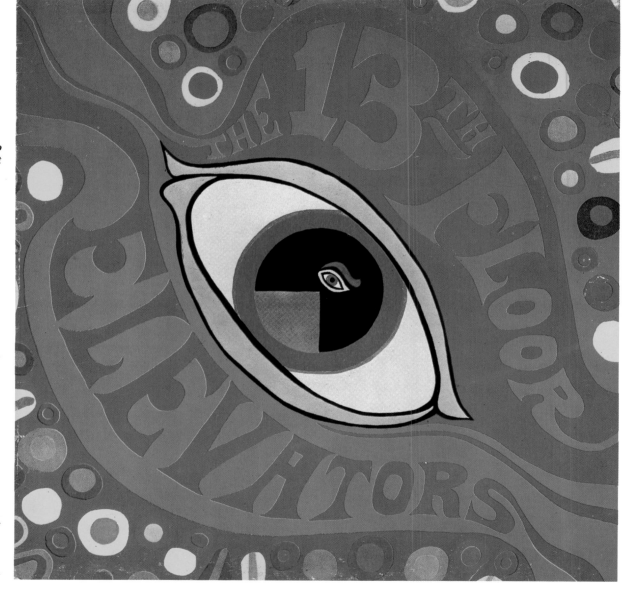

THE ELEVATORS
The band were well-known for their advocacy of hallucinogenic drugs – it's said that vocalist Roky Erickson took LSD more than 300 times, and the entire band was put on probation after being arrested in 1966. Clementine Hall says they were the first band to drop acid on stage: "In most recordings and rehearsals we turned on to LSD. You can't get more psychedelic than that."

A SYMBOL of mysticism, the pyramid seen within the big eye on the cover was originally used as a graphic on the band's drum kit. Clementine Hall explains that the pyramid was "imaged from the US dollar bill. It had a spiritual meaning, the 'In God We Trust' that goes with it on the dollar."

The eye of the storm. The eye of Horus. The third eye. The eye as the window of the soul. An eye within an eye. An eye for an eye.

THE 13TH FLOOR ELEVATORS

One of the earliest psychedelic rock bands (though they hailed from Austin, Texas, rather than San Francisco), The 13th Floor Elevators lay claim to being the first to advertise themselves as a psychedelic band, preceding even The Grateful Dead by two weeks. Their name was heavily symbolic of the times – the thirteenth letter of the alphabet being M (for marijuana), and as few US buildings have thirteen floors for superstitious reasons, the name implied that if you wanted to reach a new and untried level of consciousness (the thirteenth floor) you'd better travel by a different chemical route, and you'd better buy the record.

SPECIFICATION

- *Artiste* The 13th Floor Elevators
- *Title* The Psychedelic Sounds of The 13th Floor Elevators
- *Painting* John Cleveland
- *Record Co.* International Artists, 1967

HAIGHT IS RIP?
A similar artwork to the cover later appeared as a poster in San Francisco with different wording. However, Clementine Hall is certain that John Cleveland's cover art came first... "It was entirely his own and was absolutely original."

THE TUBES, Remote Control

SAN FRANCISCO-BASED BAND The Tubes were trying to execute a project with creative maturity. As the Monty Pythons of rock, who'd had a hit with "White Punks on Dope," they had already explored all possibilities of rock 'n' roll excess and showbiz extravagance. They felt it was time to incorporate their theatrical and musical skills into a "theme" production – the concept album. The cover represents TV as America's pacifier, the eternal babysitter. The concept is that young babies learn all about life from the "boob toob."

THE BABY
The model was Leighton Farr, the son of Ricki Farr, The Tubes' manager.

VIDIOT
*The original title of the album was **Vidiot**, but it was later changed to **Remote Control**. This era was pre-MTV and the band's message was that TV rots your brain.*

PRAIRIE PRINCE:
"We hit upon the concept of using a baby to represent a 'TV child.' We imagined an infant abandoned in the city. The first tests were at a Hollywood bus station featuring TV viewing chairs in the waiting room. Then Jeff Ayeroff suggested utilizing a child's safety seat."

PROPMAKER
The Vidiotchair was designed by Cotten and Prince and built by Dave Butchmatic Mellott and Matt Leach. Mellott is pictured here at the Hollywood bus station.

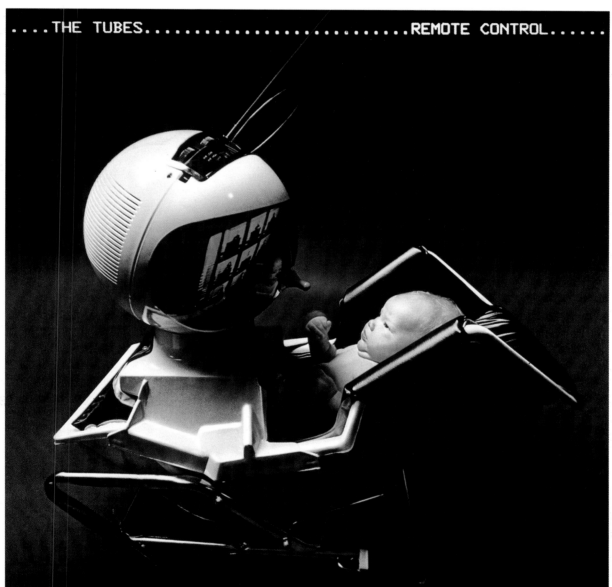

....THE TUBES........................REMOTE CONTROL......

MICHAEL COTTEN
of The Tubes: "The album cover was created at a time when The Tubes at last decided to live up to their name and design a project based on 'TV babies.' The album, which was co-written with producer Todd Rundgren, traced the development of an idiot savant child whose entire experience of growing up was confined to what he saw on a TV screen."

THE TV SCREEN
is showing *Hollywood Squares*. The band shot the image on the set of *Hollywood Squares*, with Merv Griffin on set, and used their names as those of the guests.

SPECIFICATION

- *Artiste* — The Tubes
- *Title* — Remote Control
- *Art Direction* — Roland Young
- *Design* — Michael Cotten & Prairie Prince
- *Photography* — Jim McCrary
- *Cover Co-ordination* — Chuck Beeson
- *Concept Co-ordination* — Jeff Ayeroff
- *Record Co.* — A&M, 1979

REJECTED TITLES

1. **To Stupid To Live**
2. **TV Face**
3. **Thinks TV**
4. **Boob Tubes**
5. **Boob TV**
6. **Ontro**
7. **The Tubes Wee Wee Ga-Ga**
8. **Vices And Visions**
9. **KVPC (Kiddie Viddie Pleasure Center)**
10. **Tubes No.5**
11. **Tubes On**

BOOB TUBES

MICHAEL COTTEN AND PRAIRIE PRINCE

*Michael Cotten and Prairie Prince have worked together for over 20 years. They were the founder members of The Tubes and have also worked as exterior and interior designers, creating murals, theatrical productions, and graphic and video arts. Their clients include Chemical Bank and Macy's and their work has appeared in **Architectural Digest**, **Interiors**, and **Domus**. They have designed sets for Michael Jackson, Porsche, Compaq Computers, and McDonald's. They have recorded ten albums as The Tubes and designed album covers for Journey, Todd Rundgren, and Jefferson Starship.*

WES MONTGOMERY, Road Song

HOW APPROPRIATE THAT THE DESIGNER of jazz guitarist Wes Montgomery's *Road Song* made the photograph his priority. For this is one of the world's great photographs. It is very rare for geometry – a predominantly cool aspect – to combine so effectively with emotion – a predominantly hot aspect. The composition is simple and exquisite; slowly and gracefully the fence leads the eye via a generous sweep to the taillights of a car in the distance… Is the car parked? Or about to depart? Is it waiting for someone, or leaving something behind? A story is suggested but not told. The overall mood is of longing, with a hint of mystery. The adroit use of an extremely wide angle, more usually a sensational device coupled with the early evening light, haunting rather than sentimental, completes the faultless image… made more poignant by the title. And made still more poignant by the untimely death of Wes Montgomery shortly afterward. This record and this image are a last farewell. One for the road. A road song.

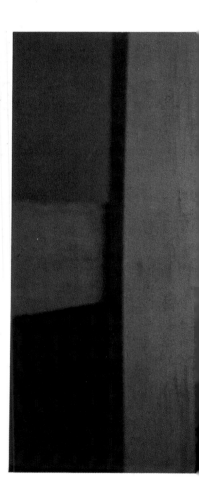

ROAD SONG
GREENSLEEVES
FLY ME TO THE MOON
YESTERDAY
I'LL BE BACK
SCARBOROUGH FAIR
GREEN LEAVES OF SUMMER
SERENE
WHERE HAVE ALL
 THE FLOWERS GONE?

IT SAID ROAD TO ME
Already familiar with his photographs, **Road Song***'s producer Creed Taylor hired Pete Turner for all of the CTI/A&M jazz covers (CTI stands for Creed Taylor Inc.). Turner would present a selection of images that he thought might be appropriate to the title, and Taylor would take his pick. Though he often chose images that had "nothing to do with the title" according to Turner, in this case he felt that "the fence did seem appropriate, especially because of the car taillights, which said 'road' to me."*

THIS WAS ONE of the first CTI releases with a gatefold format with the photo continuing on to the back cover. Sam Antupit: "A gatefold uses the full 35mm frame of Pete's picture. It's a perfect photograph, and we didn't want to crop one hair of it or make it just a flat image… it came before anything else."

CTI COOL
Designer Sam Antupit: "The idea was to make the CTI sleeves as unlike the rambunctious, full-bleed stuff in the jazz bins as we possibly could – we wanted a layout that was really 'cool.' The covers aimed to convey the inherently measured and succinct image of jazz."

SPECIFICATION
- *Artiste* Wes Montgomery
- *Title* Road Song
- *Design* Sam Antupit
- *Photography* Pete Turner
- *Record Co.* A&M/CTI, 1972

THE CAR LIGHTS
The car was nothing special. It just happened to be part of the traffic coming and going to and from the airport. Pete Turner wanted other shots with cars so he waited for another car to come along, this time with the headlights coming toward the camera. The taillight shot was chosen for the cover as it looked more evocative.

PHOTOGRAPHER PETE TURNER took the photograph for Montgomery's album some years before it was actually used: "The cover photograph for Wes Montgomery's *Road Song* was taken with a Nikon F camera with a 20mm wide-angle lens in Kansas City in 1967. The fence was along the edge of the airport and I saw it as we landed at Kansas City airport. I made a note of it and went back there another time after finishing another shoot. It was very new and looked great through the wide-angle lens."

THE CAR WAS ONE OF MANY that happened to be driving along the airport perimeter fence. Pete Turner says: "I set up the photograph to take advantage of cars passing by. The idea was to work through the best light of sunset and dusk with a lot of variations. In some cases the cars were closer to the camera, but the best results were when they were far away."

SAM ANTUPIT

*Based in New York, Sam Antupit has worked as a designer at **Harpers Bazaar**, **Show**, **House & Garden**, **Mademoiselle**, and **Vogue** magazines, and produced the formats for **The New York Review of Books** and **Art In America** as well as **Harpers** and **Ms** magazines. He was art director at **Esquire** between 1964 and 1968 and again in 1977. He served as director of design at fine art publishers Harry N. Abrams from 1981 to 1995, and on leaving he established Common Place Books and has served on the boards of the American Institute of Graphic Arts and Documents of American Design.*

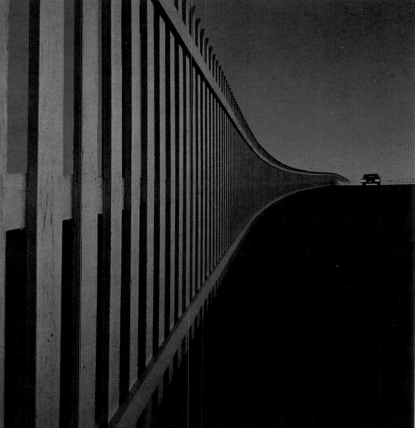

STEREO A&M SP 3012

WES MONTGOMERY: ROAD SONG

A&M RECORDS

CTI

ARRANGED BY DON SEBESKY

ART PRODUCTION

The cover was put together by Sam Antupit using the conventional artwork process – a pasteup on artboard with overlays for type and a composition trace for dropping in the photographs. Sam recalls that while doing the mechanical artwork during his lunch break at *Esquire*, "My editor walked past, looked at it and said 'Wow – that's going to be the best magazine cover we've ever had.' Guiltily, I had to admit to him that I was moonlighting, and they weren't too upset."

ENIGMATIC
Sam Antupit comments "I like the way the taillights make the picture feel enigmatic – you don't know if the car is moving or stopped. We drove the printers crazy because we were very insistent over how we wanted the lights to look. We wanted to keep them clear but not too bright, but the printer kept making them look like lollipops. We proofed the cover three times at the printing stage."

THE SHOT THAT photographer Turner took was "not retouched or manipulated, but the use of a wide-angle lens does enhance the perspective and thus the drama. Photographing at dusk meant that it has that wonderful blue color you see at that time of day. I also used indoor film, which tends to add more blue than normal daylight-balanced film."

PETE TURNER

*Pete Turner began his photographic career with a six-month expedition to Africa for **National Geographic** in 1959. His extensive body of work has included: photographing Elizabeth Taylor and Richard Burton on the set of **Cleopatra**; exhibitions at the Museum of Modern Art in New York and in galleries in Europe, Asia, Australia, and South America; advertising campaign photography for Esso, BMW, Philip Morris, Bell Atlantic, and United Airlines; and record sleeve shots for Steely Dan and George Benson, among others. His photographs are in numerous permanent museum collections, and he has received more than 300 design and photography awards, including the Outstanding Achievement in Photography Award from the ASMP. His lifelong fascination with Africa is developed in his forthcoming book, **God's Ears**.*

ONE OF SIX THINGS
*"I loved that album. There are six things that I'm eternally proud of having done in my career and **Road Song** is one of them – it's so evocative of the title and music. It was a joy of a project." – Antupit*

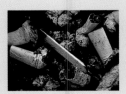

PETE TURNER'S *photographs were used on two other CTI releases by Wes Montgomery – **A Day In The Life** and **Down Here On The Ground**.*

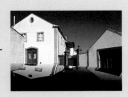

"SAM CAME UP with this layout, which we used many times for various artists who released albums on CTI. Creed and I both liked that layout – it also allowed us room to do a portrait of the artist on the back" – Pete Turner. Designer Sam Antupit took pains to respect the integrity of Turner's photograph: "I knew I'd never want to crop one of Pete's photographs, so showing them in the best possible light was the first consideration."

THE BEATLES, Sgt. Pepper's Lonely Hearts Club Band

IT WAS A TIME TO GET HIGH. It was a time to do your own thing, because you could. The Beatles could, and they did. The *Sgt. Pepper* album took months to record, and the cover took weeks to prepare. The result was one of the finest albums ever produced, with probably the most memorable album cover to match. Initiated by Paul McCartney, the idea became a team effort. Input came from all quarters. From the gallery owner to the photographer, from the group to the painter, from the studio assistants to Dutch art group The Fool, from the drugs to the cardboard cutouts. The whole show was orchestrated by pop artists Peter Blake and Jann Haworth. As Sgt. Pepper said "A splendid time is guaranteed for all."

IN THE BEGINNING

Paul McCartney's initial sleeve concept was of The Beatles standing in an Edwardian sitting room in front of a wall covered with framed photographs of their heroes. One of his pen-and-ink drawings shows the four Beatles, all sporting mustaches, wearing long military band jackets complete with epaulettes, holding brass band instruments. Among the photographs on the wall are trophies and shields and a pin-up poster of Brigitte Bardot. Further drawings had The Beatles in front of a big floral clock surrounded by lots of friends and dignitaries. Gallery owner and Beatles confidante Robert Fraser suggested that they employ a "real artist" to produce the sleeve, and proposed Peter Blake.

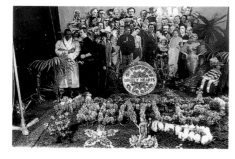

LOCATION

The photo shoot took place at Michael Cooper's Chelsea studio, 4 Chelsea Manor Studios, Flood Street, London, on Thursday, March 30, 1967.

PHOTOGRAPHY

The shot was taken using a 5in x 4in Sinar Monorail camera on Kodak transparency film. The lighting was electronic flash made by Strobe Lighting Ltd. One large "fish fry" unit bounced light off the sloping ceiling and two long units, used as fill-in on either side, were connected to a floor-standing power unit of 5000 joules. This gave a huge amount of light.

SPECIFICATION

- *Artiste* The Beatles
- *Title* Sgt. Pepper's Lonely Hearts Club Band
- *Design* MC Productions and The Apple
 Staged by Peter Blake and Jann Haworth
- *Photography* Michael Cooper
- *Record Co.* Capitol/EMI, 1967

MAE WEST'S comment when asked to agree to her appearance on the cover was "What would I be doing in a lonely hearts club?" When the concept was explained to her she agreed.

THE PRODUCTION

Nigel Hartnup, Assistant: "My job, along with old college friend Trevor Sutton, and studio assistant, Andrew Boulton, was to find photographs of all these people and make photographic life size copies, and color them to Peter Blake's specification with special tints and dyes. They were then mounted onto hardboard and cut out. It was an enormous task. It all became very silly when waxworks of The Beatles and Sonny Liston arrived from Madame Tussaud's.

Everyone started bumping into each other thinking "are they real or are they a cutout?" On the day of the shoot, the small studio was getting packed with hangers-on treating it like a party, filling the place with hash smoke, and we couldn't hear one another. Finally I blew my top and threw everyone out until we were ready. I think a few feathers were ruffled but I was in no mood to care. A very stoned Michael Cooper finally realized that the set was not going to work. Lights were reflecting off the cutouts, and I had to stand on a stool with my head jammed in the corner of the ceiling in order to see the camera back, shouting 'Tilt Aleister Crowley back, shift Bob Dylan to the left, tip Fred Astaire up, Marilyn Monroe a bit more forward' – it was bizarre."

AND IN THE END

When asked recently about the cover, Ringo's comment was "I suppose I must have been there because I'm in the photograph. Ask Paul, it was really his thing."

ONE OF THE many myths about the cover was that these were marijuana plants. Although there was a lot of the stuff smoked on the day of the shoot, these were not dope. They were, in fact, your garden variety *Aucuba japonica variegata.*

FUEL FOR THE "Paul is dead" myth were writer Stephen Crane raising his hand over Paul's head in a blessing (he's not, he's waving at us) and roadie Mal Evans supposedly standing in for Paul on the back cover.

THE AUDIENCE OF HEROES

Peter Blake suggested an imaginary audience standing behind The Beatles, and this developed into the idea of a sculptural collage. Everything was done by consensus between The Beatles, Robert Fraser, Peter Blake, and his then wife, artist Jann Haworth. Each drew up a list of characters. Paul's ranged from Fred Astaire to William Burroughs, George's were all Indian gurus, John's included Jesus, Hitler, and Gandhi. Jesus was dropped due to US anger over John's "Jesus/Beatles" statement. Hitler was discarded at the last minute and, under pressure from EMI, they removed Gandhi from the list. Ringo said he would go along with everybody else's list.

ACTOR LEO GORCEY
was originally in this space but was painted out because he requested a fee.

CHECK PLEASE!
The money men at EMI were horrified when they saw the bill for the sleeve. Their usual budget for a record cover photograph was £25, perhaps rising to £75 for an act as big as The Beatles. Copyright and retouching fees for the cut-out figures came to £1,367.13s.3d. Robert Fraser and Michael Cooper's fees amounted to £1,500.12s.0d out of which Peter Blake was given a mere £200.

THE ROLLING STONES
shirt had been given to Michael Cooper by a New York radio station for his son Adam, and was put on a Jann Haworth doll to dispel any notion that The Beatles and The Stones didn't get on well. Later that year when Michael did the cover for The Stones' *Satanic Majesties* album, he hid four pictures of the Beatles in the undergrowth.

"MY DREAM CAR at the time was a Marcos and a friend had given me a toy model of one as a joke, so I placed it in the doll's right hand." – Nigel Hartnup

THE BUST was taken from John Lennon's garden and was later used as the basis for the Peter Blake portrait of Sgt. Pepper, which appeared on the insert.

In the end The Fool produced a wavy design for the inner sleeve which fitted in well with the rest of the package.

THE INNER SPREAD
The Beatles hired Dutch art group The Fool to paint a scene for the inner spread. Robert Fraser told The Beatles it wasn't very well painted. Paul: "We said, tough shit, it's our record, you may be our consultant, man, but it's not your record and The Beatles want it. We resisted for quite a few days. I've since seen it and I know he was quite right."

PASTICHE

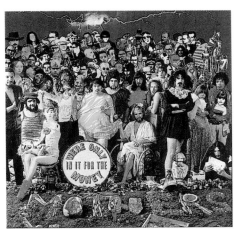

Frank Zappa and The Mothers of Invention satirized the album cover with their own, which came out in 1968 and was entitled **We're Only In It For The Money**. *The Fab Four were allegedly not amused. In Zappa's version the name Mothers was spelt out in carrots and melons. Such notables as Lee Harvey Oswald and Rasputin lurked in the background and The Mothers of Invention were dressed in drag.*

Sgt. Rutter's Darts Club Band *was The Rutles parody, produced for Eric Idle's TV show* **All You Need Is Cash** *– a direct spoof on the life and times of The Beatles. The sleeve used the Michael Cooper photo and The Rutles' faces were stripped in over The Beatles and their waxworks. The drum and flowers were retouched accordingly.*

BOW WOW WOW, See Jungle! See Jungle! Go Join Your Gang…!

IT'S NOT ALWAYS EASY to put your finger squarely on why you like something. *See Jungle!* has a distinctive quality that sets it apart despite what might appear as detracting elements such as the very flowery clothes, or the rather muddy apology of a lake; the crass publicity-seeking nudity, the garbage in the foreground, or the dull rowboat in the background; or an overstated homage to a famous 19th-century painting now full of obnoxious blokes. So what's its secret? It could look like an amateur operatic society dress rehearsal by a drab suburban pond, but somehow it doesn't. Instead it looks magical. Decadent yet peculiar. Incandescent. Is it the lighting? Is it her gaze, directed away from her colleagues and focused on us, the viewers? What is she thinking? What are we thinking? Are we thinking, "why does this image work so well?"

GIVE ME THE MANET

Bow Wow Wow had used a novelty flip-top cover for a pro-home taping song called "C30 C60 C90 GO!" and Malcolm McLaren wanted something equally arresting for the album. He had the idea of appropriating an old painting, and considered several, including **Liberty Leads The People** *by Delacroix and* **The Bolt** *by Fragonard, both of which had an underlying sexual element, before deciding on*

Manet's **Déjeuner sur l'herbe***. The aim was to shock, and likewise, when* **Déjeuner sur l'herbe** *was painted in 1863, it was considered immoral to have two clothed male artists discussing the female form next to a naked woman.*

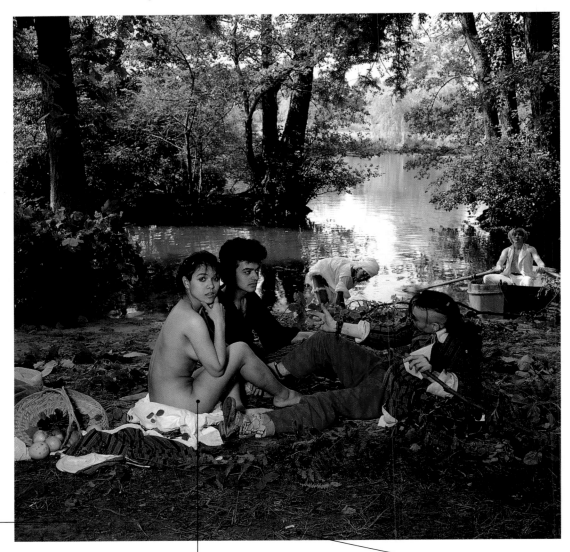

LOCATION

Earl spent one Sunday driving up and down English riverbanks trying to find a place that looked right and didn't have a housing estate in shot. The eventual location – a pond near Box Hill in Surrey – was very similar to that in the Manet painting.

SPECIFICATION

• *Artiste*	Bow Wow Wow
• *Title*	See Jungle! See Jungle! Go Join Your Gang Yeah! City All Over! Go Ape Crazy!
• *Art Direction*	Malcolm McLaren
• *Design*	Nick Egan
• *Photography*	Andy Earl
• *Record Co.*	RCA, 1981

ANNABELLA LWIN was persuaded by Malcolm McLaren that taking her clothes off was what she had to do for the band, but he told her "For God's sake don't tell your mum," as she was underage at the time. When her mother discovered what they'd done, Annabella was hauled off to an aunt's house on Dartmoor and they were told they'd never see her again. RCA threatened to sue McLaren for the signing fee unless he produced her within a week. Eventually, it all calmed down and Annabella returned.

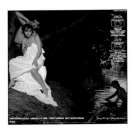

GO NAKED!

Malcolm McLaren wanted the cover to be a 20th-century Romantic design in the tradition of Rousseau's quote that "craft must have clothes but the truth loves to go naked." It was nature and Romanticism as an alternative to the individualistic and pragmatic philosophy of Thatcherite Britain.

"ANNABELLA'S FACE was angelic, and we lit it with a flash to bring it out. We had to tear down branches and lay them on the ground, because the location was just a pathway. It still looks much the same today." – Andy Earl

SEE WHAT?

The outrageous album title was from a song lyric that Malcolm McLaren once wrote about spending a night in the woods as a child. Apparently, he'd put plastic bags around his feet because he was scared of snakes!

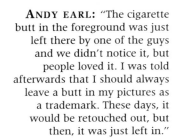

ANDY EARL: "The cigarette butt in the foreground was just left there by one of the guys and we didn't notice it, but people loved it. I was told afterwards that I should always leave a butt in my pictures as a trademark. These days, it would be retouched out, but then, it was just left in."

ALTERNATIVES

Several alternative covers were produced using different shots.

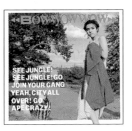

BOB DYLAN, Self Portrait

A SELF-PORTRAIT, A PORTRAIT OF ONE'S SELF, how we think we look to the rest of the world. Men generally only see themselves when shaving, women when putting on makeup. When we see a photograph of ourselves, or hear a recording of our voice, we are quite often surprised. Is that what I *really* look like? Is that how people see me? So when it comes to painting a self-portrait, what do we actually paint? Does the rest of the world say: "Is that what you really look like?" Bob Dylan painted this portrait of himself in lush, rich colors and textures, just like his music, in fact. It doesn't look very much like Dylan, but then again perhaps it does to Dylan. The answer, my friend....

BIG PINK
*The first time the public saw Bob Dylan's art was the cover painting he did for The Band's debut album, **Music From Big Pink** – an album recorded in a pink house on Overlook Mountain, West Saugerties, upstate New York.*

THICK PINK
The painting is executed with rich daubs of color thickly applied to the face, yet leaving areas of bare canvas in the background, reminiscent of Kandinsky in a

casual mood. While being iconic, the face and expression are paradoxically impenetrable. Is there meaning at all? Does the vivacious pink juxtaposed with the black and blue symbolize artistic extremes of mood? Or is it no more than a simplistic painting that makes a striking record cover?

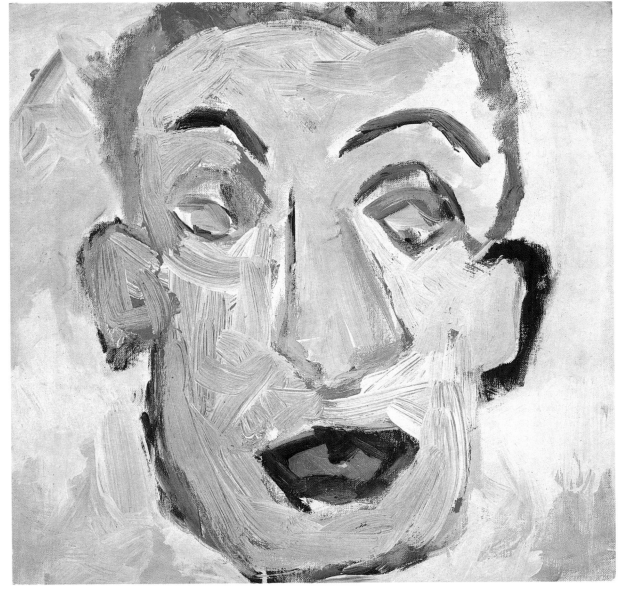

THICK PAINT
The portrait was done in thick oil paint, probably Liquitex, and painted on canvas on a wooden stretcher frame. Dylan painted his self-portrait at his home on Bleecker Street in New York's Greenwich Village.

DELIVERY FOR MR. BERG!
John Berg, CBS art director: "Dylan called me and we agreed he would deliver the cover painting outside my office at the CBS building on 52nd Street at 11 am. He said he would be in a blue station wagon. I asked Ron Coro to wait for him and take delivery. Bob put the unwrapped painting on the hood of his station wagon and he and Ron discussed it for a while. I watched from my window ten floors up. Several thousand people passed by and nobody noticed!"

DYLAN ALSO PAINTED *the cover of 1974's **Planet Waves** album – again in the primitive – style inscribed it with the words "Moonglow" and "Cast Iron Songs & Torch Ballads."*

SPECIFICATION

- *Artiste* Bob Dylan
- *Title* Self Portrait
- *Design* Ron Coro
- *Painting* Bob Dylan
- *Record Co.* CBS, 1970

BOB DYLAN: "The way it turned out, the album became a concept record with a title that could be taken a ton of ways. Staring at the blank canvas for a while encouraged me to blindfoldedly make a picture that would paste all the songs together between the sleeves. It didn't take a whole lot of strokes to complete the face. Art lovers claimed it was primitive and maybe it was, if not having any formal art school training makes it so. My painting style, which was underdeveloped at the time, had more to do with allowing my eye instead of my mind to regulate my senses. This is clearly not that, it is more like 'which came first? the title or the testimony?' In some ways probably the title. It wasn't my purpose to paint my own picture anyway. Pop art was coming into focus, but it was coming out of a more traditional approach that had been discarded, so my composition couldn't be called that. It was more like a rough sketch acrylically done. Watercolor might have had more depth."

SELF PORTRAIT

SYSTEM 7, 777

SEVENTH HEAVEN, LIQUID SEVEN, seven eleven, nine in between, nine planets, solar system, System 7. It all flows together like the viscous numbers on this design by David James. It all flows together in reality and not in the computer. It all flows together like the ambient music on the album itself. Not only is the cover design actually constructed from opalescent screens and oily liquids one over the other, but the unusual colors are created in the studio for real, not added afterward. No manipulation here – only the genuine article. Spare no expense. One for the money, two for the show. Three for the Trinity and four for the Creation. Three and four make seven, and there are seven wonders of the world, seven sins in your heart, and seven letters in ambient. We have here magic numbers and a magic sleeve design.

LIQUIDITY

David James came up with the idea for the sleeve design following conversations with Steve Hillage and Miquette Giraudy of the band. He suggested the use of liquids in the design, but says that the sleeves were inspired by the nature of the music and by certain mystical beliefs held by the musicians. David was given free reign to do whatever he felt right, and the band trusted him completely.

THE LOGO

was designed by David James when he was first commissioned to work with the band by the record company. The original design was drawn by hand. The three sevens for the title were also drawn by hand to complement the logo. David James preferred numerals to words because of their simplicity.

PROJECTIONS

The entire cover image is one photograph and was created in camera, without the use of a computer. It took three days to shoot and involved an elaborate setup of projections, molds, and separated levels of flowing liquid.

SYSTEM 7 X 2 = 777

System 7's second album, *777*, was the fourth or fifth design that David James produced for the band. The design was linked to previous sleeve artworks, particularly *Attitude* (below), a collaborative work with photographer Trevor Key.

ARTWORK

A line drawing was shown to the band as a guide to the layout, but David wasn't exactly sure how it would look as the whole thing was a bit of an experiment. The final image took shape during the shoot, mainly through trial and error. The artwork consisted of two color transparencies – one for the front and one for the back.

DAVID JAMES

Album covers for Boy George, Neneh Cherry, and Soul II Soul established James' reputation as a designer. In 1990, with Alex Fisher and David Sims, he launched the counterculture magazine **Road** *using unique custom-designed typefaces. He formed Alias with Gareth Hague to design and market these typefaces, and success led to campaigns for Levis and Mazda, and designs for Koji Tatseno and* **A Be Sea** *magazine. Since 1996, James has been art director for Prada.*

The cover of **Water***, System 7's first album, also designed by David James Associates.*

THE VERDICT

David James: "I am extremely happy with the sleeve design – although it would now be much easier to create on a computer. This wouldn't necessarily make it any better."

SPECIFICATION

- *Artiste* System 7
- *Title* 777
- *Design* David James at David James Associates
- *Record Co.* Big Life, 1993

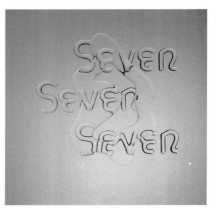

The back cover.

THE ROLLING STONES, Some Girls

SEXUAL AMBIGUITY has been one of the many sensational trademarks associated with The Rolling Stones. Manly they may be, but they have often been photographed sporting women's clothes and wearing makeup. Their motivation was usually an outrageous video shoot or flirting for a publicity still.

The cover for *Some Girls* epitomizes the tongue-in-cheek image that the world's greatest rock 'n' roll band seem to have pursued for more than three decades. It's a wonderful, jocular side swipe at the world of celebrity and the role of the paparazzi. Although some of the rich and famous didn't initially see it that way. With lawsuits threatening, the joke turned sour. It seems you can't always get what you want.

MICK JAGGER:
"The idea was that when you pulled the inner sleeve out from the main cover it would give you different views through the windows. Nobody ever cleared the rights on the pictures with all the film stars and that got us into a whole lot of trouble. We had to change the whole thing and it turned out to be a bit of a nightmare. The first batch of records with all the film stars on had to be withdrawn, re-done, and re-released and

became a bit of a mish-mash. The copyright holders all got mad. These were just pictures snipped out of old magazines that the designers thought were public domain. The result did slightly ruin it for me as it became a legal thing rather than a fun thing. The lawyers didn't seem to have much of a sense of humor. The current version on CD is a not very nice hash-up of the second version. I like the front cover the best. The original version particularly, with stars like Joan Crawford on it."

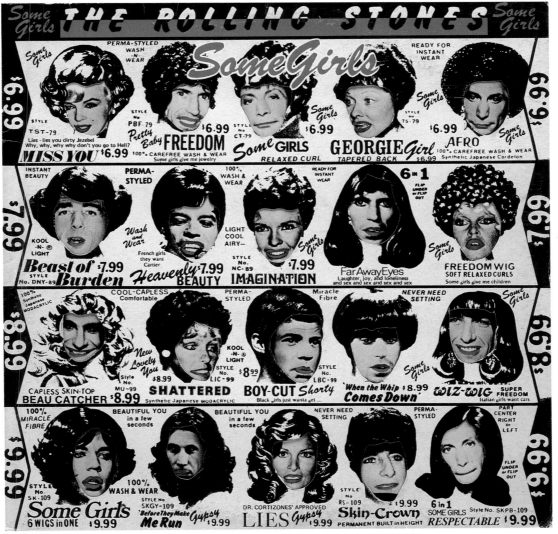

WIGS AND MAKEUP
*"It was really good because all these people looked very funny in the wigs, especially the band," says Mick Jagger. "The band pictures were existing found press pictures which were then colored in. There were these cheap double-uplift wash 'n' wear bras, around which we put the titles of the songs. There were also titles next to the wigs like **Georgie Girl** or **Boy-Cut**."*

"IT WAS ALL NICKED *from the wig ads in those 60s black magazines. The thought was that the wig-creation faces would be replaced by famous movie stars and The Rolling Stones." – Mick Jagger*

THE INNER SLEEVE
The stars on the inner sleeve included Marilyn Monroe, Jayne Mansfield, Elizabeth Taylor, Dirk Bogarde, Liza Minnelli, Brigitte Bardot, Lucille Ball, and not for the first time on a Stones album cover, a Beatle – George Harrison.

PETER CORRISTON
*Peter Corriston studied art at the Tyler School of Art, Philadelphia, and has had work accepted into the permanent collection of the Library of Congress. He has been nominated five times for a Grammy® award and won in 1981 for Best Album Package for The Rolling Stones' **Tattoo You** album. His awards include the Award of Excellence, **Communication Arts Magazine**, and the A.I.G.A. National Show, Graphic Poster Annual Print Design Award. Peter is an instructor at the Tyler School of Art, Philadelphia, and the School of Visual Arts, New York.*

IT'S ALL LIES, I TELL YOU!
*Peter Corriston: "As I remember it, my concept was originated by Mick Jagger giving me a working title of **Lies**. I've always been a fond observer of fringe editorial and advertising communications. The black American magazine **Jet** offered such material. A wig ad I found seemed to tell lies and make false promises. Combined with the English male propensity for dressing in drag it seemed a perfect confection."*

SPECIFICATION

- *Artiste* The Rolling Stones
- *Title* Some Girls
- *Design* Peter Corriston
- *Record Co.* Rolling Stones Records, 1978

SOME GIRLS

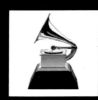

© NARAS 1999

Aubrey Powell

THE ANNUAL GRAMMY® AWARDS

"Grammy® winners are selected annually by the voting members of The National Academy Of Recording Arts & Sciences, numbering over 8,000 creative contributors to the field of recording. Grammys® are awarded to individuals who are acknowledged for their outstanding artistic and/or technical achievement in the recording field. Winning recordings are disclosed at the annual Grammy® Awards presentations." — The National Academy Of Recording Arts & Sciences, Inc.

The Grammy® Awards have been held since 1958 and are the yardstick by which the recording community judges itself. The categories include all kinds of awards, from the obvious Best Song Of The Year to the Best Spoken Album For Children and the Best Polka Album! There are candidates not strictly connected to the recording, but who are there by strong promotional association – for example, the award for Best Long Form Music Video. There is also an award for the Best Recording Package and, in recent years, Best Boxed Recording Package. The annual ceremony is the equivalent of the Oscars in the movie business, and is televised nationally across the United States and in many other parts of the world. As with all showbiz events, it is conducted with as much hype, exposure, glamour, bitchiness, and glittering panache that a self-congratulary, pat-on-the-back, billion-dollar business party can muster. Famous bands and prerecorded videos interrupt the awards to help create 12 hours of continuous music television. Music journalists, MTV, the paparazzi, and the showbiz magazines have a field day.

If this sounds cynical, it isn't meant to. In the fickle world of top-twenty hits and the importance of corporate market share, it is a very sound way of evaluating current creative talent and justly recognising the longevity of others. The music business has its heroes in the same way as the movie business, and the really talented artistes appear year after year – if not as contenders then as presenters or performers, who have previously earned the recognition of their peers. The accolades given to album cover designers are hailed with the same respect, a little more low-key, granted, but nevertheless a Grammy® nomination is considered prestigious, something to be coveted, especially if one wins.

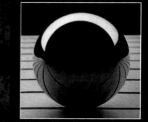

1976

As an occasion it's not all "here and now." The Recording Academy has created Lifetime Achievement awards, Grammy® Legend awards, and Hall Of Fame awards in reverence to the musicians of yesteryear. Some have to be given posthumously as a gesture to those who were either not around to participate in the awards when they began in the 50s, or whose musical influence reinvented itself a generation or two later in the form of today's music, and finally earned the respect it so rightly deserved. Generally, it's a fair assessment of music business sentiment. It's a private party shared globally by those who watch and listen and make the music scene happen. If you ever consider a career in music, then watching the Grammys® should be regarded as the essential initiation ceremony or even as a rite of passage.

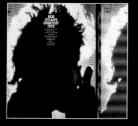

1967

From the very beginning, album covers have been considered an important part of the process of delivering the music to the public. Records could have been popped into protective brown paper bags – after all, radio initially sold the music and you couldn't touch or see the performers – but some bright spark thought it might be better to decorate the package to enhance the joy of the listener. Hats off to that Tin Pan Alley pioneer!

Here are all the winners of the award for Best Recording Package since the Grammys® began in 1958. It is particularly interesting to note that the very first art director awarded for his package design on May 4, 1959, at the 1st Annual (1958) Grammy® Winners ceremony was none other than Frank Sinatra. It's true what they say – all album cover designers really want to be pop stars. Hand me that guitar.

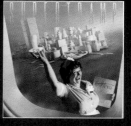

1973

And the award for Best Album Cover goes to…

1958 Best Album Cover: ONLY THE LONELY *(Frank Sinatra)*.
Art Director: FRANK SINATRA *(Capitol)*

1959 Best Album Cover:
SHOSTAKOVICH SYMPHONY NO.5 *(Howard Mitchell)*.
Art Director: ROBERT M. JONES *(RCA)*

1960 Best Album Cover: LATIN A LA LEE *(Peggy Lee)*
Art Director: MARVIN SCHWARTZ *(Capitol)*

1961 Best Album Cover:
JUDY GARLAND AT CARNEGIE HALL *(Judy Garland)*.
Art Director: JIM SILKE *(Capitol)*

1961 Best Album Cover – Classical: PUCCINI: MADAME BUTTERFLY
(Santini cond. Rome Opera Chorus & Orchestra).
Art Director: MARVIN SCHWARTZ *(Angel)*

1962 Best Album Cover:
LENA…LOVELY AND ALIVE *(Lena Horne)*.
Art Director: ROBERT JONES *(RCA)*

1962 Best Album Cover – Classical:
THE INTIMATE BACH *(Almeida, Majewski, De Rosa)*.
Art Director: MARVIN SCHWARTZ *(Capitol)*

1963 Best Album Cover: THE BARBRA STREISAND ALBUM
Art Director: JOHN BERG *(Columbia)*

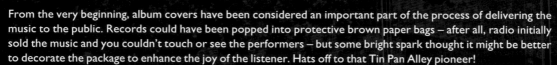

1979

1981

1991

1963 Best Album Cover – Classical:
Puccini: Madame Butterfly *(Leinsdorf)*.
Art Director: Robert Jones *(RCA)*

1964 Best Album Cover: People *(Barbra Streisand)*
Art Director: Robert Cato.
Photographer: Don Bronstein *(Columbia)*

1964 Best Album Cover – Classical: Saint-Saëns: Carnival Of The Animals/Britten: Young Person's Guide To The Orchestra *(Fiedler, Boston Pops Orchestra)*
Art Director: Robert Jones.
Graphic Artist: Jan Balet *(RCA)*

1965 Best Album Cover – Photography:
Jazz Suites Of The Mass Texts *(Paul Horn)*.
Art Director: Bob Jones.
Photographer: Ken Whitmore *(RCA)*

1965 Best Album Cover – Graphic Arts: Bartok: Concerto No.2 For Violin/Stravinsky: Concerto For Violin *(Silverstein, Leinsdorf, Boston Symphony Orchestra)*
Art Director: George Estes.
Graphic: James Alexander *(RCA)*

1966 Best Album Cover – Photography:
Confessions Of A Broken Man *(Porter Wagoner)*
Art Director: Robert Jones.
Photographer: Les Leverette *(RCA)*

1966 Best Album Cover – Graphic Arts: Revolver *(The Beatles)*.
Graphic Art: Klaus Voormann *(Capitol)*

1967 Best Album Cover – Photography: Bob Dylan's Greatest Hits.
Art Directors: John Berg & Bob Cato.
Photographer: Roland Scherman *(Columbia)*

1967 Best Album Cover – Graphic Arts:
Sgt. Pepper's Lonely Hearts Club Band *(The Beatles)*
Art Directors: Peter Blake & Jann Haworth *(Capitol)*

1968 Best Album Cover: Underground *(Thelonius Monk)*
Art Directors: John Berg & Richard Mantel
Photographer: Horn/Griner Studio *(Columbia)*

1969 Best Album Cover: America The Beautiful *(Gary McFarland)*
Painting: Evelyn J. Kelbish. Graphics: David Stahlberg *(Skye)*

1970 Best Album Cover: Indianola Mississippi Seeds *(B. B. King)*
Cover Design: Robert Lockart. Photography: Ivan Nagy *(ABC)*

1971 Best Album Cover: Pollution *(Pollution)*
Album Design: Dean O. Torrance
Art Director: Gene Brownell *(Prophesy)*

1972 Best Album Cover: The Siegel Schwall Band
Art Director: Acy Lehman
Artist: Harvey Dinnerstein *(Wooden Nickel)*

1973 Best Album Package: Tommy
(London Symphony Orchestra/Chamber Choir)
Art Director: Wilkes & Braun, Inc. *(Ode)*

1974 Best Album Package: Come & Gone *(Mason Proffit)*
Art Directors: Ed Thrasher & Christopher Whorf *(Warner Bros.)*

1975 Best Album Package: Honey *(Ohio Players)*
Art Director: Jim Ladwig *(Mercury)*

1976 Best Album Package: Chicago X *(Chicago)*
Art Director: John Berg *(Columbia)*

1977 Best Album Package: Simple Dreams *(Linda Ronstadt)*
Art Director: Kosh *(Asylum)*

1978 Best Album Package: Boys In The Trees *(Carly Simon)*
Art Directors: Johnny Lee & Tony Lane *(Elektra)*

1979 Best Album Package: Breakfast In America *(Supertramp)*
Art Directors: Mike Doud & Mick Haggerty *(A&M)*

1980 Best Album Package: Against The Wind
(Bob Seger & The Silver Bullet Band)
Art Director: Roy Kohara *(Capitol)*

1981 Best Album Package: Tattoo You *(The Rolling Stones)*
Art Director: Peter Corriston *(Rolling Stones/Atlantic)*

1982 Best Album Package: Get Closer *(Linda Ronstadt)*
Art Directors: Kosh & Ron Larson *(Elektra/Asylum)*

1983 Best Album Package: Speaking In Tongues *(Talking Heads)*
Art Director: Robert Rauschenberg *(Sire/Warner Bros.)*

1984 Best Album Package: She's So Unusual *(Cindy Lauper)*
Art Director: Janet Perr *(Planet/RCA)*

1985 Best Album Package: Lush Life *(Linda Ronstadt)*
Art Directors: Kosh & Ron Larson *(Asylum)*

1986 Best Album Package: Tutu *(Miles Davis)*
Art Director: Eiko Ishioka *(Warner Bros.)*

1987 Best Album Package: King's Record Shop
(Roseanne Cash)
Art Director: Bill Johnson *(Columbia/CBS)*

1988 Best Album Package: Tired Of Runnin' *(O'Kanes)*
Art Director: Bill Johnson *(Columbia/CBS)*

1989 Best Album Package: Sound + Vision *(David Bowie)*
Art Director: Roger Gorman *(Rykodisc)*

1990 Best Album Package: Days Of Open Hand
(Special Edition Hologram Digipak) (Suzanne Vega)
Art Directors: Len Peltier, Jeffrey Gold, Suzanne Vega *(A&M)*

1991 Best Album Package: Billie Holiday: The Complete Decca Recordings *(Billie Holiday)*
Art Director: Vartan *(GRP)*

1992
Best Album Package – Compact (Special Package):
Spellbound *(Paula Abdul)*
Art Director: Melanie Nissen *(Capitol/Virgin)*

1993 Best Recording Package:
The Complete Billie Holiday On Verve 1944–1959 *(Billie Holiday)*
Art Director: David Lau *(Verve)*

1994 Best Recording Package: Tribute To The Music Of Bob Wills And The Texas Playboys *(Asleep At The Wheel)*
Art Director: Buddy Jackson *(Liberty)*

1994 Best Recording Package – Boxed:
The Complete Ella Fitzgerald Song Books *(Ella Fitzgerald)*
Art Director: Chris Thompson *(Verve)*

1995 Best Recording Package: Turbulent Indigo *(Joni Mitchell)*
Art Directors: Joni Mitchell & Robbie Cavalino *(Reprise)*

1995 Best Recording Package – Boxed:
Civilization Phase III *(Frank Zappa)*
Art Directors: Frank Zappa & Gail Zappa *(Barking Pumpkin)*

1996 Best Recording Package:
Ultra lounge (Leopard Skin Sampler) *(Various Artists)*
Art Directors: Andy Engel & Tommy Steele *(Capitol)*

1996 Best Recording Package – Boxed: The Complete Columbia Studio Recordings *(Miles Davis & Gil Evans)*
Art Directors: Chika Azuma & Arnold Levine *(Columbia)*

1997 Best Recording Package: Titanic – Music As Heard On The Fateful Voyage *(Various Artists)*
Art Directors: Hugh Brown, Al Quattrocchi, & Jeff Smith *(Rhino)*

1997 Best Recording Package – Boxed: Beg, Scream & Shout! The Big Ol' Box Of 60s Soul *(Various Artists)*
Art Directors: Hugh Brown, David Gorman, & Rachel Gutek *(Rhino)*

1998 Best Recording Package: Ray Of Light *(Madonna)*
Art Director: Kevin Reagen *(Maverick/Warner Bros.)*

1998 Best Recording Package – Boxed:
The Complete Hank Williams
Art Directors: Jim Kemp & Virginia Team
(Mercury Records Nashville)

1986

1990

1996

THE ROLLING STONES, Sticky Fingers

IN 1969 MICK JAGGER AND ANDY WARHOL were at a party in New York when Andy casually suggested that a real trouser zipper might make an interesting idea for an album cover. A year earlier they had been at loggerheads over Warhol's idea for the Stones album *Through A Glass Darkly*. Mick had thrown it out, then commissioned someone else to do a similar design. Warhol felt that he had been ripped off. He was unusually angry and wanted payment. That the outrageous and well-established Pop Artist should attempt to collaborate again with the raunchiest of rock 'n' roll bands following this contretemps seemed a little strange. However, Jagger took the bait, insisting that Andy create the cover personally. A year later Mick presented it to the rest of the band, and the result was *Sticky Fingers*. A suitable end to a sticky situation.

MICK JAGGER: "The Brothers Jay and Jed Johnson were involved with Andy. Jay modeled the jeans and now works for the architect Allen Wantzenberg. His brother Jed did the interior design for my New York home. He sadly died on the TWA flight that crashed off Long Island recently."

THE PHOTO SESSION

Andy Warhol took the cover shot himself. Many people assumed that the model in the jeans was Mick Jagger – it wasn't. Glenn O'Brian, one of Warhol's assistants, recalled, "I was at the Factory when Andy was photographing the cover. He first used Jed Johnson as the model for the front cover, wearing the jeans that were to contain the zip fastener. Then he approached me, and asked me to drop my trousers and pose for the inner sleeve. I knelt in front of him in my jockey shorts ready for the first Polaroid to be taken. As a new boy at the Factory I wasn't sure what to expect, we were right in the middle of the photoshoot when in through the door walked three straight businessmen mistaking the studio for an architect's office. Shocked at the famous artist's work in progress, they turned and ran for their lives."

SPECIFICATION

• *Artiste*	The Rolling Stones
• *Title*	Sticky Fingers
• *Concept & Photography*	Andy Warhol
• *Packaging Design*	Craig Braun
• *Record Co.*	Rolling Stones Records, 1971

LETTERING
The red lettering on the front cover is designed to make it look like it has been applied with a rubber stamp, which adds to the cover's rough and ready feel. The color red gives it an immediacy.

MICK JAGGER: *"As I recall this was the first time that we asked Andy Warhol to get involved with an album cover. We were friends and he was easy to work with. Andy presented us with a mock-up of the jeans and the pants on the inside using a real zipper, so when it was undone you could see the underwear. I knew it was going to be a problem. Firstly the cost, secondly the process of making the zipper, and thirdly the job of shipping and stacking. It was a big fight all the way to get the cover accepted. Atlantic Records were pretty good about it – probably because it was our first record with them and people were a little more open-minded then. However, I'm sure we had to absorb some of the costs and it probably cost us an arm and a leg. Andy loved the cover. He liked the idea of making a new twist on what had previously been a rather static image by using a real zip. We worked with Andy again for the Love You Live cover."*

...AND EVEN CHEAPER IDEAS
Paul Morrissey: *"Andy would have been commissioned to do the job, and would simply have asked whoever was around that day to come up with some ideas, and he'd be grateful for any that he felt would get him noticed."*

THE INNER SLEEVE
Craig Braun had to insert another layer of cardboard to protect the vinyl record from the metal zipper. So Andy had to photograph another shot of a young man in his underwear. This obviously appealed to Warhol's sense of fun. As you open the cover you find what you'd expect to find underneath a pair of jeans, namely underwear.

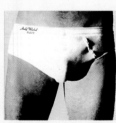

CHEAP SEX
Paul Morrissey, Andy's former manager: "Andy was sensible enough to know not to be pretentious when doing album covers. This was a realistic attempt at selling sex and naughtiness. It was done simply and cheaply, without the pretensions that seem to go with other covers"

EARLY WORK
Warhol first worked as an illustrator. His early drawings can be seen here on jazz album covers. They are reminiscent of the French artist Jean Cocteau and contrast greatly with his later work.

SPANISH FLY

In Robert Franks' unreleased movie of the Stones' 1972 *Exile On Main Street* tour, **Cocksucker Blues**, Mick Jagger is supposed to have described Andy Warhol as a "voyeur." The late Spanish dictator, General Franco, must have shared the same opinion because he banned the cover in Spain. The photo that replaced the provocative zipper was of a can of syrup and syrup-coated fingers, looking a lot more suggestive and rude than a pair of snug-fitting jeans – except to Franco.

THE ROLLING STONES LOGO

Mick Jagger: "This was the first time that we used the tongue logo. I gave a brief to John Pasche of what I wanted. I took the idea from an Indian calendar showing the disembodied tongue of the god Khali at the side of her face. I asked John to make it more modern but still keeping the same premise."

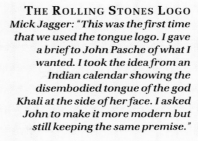
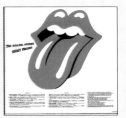

EXTRAVAGANT PACKAGING

At the time the cover was considered to be quite outrageous. Not just because it was a meeting of two great pop icons – Jagger and Warhol – over a piece of art, but because of the blatant sexuality of the image and its extravagant packaging. Craig Braun, the package designer, was given the unenviable task of turning the artwork into a three-dimensional album cover, complete with a real life-size movable zipper. He remembers that there were some alternative suggestions. One was to release the album in a clear plastic jacket with heat-sensitive liquid crystals inside so you could create your own light show, and another idea was a fold-out cover of Jagger's castle in the South of France! Mick Jagger, intuitive as ever, knew that Warhol's titillating artwork was the right choice.

OH WOE IS ME, FOR I AM UNDONE!

The marketing department were inundated with complaints that the metal zip was damaging the vinyl inside the cover, literally scratching the track 'Sister Morphine' and making the record unplayable. Craig Braun came up with the solution of pulling the zipper halfway down to the center of the record so that only the label became damaged – something Andy Warhol would definitely have approved of. Even so, Braun never did work out how to stop the zipper scratching other album covers when they were racked together.

ANDY WARHOL

Andy Warhol was born Andrew Warhola in Philadelphia on August 6, 1928. The only member of his family to attend college, he entered the Carnegie Institute of Technology in 1945, where he majored in pictorial design. Upon graduation, Warhol moved to New York, where he enjoyed a successful career as a commercial artist, and in 1957 formed Andy Warhol Enterprises. Three years later Warhol began a series of artworks based on comics and advertisements that marked a turning point in his career. He enlarged and transferred the source images onto canvas using a projector. Many of these paintings remain icons of 20th-century art, including his Campbell's Soup Cans, Marilyn, and Elvis series. In 1963 Warhol established a studio at 231 East 47th Street, which became known as the Factory. He began to work in other media, producing records (**The Velvet Underground And Nico**) and making films such as **Chelsea Girls** and **Empire**. In 1968 he was shot in a near-fatal attack by Valerie Solanis, founder of SCUM, the Society for Cutting Up Men. He launched **Interview** magazine in the 70s, and in 1986 hosted his own show, **Andy Warhol's Fifteen Minutes**, on MTV. Andy Warhol died on February 22, 1987, following routine gall-bladder surgery.

"IT WAS A cheap camera and cheap film. I've no idea what brand. The model would have been someone who was hanging around the studio that day; someone who had a nice crotch," said Andy's former manager, Paul Morrissey.

THE DOORS, Strange Days

"I HATED THE COVER OF OUR FIRST ALBUM", Jim Morrison, lead singer of The Doors, told John Carpenter of the *Los Angeles Free Press* in 1968. "So for *Strange Days,* I said: 'I don't want to be on this cover. Put a chick on it or something. Let's have a dandelion or a design…' and because of the title everyone agreed, 'cause that's where we were at, that's what was happening. It was right." Well, not quite, Jim. He didn't end up with the dandelion, but neither did he end up on the cover. What The Doors did get was a cover that could have been straight out of Fellini's *La Strada* – a veritable freak show of carnival characters, complete with strongman, jugglers, and midgets parading, not in an Italian town piazza, but on a New York side-street. And why, you may ask, are they performing for the snooty model in the doorway? Weird scenes inside the goldmine.

THE BRIEF
The Doors were looking for a cover that was different than what the other Californian bands were doing. "We didn't want anything psychedelic as we weren't that kind of band," said keyboard player Ray Manzarek.

*"We were looking for something more 'strange,' more Fellini-esque. Something along the lines of **La Strada** or Ingmar Bergman's **Seventh Seal**." The band met up with the art director at Elektra Records, William S. Harvey, and briefed him on what they were looking for. "We wanted a Fellini scene, little people, circus folk, people with marvelous faces. We told Bill that it had to be surreal. We were into lots of Daliesque things," said Ray. "We just told him to go off and do something along those lines."*

WHO'S ZOO?
The people on the cover were a hodgepodge of amateurs, professionals, and friends – people gathered from all over the city.

THE TRUMPET PLAYER *was found by Bill Harvey: "I took a taxi driver and pulled him out of the cab and said 'For five bucks, will you stand over there and blow a trumpet?' Because he had on this battered old hat I thought, 'He's perfect'."*

THE JUGGLER *was the photographer's assistant, Frank Kollegy, who later appeared on several other album covers that Brodsky photographed.*

THE PERMIT
Photographer Joel Brodsky should really have obtained a permit to photograph on a New York street. Instead, he gave the local resident's association $500 – "More than we got paid for the job."

THE CAST
"There are the 'freaks' that Jim had asked for… the acrobats, the juggler, the strong man, the two midgets. One dances and waves his magic wand for the camera while the other proffers his tambourine to a beautiful model standing in a doorway. That was the chick Jim had wanted on the cover. And look, she's wearing a long hippy caftan and sandals. She was our tip-of-the hat to all the psychedelic bands of 1967" – Ray Manzarek.

THE MYSTERIOUS MODEL
The model standing in the doorway on the back cover was Zazel Wild, a friend of the photographer's wife, now a magazine editor in New York.

STRANGE TODAYS
*Ray Manzarek still loves the cover. **Strange Days** is also his favorite of all Doors albums. "It was a great time for us – on this album we experimented a lot with distorted voices, backward piano, and other weird stuff. There was a wonderful vibrancy and a reflection of heightened awareness. For me, Jim summed up that time at the end of the 60s when he wrote 'In that year we had a great visitation of energy'."*

OH MY DOG!

When it came to the cover for **Strange Days**, Jim Morrison had some pretty strange ideas. *"Originally I wanted us in a room surrounded by about 30 dogs but that was impossible because we couldn't get the dogs, and everyone was saying 'What do you want dogs for?' And I said that it was symbolic, that it spelled God backward."*

A RELUCTANT SEX SYMBOL

*Jim Morrison objected to being seen as a sex symbol and thought this distracted attention from the music. Nevertheless, during the frenzied media blitz to promote the first album, he succumbed to record company pressure and accepted the fact that sex sells. Elektra's founder, Jack Holzman, even hyped **The Doors** album by using billboards on Sunset Boulevard. It was the first rock album to be promoted in this way.*

THE STRONGMAN was from a circus but also worked as a part-time doorman.

THE ALBUM cover has no band name and no album title on the front. It is only identified by the two posters on the wall in the background – strangely, posters advertising the first Doors' album, pasted over with a banner proclaiming "Strange Days."

LOCATION

The album cover photograph by Joel Brodsky, was taken in Sniffen Court, a flagstoned mews in New York on East 36th Street between Third Lexington avenues. These former 19th-century stables are now private homes – except for one housing the Murray Hill Comedy Club, the oldest private theater group in New York City. It's hard to believe this location is not somewhere in Europe.

THE MIDGETS

Bill Harvey: "I went up to this strange residential hotel, on Broadway around 70th Street. Very, very odd place. Odd people were there. I was looking for these twin midgets. I knocked on the door and the door opened and I look down and there they are. I came in, and they had all their clothes laid out on the bed. They were as neat as pins, I mean everything was just perfect. They were just sweet people, awfully nice men. 'Do you want us to wear this? or do you want us to wear that?' they asked."

THE DISTINCTIVE LOGO,

Designed by Bill Harvey in 1966, the Doors logo is still an integral part of their artwork today. Although very much of the 60s, the type style also has a feel of the 30s – especially relevant as The Doors recorded material by Kurt Weill and Bertolt Brecht. The "teardrop" type style of the 'The' was a deliberate acknowledgement of The Paul Butterfield Blues Band, another Elektra act, whose logo incorporated the same typeface. Paul Butterfield was one of Robby Krieger's blues guitar heroes.

ARTWORK PRODUCTION

A Panon panoramic camera was used with 120 transparency film. The artwork consisted of one color transparency wrapping around from front to back. Typography on the back was on an overlay with percentage tints indicated for color.

WILLIAM S. HARVEY

Bill Harvey moved to the newly-formed Elektra Records from Fairchild Publications in the mid-50s. He designed the original "butterfly" Elektra logo and went on to produce many album covers and graphics for the fledgling label. By the 60s, he was not only the art director but also general manager of Elektra. He was responsible for the album covers of countless Elektra artistes including The Paul Butterfield Blues Band, Love, Tim Buckley, and folk artist Judy Collins. Bill Harvey died in the early 90s.

ON THE ROAD

*While they were on tour, between changing planes at Kennedy Airport, The Doors met with Bill Harvey and Joel Brodsky. They were presented with the album cover photograph and immediately loved it. "It was everything we had asked for" said Ray. "It was all there. Bill and Joel had assembled a **La Strada** circus troupe, the strong man, the juggler, the little people."*

YES, Tales From Topographic Oceans

EVIDENCE OF PREHISTORIC ENGINEERING survives in many forms. The straight tracks of ancient Britain, known as ley lines, and the significance of their accurate alignments and mathematical proportions, are to be found linking places such as Glastonbury Tor, Avebury, and Stonehenge. They are found also at the Great Pyramid of Cheops at Giza in Egypt, the Mayan Temple at Chichen Itza in the Yucatan peninsula of Mexico, and occur as the mysterious *lung-mei*, or dragon paths, that run between astronomical mounds and high mountains in China. Roger Dean took these fascinating notions from John Michell's book *The View Over Atlantis* and used them to great effect in his painting for the cover of *Tales From Topographic Oceans*. This is oceanography at its best.

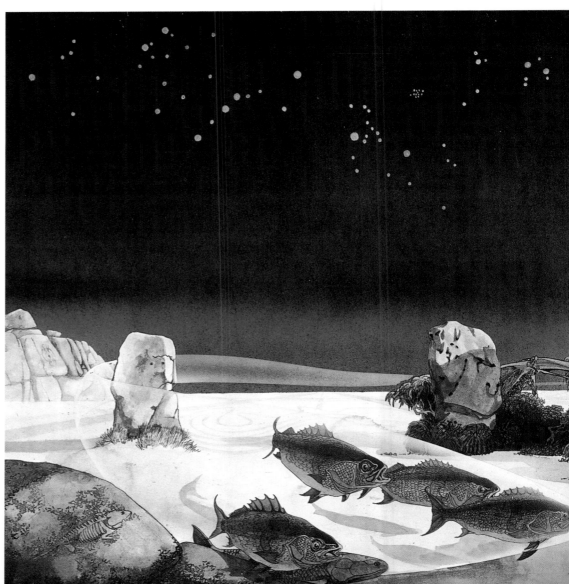

TALES OF ROGER DEAN

Roger Dean studied furniture design at the Royal College of Art, London, under Professor David Pye and Sir Hugh Casson. One of his first commissions on graduating was to design the foam landscape seating at Ronnie Scott's Jazz Club in London's Soho. It was there that he met Jim Parsons, manager of a band called Gun, who asked Roger to design Gun's first album cover. (Coincidentally, Jon Anderson of Yes played with Gun in 1968.) Roger really broke through into rock 'n' roll with his cover design for Osibisa's first album. Following this success, in 1971 Phil Carson, then head of Atlantic Records in the UK, suggested him for **Fragile**, *the debut album from Yes. This was such a successful collaboration that Dean continued to design all the Yes covers, forming a continuing story in pictures.* **Tales From Topographic Oceans** *was the fourth Yes album.*

THE VIEW OVER ATLANTIS

Yes and Roger Dean both worked independently, and yet it was a compatible partnership rather than one influencing the other. Roger Dean: "On a flight to Tokyo the band shared a hashish cake that they had brought with them. This resulted in five hours of numbed silence during the first half of the flight." Then, on the last leg of the flight from Alaska to Tokyo, Roger remembers talking with Jon Anderson about a book called **The View Over Atlantis** *by John Michell. The book argues that the whole of the earth was linked in prehistoric times by a common cultural heritage whose origins are traced back to the lost civilization of Atlantis. Roger decided that the cover design should form a code or pattern which would provide a link through all future covers for Yes.*

SPECIFICATION

• *Artiste*	Yes
• *Title*	Tales From Topographic Oceans
• *Design*	Roger Dean
• *Illustration*	Roger Dean
• *Record Co.*	Atlantic, 1973

SYMBOLS AND ICONS

Roger Dean usually paints intuitively and rapidly. The cover for *Tales From Topographic Oceans* proved more difficult to execute because of the symbolism and iconography he wanted to convey. All the images are accurate representations. The fish hiding under the rock in the foreground is a prehistoric species, the others are salmon trout. They swim enveloped in a sheath of water stretching over the desert and lit by the sun rising behind the Mayan pyramid.

THE YES LOGO

Roger Dean wasn't satisfied with the logo he had done for Yes for their **Fragile** *album, so he experimented with the three letters Y, E, and S and eventually settled for lowercase lettering with a flourish connecting the Y and S, threading through the E. The pencil drawings for the Yes logo and a finished version in color are now part of the permanent collection at the Victoria and Albert Museum in London.*

THE LETTERING had to be as dramatic as the cover painting. The title of the album suggested the 19th century and Gothic images from Poe's *Tales Of Mystery And Imagination*. It also had a New Age dimension and an "astral travel" flavor introduced by Jon Anderson.

CHANGING COLORS
The images were first drawn in pencil and then colored using watercolor and inks. Although this technique made the foreground leap out in 3-D as it was so vivid, the inks were chemically unstable and began to change color. Roger had to go back and re-color much of the painting. To avoid this happening with future work he changed to painting in acrylics. Unlike the paintings for future album covers, which were usually done 6in by 4in, this was drawn the same size as the cover – 12in x 24in.

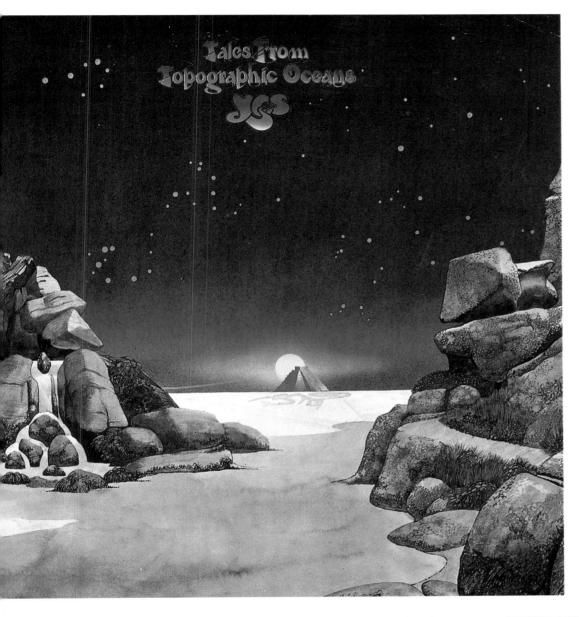

*Tales From Topographic Oceans was inspired not only by John Michell's book **The View Over Atlantis**, but also by **Autobiography Of A Yogi** by Paramahansa Yogananda, founder of the Self-Realization Fellowship.*
In 1964, three years before The Beatles turned on to the Maharishi Mahesh Yogi, and several years before other rock bands found their gurus and were given their mantras, this book was given to Elvis Presley by his hairdresser, Larry Geller. It was the beginning a spiritual awakening for the king of rock 'n' roll.
Jon Anderson, lead singer of Yes:
*"The **Topographic Oceans** album cover was created at a very important time, both musically and spiritually for Yes. I remember a conversation I had with Roger Dean in which we were discussing the book **Autobiography Of A Yogi** by Paramahansa Yogananda, which I had been given by Jamie Muir of King Crimson at Bill Bruford's wedding. It awoke my spiritual life and taught me all about Christ's energy. It explained about Sanskrit, which is the oldest language on earth, and revealed in four shastric scriptures, many ancient rituals. This was the spirit behind the making of the **Topographic Oceans** album. We were so pleased with Roger Dean's interpretation that we visualized it on tour with many projected images from the sleeve."*

FAMOUS ROCK STARS

Roger Dean regards himself primarily as a landscape artist, and his inspiration came from geological forms which he re-shaped with his unique style into semimythical scenes. The rock forms were taken from a collection of images from postcards of famous rocks such as Brimham Rocks, the Last Rocks at Land's End in Cornwall, the Logan rock at Treen in Scotland, and the standing stones of Avebury and Stonehenge in Wiltshire, England. Jon Anderson asked Roger to include the Mayan Temple at Chichen Itza with the sun behind it, and Alan White suggested using the mysterious markings of the plain of Nazca in Peru.

OTHER YES COVERS
*Roger Dean never felt the cover for **Tales From Topographic Oceans** was that successful, preferring **Yessongs**, **Close To The Edge** (below left) and **Relayer** (below right).*

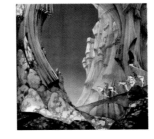

LIKE A VIRGIN
Roger Dean designed the first logo for the fledgling record company, Virgin, in 1970 and the mirror-image virgins logo appeared on countless record labels.

ROGER DEAN

*Roger Dean was born in 1944 in Ashford, Kent, England. He studied industrial design at Canterbury School of Art and in 1965 went to the Royal College of Art in Kensington, London, where he studied furniture design. During the 70s Dean established himself as a very successful artist, and his posters, prints, and books have sold worldwide. He has held several exhibitions of his paintings including the Institute of Contemporary Art and the New York Cultural Center. He has also published two books of his work, **Views** and **Magnetic Storm**, and, in association with Storm Thorgerson, compiled and edited the **Album Cover Album** series of books.*

THE ROLLING STONES, Their Satanic Majesties Request

AT THE HEIGHT OF FLOWER POWER in the heady days of 1967, two of the world's most famous groups were jockeying for position over who could create the most lavish and expensive cover artwork. The Beatles had produced *Sgt. Pepper* and The Rolling Stones were not to be outdone. The attitude was fiercely competitive, yet quite friendly. The Beatles cover was of a constructed piece of pop art sculpture by Peter Blake. Their Satanic Majesties built their own bizarre set resembling a surreal arts and crafts hippie fair. Nevertheless, it worked, and summed up their spirit of graphic adventure. Oddly enough, both chose Michael Cooper as their photographer, Cooper's agent happened to be gallery owner Robert Fraser, who in turn was chums with both bands and was also their dealer. Was this a rock 'n' roll conspiracy?

3-D CAMERA
Nigel Hartnup, Cooper's assistant: "While we were preparing all the background figures for **Sgt. Pepper**, Michael Cooper went to New York to make enquiries about using an enormous 3-D camera for The Stones album cover. The camera was on a semicircular track about 40 feet wide. The set was built in the middle and the camera moved around taking about five photographs at specific points. They were then printed in strips and mixed together in precise position and order and a plastic screen fitted over the print."

THE SCREEN
was constructed in prismatic stripes that exactly matched the width of the stripes in the photograph. As a result, if these were vertical, each eye saw a different set of images, so creating an illusion of 3-D. If the stripes were horizontal, both eyes saw the same picture, but a different one when the screen/ photograph was moved. This idea could be utilized to create the impression of movement. Michael Cooper couldn't quite grasp this when the technicians explained it to him, and anyway, he liked to think he could break the rules. He wanted a 3-D photograph, but he also wanted movement, so he decided to do both. He made The Stones move their arms in various ways for the different shots. When it was produced, the 3-D worked quite well, but their arms were blurred and indistinct.

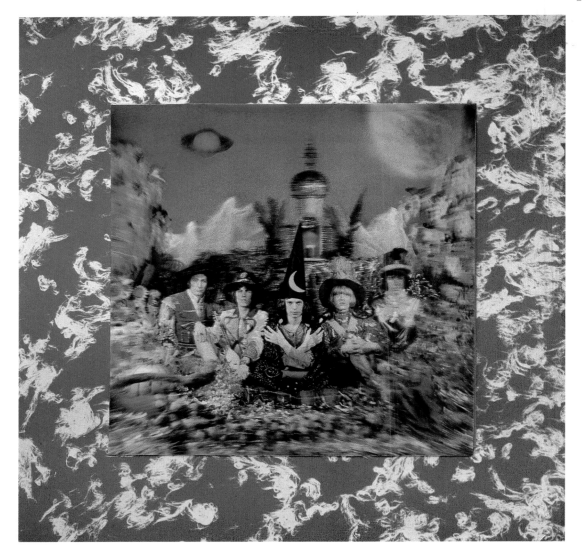

THE IDEA
"We all knew each other through Robert Fraser. We were using a lot of the same people as The Beatles for various projects and turning up at each other's recording sessions. I think it was Michael Cooper's idea to do a 3-D acid trip-type cover. He showed me some of those cheap souvenirs that have 3-D movement in them and was keen to do a cover like that; but it did present all kinds of problems." – Mick Jagger

BY THE TIME THE band arrived at the studio Michael had already got a lot of the materials and props along with glue and adhesive tape. He sent Keith Richard off to buy plants and flowers – difficult, as this was a Sunday. He asked Bill Wyman to hang the planet Saturn from the ceiling and when the props ran out he sent the rest of the band out on errands to find more decorations.

INNER SLEEVE
This was a montage of Renaissance figures, Indian mysticism, flowers, planets, and a psychedelic maze with "It's here" at the center.

ART SCHOOL TRIP
Mick Jagger: "The studio was in New Jersey. When we got there I thought Michael Cooper would have it all ready, but it wasn't. Michael could be a bit untogether at times. We were like pre-art school kids sticking the set together with bits of glue, making the whole thing up as we went along. Most of us were on acid, and trying to make the set and to do our clothes properly with Michael and his model makers was extremely difficult. Acid tended to make the whole process take a little longer, especially with the glue, you know! Anyway we all joined in. It was a bit like doing Christmas decorations really. We put all the sparkly bits, like Christmas wrapping, and some pictures of The Beatles in there. It was great fun."

AN EXPENSIVE PRODUCTION
It was estimated that the photo session cost £15,000 – a tremendous amount of money in 1967. The plastic 3-D photo was glued on to the cover by hand for the initial run in the US, Europe, and Japan. This process was so expensive that the photograph was eventually printed directly on to the cover with no 3-D effect.

SPECIFICATION
- *Artiste* — The Rolling Stones
- *Title* — Their Satanic Majesties Request
- *Design* — Michael Cooper
- *Photography* — Michael Cooper
- *Record Co.* — Decca, 1967

PULP, This Is Hardcore

THE MODEL is an 18-year-old Russian girl called Ksenia. She is 5ft 4in tall and an up-and-coming glamour model. Her hobbies are swimming and tennis.

SEXY GIRLS ON COVERS rarely have any serious rationale for being there. Pulp's *This Is Hardcore* is different; even if the intention is not obvious. Hardcore is an expression often used to indicate blatant pornography. It can also be used to describe a rock band's desire to be taken seriously about their work. Jarvis Cocker, Pulp's lead singer, intended this cover to illustrate his own internal confusion about being a pop star in isolation – a familiar neurosis of the rich and famous. The title and cover are supposed to be a paradox. Does it work? Pulp fact or pulp fiction?

THE BRIEF
Peter Saville: *"One day the phone rang and it was Jarvis Cocker. He said 'I would like to talk to you about a cover for our new album.' He came around with Steve from the band, and they outlined their problem to me. They needed to reposition Pulp. They'd had a certain pop success in the mid-90s and were rather the heavier side of lightweight. They wanted to present Pulp more as a rock band. The music was a lot deeper, darker, and moodier and they called it **This Is Hardcore**."*

PHOTOGRAPHY
Horst Diekgerdes shot the photographs with a Pentax camera with a 6/7 medium format negative. He used a mixture of daylight and flashlight.

THE LOCATION
is Peter Saville's apartment, which had been featured in *Elle Decoration* magazine. Jarvis Cocker had seen the feature and thought it might be a good backdrop for the cover shot. The apartment used to be an Indian millionaire's bachelor pad in the 70s.

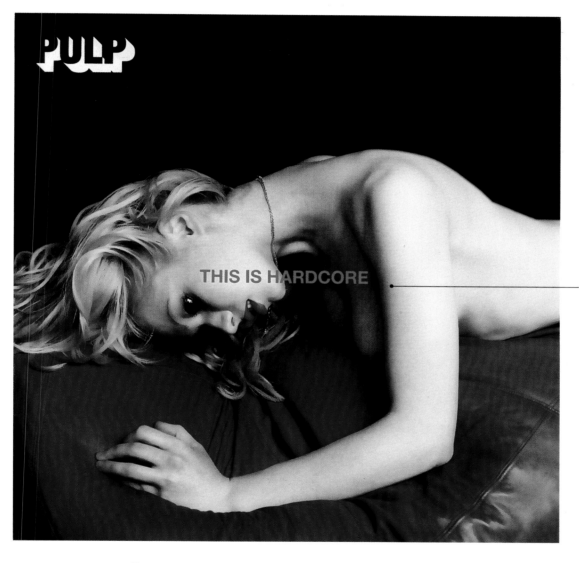

THIS IS NOT PORN
Peter Saville: *"The title was more about the 1997 spirit of Pulp – it was not about pornography. It was the new, hard, resolute spirit in Pulp. The band wanted to be taken seriously. Jarvis talked to us about fame and how it changes the world around you – yet you are still supposed to be the same person. He would go to a dinner party and was supposed to be the star guest, but to him everyone else seemed more glamorous."*

PETER SAVILLE used a censorship-type approach to the typography, as if it had been stamped on by the Board of Censors. The title was carefully positioned between the eyebrow, chin, and arm. The typeface was Helvetica Bold.

SPECIFICATION

- *Artiste* — Pulp
- *Title* — This Is Hardcore
- *Art Direction* — Peter Saville & John Currin
- *Photography* — Horst Diekgerdes
- *Design* — Howard Wakefield & Paul Hetherington
- *Record Co.* — Island, 1998

PRODUCTION
John Currin flew over from the States and had long sessions talking with Peter Saville about what this album was all about. John did a casting for a photographer, and chose Horst Diekgerdes, a fashion photographer. They then did a casting for people who looked larger than life. They shot Pulp with the extras within this tableau and created this weird world. The Hilton Hotel in Park Lane, London, was used for the location. Once the group saw the photographs, it turned out they were looking for a stronger, more hardcore image. Having run out of funds they shot the last day in Saville's apartment, which is where the actual front cover photo was taken.

THE PAINTERLY EFFECT
Howard Wakefield: "We used an effect on all the photographs on the album using an Adobe Photoshop filter called Smart Blur. It gave the photographs a very painterly quality."

OUTRAGE
The artwork was branded as sexist by graffiti artists around London. Poster's advertising the album were defaced with slogans such as "This Offends Women." In response, a band spokesman said: "Anyone who listened to the album and thought that Pulp are in any way sexist is a fool." Jarvis Cocker explained that one of the themes of the album was the deadening and dehumanizing nature of pornography.

KRAFTWERK, Trans-Europe Express

WHILE RESEARCHING Kraftwerk's *Trans-Europe Express*, the following fax arrived
from Herr Scumeck Sabottka of MCT, their management office in Berlin:
*"We have received your fax dated 11 August where you are requesting the artwork for Kraftwerk's
Trans-Europe Express. I've got confirmation from the band that you may use and print the
artwork which we will supply you with. However, the band members do not wish to answer your
detailed questions but they may send you an information sheet."*
However, we did not receive an information sheet, and therefore
in respect for Kraftwerk's wishes….

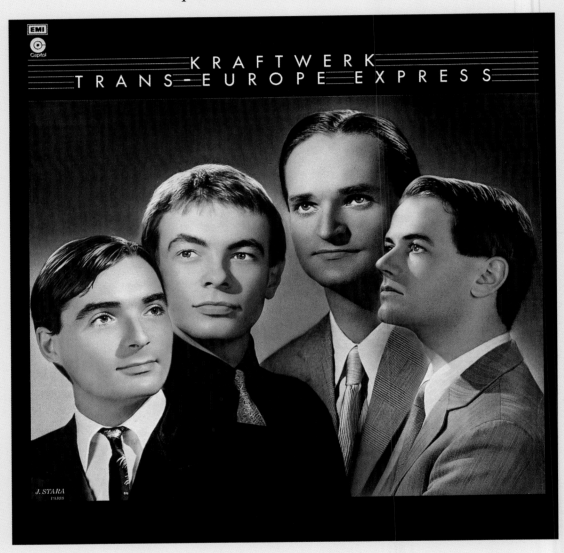

SPECIFICATION

- *Artiste* **Kraftwerk**
- *Title* **Trans-Europe Express**
- *Photography* **J. Stara, Paris**
 Maurice Seymour, New York
- *Record Co.* **Capitol/EMI, 1977**

JARRETT, PEACOCK & DEJOHNETTE, Tribute

HAND-DRAWN, HOMESPUN, semi-childlike, smudgy kind of lettering design is not uncommon, but good versions of it most certainly are. What distinguishes this piece, designed by Barbara Wojirsch for modern jazz players Jarrett, Peacock, and DeJohnette's tribute to three old jazz greats (Parker, Coltrane, and Davis), is the restrained execution. It is adroitly balanced, ethnic, and ink-stained, but never overdone. There is the split level of color, of title lettering, and of musician names. Of sky and grass, old and new. The colors themselves are simple – black and white and a slightly jarring but very cool, jazzy green and blue. And last, but by no means least, what distinguishes this cover design is the underlying idea; modern musicians still fly free (in the air) while below (underground) lie the departed old jazz musicians, buried but not interred. The

THE DESIGNER
"Barbara Wojirsch is an artist in graphic language. She works in collage and drawings and makes several solutions and ideas. She can work without a specific job in mind. Usually Manfred Eicher of ECM helps to select what images might be suitable for which particular project at ECM." – Dieter Rehm

WORKING COUPLE
Wojirsch and her husband Burkhart together designed many ECM album covers for artistes such as Keith Jarrett, Gary Burton, Jan Gabarek, and Chick Corea until Burkhart's untimely death. The sleeves that they produced together set a standard that is still successful today. Their use of typography, illustration, and photography always had a clean and pure approach that looks as new today as it did in the 70s. After Burkhart's death, Barbara carried on their shared legacy. The covers she has since designed on her own show a distinct and familiar style. The influences of designer Willi Fleckhaus and the Ulm School are also apparent in her early work.

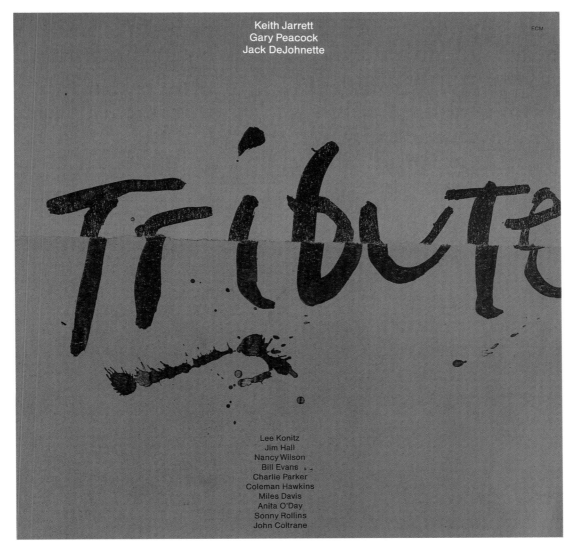

title, *Tribute*, is itself split-level. Joining sky and grass, bridging the two musically connected worlds, offset and unlevel, an affectionate testament to what those now owe to those who went before.

TECHNIQUE
The artwork consisted of two sheets of colored paper, the green with a torn edge laid over the blue. The title was written in brush script over both sheets using a water based ink as used in Japanese brush painting. The two papers were then nudged out of alignment. The traditional type at top and bottom were put on an overlay.

BARBARA WOJIRSCH
*Born on June 2, 1940, Wojirsch attended the Stuttgart Academy Of Fine Arts in Germany, where she studied painting. An essential feature of her graphic work lies in the expressive power of her drawing. Her delicate and distinctive style and her lacy handwriting feature in many of her pieces, such as **Conte de l'Incroyable Amour** (above left) for Anouar Brahem and the delightful cover of Barre Phillips' 1992 album, **Call Me When You Get There**, which features a scribbled map and travel directions on the front cover and an excerpt from a short story on the back.*

SPECIFICATION
- *Artistes* Jarrett, Peacock & DeJohnette
- *Title* Tribute
- *Design* Barbara Wojirsch
- *Record Co.* ECM, 1990

JOHN LENNON & YOKO ONO, Two Virgins

SO, HERE'S THE FULL MONTY. Or a half Monty, to be exact. Ths is the back cover of *Two Virgins*. Permission was refused to show the front, so you will have to use your imagination. Now, this is an outrageous album cover. John Lennon later declared "I wanted people to be shocked." He succeeded in not only shocking them, but turning off many existing Beatles fans. In an interview on BBC TV's *Michael Parkinson Show* he said, "The alienation started when I met Yoko. We fell in love and we married. A lot of people think that's odd, but it happens all the time. Yoko just happened to be Japanese, which didn't help much; and so now everybody thinks that John's gone crazy, and I know we did the *Two Virgins* album which also didn't help much!"

CORRECT EXPOSURE
Tony Bramwell, former head of promotion at Apple: "It was a Saturday afternoon. John called up and asked me to bring him some milk. I went over to the flat; Ringo's actually, in Bryanston Square, London. When I got there he said 'You know all about cameras. Could you set this one up for the correct exposure and on the delayed action timer?' So I set the camera up on a tripod in the doorway across from the bedroom."

THE NEXT DAY
"I went round and John handed me this roll of film saying it was a bit 'dodgy.' I took it round to Sky Processing in Maddox Street and explained that it might be a bit of soft porn. 'No problem' they said. When I collected the contacts they were quite shocked."

PAPER OR PLASTIC?
When the album was finally released in the US, it was sold in a brown paper bag with a circular hole cut out to reveal only John and Yoko's faces. It reputedly sold 25,000 copies in the United States and is today a vinyl rarity.

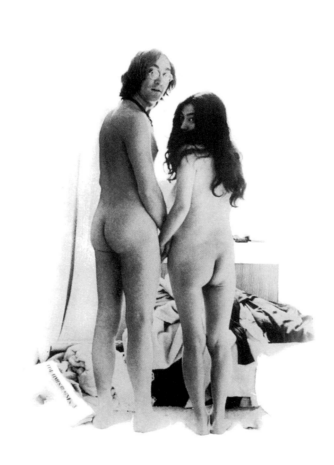

Produced by John and Yoko

EMBARRASSMENT
John Lennon always claimed that The Beatles' success had given him the power to do other things that would make people sit up and take notice. It was his idea to photograph himself and Yoko naked on the front and back of the album sleeve. Yoko, apparently, was embarrassed by the concept. She had already made an art-house film about bottoms, but claimed that she felt shy about appearing in the nude herself.

NUDITY
*In 1968 public nudity was making headlines with stage shows such as **Hair** and **Oh Calcutta!** John Lennon felt that he was breaking new ground by being so audacious. The intention backfired, creating bad press and poor public reaction, coupled with charges of obscenity and ripoff.*

SEIZURES
When a US record deal was signed by Artie Mogul of Tetragrammaton Records, the first imports were seized by US Customs and confiscated. The record was a commercial failure, but John felt it was "a statement."

FORBIDDEN FRUIT
*When the photographs and tapes for **Two Virgins** arrived at the Apple offices, Peter Brown, an Apple Corps executive, thought they were a joke and locked them away in his desk.*

BETTER BODIES
Sir Joseph Lockwood, Head of EMI Records and distributor for Apple Records, had a meeting with John Lennon, Yoko Ono, and Paul McCartney at EMI's headquarters. John had brought Paul along for moral support. Sir Joseph agreed to press the record but not to distribute it. When he asked what the cover meant, Yoko said "It's art," to which he replied, "I should find some better bodies to put on the cover than your two. They're not very attractive. Paul McCartney would look better naked than you." This didn't go down very well with John or Yoko.

ADAM AND EVE
There was a trial in the US for obscenity over the cover. Experts tried to defend it stating that the pictures were in the tradition of Christian iconography depicting Adam and Eve. The judge threw the claim out of court and the record company lost its case.

SPECIFICATION

• Artistes	John Lennon and Yoko Ono
• Title	Unfinished Music No. 1. Two Virgins
• Design	John Lennon and Yoko Ono
• Photography	John Lennon
• Record Co.	Apple, 1968

THE VELVET UNDERGROUND, The Velvet Underground & Nico

THOUGH THIS ALBUM COVER for The Velvet Underground is just a common banana, and though it has a rather obvious reference to male genitalia, and though it is just a straightforward silkscreen made from a simple black-and-white acetate film, it is a very successful record cover, and in the years after its release became a very collectable art print. Pop artist Andy Warhol had the uncanny knack of taking cheap ephemera, cheap ideas, and cheap packaging and turning them easily and spontaneously into expensive packaging, or what we call Art. Even his name was on the front of the album cover and not that of the band. Now, what instrument was it that Andy played?

MANAGEMENT
Warhol manager Paul Morrisey claims he discovered the group and added singer Nico so that there was at least one attractive member, then signed them to a management contract. Warhol paid for their equipment. According to Morrisey, Warhol made them famous by their association with his reputation as an underground film producer. Morrisey: "We presented the act in an elaborately staged film and light mixed media event called the **Exploding Plastic Inevitable.** *We also financed their first album and sold it to Verve. Andy was right in that there was no money made from the venture, as Lou Reed decided to disband the group in order to invalidate the management agreement before the record was released."*

DIRTY
Paul Morrisey: "The cover was one of many obscene suggestions put forward by whoever was standing around. No one remembers who suggested it, but everyone agrees that it was dirty enough."

TAKE A SOLO, ANDY!
"Nobody knew us or cared about us," said Lou Reed. "The prominence of Warhol's name created a persistent myth about The Velvets. Everybody thought Andy Warhol was the lead guitarist."

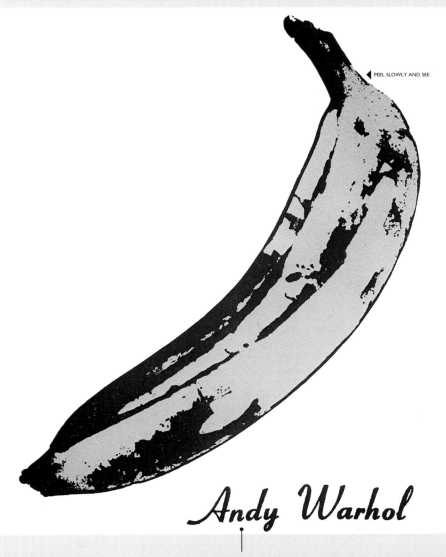

PEEL SLOWLY AND SEE

Andy Warhol

THE GATEFOLD
sleeve had a banana on the front that you could peel off, with the words "Peel Slowly and See" and an arrow printed next to it. When peeled, a pink flesh-colored fruit was revealed. Lou Reed told *Rolling Stone*: "The banana actually made it into an erotic art show."

ART SELLS
Before Warhol became involved with The Velvet Underground, manager Paul Morrisey spent most of his time inventing experimental films that Andy could present, or engineering personal appearances to earn income and increase recognition of his name – vital when trying to sell modern art. Realizing that experimental films were not capable of generating real income, he directed his film budget into managing a rock 'n' roll group, where the money seemed to be. Morrisey says that Warhol was frightened of the idea, didn't think it could work, and didn't want such a responsibility. Morrisey assured him that he could handle it.

A COVER UP
The Factory's artistic director, Ronnie Cutrone: "Someone employed by Verve had to sit there with piles of albums, peel off the yellow banana skin stickers and place them over the pink fruit on the cover by hand."

THE BAND USED Warhol's name as a means of being noticed – it was their first album and no one had heard of them. Later editions had the band's name printed on the front. Warhol's name appeared as author of the image and carried with it the idea that the music itself was some kind of "art" – not just popular music.

FIRST PRESSING
The original gatefold sleeve had a very short life, appearing only for the first pressing, after which the peelable banana and gatefold were dropped to increase the profit margin. A non-peelable banana would have been far less expensive to produce. Peelable originals have now become collector's items, changing hands for around $500 apiece.

SILK-SCREEN
To create the finished artwork, Andy Warhol took a photograph of a banana and transferred it on to acetate, pulling out any colors or marks he didn't want. He then made a photo-silkscreen and printed several copies.

SPECIFICATION
• *Artiste*	The Velvet Underground
• *Title*	The Velvet Underground & Nico
• *Design*	Andy Warhol
• *Photography*	Andy Warhol
• *Record Co.*	Verve, 1967

PINK FLOYD, Wish You Were Here

AFTER THE WORLDWIDE SUCCESS of *The Dark Side Of The Moon*, Pink Floyd were finding things a little more problematic than expected. They wanted to maintain standards in recording and on tour, but were having difficulty keeping their private lives together and the band intact. The theme of the album duly surfaced as "absence" – emotional and physical absence.

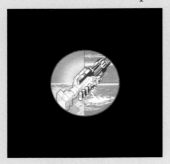

In relationships, when people withdraw their commitment – their emotional presence – and become absent, it is often for fear of getting hurt or being "burned." Hence a burning man – a man on fire. Even the actual album cover was "absent," wrapped in shiny black plastic and only visible when the wrap was removed after purchase. It is said that some purchasers, being keen Floyd fans, did not remove the black shrink-wrap, but slit it open along the edge to remove the record, at the same time hiding the cover design forever. What could be more absent than that?

OBJECTIONS OVERRULED
Hipgnosis thought that this cover worked well. CBS thought that the shrink-wrap was stupid – why do great graphics if you can't see them! They rang Steve O'Rourke, Pink Floyd's manager, to object. Their objections were dismissed.

OTHER IMAGES
Other images in the package continued the theme of absence using the four elements – earth, air, fire, and water – as motifs. The front cover was fire, and the liner bag was air, hence the red veil which made the scene behind less visible or more absent. In fact, there is a naked woman there if you look hard. There was a postcard insert for water (see below) that showed a person diving into a lake without a splash. No splash, perhaps no diver. A phantom diver, absent, but still present.

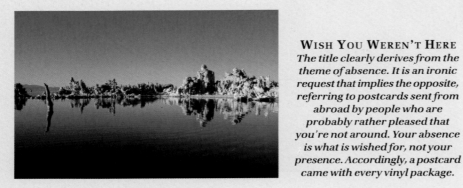

WISH YOU WEREN'T HERE
The title clearly derives from the theme of absence. It is an ironic request that implies the opposite, referring to postcards sent from abroad by people who are probably rather pleased that you're not around. Your absence is what is wished for, not your presence. Accordingly, a postcard came with every vinyl package.

THE LOCATION
for this photoshoot was the back lot of Warner Brothers film studios in Burbank – the land of make-believe, where nothing is real and all is absent.

THE DIVING MAN
In order to keep still long enough for the surrounding ripples to die away, the diver performed a yogic head stand. Photographed at Mono Lake in the Eastern Sierras of California, the diver used a special cradle apparatus positioned firmly on the bed of the lake. Thanks to his yoga skills, he was able to hold his breath for two minutes, or so. (Do not try this at home.)

SPECIFICATION
- *Artiste* — Pink Floyd
- *Title* — Wish You Were Here
- *Design* — Hipgnosis and George Hardie
- *Photography* — Hipgnosis
- *Record Co.* — EMI (Harvest), 1975

THE MEANING OF LIFE
The image on the left was intended for the album package but was not used. It has appeared instead in the song book and other assorted Floyd ephemera through the years. The image was photographed on 35mm transparency film with a Nikon camera using available daylight. What is not so clear is what the maniac swimmer is up to swimming in sand rather than water. Is he a fitness freak? Absent in the brain department? Did he emerge from the sea at such a great speed that he carried on up the beach and over the dunes, obsessed with the act of swimming, oblivious to his surroundings, and devoid of purpose? What is the point of it all? What, indeed, is the meaning of life?

RECORD LABEL
The label used the handshake motif – setting it against a night scene of pyramids and a full moon.

THE HANDSHAKE was considered to be an empty gesture. The businessmen in suits allude to the song 'Have A Cigar.'

DAVID GILMOUR: *"Despite the difficulties of having to follow a success like The Dark Side Of The Moon and the lack of communication within the band during 1974/75, we managed to make what I consider to be the best, or certainly my favorite, album of our career. The music to me is about space and solitude. Storm produced a cover that was a visual mirror, reflecting the sense of absence that pervaded both the music and the musicians at the time."*

MECHANICAL HANDSHAKE
The sticker art was illustrated by George Hardie, who worked closely with Hipgnosis both on the concept and on the artwork. This sticker was attached to the outer black shrink-wrap for identification. The mechanical handshake echoes the burning man's handshake, while the four quadrants refer to the four elements, the four band members, and the four faces of the package.

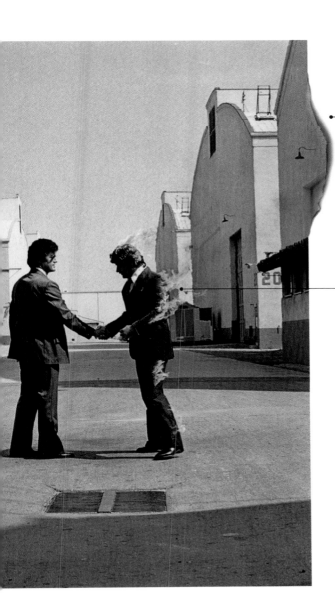

FRAME BREAKS
The edge of the white – not the edge of the picture – is singed. The idea was to suggest that the border had an edge, that it was real, and was a rectangular hole, or frame, through which one saw the scene beyond.

THE BACK COVER
A businessman in the Yuma desert offers the viewer a copy of Wish You Were Here, presumably at a really nifty price. He is faceless, his body is missing, as presumably is his humanity. This image was intended to reflect "Have a Cigar," a song on the album, and to utilize the image of earth, one of the four elements. It embodied Floyd's critique of the corporate side of the music business. Biting the hand that feeds, perhaps, or rather the glove, since the hand was absent.

THE BURNING MAN really is on fire, no retouching here. Stuntman Ronnie Rondell was doused with gasoline and set alight. He did, however, wear an asbestos suit and wig. The first take was very scary. The wind was blowing in the wrong direction, and flames were driven back against his face, burning his mustache – his real mustache. In the end, due to the wind direction, the shot was taken with the burning man on the left, shaking with his left hand, and the transparency flipped over for the artwork. Rondell: "It was pretty easy to do, not too life threatening, and paid well."

SHINE ON YOU CRAZY DIAMOND

This song, arguably Pink Floyd's most famous track, referred in part to the absence of Syd Barrett. Though not the founder of Pink Floyd, he was a prime mover in turning the band into something unique, and embodied much of the spirit of experimentation and atmosphere that were their hallmarks. Syd turned up during the recording of the backing vocals at Abbey Road, having not been seen for seven years. He looked pale and vacant and asked if he could help. There was nothing he could do.

WHY SO KOI?
*In 1996 a live version of the title song, "Wish You Were Here," was released as a single from the album **Pulse**. The image of a grim, black-clothed couple seated in a vet's waiting room holding their pet goldfish in fish bowls, comes from a line in the song: "We're just two lost souls swimming in a fish bowl, year after year."*

THE MOTHERS OF INVENTION, Weasels Ripped My Flesh

IT'S ALWAYS UNFAIR when asked to name a favorite book or film, because there are always too many. But if you were to hold a gun to our head, or a weasel to our flesh, then this cover design would be right up there with the best. The quirky style of Neon Park seems to perfectly convey the irreverence of The Mothers Of Invention. A suave but vacuous character from a 50s advertisement shaves with a live weasel, smiling inanely, as if enjoying it, while the rodent rips his flesh. The Pop-Art colors help to reduce pretension, giving it a trashy edge, softening the violent content to make it humorous rather than repellent. Altogether a sharp, crisp mixture of satire, meaning, and horror, and precisely what one would hope from those mothers of true invention, Neon Park and Frank Zappa.

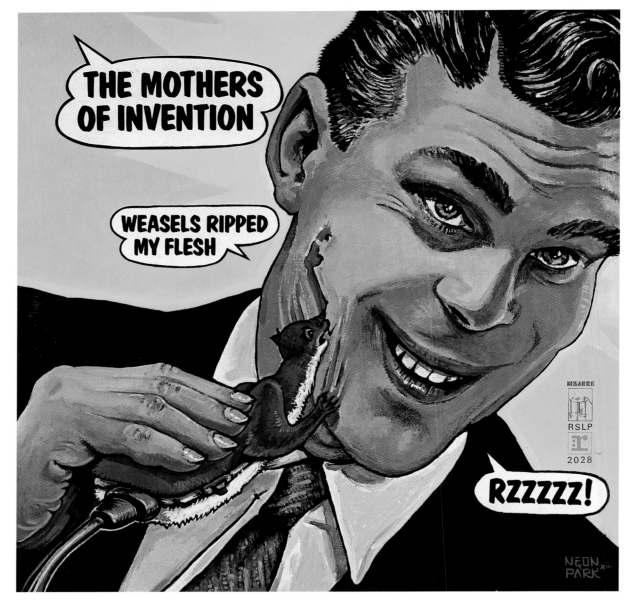

"ZAPPA HAD been captivated by the title of a story that had appeared in a men's adventure magazine, maybe it was *Argosy*, which was called 'Weasels Ripped My Flesh.' I believe Frank left it up to Neon to come up with the image." – designer Neon Park's widow

OFFENDED *Warner Bros. were not very happy about the album cover.*

RZZZZZ!

They said it wasn't up to their standard. Even after they finally consented to its use there were problems. The printer was really offended because his assistant wouldn't touch the painting. She refused to pick it up with her bare hands. Zappa and Park were tickled pink by all the fuss.

COMMISSION *Neon Park was working as a poster artist with the Family Dog, a San Francisco design collective, when he got a call from Frank Zappa. Frank had seen Park's drawings for a group called Dancing Food and wanted him to paint the cover of the next Mothers album.*

"NEON FOUND an ad for an electric shaver in an old 50s *Life* magazine," says Chick Strand. "It was of a man dressed in a suit and tie, shaving with an electric razor. The guy had bloody wounds all over him. Neon changed the razor into a weasel and that was it. In doing this he changed the manly image of a guy on a dangerous adventure to a city guy with an animal for a razor, and a big smile, content as could be, as if it was his daily routine."

THE CONTENTS

A collection of assorted snippets and live outtakes recorded from 1967–69, the album included appearances by Lowell George during his stint with The Mothers. Neon Park later produced several covers for Lowell George's band Little Feat (see below and page 56).

FOR THE FIRST and last time, Neon Park gave one of his paintings to a musician when he gave the cover painting to Frank Zappa. It didn't seem to mean much to Zappa, while for Neon Park, it was in recognition of Frank's incredible work – from one artist to another. Neon had no qualms about painting another larger painting, exactly the same, and selling it later.

Left: Little Feat, **Dixie Chicken,** *1973*

Right: Little Feat, **Feats Don't Fail Me Now,** *1974*

IN RETROSPECT
"I guess it was an infamous cover, although by today's standards it's pretty tame. It's not like eating liver in Milwaukee. I was greatly amused by the cover and so was Frank." – Chick Strand

SPECIFICATION	
• *Artiste*	The Mothers Of Invention
• *Title*	Weasels Ripped My Flesh
• *Illustration*	Neon Park XIII
• *Record Co.*	Bizarre/Reprise, 1970

MOBY GRAPE, Wow

WHOA, WHAT HAVE WE HERE? A humongous bunch of grapes on the seashore, big as a house, that's what. Grapes as big as a whale. Moby Grape. And who are those people coming ashore to look and marvel, and say "Wow, what's that?" Giant Dali-esque grapes propped up on a seashore, but not a Dali-esque seashore, more like one from an old etching (although, in fact, newly drawn from Victorian woodcuts by designer Bob Cato). The onlookers come perhaps from an older world, peering up at this strange arrival from a newer age. No band name or record title, just a massive bunch of grapes. Excessive, noisy, enormous, out-of-place grapes, but strangely fitting, gravely sitting, inexorable on the sand, in the bay of plenty. Sands of time, grapes of wrath.

"**THE GRAPES** represent us – everyone's coming in their boats to see Moby Grape, pointing at us as though we were some kind of phenomenon and they were all trying to see what we were about. That's how it felt at the time, and Bob just expressed that for us." – Peter Lewis of Moby Grape. The group were formed in San Francisco in 1966 and were allegedly named after the punchline of an absurd joke: "What's blue, large, round, and lives in the sea?" Answer: Moby Grape.

UNTITLED
According to guitarist Peter Lewis, the title was left off the cover because "At the time, we were into 'process' rather than 'product.' What was in the box was more important than the box. What we were saying with the music and the things we wanted to change were more important than the commercial aspect, and having no title on the cover put the emphasis on the music."

MORE PIE, DEAR?
*Wow's original title was **Hot Mom And Apple Pie**. Based on a photo intended for the cover, it had the band dressed as Superman and spacemen being offered apple pie by a "hot" granny. But during recording sessions for the album, singer Skip Spence flipped out, smashed up a hotel lobby and the studio with a fire axe and brandished it at CBS executives in their offices before being wrestled to the ground. He was institutionalized*

for six months, and nervous of having him pictured on the cover, CBS asked for another design.

SIGNING THE BAND
Though embroiled in a dispute with their manager over ownership of the band's name, Moby Grape were showered with record deals in late 1967. Offered a meaty financial package, they eventually signed to CBS on the premise that the label would extricate them from their management contract. They never did, and though the band attempted to swing a name change (they wanted The Cows) CBS preferred the better-known, catchy Moby Grape. Peter Lewis recalls an uneasy relationship between band and label, and that the only person at CBS that the band warmed to was art director Bob Cato, who Lewis remembers as being "not square at all – CBS wasn't as cool as the smaller labels, but Bob Cato stuck out from the rest – even though he wore a suit, he was still hip. We liked him, and we wanted him for the cover, as we felt he was the only one at CBS who understood us."

VICTORIAN WOODCUTS
Designer Bob Cato came up with the surreal cover image with no input from the band. Peter Lewis: "It was all Bob's deal – we just saw the finished product and that was it." The image was constructed as a collage of various Victorian woodcut illustrations, watercolor prints, and old pen-and-ink drawings, which were then hand-colored and painted over by Bob."

SPECIFICATION

- *Artiste* Moby Grape
- *Title* Wow
- *Design* Bob Cato
- *Illustration* Bob Cato
- *Record Co.* CBS, 1969

WOW

PETER ERSKINE, You Never Know

ECM's EXCELLENT ART DIRECTOR, Dieter Rehm, selected this image from Gabor Attalai because it so clearly expressed both the music of Peter Erskine and the visual philosophy of the label. A simple, but eloquent, piece of land art fashioned, presumably, by swinging the wooden bow backward and forward across the sand. Or was it wrought by accident? Or by unknown hands, by visitors from afar – left on the beach as a signal or message for us to find later? You never know. More fanciful is the idea that the position of the bow is purposeful, forming the character ∋ which is, in fact, a mirror E. An E for Mr. Erskine and for ECM Records. Guess we'll never know.

GHOST WRITING

"I find the interplay of the back and front photos very strong," says Dieter Rehm, *"not least, because they appear to have equal importance. I always love front and back solutions that reveal comparable degrees of tension. The front cover photo with the drawing of the wooden bow through the sand seems as if it was done by a ghost (you never know), while the back cover with the double circle in the sand and the flickering light on the waves evokes associations of a close encounter with extraterrestrials. Of course, you don't have to over-interpret, but can simply regard these pictures as pure and beautiful pieces of land art."*

THE TITLE

*Peter Erskine came up with the title **You Never Know**. What it meant for him specifically was that you never know what's going to happen when you make a record for ECM. He arrived at Oslo's Rainbow Studio with synthesizers and ended up making a very sparse acoustic piano trio album in the tradition of Paul Bley and Bill Evans.*

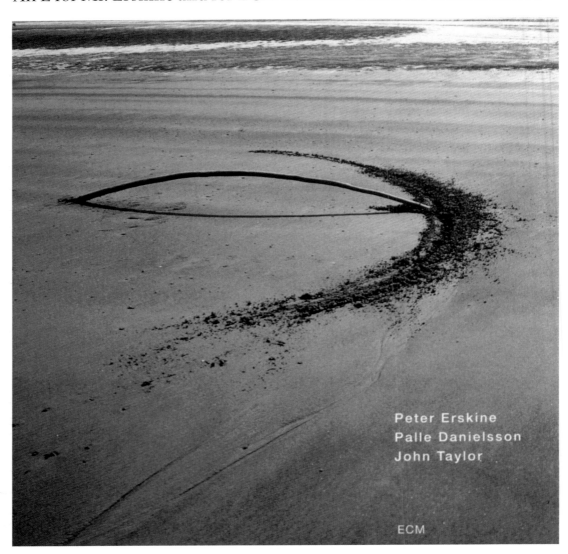

Peter Erskine
Palle Danielsson
John Taylor

ECM

GABOR ATTALAI:

"I drew the lines with a huge branch that I found on the lake shore. I pushed it into the sand, walking around. It signifies, in part, the idea of the negative. I worked many times with this dimension, using the word as a commercial sign, things I felt were banal – a reflection on our society in the 70s. Also, it has a romantic feel – I wonder how people in the 11th century first drew an arc for an apse in a Gothic church."

THE TITLE is left off

the front cover to avoid immediate interpretation of the photographic image.

VINYL FAREWELL

Dieter Rehm: "I'm still happy with the cover. I wish we'd had the opportunity to make an LP version. But ECM finally had to bow to the demands of the jazz market and give up on vinyl. Nonetheless, we miss the larger field that the LP cover offered and the opportunity to work with different paper textures. The CD format presents different challenges."

DIETER REHM

Dieter Rehm was born in 1955 in Memmingen, Germany. From 1974 to 1981 he studied fine arts at the University of Munich and with Professor Gerd Winner at the Academy of Fine Arts, Munich. He has designed album covers for ECM since 1979. In 1986 he began teaching photography at the Academy of Fine Arts in Munich. In 1981 Dieter Rehm won the Prix Special for Experimental Photography at the Triennale International, Fribourg, Switzerland, and in 1987 was awarded the Bavarian Government Patronage Prize for Photography.

THE LOCATION for the front and back photographs is the shore of Lake Balaton in Hungary. As an artist who is interested in combining different media, photographer Gabor Attalai made these pictures as part of his continuing work.

ECM STYLE

Sparseness and austerity are hallmarks of ECM cover design. In this case, music and title are combined with images chosen by Dieter Rehm and producer Manfred Eicher to make an intriguing trinity.

SPECIFICATION

• *Artiste*	Peter Erskine
• *Title*	You Never Know
• *Design*	Dieter Rehm
• *Photography*	Gabor Attalai
• *Record Co.*	ECM, 1993

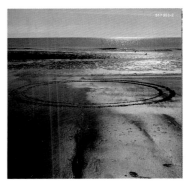

The back cover.

THANK YOU

Action Records, Wayne Adams, Jon Anderson, Sam Antupit, Martyn Atkins, Gabor Attalai, Nicholas Ball, Dave Barbarossa, Paul Barrère, Lou Beach, John Berg, Chris Bigg, Kim Biggs, Peter Blake, Arthur Blythe, Richard Boon, Dickie Braganza, Moshe Brakha, Warren Bramley and Factory Records, Tony Bramwell, Craig Braun, Keith Breeden, Neville Brody, Joel and Valerie Brodsky, Sam Brooks, Peter Brown, Steve Byram, Pat Carroll and Central Station Design, China Records, David Clayton, Anne Coffey, Collectors Records, Paul Conroy at Virgin Records, David Coppenhall, Alan Cowdray, John Craig, Jon Crossland, Cameron Crowe, Robert Crumb, Danny Cuming, Michael Cuscuna, Ronnie Cutrone, Davies and Starr, Dominic Davies, Justin de Villeneuve, Roger Dean, Warren Defever, Charles Dimont, Ian Dury, Andy Earl, ECM Records, Nick Egan, Michael English, Roger Eno, Arthur Ransome Evans, Tom Evered and Blue Note Records, Bryan Ferry, Robert Fisher, Patrick Forwood, Robert Franks, Jim Friedman, Martin Fry, Jill Furmanovsky, Peter Gabriel, Chris Gabrin, David Gale, Malcolm Garrett, David Gilmour, Kevin Godley, Leigh Gorman, Ahmed Gottleib, Jean-Paul Goude, Graham Gouldman, Derek Green, Gene Greif, Brian Griffin, Ida Griffin, Mick Haggerty, Tom and Clementine Hall, John Helliwell, Nigel Hartnup, Jeri Heiden, Mark Hess, Brian Hinton, Keith Holzman, Liam Howlett, Freddie Hubbard, George Hunter, Ian Hutchison, Kenji Ishikawa, Mick Jagger, David James, Alex Jenkins, Glyn Johns, Kenney Jones, Kazuhiko Kato, Pauline Kennedy, Jo Kessler, Andrew King, Karen Kirishima, Simon Kirk, Kosh, Jim Ladwig, David and Linda LaFlamme, Simon Larbalestier, Johnny Lee, Peter Lewis, Klaus Mai at KM7, Ray Manzarek, Dave Margereson, Graham Marsh, Fergus McCaffrey at the Michael Werner Gallery, Malcolm McLaren, Joe McMichael, Merck Mercuriades, John Michell, Barry Miles, Patrick Milligan, Russell Mills, Paul Morrissey, Susan Nash, National Academy Of Recording Arts & Sciences, Nick Neads, Dominic Norman-Taylor at All Saints Records, Rob O'Connor and Stylorouge, Humphrey Ocean, Ray Ohara, Vaughan Oliver and V23, Junie Osaki, Ruth Panscher, John Pasche, Doug Payne, Charlotte Powell, Prairie Prince, Ron Raffaelli at www.classicrock.org, Dieter Rehm, Jamie Reid, Jake Riviera, Wendy Robinson, Mick Rock, Murray Rose at Big Life Records, Michael Ross, Richard Roth, Jeff Rund, Ivor Watts Russell, Scumek Sabbotka at MCT, Koichi Sato, Peter Saville, Jeffrey Scales, Stephane Sednaoui, Norman Seeff, Bob Seideman, Adam and Val Sieff, Greg Shifrin, Maggi Smith, Kay Snowden and One Little Indian Records, Justin Speare and 4AD Records, Rachel Speers, Ringo Starr, Chick Strand, Sugerbush Records, Danny Thomas, Chris Thomson at Yacht Associates, Alan David-Tu, Pete Turner, Richie Unterberger, Tim Vary, Christian Vogt, Karl Wallinger, Nigel Waymouth, Malcolm Webb, Alan Weinberg, Kevin Westenberg, Paul White and Me Company, Snoo Wilson, Barbara Wojirsch, Matthew Wrbican and the Andy Warhol Museum, Tadanori Yokoo.

PICTURE CREDITS

Bridgeman Art Library, London/New York p.132 center left; Ronald Grant Archive p.91 bottom center; Collection of the University of Arizona Museum of Art, Tuscan, Gift of C. Leonard Pfieffer p.45 bottom right, p.88 center right.

Text passages quoted from the following books:
The Hollow Earth by Raymond Bernard, Citadel Press, Carroll Publishing Group, New York.
Both Sides Now by Brian Hinton, Sanctuary Publishing, London

DORLING KINDERSLEY WOULD LIKE TO THANK

Caroline Hunt; Neil Lockley; Julie Oughton; Mariana Sonnenberg; Flavia Taylor.

Album titles are shown in italics

BACKISPIECE
Undercurrent
Bill Evans and Jim Hall
United Artists, 1962
Design by Frank Gauna and Alan Douglas
Photography by Toni Frissell

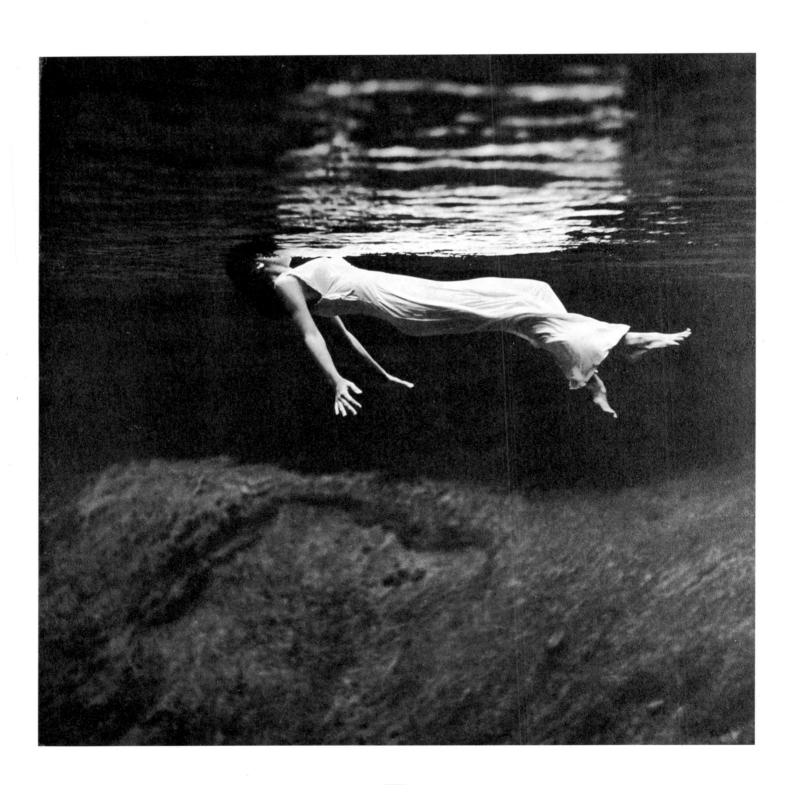